Willard Van Dyke

Willard Van Dyke

Changing the World Through Photography and Film

James L. Enyeart

UNIVERSITY OF NEW MEXICO PRESS ❦ ALBUQUERQUE

12 11 10 09 08 1 2 3 4 5 ɔ

Library of Congress Cataloging-in-Publication Data

Enyeart, James.

Willard Van Dyke : changing the world through photography and film /

James Enyeart.

p. cm.

Includes bibliographical references and index.

ISBN 978-0-8263-4552-3 (cloth : alk. paper)

1. Van Dyke, Willard.

2. Photographers—United States—Biography.

3. Motion picture producers and directors—United States—Biography.

I. Title.

TR140.V3786E59 2008

770.92—dc22

[B]

2008023196

Book design and type composition by Melissa Tandysh

Composed in 10.5/14 Minion Pro

Display type is ITC Zapf Chancery Std

Willard truly believed that art—once you got it right—
could change the world.

—Barbara Van Dyke
October 11, 1999

Contents

List of Illustrations

Acknowledgments

❧ I am deeply grateful to Barbara Van Dyke for her trust and encourage-
ment. She was indispensable in aiding and guiding much of my research,
and it is to her that we owe the care and preservation of her husband's leg-
acy. I am indebted to Murray Van Dyke and Neil Van Dyke for their gen-
erous help and cooperation. I am also grateful to Alison Van Dyke for her
reassurance, interest, and help. That both Van Dyke families assisted so
graciously reflects how important both are to this story.

I am indebted to the Pinewood Foundation for supporting my research
and travel and enabling me to devote time to writing. This book could not
have been realized without the foundation's commitment to the project.

Roxanne Malone, my colleague and spouse, provided indispensable
assistance by discussing and analyzing with me the human relationships
presented here. Her insight as an artist helped me to appreciate the com-
plexity of Willard Van Dyke's life and work. I would also like to thank Laura
Balderas and Kirsten Gerdes, who served as my research assistants at the
College of Santa Fe.

The following individuals contributed in significant ways, either by
giving personal interviews or by providing essential research assistance
and materials. I wish to express my deepest appreciation for their generos-
ity and interest: Richard Angelo, Miriam Arsham, Anthony Bannon, Tom
Barrow, Celeste and Armand Bartos, Leslie Squires Calmes, Shirley Clarke,
Howard Enders, Peter Galassi, Tom Halsted, Alexander Hammid, John
Hanhardt, Austin Lamont, Susan Landgraf, Ben Maddow, Adrian Mancia,
Linda Montoya, Doug Nickel, Gerald O'Grady, Richard Oldenburg, Ted
Perry, Vlada Petric, Katherine Pratt, Donald Richie, Dick Rogers, Amalie
Rothschild, Amy Rule, John P. Schaefer, Charles Silver, Ralph Steiner,
Rachel Stulhman, John Szarkowski, Mike Weaver, Murray Weiss, Cole
Weston, and Susan Zielinski.

I wish to acknowledge and thank the following institutions for their assistance: the Ansel Adams Publishing Rights Trust, the Columbia University Oral History Research Office, the Center for Creative Photography at the University of Arizona, and the photography and film departments of the Museum of Modern Art in New York City.

J. E.

Introduction

꿈 WILLARD VAN DYKE WORKED HIS WAY THROUGH THE TWENTIETH
century chasing two elusive muses, photography and film. They are elusive
because their powers to represent reality and create abstractions embody
morphic extremes that both exalt and mislead artists who believe that har-
nessing the one power will overcome the other. The setting for Van Dyke's
life story is thus connected to the story of how these two muses changed
the way the world was perceived.

It is no wonder that the world was unprepared for the invention of pho-
tography when it arrived. It was an astonishing event that turned science, the
concept of personal identity, and artistic conventions upside down, chang-
ing all notions about reality itself. When its invention by the French master
of dioramas, Louis-Jacques-Mandé Daguerre, was announced in 1839 as a
"work of genius," the art establishment stood back in horror. Art was about
to be seduced by science. Earlier, Daguerre's dioramas had infused theater
with a magical suspension of reality, which was the talk of all Paris. His
productions included an operalike stage, which contained moving painted
scenes that were cleverly lit by lanterns from the front and back to give the
illusion of the passage of time. As pastoral scenes were scrolled across the
stage, attendants walked the aisles of the darkened theater with contain-
ers of scented materials to engage the audience's emotional sense of smell
in relation to changing panoramas. For example, in an Alpine scene of

sentimental euphoria attendants carried buckets of daisies and goat manure up and down the aisles to recall with all authenticity the full experience of being there.

But Daguerre's photography went beyond illusion and imagination, especially in terms of its revelation of scientific time as the ultimate embodiment of existence. The very essence of life was frozen in place; time was stopped, producing likenesses so exact that the mind was fooled into forgetting the omission of color in its black and white rendition and changing forever perceptions of reality in both art and science. Edgar Allan Poe, for example, writing from the other side of the Atlantic for the popular press said that "all language must fall short of conveying any just idea of the truth. . . . For, in truth, the Daguerreotype plate is . . . *infinitely* more accurate in its representation than any painting by human hands."[1]

From as early as the fifteenth century painters had increasingly owed a debt to various apparatus fixed with lenses as an aid to their work. However, over the next several centuries, right up to the twentieth century, it became commonplace for painters to produce highly realistic pictorial impressions of nature without revealing their lenticular-assisted sources. And when photographs began to be used as substitutes for sketches in producing a painting, it became a deep dark secret.

Photography, on the other hand, had the burden of its scientific and mechanical heritage as an obvious source, becoming an artistic controversy overnight in revealing as it did all the blemishes of unadorned truth in the physical world. The idea of beauty and truth in art would be revolutionized as a result, and photographers would have to fight for the better part of a century for their unique artistic place in the art world.

In Europe photography developed within a bifurcated realm where critics, such as Baudelaire, claimed that photography was all science and could not be an art and "must, therefore, return to its true duty, which is that of handmaid of the arts and sciences . . . like painting and shorthand, which have neither created nor supplemented literature."[2] In spite of such protestations, by the end the century, a small number of camera artists in Europe and throughout the world began to receive recognition for their works even though most were imitative of painting. With the growth of the new medium came a new breed of artists who insisted on photography's own unique powers of expression. The struggle continued for the remainder of the nineteenth century but largely only in the mind of painters and poets, since the public welcomed the miracle images unconditionally.

In America, at the beginning of the twentieth century, Alfred Stieglitz admonished his artistic peers to embrace their medium as an art form with its own integrity rather than as one that merely offered pictorial imitations of painting. It was not an easy passage. There were those photographers who believed that photography was the perfect medium to appeal to emotions through romantic, "painterly" settings, and there were those who wanted something as raw and modern as the new work of modernist painters and sculptors. The clash between the two schools of thought was rife with rhetoric about photography's artistic principles but little mention about its relevance to society. The social question for American photographers in the arts would not arise until society itself began to fail early in the twentieth century.

At the end of the nineteenth century another discovery for image making came into its own. Born out of the technology of photography, film, or "moving pictures" as it was called then, made its debut and quickly developed from a medium that portrayed theatrical fantasies and illusions to one that recreated frightening spectacles of reality and offered silent depictions of epic subjects. By the twentieth century no one figure predominated in the spread of artistic film, but artists in Europe, Russia, Asia, and America produced individual artists who labeled themselves independent filmmakers in an attempt to separate their aesthetic and philosophic productions about the human condition and society from the populist dramas of Hollywood. Russian and French artists led the way in searching for the kind of unique expressive character inherent to film just as Stieglitz had done with photography. The idea of film as art, however, was as alien to the public as the idea of artistic photography.

Into this early twentieth century clamor for photography's recognition as an art form stepped Willard Van Dyke, who in the early to mid-1920s was among the few to bridge both photography and film. Through his broad-reaching vision he provided history with significant achievements in both. His works are admired by the practitioners of both mediums, and he is acclaimed in the literature of both fields. He was driven by an insatiable desire to effect change and a compulsion to gain power over systems and ideas in art and society alike.

Ever seeking greater challenges, he changed directions precipitously throughout his career, at times to the detriment of the depth of his accomplishments. There were, however, compensations—he experienced adventure and absolute freedom, which carried him across an exciting spectrum

of artistic concerns and brought him into contact with the personalities of his time. And in spite of his restless nature, his place in history is secure, largely owing to works he created during the 1930s and 1940s in close association with colleagues like Ansel Adams and Edward Weston in photography and Ralph Steiner and Pare Lorentz in film. These artists and many others with whom he worked during one of America's most significant periods of social and artistic upheaval collaborated on several projects, which became landmarks in the history of art, including in photography the famous Group f/64 and in film the great documentary *The City*. And when Van Dyke, in a Faustian manner, hungered for new human experiences and intensity of life born of a kind of hubristic rebelliousness toward convention, he entered the dark world of artistic politics as an arbiter of taste and history. He became an energetic player among the warren of experts at the Museum of Modern Art (MoMA) in New York, becoming its first director of the department of film.

If Van Dyke had one friend he could depend on throughout his emotionally driven life, it was Ralph Steiner, who was one of America's great modernist photographers and filmmakers. Steiner was one of the first photographers admired by Van Dyke when he was yet himself a young man in his twenties. Although they were separated in age by less than a decade, Steiner became Van Dyke's most caring mentor. In the thirties Van Dyke and Steiner collaborated on a series of documentary films that are among the best of the period. Their special bond was based more on their shared politics and attitudes about art than their personalities. Van Dyke was charming, competitive, and very serious, all of which owed to his small town protestant upbringing. Steiner was thoughtful, yet satirical, humorous, Jewish, and very much a New Yorker. Steiner was an important artist but also a cutting social critic. In his writing and no less in person, Steiner used humor as an irreverent weapon, honed to expose disingenuousness wherever he found it.

I met Steiner when he was in his late seventies, and in spite of his sometimes heavy-handed advice about how to make art and live life, he became a loving member of our family. I was happy to hear from him when he phoned one hot summer day in 1981 to propose that I meet Willard Van Dyke. He began the conversation sarcastically by declaring that Alfred the Great (Alfred Stieglitz) was a pompous blowhard. He had known Stieglitz, whom he disliked for his officious and preachy manner of speaking and because he disagreed with his view that anyone who might use the medium

commercially to make a living was not a true photographer. Steiner relished being an outsider; he worked for commercial interests with the conviction that good design inspired by the arts could change and improve the face of commerce. He had also allied himself in the twenties with one of Stieglitz's closest former friends and artistic collaborators, Clarence White, who left the fold to start a school that taught that aesthetic and commercial interests were not mutually exclusive. Stieglitz saw such ideas as sacrilege and artistic suicide.

Steiner ranted on that Stieglitz had abused music when he claimed it was a standard by which his own photographs might be judged. He abhorred fallacy but denied he knew the meaning of the word "truth," which he believed was worn by Stieglitz on his lapel like a medal from uncertain wars. Steiner's comments were a way of having fun with an icon whose photographs he admired but whose personality he thought could have used a little humility. In a light segue Steiner said how much he had enjoyed being entertained by our ten-year-old daughter who played the piano for him with passion and animation. His call that day was really about passion—the kind of passion one artist can have for the work of another artist, especially in the embrace of lifelong friendship.

It was of no small importance to me that this critical and insightful observer of photography and film had put his faith in Willard Van Dyke. Steiner ended the conversation by saying that his good friend had recently asked him what preparations had he made for his photographs and materials after he joined the other "hypo-stained saints of photography in the cosmic soup of oblivion." He told Van Dyke that he was placing his works at the Center for Creative Photography in Tucson and that Van Dyke should visit me at the center about his own work.

In the summer of 1983 Van Dyke did come to Tucson with his son Murray to talk about placing his life's work at the center. I recognized him from photographs made by another of his mentors, Edward Weston. Van Dyke was 5 feet 8½ inches tall with crisp blue eyes and sandy brown hair, Weston 5 feet 5½ inches tall with freckles and sandy brown hair. There was a striking physical resemblance between the two men during the 1920s, and their personal interests even more closely matched. They were deadly serious, yet lively, extremely social, and obsessed with women. Van Dyke could easily have been mistaken for one of Weston's sons. Cole Weston, Edward's youngest, said that he always thought that "He [Van Dyke] sort of looked like Dad in a way, and was a lot like him in other ways."[3]

Van Dyke and I spoke informally about Steiner and other photographers we both knew. We traded anecdotes about Ralph Steiner, Ansel Adams, Ben Maddow, Edward Weston's sons, Peter Stackpole, and Imogen Cunningham. All of these artists played significant roles in Van Dyke's early development as a photographer. As we discussed his work another topic arose, which was of equal importance to him. It concerned his memoirs, which he had been working on for some time.

Van Dyke was a talented storyteller and was known among his friends as someone who expressed himself emotionally and boldly. He had worked on his manuscript in the past with two different editors but was dissatisfied with the results of both. Ultimately he had begun to whittle it down himself to about two hundred pages, which he showed to me, cradling it as if it were a newborn. I agreed to help him with its publication, and he was looking forward to completing it but died before he could do so. In its incomplete state it was not publishable; he had reworked the draft so much that it had become a sanitized chronology of his life and accomplishments. And yet there were also extensive, beautifully detailed prose images, images as inspired as his photographs and films, especially when he unleashed his unusual talent for storytelling and narrative. In writing his biography I have benefited immeasurably from his memoir by being able to include such passages and other aspects of the best moments in his life as he offered them up for consideration.

Prior to our visit Van Dyke had asked Steiner to read and comment on his manuscript. Steiner secretly wrote me the following letter about his response to Van Dyke:

> I have for a year been offering advice until my wise wife tells me I will lose a fifty year friend. So into your hands. I will say this time to you that I have been urging that Willard write how it felt rather than how it was. For the dry, *was*, we have Beaumont's version [referring to Beaumont Newhall's books on the history of photography]. Caroline [his wife], a summa cum laude history major seduced me into reading good historical books by saying "history is not dates; history is people." And if ever there were people with blood flowing in their veins, it flowed in those Californians. Their lenses may have been at f.64, but they were wide open—sometimes too wide. I genuflect in your direction and will now forever hold my peace.[4]

Steiner's earlier advice to Van Dyke touched on issues that he found missing in his friend's writing:

Willard, my close friend:

A most bright photo editor dame visited for an afternoon and said she would send me a great book—"The Forgotten Ones" by Milton Rogovin. Yes, I too had never heard of him—a Buffalo retired optometrist.

. . . I'll never forget your passionate cry against life which you made at the Whitney: "I wanted to change the world!" I still hear it, and in a way it accuses me: what am I doing with clouds? Ah well, no answer to that but that I wanted to do them, and in life there are few 1 plus 1 equals 2 answers.

. . . Rogovin is talking [in his book] " . . . It takes photography, it takes sociologists, it takes working people, it takes teachers—a lot of different people to make a change. . . . Jacob Riis, when he was very despondent at the results he was getting, said he would go to a friend of his who was a stonecutter and he would watch him work. The stonecutter would hammer—would hammer that stone once, twice, ten times and nothing would happen. Fifty, a hundred times and nothing would happen. Then after the hundred and first blow, the stone would split, and Riis said it was obvious that it wasn't the hundred and first blow that did it. It was all of the blows together."

I'm certain that Rogovin was an old Socialist or Bolshevik and that his father was a pious Jew, crying out to God to make the world better. My failing to go any distance in liking the book . . . is that it is logical. . . . Think of the beyond-logic words, which helped defeat the Nazis and the Depression: "Blood, sweat and tears" and "The only thing we have to fear is fear itself." *Put some of your passion in your book.* From you we don't need logic.

R. St.[5]

In a subsequent letter, Van Dyke admitted to Steiner that he might not live to see his memoir published. He had by that time (1984) had three heart attacks over a period of twenty years, which he shrugged off as if he were overcoming the flu. Throughout his life heavy social drinking was part of his daily routine, and there was never a time when he was completely

monogamous. He confessed to his last female companion in Santa Fe (he was at the time still married to his second wife) that his memoir was mostly about his work and about the people who had something to do with his work.[6] He admitted that he had written little about his families, but that in the final analysis it was his work that was important to him and the people who influenced that work. What he failed to recognize was just how much his family relationships had also been a part of his work, especially that of his second wife Barbara.

The qualities that made him an exceptional visionary artist and film-maker (founder of Group f/64, recipient of several first prizes at the Venice Film Festival, and nominee for academy awards), included idealism, acute social consciousness, and a love for adventure, all of which were accompanied by an intense drive to avoid conventional modes of thinking in art and life alike. He tried to keep his addictions and trysts within the bounds of social acceptability by hiding them from view, hoping thereby to avoid injury to others and himself. However, nothing was ever so secret as he thought, which only intensified the inevitable hurt.

Van Dyke was also an uncompromising perfectionist whose idealism was accompanied by an obsessive need to control every aspect of his life. He fought the clock at every turn, commenting in his twenties that there was so much to do and how little he had achieved at his "advanced" age. When he was thirty years old he wrote a letter to Mary Barnett, his first wife, in which he imagined how he might be remembered.

> On this trip, and because of many trips and much sun and sky and because of hills with haystacks on them and a one-armed Frenchman who made good wine, because of days and nights of love, because of the blue Carmel sea, because of other faces in other lands—at last I am beginning to see what it is that I would like all of my still photographs to say when they are seen together.
> . . .
> There should be a body of work, of words and of images boldly made of silver. . . . The pain, the ways of life, and the ways of change, I shall record as I see them. That is my work.[7]

Austin Lamont, friend, filmmaker, and publisher of *Film Comment*, wrote to Van Dyke about his response to the manuscript:

You seem to have left a lot of things out of the book that I think should be in it. I think you should write about everything, put it all in, even the things you are uncomfortable with. . . . Many people will buy this book because they have heard of you, or love you or hate you. But you have the capacity to write about yourself and your times in a way that can interest people who have never heard of you. I think you should write for them.[8]

No one was more intimately familiar with the manuscript than Barbara Van Dyke, his second wife, who began a crusade after his death to have it serve as the basis for some kind of publication about his life and work. Although their thirty-seven year relationship was tempestuous and they were separated for the last six years of their marriage, Barbara and Willard Van Dyke's own story was a love story. They were together when he died and on her own deathbed, she continued filling in details for me in order that the complete story might be told. In a letter to Donald Richie, a close friend and colleague of Van Dyke's at MoMA, she wrote a revealing synopsis about the man she never stopped loving:

I happen to agree with Steiner . . . that much of Willard's innate story telling ability is missing in the book. He might have done better to have dictated and worked from transcriptions, but he didn't. I wish he had written a more intimate and forthright [auto] biography and less a litany of who he knew when he wrote of what he chose to select out of this not-un-complicated life.

What is missing in the book for me is Willard's very remarkable comfortableness with PROCESS. He didn't live by the rules, he could be maddening as well as charming and he could often switch opinions with lightening [sic] speed. But his native sense of the process of things kept him as a catalyst in all the jobs he held. He thought of himself as Gandalph [sic] and he wasn't too far wrong. Ralph Steiner really understood that part of Willard better than anyone. . . . There were 1,000 moments of influence and change that he affected either by being difficult or contentious or seductive and charming.[9]

In 1998, fifteen years after I first met Van Dyke and expressed interest in his memoir, Barbara Van Dyke and the unfinished manuscript reentered

my life. She was still knocking on doors trying to honor his last wishes. She had tracked me to my home in Santa Fe, and in her usual strong manner persuaded me to assist her once again.

Intrigued by Van Dyke's life and Barbara's relentless quest for publication of the manuscript, I suggested to her that it might serve as an important resource for a full biography. Barbara agreed, and because the road had been so long with so many unfruitful turns, she asked only that in my search for the missing stories and details I promise to make every effort to find Willard's "voice" and that the full story be told. In that regard, I remember well what Ben Maddow, screenwriter and poet and another collaborator of Van Dyke's, wrote to me about his own efforts in writing a biography of W. Eugene Smith:

> The purpose of a biographer, then, is to perform a miracle like that of Christ upon Lazarus; to bring up out of an archival grave in an alphabetical cemetery, the corpus of an artist surrounded by work as if by angels; and then to blow breath into his character, so that when we open the pages of his biography, he lifts up and speaks to us again; he shows us his numerous talents, his genius perhaps, and does not neglect to display his wounds and his vices. What makes Achilles walk and talk to us in the verses of the Iliad, is not only his heroism but his weakness: his Achilles' heel.[10]

In every aspect of his career Van Dyke gave much of his energy and commitment to organizing others who shared a passion for artistic ideals and social concerns. His drive to be an artist and yet simultaneously direct the energy of others inevitably helped him to break new ground in his work. His mature persona was an unsettled one that demanded constant action and diversity to satiate a lack of connectedness to the world; something that was deeply rooted in his childhood and his own nature.

History has reserved very few places for those like Van Dyke who was burdened with multiple talents. And to an even greater extent history is more adoring of product than process. There are very few artists who ever move from making objects of one kind to another or to advocacy (in the form of criticism, museum work, etc.) and return as artists to a favorable audience, which Van Dyke did the last decade of his life with measurable success.

So the contributions of this gifted artist cannot be gauged solely by his standing among other filmmakers and photographers but also must

be measured by the intensity of the life he lived on multiple levels in the art world and by his influence, which continues to have a ripple effect on artists and institutions. His story is about unrelenting devotion to social consciousness and artistic integrity, draped like a thick veil over his own failings and emotional isolation. It is about a man of great charm who could motivate the elite but who at the same time could not sustain personal relationships. It is about someone who wanted to "change the world" through his work. It is the story of every person who looks to professional achievement as the measure of who they are or hope to be, no matter what the consequences. It is also about learning not to confuse art with life.

1

Family History

✤ WILLARD AMES VAN DYKE, SON OF LOUIS WILLIAMSON VAN DYKE
and Pearl Ames, was born December 5, 1906, in Denver, Colorado, where he
lived until he was five. He then moved to Fort Collins where he developed
a lasting affection for the countryside and small-town life. At age twelve
his family moved again, this time to New Orleans for a short stay and then
to California, where he grew to adulthood and found his passion for pho-
tography and film. His family moved frequently throughout his childhood,
sometimes several times in a single year. The emotional and psychological
impact of not being able to develop a sense of belonging combined with
constantly having to adjust to new schools, friends, and social structures
contributed, no doubt, to the restless nature and strong desire for control
that characterized his adult self.

Nevertheless outside forces also have positive influences on one's life,
and for Van Dyke, growing up in the West had significant and lasting ben-
efits. The dramatic and solitary topography of that landscape and the ar-
dent individualism of the populace helped Van Dyke develop a sense of
self-sufficiency and independence. The California landscape and its natu-
ral wonders became the foremost resource for his growth as an artist. His
California years represented a period of time in which he referred to his
attitude about art as "man against nature." At age twenty-nine, he left Eden
(how he described northern California), and moved to New York, where

omnipotent and benevolent nature was replaced by a harsher world shadowed by the Depression and World War II. He evolved a more urgent sense of social consciousness and turned inward, searching for balance among the vagaries of art, social conscience, and his own psychological stew of demons and ideals. He now characterized his view of the world as "man against himself."

The few months he lived in New Orleans gave him yet another kind of perspective. When in later years during times of trouble he replayed his childhood experiences as adult pantomimes, he recalled his time in the South as one of the happiest times of his life. In the comfort of those memories he found a kind of emotional poultice for the wounds that life invariably inflicts on us all.

Van Dyke was the eldest child in his family; he had two sisters and a brother, a doting mother, and an absentee father. According to his memoir, he was greatly favored by his mother. He said she fawned over him and pushed him like a relentless stage mother, promoting and developing his precocious sensitive nature. She promoted his cleverness, in contrast to his father, whose rural Dutch ways dominated the fortunes of the family. But if this childhood memory was accurate or at least if his mother's favoritism was as blatant as Van Dyke recalled, there was, nevertheless, little apparent resentment of him by his siblings in their adult years. Family letters suggest the opposite; his sisters adored him, his brother eventually worked for him, and his mother was deeply concerned for her eldest child and seemed to want the best for him. Van Dyke, no doubt, felt his mother's constant attention to be oppressive and perhaps small incidents loomed larger than life in his memories. In many ways Van Dyke was frail and vulnerable as a child and his antennae were always out feeding his not insubstantial sense of self and creativity.

The Van Dyke family history in America begins with Hendrick Van Dyck, who emigrated from Utrecht to New Amsterdam (in Schoharie County, New York) in the early 1600s. It is noted in the Van Dyke family bible that he was an "Indian fighter who led a party against Indians at Greenwich in the winter of 1642." In 1640 settlers from the New Haven Colony to the west purchased land from the Siwanoy Indians. A short time thereafter, Dutch and English settlers massacred the tribe in a dispute over the land that became Greenwich, Connecticut. It is probably this battle that the unknown writer described in the family bible. Hendrick Van Dyck also served from 1639 to 1652 as ensign commandant and fiscal chief

of the West India Company under Peter Stuyvesant, director-general of New Netherland (Amsterdam). The sketchy genealogical history of the Van Dykes reveals that each of the male descendants in subsequent centuries, up to the twentieth century, served similar military tours of duty, a heritage common to most ancestral Americans.

Jacob Van Dyke is listed in the Van Dyke papers as participating in the defense of Middle Fort at Schoharie in 1780, serving as a scout and rifleman sharpshooter. Cornelius Van Dyke fought in the Revolutionary War in 1777 and later was a representative to the legislature at Albany. Lawrence Van Dyke served in the War of 1812 at Middleburg, and John Jay Van Dyke (Willard Van Dyke's grandfather) took up arms in the Civil War as first lieutenant for the First Illinois Light Artillery. Willard Van Dyke, aware of the paternal history of the Van Dykes, became a collector of firearms and was an avid sportsman.

Although there are records for the paternal side of Van Dyke's family, little was recorded concerning his maternal ancestry. His mother could recall bits and pieces from oral history. In letters to Willard Van Dyke from his mother (1884–1954) he learned that she was the daughter of a Great Lakes ship captain who owned his own fleet of ships. Her mother, who was French (née Chennault), was a cosmetician who made her own wares. Willard's mother was raised with all the benefits that Detroit's Victorian society could offer in education and exposure to arts and literature. In 1945 she wrote a long letter to Van Dyke, which reminisced about the past, particularly recalling what life was like in a large comfortable home on the banks of Lake St. Claire within commuting distance to Detroit. She wrote about her fondest memories of the family gathered round the family organ singing hymns on a Sunday mornings, noting "How very important music is in the category of cultural education. Even though one does not excel or become a great musician, the training has a definite influence."

Her conviction that it was important to be culturally educated, regardless of one's distance from actual cultural events and institutions, was a critical part of her influence on Van Dyke. His founding the short-lived but well-known coalition of like-minded photographers in California in 1932 known as Group f/64 was a way of creating a cultural forum for photography despite their distance from the East Coast. Alfred Stieglitz and the Photo-Secession group all but ignored West Coast photographers or so those of Group f/64 believed.

Willard's younger brother, Louis, and two younger sisters, Mary Catherine and Mary Carolyn, were still living at home during World War II and contributing to household finances, so when Mrs. Van Dyke would write to thank Van Dyke for his financial help it was about more than the money. It was also about their special bond. Willard described his mother very briefly in his memoir as follows:

> My mother was twenty years younger than my father and twenty-two years older than I. She was better educated than Dad, who had left school in the sixth grade. Years later he worked and studied, day and night for six months . . . so that he could receive his diploma from grammar school. My mother had graduated from an exclusive school for girls in Denver and had been given a scholarship for college [Stanford], but she never used it. . . . My mother encouraged any artistic tendency that she saw in me. She had played the violin and piano, had a little talent in oil painting, and was trying to make up for not having been able to develop her skills because of her own and her mother's illnesses when she was young.[1]

Foregoing her scholastic achievement because of an untimely bout with spinal meningitis and because education for young women held little practical value in society at the time, Van Dyke's mother spent several years recuperating, and by the time she was well she began caring for her mother, who had become blind from a degenerative disease, probably glaucoma.

It is almost certain that when she did marry it was in part to escape the life that fate had handed her. But love was also a prime ingredient of his parents' marriage, according to Van Dyke, even if it would have been thought unusual for his mother to marry someone as rough around the edges in 1904 as his father, a middle-aged man whose character had been forged by life as a frontiersman. He was without education and had no reliable means of support but spoke passionately about the future and opportunities for men with clever minds. He must have been charming and persuasive about his visions of what the future might hold.

Mrs. Van Dyke wrote to her son about her relationship with his father, recalling the difference in their ages, but assuring him that theirs was a happy marriage based less on romance and more on mutual devotion. Her family had opposed the marriage but in time came to accept it because of

their lifelong loyalty to each other. Van Dyke may have admired his parents for staying together, but he found marriage for himself a difficult way of life. He was married, divorced, married a second time, remaining separated during much of the second marriage.

Van Dyke described his father as a restless man, always convinced that a fortune awaited those who were in touch with rapidly changing technology. Among the seeming opportunities his father pursued, often leaving his family for months at a time, were investing and losing hard earned wages in a tunnel boring machine that failed before even one tunnel was completed in the Rocky Mountains; growing rubber trees, which died shortly after planting, in the Yucatán; and starting and losing a business for drying bananas that had overripened by being held on board ships too long to sell as confections. In nearly every circumstance these fragile dreams, as Van Dyke referred to them, were responsible for Van Dyke being raised predominately by his mother.

Van Dyke romanticized his father's failures as the adventures of a man coming up the hard way. He recalled in his memoir one day in 1918 when a man came to their house and drove away in the family Oldsmobile. His father, somber and quiet, took Willard by the hand and together they pulled a little red wagon to the neighborhood grocery store. His father spent his last few dollars on groceries and at age fifty-four took a job as a bookkeeper. Mr. Van Dyke's adventures had come to an end, but he was not short of self-esteem. A short time later he took a better paying position with the same company as a salesman of edible oils, a position he kept for the remainder of his working life.

In 1934, two years before his death, Willard's father painstakingly typed a nine-page letter to his children about his own childhood, a kind of teaching document in which moral lessons were to be gleaned from example. He wrote in a vernacular typical of his rural background (he had grown up in Florida). In other letters there is no hint of the rural dialect but instead a polished use of language and grammar. Among the stories he told were some with segregationist implications, which must have surprised and saddened Willard, whose life as an artist by that time was already dedicated to social justice and against any form of racism. Mr. Van Dyke prided himself on being a storyteller, a quality also attributed to Willard by his family and friends.

Willard recalled in his memoir the effect his father's absence had on the family. His father "dreamed on," in Willard's words, while the family

suffered from financial insecurity and lack of a place they could call home. Their nomadic lives were especially tormenting for the children and the strain on the whole family inevitably exaggerated the parents' difference in background.

As Van Dyke grew he carried with him the impact of those years, but as if blind to the source of his own disquiet, he was unable to sustain harmony in his marriages. The stress between his parents often resulted in periodic expressions of anger by his father, according to Van Dyke's second wife, Barbara. The result was that as an adult Van Dyke's emotions were close to the surface, a trait that may have contributed to his passion for the arts and fueled his drive to succeed as an artist but that cost him lasting relationships.

Barbara Van Dyke saw his relationship with his parents as unresolved issues that dramatically affected their own marriage of thirty-six years. But in spite of their living apart for a number of years, she was there to cradle him in her arms when he died on a cross-country trip from Santa Fe to Massachusetts. She had flown to Santa Fe to drive him to Harvard, where he was to be the university's first artist laureate.

Known for her own direct manner and for speaking her mind, she spent much of her life analyzing their quarrelsome exchanges. As in his parents' marriage, strong cultural differences and backgrounds tore at the fabric of Willard and Barbara's marital bonds. Van Dyke came from a vagabond life in the West and Barbara from a traditional, middle-class family in Chicago. But to the very end they professed a love for each other in letters, and following his death in a letter to the author, Barbara Van Dyke had this to say:

> The relevancy of this [Louis Van Dyke's autobiographical letter] is that, while his Dad was very dear and gentle to him as an infant and a very small child, when he became a "middle-age" child his father would lash out at him physically—for Willard something that came "out of the blue" and which terrified him.
>
> . . . Willard could never deal with any kind of anger toward him in a relationship, no matter how normal or justified it might have been . . . I think it was a factor that developed in him the charming seductive quality he had—a strategy for avoiding any kind of unexpected attack to his person. His careful control of his own anger did not mean that it didn't exist.[2]

When Van Dyke was twenty-nine years old and had moved to New York to seek a career in acting and film he received a letter from his father apologizing for the time in life when he thought that force was the way to teach responsibility. He admitted to having learned better. But it is also likely that Van Dyke's favored status in the family as a young boy resulted in personality traits that could be trying at times, if indeed he was not just outright spoiled. Nevertheless, the letter helped to restore Van Dyke's admiration for the good times in their lives.

New York was a new beginning for Van Dyke in other ways as well. He was also fleeing from an aborted engagement to be married to his high school sweetheart, and he was giving up a successful life as a photographer to become a filmmaker. Typical of artists of the thirties he was also becoming an ardent socialist. The lines between communism and socialism at the time were ignored by many artists and intellectuals in their efforts to make their work speak to the social injustices of the time. Van Dyke, in fact, renounced his work up to 1935 as no longer meaningful to him. The timing of his departure from Oakland for New York reflected his desire to seek a new life in order to fulfill what he believed was his destiny as an artist and to not let relationships interfere with that ambition.

His emotional sensitivity as a child had developed into deeply passionate feelings about his work in manhood. But this passion was plagued by stimuli that were not entirely free of shadows and distortions of memory. He suppressed his feelings about his father's shortcomings and at one point after his move to New York wrote to him soliciting memories of their happier times together. As time passed, Van Dyke began to create a mental portrait of his father that allowed him to speak to others in admiring detail of his father's life as a frontiersman in the 1880s, during which time he worked for the railroad, became an itinerant photographer of babies, and sought fortunes in South America. Indeed, he had forgiven his father for his anger, so much so that anything unpleasant was buried deep, far from conscious memory. Even in therapy some years later, it was his relationship with his mother that ironically became the focus of his discontent, not that with his father.

In the 1951 Van Dyke published an article about his father titled "And I Remember Polonius" in the November issue of the bulletin of the American Society of Magazine Photographers. By then Van Dyke was an established filmmaker and no longer making photographs; the article was an ultra-romanticized memorial to his father and an exercise in nostalgia for his own photography:

When I was eight years old we left Colorado to go to New Orleans where my father had some sort of an import-export business. Shortly after we got there I attracted a stray anopheles mosquito and a week or so later I came down with a fine case of malaria . . . and during these times of delirium and sweat my old man would spend a couple of hours each day by my bedside telling stories.

Perhaps it was because he had returned to the place where he had started out on his own that made him concentrate on the years of his life between eighteen and twenty-five, or perhaps it was just that he knew that his kid would like stories of the old West, or maybe he had a desire for me to carry out some of the things he left behind. I don't know, and I guess it isn't very important.

Van Dyke titled the article as he did because he believed that he was following his father's often repeated advice about being true to one's self (Polonius to Laertes: "This above all: to thine own self be true, / And it must follow, as the night the day, / Thou canst not then be false to any man").[3] By the end of the article Van Dyke had enshrined his father as the everyman socialist and philosopher that he so wished him to be:

I used to put a piece of gauze over my lens, or maybe kick the tripod leg when the shutter was open, and when I proudly showed the artistic results to my Dad he got a very strange look on his face and he walked to a window in the nice house where we lived and he opened that window and he spat out on the grass.

Then he turned around to me and he read me such a lecture that I've never forgotten it. He said that there was no excuse for that kind of technique, lots of people had been working for a long time to make plates faster and lenses better so photographers could make things look more like they really did look, he said, and that a long time ago there may have been some excuse for getting out-of-focus pictures and maybe sticking up some kind of phony background, but there wasn't any good reason for doing it any more, not for any son of his anyway, and by God I'd better change my ways or stop trying to be a photographer. A real photographer, that is, because a real photographer picks out the things around him that are important and then he shoots them so that anybody can understand them, and if his [technique] is extra good, people

will even see the things in a new way—with their inside meanings on the outside. If you are true to photography, Dad said, then it must follow as night follows day, you cannot be false to anything.

It took courage for Van Dyke to decide to go to New York with no experience outside of his small circle of friends and fellow artists in northern California. But he took with him a belief in the importance of being true to oneself, and many years later in the 1960s he drafted an unfinished letter to one of his then young children, trying to sort out his own childhood and growing up years.

For almost three years I have been meaning to write this letter. I've thought about it lots of times. Mornings when sleep was drifting back to wherever it may go in the daytime and nights when sleep was slow to come. These are times when I'd think about it most often. But in a way it has always been part of me, this letter, just as you have been.

What does a man think about his wife, his children, himself? Why is it so hard to tell them? Why does he always remain a stranger unable to share himself, incapable of knowing others? These are some of the questions that I have had in putting this letter onto paper. For you it may be that it shall have no value—for me it will have a great deal, because through it I will have made an effort to break through a wall. Perhaps one never makes that break, but this is my attempt. . . . When I was a very little boy I lived in Fort Collins.[4]

Many creative individuals like Van Dyke defy conventional patterns of behavior and create psychological stews of their own making. Imagination, the most forceful of all influences, becomes the primary interpreter of their memories, events, and circumstances. In Van Dyke's case, it is not possible to sort out with any exactitude whether hurt or inspiration had the greatest influence on the choices he made in his life. He colored his memories to reinforce his artistic aspirations, always distilling out the negative and burying it as deep as possible. In his mind he was doing just what Polonius advised, being true to himself.

2

Formative Years

The train pulled into the station and my mother took my big straw hat down from the rack above our seat. I put on my red coat and took my mother's hand. My father was already going down the aisle carrying my baby sister. I felt very grown up and proud. We had gotten up very early that morning in Denver and here we were in Ft. Collins where we were to live. I held my mother's hand as if to help her off the train. . . .

We lived on one side of a little square park where the library stood. I came to know the park very well. There was a kind of magic to it. . . . There was a ditch that ran all the way round it so that the grass would get water in the summer. Sometimes on hot afternoons they'd turn the water on and the little clover leaves would turn silver from the air bubbles that stayed on them. I was sure they were really silver and would reach down and grasp them carefully. But when I brought them up they were always just green.

. . . The little schoolhouse where I learned to read and write was erected in 1879. Carved into the sandstone arch above the doors were the words *Fiat Lux*, "Let There Be Light."[1]

VAN DYKE RECALLED FT. COLLINS, WHERE HIS FAMILY MOVED IN the spring of 1911, as another happy time in his life. It was where he saw his

first movie, *Cinderella*, by George Méliès, one of the earliest French masters of film. Méliès introduced magic realism to cinema by using multiple exposures, time lapse, and other inventive means to fool the eye and inspire the imagination. He created on-screen fantasies at the turn of the century, which made the unbelievable real with scenes of disappearing subjects, transformations (like pumpkins into carriages), and other feats of unworldly imaginings. For a little boy with a highly active imagination and sensitivity to the world around him the Méliès film was momentous; it opened the floodgates of his creativity, which would become his life motivation, impelling him to invent alternate realities.

Shortly after moving to Ft. Collins Van Dyke's father left for Mexico for nearly two years to import plants as cheaply as possible to produce a fruit tree orchard. He then made annual trips over the next three years to manage his business. Perennial financial hardship, combined with his father's restlessness, kept the family moving well into Van Dyke's adolescence. In Ft. Collins alone, during the five years they were there, they lived in six different houses on three sides of the park and on a farm.

Van Dyke described Ft. Collins as a peaceful place and as being of a size and shape a child could take in. It was, perhaps, because of his father's absence, which resulted in less turmoil for the family, that Ft. Collins became a pleasant memory. When his father returned from what was to be his last trip to Mexico, near the end of 1915, he announced that the family would be moving to New Orleans in order to launch his newest effort. Shortly after settling in the French Quarter, Van Dyke contracted malaria while playing games at dusk and watching movies at a drive-in theater. As mentioned earlier, his father told him stories at bedside about what it was like to be a photographer on the frontier in the early 1880s. He and his father were closer then than at any other time in life. It was Van Dyke's first glimpse into photography, which his young mind associated with the pleasure he found in movies, and movies dominated his interest more than anything else, even after he received his first camera at age twelve.

During the first two decades of the twentieth century film was silent and, like photography, depended on exaggerated visual impact and dramatic narratives to engage viewers. In grade school Van Dyke saw *Birth of a Nation* and heard D. W. Griffith speak. The experience implanted a narrative sense of cinema in his young mind, and indelible shadows of that influence would emerge in his own films in later life. In his memoir he recalled the impression that Griffith's film made on him in 1915:

One day in New Orleans our teacher told the class that there would be a wonderful movie coming to town and that the whole class would go together to see it. The movie was *The Birth of a Nation* by D. W. Griffith, who was touring the Country with the film, hiring large auditoriums and using his own projection equipment. He had commissioned a special musical score for the film and in large cities he hired twenty or thirty musicians to play . . .

Not a child spoke until the film was finished. As I rode the cable car home, the scenes played themselves over and over in my mind. I did not realize the implications of the clansmen's ride. I was too excited and thrilled by the realism that Griffith brought to the screen to understand that the film implied that blacks were getting "out of hand" and had to be disciplined. In one scene a black man chased Mae Marsh through the woods until, trapped, she jumped over a cliff to her death. Based on a folk tale that a person's retina retained an image of the last thing it registered before death, Griffith showed a doctor looking into the dead girl's eye with a microscope and seeing the face of the suspect. . . . Oblivious to Griffith's racism, for weeks after we played games in costumes made of sheets.[2]

New Orleans seems to have allowed for all the things that an eight- to eleven-year-old could order up for a day's activities: flying kites; playing in a nearby graveyard that held endless hiding places; catching crayfish in the backyard; and making popguns that shot chinaberries out of bamboo and green willow. But his life was about to take another more ominous turn. One morning in 1916, over shouts and angry exchanges coming from his parents' bedroom, he learned that they would be moving again, this time to Los Angeles. His father's business (salvaging overripe fruit from incoming ships to make confections) had failed, and they were destitute once again.

This time his father was going to build custom-made trucks in Los Angeles, Forschler dual frames, which could handle the rough brick and cobble streets in cities. Packing up their belongings, mostly what they could carry, they left New Orleans by train in the midst of a dark and menacing storm, which Van Dyke wrote about in an assignment for the fifth grade teacher at his new school. Titled *A Storm*, his little narrative revealed his inherited ability for storytelling, which was eventually reflected in his approach to documentary filmmaking:

The sky was overcast and it was growing still and warm. We were passing through old New Orleans in 1916. Father said it looked like a tornado. Suddenly the black cloud began to form into a funnel. Away off in the East we saw the funnel coming toward the ground. The train was beginning to go slowly. There was a humming that gradually grew into a wail. The wail grew into a long drawn out scream. . . . The train had stopped. The windows were all closed and the air was filled with shingles and flower pots. The tornado began to come towards the train. The train started. The tornado had just missed us.[3]

On their arrival in Los Angeles they were met at the train station by a young man, a friend of his parents from Ft. Collins. He was described by Van Dyke's mother as a rising young composer, who had written music that was fast becoming favored by touring singers and road operas. His mother had apparently met him in Ft. Collins when he was on tour with his company. She was a prolific letter writer and probably nurtured their friendship through correspondence, since there is no evidence of contact with him until they were in Los Angeles. When they arrived, her new friend helped them find a house to rent and gave them modest support while they tried to get on their feet again. But Mr. Van Dyke's dream of building trucks failed almost immediately, and by 1918 he was working as a bookkeeper for a cooking oil company, which required that the family move to San Francisco.

They lived there just a few months and then settled in Oakland. Finally, all within the same year, they moved to Piedmont (a town surrounded by Oakland) where they rented a house in an area in which Mrs. Van Dyke's desire for her children to go to the best school possible could be satisfied. Her friend, the composer, grew ever closer to the family and made frequent trips to visit them. But something was not quite right with all the generous gifts he was showering on the family and the very special attention he was paying to young Van Dyke. In his memoir Van Dyke recalled the situation briefly, but mysteriously. He stated simply that "the days were hot, the nights only a little less so, but at ten life was good for a boy. He has had little time to learn of much evil. Most of that lies ahead."[4]

Van Dyke described how at age twelve or thirteen the family friend began soliciting him for sexual favors. He implied that at first the invitations were subtle and then slowly became more explicit. But what he wrote about the circumstance falls short of claiming abuse. In adulthood he

shared with his second wife, Barbara, and a few other close friends that he was pressured by this situation until he was seventeen. At the time the friend was about thirty-five. The advances took place over several years and had a lasting impact on his relationship with his parents, whom he blamed for what happened. It was a terribly hurtful experience, which he described in his memoir as follows:

> My mother encouraged any artistic tendency that she saw in me. She . . . was trying to make up for not having been able to develop her own skills. . . . [and] that [may have] blinded her to the growing interest that [the friend] was showing in me. He had been financially supportive during the time in Los Angeles when my father was working as a bookkeeper to keep food on the family table, and he had bought a violin and saxophone for me. I was grateful to him for having introduced me to the world of music, and I enjoyed his company except for the time when he made romantic advances, which I could not respond to. His sexual preferences were not consistent with mine. During my seventeenth year I made it plain to him that there could never be the kind of relationship between us that he wished. To his credit he remained friendly with me and with my mother. So far as I know, Dad remained ignorant of the struggle that had been causing much turmoil for me.[5]

One of his assistants in New York during the mid-seventies recalled Van Dyke telling her about that period of his life and emphasizing the role he believed his mother played in the relationship. The story is filled with innuendo and contradiction; it's not clear whether he was actually abused or just felt betrayal at being propositioned by a trusted adult, not to mention family friend. Van Dyke's reported anguish does not easily dovetail with the fact that when he was in his twenties and thirties he remained in contact with the "friend" and traveled with him to Europe.

Beginning in adolescence and throughout his life Van Dyke had a very active libido. He was known by nearly every acquaintance to have had an eye for pretty young women. By the time he was twenty his sexual preference and affairs were solidly linked to what became a very long line of strong, interesting women.

Although it's not clear whether the relationship with the "friend" involved either physical or mental exploitation, the "turmoil" Willard

experienced as a result of it was very real and yielded one more unresolved, painful, incident in his youth. In a telling comment, written toward the end of his life, he still characterized the experience as "evil." He had had a lifetime to come to terms with whatever happened but was never able to transcend it psychologically. In moments of emotional stress throughout his life, he would confide in those closest to him about the event. Yet Van Dyke shows no evidence in his career of preoccupation with homosexuality, no evidence that he was either a homophobe or a homophile. Indeed, there is evidence that he was not homophobic; his commitment to social issues and human justice in his films and his later work at MoMA demonstrate his egalitarianism.

By age fourteen Van Dyke had received his second camera, a more professional folding model, and was making his own prints. But at the same time the world of film continued to offer more exciting opportunities for his precocious abilities. Through a contact of his parents' friend, he was offered an opportunity to work as an extra in a movie based on the *Rubaiyat of Omar Khayyam*. As one of hundreds of extras in crowd scenes, he found waiting for lighting arrangements, rehearsals, and scene changes an unpleasant bore. But when he was taken under the wing of one of the studio cameramen, he was instantly drawn into the illusory magic of the cinematic process, and this was a quality of the medium that remained potent for him throughout his life as a filmmaker. The cameraman gave him strips of film, cut from various scenes, and showed him how to edit and cement the strips together to create his own little films. With his salary of three dollars a day, young Van Dyke bought a toy projector and began to spend endless hours projecting the moving images on a pillowcase at home.

During this time he heard of a film that was making a stir in Oakland. It was hailed as the work of genius by those around him on the movie set but was considered disturbing and unsuitable for public consumption by much of the public press. One afternoon, after school, he stole away from home and rode his bicycle to Oakland to see for himself what all the commotion was about. To the frightful and thundering chords of the theater organist, *The Cabinet of Doctor Caligari* unleashed its graphic, otherworldly drama and captured Van Dyke's impressionable and raw imagination. He tucked the experience away as a vital stimulus among his own buried fears ("Caligari opened up some hidden fears and feelings in me that had never been touched."), and he went back every day for a week to absorb things

about the film, which changed his way of thinking about his own emotions, even at so young an age.[6]

Hollywood's silent films—its cowboy conquests and sanitized romances, which had been his movie diet up to that point—no longer satisfied his growing creative appetite. The visual banquet served up by *Doctor Caligari* fueled a newly realized desire for personal experimentation and self-expression. But his excitement for moving images waned as time went on because he lacked the ability to actually create and capture his own imagery. He felt deeply that he wanted something more than just to be the recipient of things that stirred his soul. He was being driven by urges to be the one who could make others feel things as he did. His original excitement for film was replaced by a growing interest in acting, which he did in school plays and organized groups. Fifteen years later, he would return to film as a career with his love for acting and theater intact as a part of his expression. In the meantime, he entered high school, made new friends, and began attending concerts and operas. He played the violin and saxophone in the high school orchestra and appeared in high school plays.

Van Dyke took his love of theatrics in an unexpected direction. Although he was smaller than average, he took up boxing in high school as a featherweight. He loved sports but football was out of the question. He also wanted to impress his father for whom physical prowess was intrinsically the measure of a man. But his boxing career was short lived and gave way to his more natural talents for the arts. In drama class, where he found most of his friends, he met his high school sweetheart, Mary Jeannette Edwards. They soon became inseparable, and by the time they entered college they were engaged to be married. Both she and Van Dyke loved photography, practiced it diligently, and were greatly aided by her father, John Paul Edwards, who was nationally recognized and regularly published as a pictorialist photographer.

In his memoir Van Dyke wrote that one night in early December 1924, just before high school graduation, he had a dream that changed his life. Although he had dabbled in making his own photographs and had not yet met Mary Jeannette's father, he points to this dream as the moment when he knew where all of his creative energies belonged.

> I dreamed that I was in a photographic darkroom, developing a print. I filled a tray with developer, placed the exposed paper in it, and watched with an emotion close to ecstasy as the image began

to emerge. What the image portrayed was not the important thing but rather the magic of the process. The darkest parts of the picture appeared first and then gradually the middle tones and finally the delicate details of the lightest areas. The result was a harmonious relationship that was analogous to a musical chord. It had been several years since I had developed any photographic images and then they had only been snapshots made with my first camera; this was something different. I asked my father for a Christmas present of a set of trays, a darkroom light, and some chemicals. I bought a camera with my own savings—a secondhand Graflex that allowed a certain amount of precision in seeing and focusing. The important thing was that the image through the lens could be seen upon a ground glass exactly as it would appear in the negative after it was developed.[7]

He photographed family, friends, and the town of Piedmont, but it was his portraits that caught the eye of John Paul Edwards, who, at the urging of his daughter, offered Van Dyke the use of his more elaborate darkroom and began to encourage and guide his interests in photography as an art. Van Dyke described his first impression of Edwards as follows:

He was a "buyer" for a San Francisco department store, and like a "Sunday painter," he had not developed his talent to the same extent that full time artists are able to do. . . . He showed me a number of his pictures: soft focus images of Monterey cypresses printed on matte, slightly textured paper; a view of Brooklyn Bridge, its supporting cables reminiscent of Gothic windows; a gargoyle looking out over a misty Paris; and a bromoil printed in blue ink depicting passengers on a transatlantic liner playing shuffleboard.[8]

Pictorialists like Edwards represented the dominant style of American photographers between 1900 and 1925. The major outlet for their work was a national publication titled *Photograms of the Year*, published annually. In 1925 *Photograms* reproduced a photograph by Edwards typical of the work described by Van Dyke. The image was of a cypress, entangled by its own knurled branches, sensuously cradling a wood nymph on a wind blown beach. Edwards gave a copy of this volume to Van Dyke, then a senior in high school, to acquaint him with artists in the field, which

included, among others, William Mortensen, a future nemesis of Van Dyke and other serious photographers. Earlier issues featured the work of Ansel Adams, Edward Weston, and Imogen Cunningham, all of whom became Van Dyke's friends and fellow artists just five years later.

The Edwards issue of the publication contained an article by the editor of the magazine, which made a prophetic statement about the state of photography. It harkened the end of the era represented by Edwards and other pictorialists and suggested a new direction for young moderns, a direction that Van Dyke would soon take up with great energy. The editorial focused on the following:

> The trend of the modern pictorial worker, as evidenced by the exhibitions, has been to get more and more towards what is euphemistically called "straight" photography. He is now primarily concerned with rendering the photographic process at its best as being something that cannot adequately be imitated by any other graphic process, and we find in the recent exhibitions a larger number of photographs that look like photographs and not like productions in some other medium of the artist.[9]

Within seven years of Van Dyke's graduation from high school, he had so matured as an artist that he was viewed by those photographers he had earlier admired in *Photograms* as a serious young colleague in their midst. By 1932 he, Adams, Weston, Cunningham, and others formed a group of like-minded artists. They produced a brief manifesto of photography, which amplified the editor's comments about the new modern era in photography, calling themselves Group f/64. Their work and their words were destined to make history.

By the time Van Dyke was eighteen he had become more self-confidant, in large part due to his success in theater and his association with a group of energetic friends, especially Mary Jeannette Edwards, who came from a family with a strong sense of creative accomplishment and a love of the arts. No stranger to deep feelings and intensity, Van Dyke developed an early understanding of the need for passion as an essential bridge to art and a consequent commitment to its demands for perfection.

For Van Dyke there were, however, still certain adolescent desires that needed to be fulfilled, including an ingrained desire for adventure instilled by his father's stories. So in 1925, following graduation, he and three

friends—Fred Bain, Don Flangus, and Bill Elliot—embarked on a three-week summer odyssey through four states in a half-hearted quest to find jobs and earn money for college. They piled a few belongings into a wreck of an old jalopy with bad tires, no top, and set off in mid-June for Contact, Nevada. Van Dyke kept a diary of the trip written in a narrative style in which he occasionally referred to himself by his name. A few excerpts from the diary reveal a delightful story of a meandering journey, which foretells his addiction in later life to adventure for its own sake.

June 14

Left Oakland at 6 o'clock p.m.—after many weary hours of packing and arguing. Stayed at the side of the road near Auburn this night. Fred found difficulty in making his bed and blankets surround his massive form. Listened to his many protestations against cruel fate.

June 15

Nearby stream furnished necessary fluid for morning ablutions. Ate breakfast at Colfax. Around eleven o'clock we found it exceedingly warm so we cooled off in the snow above Truckee. Donner lake looked wonderful in the sunlight. . . . We all feel dirty. We camped in Carson Sink. The spot we picked was beautiful in a peculiar way. Surrounded by reddish hued hills, which reflected the last rays of the setting sun very wonderfully. The golden shafts of sunlight flashed from the windows of a train at the foot of the mountains about four miles away. The sun sank behind the purple hills like a burnished disk of gold.

. . . We seem so all alone away out here. Don claims this is the original "Hell and gone." As I finish this, the wind is whistling mournfully around the corners of the car.

June 17

We left for Carlin after having the punctures of the day before repaired. The roads were exceptionally good for Nevada. Everyone was feeling fine, especially Bill who treated us to a few lessons in bareback riding on the hood. We arrived in Elko and Wells without event and then left for Contact. A few miles outside of the town we picked up one of the natives. The conversation I will try to repeat as nearly as I can. He asked us if there was any work in

Wells and this naturally led to our asking him about the jobs we had come to claim in Contact. He said, "There ain't nuttin to do here, all the mines is shut down." We then asked how the living conditions were. "There is 200 people and about one million mosquitoes for every person, three rattlesnakes to every street, and the sage is full of them sage ticks." This sounded interesting so Don asked him about the saloons. He said, "Them revenue officers come up here and shut up three saloons, but the other six is still worken." When we arrived in the town, we found his analysis quite correct; if anything it was a little bit modest. Laird Wilcox of the Gray Mining Company informed us that there was no work in town, so after waiting for the mail, we left for Twin Falls. We spent the night about 10 miles out of town; Bill and Fred on an ant hill and Willard and Don in the car. [The dialogue with a "native" of Contact, Nevada, had prophetic significance in relation to future Van Dyke films like *Valley Town* and *The Children Must Learn*, two of his most evocative films about poverty and the working class.]

June 27
We had a good bit of tire trouble, finally limping into Coeur D'Alene, Idaho on a flat tire. The detour before we reached this place almost proved our Waterloo, but the Jolly Roger gallantly survived the choppy sea. When we reached port, two of the fenders were very loose, threatening to leave us at any minute. Here we bought a new tire, a second hand tire, and [had] a spare repaired. Needless to say we feel better. [The ongoing saga with the car, as the quartet pushed it across terrain beyond its limits, was played out again in much magnified form when Van Dyke and his film crew drove the length of South America in 1941 to make a film titled *The Bridge*.][10]

The diary ends with the sojourners taking one last moonlight swim at the foot of Mt. Pitt (Mt. McLoughlin) in southern Oregon and then, having failed to find jobs, returning to their homes. The trip had been a rite of passage during which the four boys engaged in an abundance of male bonding rituals. Their carefree, aimless wandering across the landscape took their minds off their apprehensions of pending obligations, including earning a living or going to college.

Van Dyke was seriously involved in photography and only reluctantly enrolled at the University of California. He majored in public speaking and joined a fraternity but found that his new classmates valued athletics more than study. In an effort to belong he joined the boxing team only to be pummeled in the first contest by a classmate who went on to become part of the U.S. Olympic team. By the end of his second year he was facing a number of required courses he had avoided, including reserve officers' training. He said he found the idea of making reserve officers' training a required course in college repugnant and knew his father was very much antiwar. He was feeling more and more alienated from those things that he loved and gave him a sense of well-being, especially photography.

He dropped out of college and took a job as a messenger at a bank. A few months later he went to work for an insurance company helping to collect delinquent premiums. His supervisor was arrested for embezzlement, and he went looking for work again, this time at a cannery, which he quit after two days. He finally found a job at a gas station where he could work at night and photograph during the daytime. It also gave him time to pursue his love of adventure. A friend offered to teach him to fly, which helped the friend maintain his commercial status because it meant flying regularly.

The plane was a Great Lakes Trainer, a two-place cockpit biplane patterned after a bomber called a Hell Diver. . . . It was one of the few airplanes in the world that could make an outside loop—a maneuver that put the pilot on the outside of a circle, submitting him to great stress as the centrifugal force tried to throw him out of the plane. Any craft that could stand up to such stress was safe for any kind of flying as long as the pilot could fly at all.

Although I have had many wonderful experiences in my life, nothing could surpass the thrill of those hours in the air; the feel of the wind on my face with a white scarf trailing behind, the roar of the engine as we came out of a dive, the wonderful responsiveness of the controls, the whistling of the air through the struts as the engine idled on the approach to landing, and above all the feeling of control over gravity.[11]

For the next several years Van Dyke continued to rent planes and fly whenever he needed a rush. But the energy he drew from that kind of adrenal activity was soon replaced by his growing excitement for photography.

In 1928 he met Annie Brigman through John Paul Edwards, who had recommended Van Dyke to make lantern slides of her photographs for lectures. Brigman, then sixty years old, had been a member of Alfred Stieglitz's Photo-Secession in 1906 and was regarded with awe and respect for her pictorial work. Her romantic soft-focus images of nude woodland nymphs (her sister and herself) were reproduced in a number of issues of Stieglitz's famous journal *Camera Work*. It was an unusual honor for a "western" photographer, especially in view of the number of California pictorialists, like Cunningham and Weston, who were known through other publications at the time of the Photo-Secession (1902–17) but not included in *Camera Work*. Only one other western photographer, Ansel Adams, was accorded similar recognition by Stieglitz when he gave him an exhibition at his gallery, An American Place, in 1936. Stieglitz's reluctance to include more California photographers, especially Weston, was always seen as benign neglect of West Coast photographers. To most it represented a snub of their local artistic icon, Weston.

As history later revealed, both Stieglitz and Paul Strand (his closest cohort for many years) questioned the influence of Weston and saw him as direct competition to their dominance of the then fledging art world of photography.[12] In 1928 Stieglitz wrote to Strand that he thought Weston was a nice person but that he tried too hard to be an artist. Although Stieglitz seemed to have respect for the intelligence of Weston's photographs, he thought his cubist-inspired work was superficial and not creative. The underlying tenor of Stieglitz's and Strand's statements about Weston's photography was, in all likelihood, that they were concerned about the competition that his developing formalist style represented to their own modernist ideas based on European influences. They could not ignore his growing recognition and influence but could lock him out from the New York photography scene.

Stieglitz was also miffed in the years that followed their first meeting in 1922 because Weston did not acknowledge him as an important influence. After Van Dyke met Weston in 1929 he adopted Weston's disdain and dislike for Stieglitz even though both he and Weston continued to admire his photographs. Many years later, in a letter from the mid-1970s, Ralph Steiner renewed the discussion about the difference between Stieglitz and Weston:

I ordered Edward Weston's second daybook—California. I hold the thought of reading it as a reward at the end of the day's work. I

read slowly—treasuring—holding back—not too fast. How unlike, thank God, Alfred—how un-pompous. Many of his problems I relate to. What direct joy in borning [birthing] things theretofore unknown. I can't guess what all those hordes of women were like. There were, I'd guess, more lost people in California in those days who needed someone kindly, knowing who he was, and with a penis. He did have ample ability to be bored with what wasn't central to his life and work, but it seems to me he may have been too gentle to shoo away the flies with enough vigor to keep them away. Stieglitz' response to Weston's work: "not enough fire—not related to today." Just another example of what makes people today refer to him as the Clubman—taking pleasure in blackballing anyone who didn't kiss his feet. I've reread Norman's "Stieglitz," the Seer. "Seer," my ass. . . . Weston built no pedestals under himself. I must say that although Paul [Strand] did not use the word "TRUTH" a lot, he never did think of himself as a genius—or at least talk in those terms. He talked about tomorrow's printing problem and such. On him who would glitter, the sun never shines.[13]

At age twenty-two, when Van Dyke met Brigman, he was already fully committed to photography. His night job gave him the time to totally absorb himself in the literature of the field, especially *Vanity Fair*, and to spend endless hours putting into practice the principles and process demonstrated by Edwards. But when he met Brigman his creative juices began to surge like never before. Brigman's work was far more erotic and adventuresome for the time than anything he had experienced before. Her home was also a gathering place for artists and writers of the region. In the spirit of the twenties, it was a place of alternative lifestyles, which mirrored the social iconoclasm of the speakeasy and jazz.

Howard Zinn wrote about this period of American history in his masterful study of social conflict in America, *A People's History of the United States*:

> There was some truth to the standard picture of the twenties as a time of prosperity and fun—the Jazz Age, the Roaring Twenties. . . . The general level of wages for workers rose. Some farmers made a lot of money. The 40 percent of all families who made over $2000 a year could buy new gadgets: autos, radios,

refrigerators. Millions of people were not doing badly—and they could shut out the picture of the others—the tenant farmers, black and white, the immigrant families in the big cities either without work or not making enough to get the basic necessities.[14]

Typically, most artists of the period lived modestly by some means of commercial subsidy. Brigman freelanced, making portraits, writing, and producing commissioned works for publication. The majority of her politics and her views on social issues, mores, and cultural participation were revealed through her works of art and the environment in which she lived. Van Dyke described her as follows:

She lived in a little studio in a barn on an unpretentious street [683 Brockhurst] in Oakland, California. It became the center of a considerable amount of creative activity and a meeting place for many kinds of artists. . . . The entrance was through a wild and lovely garden dominated by a venerable wisteria vine whose trunk I could not encircle with my hands. For a brief time in the spring it blessed the space around it with a profusion of bright blue blossoms. It was then that Annie would declare that the gods were smiling on the earth once again and call for a celebration. Friends said that fair young men, dressed in velvet smocks would gather around the great old plant and drink mead while they chanted and sometimes recited poetry.

This took place long before I was aware of Annie, but after I became her friend I heard the story. It was completely in character. Her photographs were of the soft focus school and often Annie would take off her clothes beside some secluded mountain stream, set up her camera with a time-release shutter, and pose as a naiad or a woodland nymph. Photography for Annie was not the result of certain predictable chemical and physical reactions; it was a mystic rite that some people had learned from the gods. Thus, that tale of her sensuous paganism, although probably apocryphal, suited her perfectly. Her ardent love of nature surfaced even in domestic decisions. When the barn was being remodeled a problem arose in building the bathroom. The only logical place to put it had a lovely tree happily growing in the exact spot. That was no problem for Annie; of course there could be no question of removing the tree.

All the carpenters had to do was build the walls around it, provide a hole in the roof for its trunk, and hang the shower from one of the lower branches. If one were to shower during a rainstorm, that was all the better—the rain could come through the roof around the trunk and add to the piped water. A true daughter of Zeus, Annie never interfered with nature.

The winters in Oakland were chilly and a little heat was welcome, so a fireplace was built in the barn. It always smoked a little, but that was a minor inconvenience. The walls, however, presented an aesthetic problem. They had never been finished, and the rough studs and boards presented unpleasant surfaces to the eye and touch. But one of Annie's young friends, William Justema, had a solution. [He covered the walls with tea paper and monks cloth on which he painted patterns.] Billy was an acquaintance of John Paul Edwards and a protégé of Margarethe Mather, Edward Weston's early photographic partner.[15]

Mather had been more than a partner to Weston. She had introduced him to the larger world of demimonde sensibilities in her circle of friends and through her soirées. She was lesbian and open toward all sexuality. Justema was gay. Justema once told me that he believed there was real love between Weston and Mather but that they never consummated that love sexually. It was also Mather who helped usher Weston out the door of pictorialism and into the era of modern artistic ideas. Her own photographs from the late teens and early twenties were inspired by Japanese woodblocks and had a real sense of cubistic geometry.

About a year later Brigman moved to Southern California to live with her sister, leaving her studio, darkroom, and home vacant. Some months later Van Dyke wrote and offered to rent her place. She readily agreed, and he began what he referred to as "one of the happiest and most productive periods of my life."[16] In addition to John Paul Edwards, Brigman and Imogen Cunningham became the strongest influences on his life and his work at that time. Van Dyke had asked Edwards to introduce him to Cunningham, whose work was familiar to him from issues of *Photograms of the Year*. Her work, though pictorial, had begun to evolve into a very individual modern style as early as 1916. When he arrived at her house, carrying his first real portfolio of photographs, he was dressed in his finest. Throughout his life Van Dyke always gave special attention to his clothes, which might be

characterized as elegantly casual. On this occasion his appearance had an unusual effect on Cunningham:

> I think I wore saddle shoes and a white turtleneck sweater. Imogen poured some tea, we chatted a bit and then she looked at my photographs, five of them. . . . She was polite, but not very enthusiastic. Later I learned that she told someone that I was nice enough but that I would never be a photographer, I was too pretty. I was amused by her vitriolic quality and we became close friends. Ansel [Adams] used to say that she had three percent acetic acid in her blood, but behind her acerbic exterior was a sensitized, warm, observant human being. . . . Small and slim she nevertheless had strength born of determination and love of what she could do with a camera.[17]

On another occasion he remarked that

> there were times when she would let me have her studio for an afternoon if I had a particularly urgent reason—some young lady whose house we couldn't use—and Imogen would conspire to bring this young love affair to a reasonable conclusion.[18]

In the converted garage that included Edwards's darkroom, which was used by Van Dyke, were piles of hundreds of magazines and pictorial annuals. While his prints and negatives dried, Van Dyke immersed himself in the work of photographers published in *Pictorial Photography in America*, *American Photography*, and *Camera Work*. Most of what he saw was soft-focus, romantic landscapes made in a style that imitated the look of etchings and paintings, except for *Camera Work*, which offered something more. The photographs were reproduced in rich, warm-colored gravures on paper of the finest quality. The design was elegant and modern, and each issue was filled with critical essays by photographers and critics. As the official journal of the Photo-Secession (1902–17) the photographs and articles were intended to present both the history of the medium as an art form and the leading edge of photography of the time.

Stieglitz had borrowed the secessionist concept from a German and Austrian movement in painting with the intent of making his group provocative. His goal was to gain attention and to promote photography as an

art form equal to other arts and to compel recognition of its independence from the florid picturesque imitations of salon photography. Van Dyke understood the zealousness of Stieglitz. It represented the kind of passion he could identify with, and he acknowledged in his memoir the importance of being able to see so much of the medium's history in *Camera Work*. But by 1928 he was also hearing from his older colleagues about the arrogance and self-importance of Stieglitz.

In a book published a few years later by Thomas Craven, critic and historian, entitled *Modern Art: The Men, the Movements, the Meaning* this other aspect of Stieglitz was laid bare:

> In the bedlam of half-baked philosophies and cockeyed visions in 291 [291 Fifth Avenue, Stieglitz's gallery], he [Stieglitz] shrewdly managed to hold the position of arbiter, to maintain a reputation for superior acumen. He did this, it seems, by an intuitive sense of the fundamental weaknesses in the gabble that enveloped him. By no means an intellectual and untrained in the handling of ideas, he had a talent for re-assembling notions and presenting them in a prophetic style which, veiling their inherent weaknesses, made them more inspiring and important in his own mouth than in the mouths of the original purveyors.[19]

The issues of *Camera Work* were more than a decade old when Van Dyke first saw them, but the last issue containing the work of Paul Strand was a revelation to him:

> The portraits of a sandwich man on the lower East side in New York, a blind woman, a white picket fence, and two men standing in the shadows of the elevated train were fresh and commanding . . . [were] unlike anything I had ever seen before. The magazine was even printed on paper different from [that used for] conventional pictorial work: smooth double-weight stock more suitable for Strand's subject material, rather than the usual thin rice paper that would have been used.[20]

Stieglitz wrote that in this last issue of *Camera Work*, Strand had struck a new note foretelling a fresh approach. Less than a decade later, Van Dyke and Strand would become friends, share their political ideals, and work

together in New York. But Strand's hard-line extreme left stance would eventually end their relationship. Van Dyke attributed his own socialism to his father, but in all likelihood it was an accumulation of influences from the intellectual and artistic circles of the day. When he met Strand, his socialist convictions were largely unstructured. His political views were more in the spirit of the leftist idealism that characterized Sinclair Lewis and Lewis Mumford.

Van Dyke continued to be influenced by pictorialist photographers, including Edwards and Brigman, but was more inspired by Cunningham's geometric sense of composition. He described his own images as "pictures of back-lit eucalyptus trees against a misty valley, shadows of branches cast upon a white-washed wall, the receding arches of a Spanish mission portal."

In 1929 the Palace of the Legion of Honor in San Francisco held an exhibition of photographs by various photographers. Van Dyke and Mary Jeannette went to the opening with her father. There they saw three galleries filled with a preponderance of pictorialist works. But two photographs by Weston, who Van Dyke did not yet know, caught Van Dyke's eye. One was a profile of a squinting man, his dark skin shining in the sun, and the other was of a single nautilus shell in subdued light. Both photographs were sharply focused with unusual definition in all of the tones. He returned to both images several times after surveying the galleries.

The profile of the man was a portrait of Manuel Hernández Galvan, a general and also a senator in the Mexican government during the period when Weston was in Mexico with Tina Modotti, his lover and fellow photographer (1923–26). Galvan, a gregarious "man of action" as described by Weston, was shot and killed by a political opponent a short time after the photograph was made in 1924. Galvan had been mixed up in factional wars for control of the government by a succession of anti-Catholic presidents, including Alvaro Obregón. The Mexican government had kept in force the constitutional edict of 1917, which restricted the Catholic Church and its activities by forcing church closures, banning religious gatherings, and permitting other forms of religious persecution and oppression. Finally, a grassroots rebellion that became known as the Cristero War took up arms against the government, particularly in the western countryside. Coalitions of women from all classes led the challenge, followed by their husbands, sons, and brothers who fought long and bloody battles with the Federalists. Obregón was assassinated in 1928, and Galvan's death may well have been

tied to this historic conflict. Weston described making the photograph and Galvan's death in his journals:

I wanted to catch Galvan's expression while shooting. We stopped by an old wall, the trigger to his Colt fell, and I released my shutter [he was using a hand-held Graphlex camera, an experimental departure for him, as he usually used an 8 × 10-inch view camera]. Thirty paces away a peso dropped to the ground—"un recuerdo," said Galvan handing it to Tina.

... Shot dead by political opponents, as I had guessed. The murder took place in "The Royalty" where three years ago Llewellyn and I used to sit over hot rum punches. He had no chance—fell dead across his table, shooting as he fell, but shooting with eyes already dead. I suppose one might say he died as should a man of action,—but it was a monstrous tragedy.[21]

The photograph of the single nautilus shell was from a group of shells Weston had photographed on his return to Glendale, California, in 1927. Peter Krasnow, a painter and lifelong friend of Weston, took him to visit another painter, Henrietta Shore, who was an important influence on Weston's vision. Although Weston's early interest in photographing objects began with folk crafts and his famous *excusado* in Mexico, he first saw nautilus shells in Shore's studio and as subjects in her paintings. He borrowed a group of shells and began his own interpretations. In his daybooks he was careful to describe the experience as one of stimulation and not copying another artist's vision. He admitted the significant role that Shore played in pushing his work into its next stage of a more coherent devotion to form for its own sake. He also noted that he felt free to borrow inspiration from anyone in the form of subject matter or life-expanding experiences, which he did from Margaret Mather, Tina Modotti, Henrietta Shore, and many others, including his apprentices, as time would reveal in his future relationship with Van Dyke.

In Mexico Weston had been making startling sculptural images of folk objects and vernacular subjects like the painted edifices of *pulquerias* (bars), and he experienced a growing obsession with form in its most primitive state. By the end of his stay he had evolved, producing a study of his apartment's toilet titled *Excusado*, which ignored the utility of the object and treated it as a glorious, polished, sculptural form, equal in every way to

the modern abstract works of Brancusi. He was already treating nudes in the same manner—not as naked bodies but as direct sensual forms.

Finally, Van Dyke asked Edwards about the works in the exhibition and Edwards told him they were by a friend of his, Edward Weston. Van Dyke told Edwards that he was intrigued by the photographs but wasn't sure he liked them. He asked Edwards if he would introduce him to Weston. Weston was standing in a corner observing the crowd when they walked up to him. In his memoir Van Dyke described his impression of meeting Weston for the first time:

> Weston was a small man with sandy hair, freckles, and a mous-tache. Habitually he wore plain grey trousers, but his eyes betrayed a sense of humor that rapidly came to the surface when he was amused. His way of looking at a woman made her feel happy with herself and very feminine, a reaction that often revealed her feel-ings. In all the years I knew him, I never met a woman who was not attracted to him. I liked him at once, but I was a little in awe of him and his photographs puzzled me. They were not like any other pictures I had ever seen.[22]

Meeting Weston was a defining experience for Van Dyke. For weeks he could think of nothing else. He knew his life had been changed, that it had to change, and that somehow he had to find a way to understand why he was so drawn to Weston's work and to him.

❧ Portraits of
Williard Van Dyke

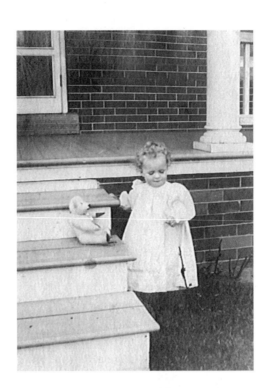

1. Willard Van Dyke
at age of one year, 1907

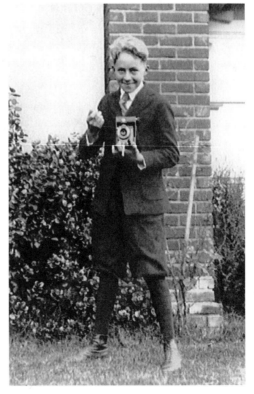

2. Willard Van Dyke
at age of twelve with
first camera, 1918

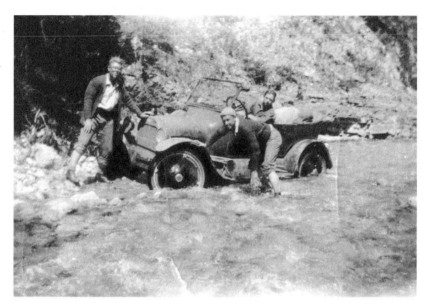

3. Nevada trip, Willard Van Dyke and friends, Van Dyke driving, 1925

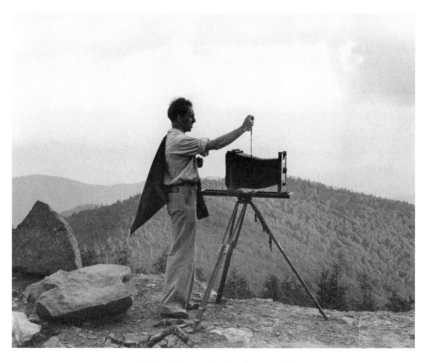

4. Willard Van Dyke, California, 1929

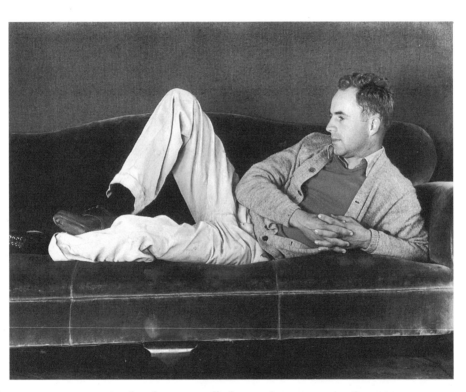

5. Edward Weston, Willard Van Dyke in Weston's studio, 1933

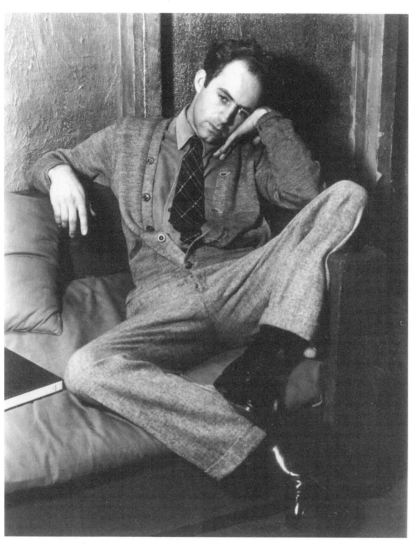

6. Edward Weston, *Willard Van Dyke in Weston's studio*, 1934

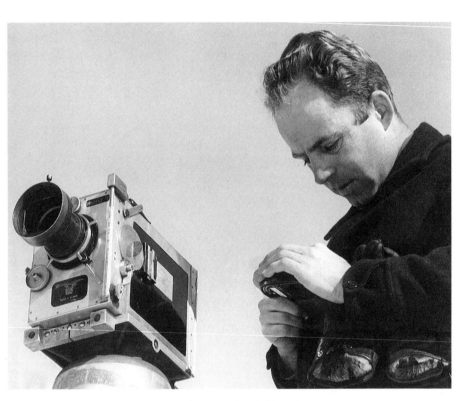

7. Willard Van Dyke shooting *The Children Must Learn,* 1938

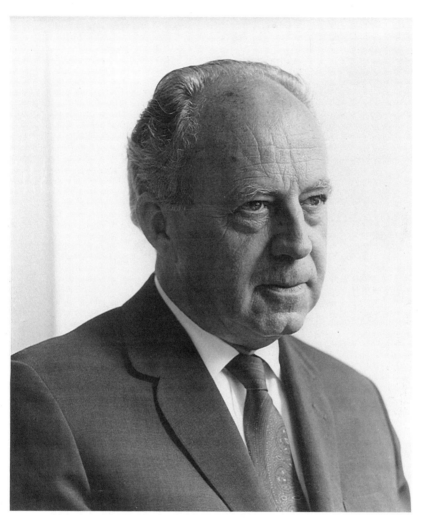

8. Willard Van Dyke, 1965

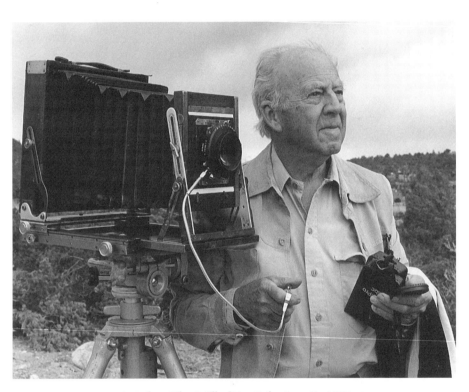

9. Robert Gilge, Willard Van Dyke, Santa Fe, 1982

3

The Weston Years

✦ ABOUT A MONTH AFTER THE EXHIBITION AT THE PALACE OF THE Legion of Honor, Weston returned to San Francisco to give a lecture at a small gallery in Berkeley that screened experimental films and presented lectures on photography. Weston was forty-two and by 1928 was an established artist of international fame. He had made dramatic changes in his life, having left his family to live in Mexico with Tina Modotti, where he developed a body of work that was to become one of the hallmarks of American modernism. He had also been to New York where he met and developed relationships (sometimes contentious) with Alfred Stieglitz, Paul Strand, and Charles Sheeler.

Van Dyke attended the lecture, having thought a great deal about the photographs of Weston's he had seen at the exhibition. Following the lecture Van Dyke shyly approached Weston to talk to him about his work and to ask if he took pupils. Weston said he never took pupils and abhorred the idea but that from time to time he had taken on apprentices. Most of Weston's apprentices had been women, who also became his lovers, something Van Dyke could not have known at the time. He told Weston that if the time was ever right again, he would love to serve as his apprentice. But in his gut he believed that Weston's comment was just a polite put-off. Over the next several months Van Dyke worked hard on his photography, trying to teach himself the meaning of the modern vision he had observed in

Strand's work in *Camera Work* and heard Weston speak on at the lecture. He turned first to landscape, nature, and portraits with the same sense of stark drama he had observed and felt in the works of Weston and Strand.

He admired Weston's apolitical views even though he considered himself somewhat of a socialist. But Van Dyke was not an activist at age twenty-two, and the artistic milieu in which he circulated was essentially cynical about politics, politicians, and the economy. He and his community of like-minded friends lived a life of withdrawal from all but their coveted concerns for art, music, and a desire to live life as they wished, not as expected by society. Their self-made ideology denounced materialism, expressed concerns for the oppressed workers and poor of the world, distrusted all forms of hierarchical governments, and insisted on their rights as community-based independents. But not being engaged in any form of activism, they belonged to no formal organizations and did not endorse the theories of Karl Marx or others. Their socialism was more of a lifestyle than a political philosophy.

The superficial prosperity of the Roaring Twenties gave no hint of the dark days that lay ahead for them and their youthful laissez-faire way of life, not to mention the world at large. In 1928 there were few signs of the catastrophes to come, worldwide economic failure and nature's wrath in the form of devastating drought. Even the most perceptive minds among the country's leaders in industry, agriculture, and the economy, including the White House, could not foresee the coming of the Great Depression.

Van Dyke had grown up poor and heard stories from his father about the unending poverty of the rural South. But now he lived on his own and was responsible for his own destiny, economic and otherwise. He had also taken a job at a filling station, not just to support his photography but also because he and Mary Jeannette were planning to be married. They kept their engagement to themselves for the time being, but they had begun to make long-term plans.

In September, just a couple of months before his twenty-third birthday, Van Dyke received a letter from Weston saying that he had a little time and if Van Dyke could make the trip to Carmel, he would be happy to look at his work and consider having him around for a while. Van Dyke was elated but nervous. He had only made eight photographs that he thought amounted to much, and two of them had been made after he saw Weston's work at the Palace of the Legion of Honor. One of his photographs was a portrait of an athlete very much in the style of Weston's portrait of the

Mexican politician Galvan and the other was a geometric abstraction, a close up of tracks left in sand by a steam shovel.

Van Dyke took his slim portfolio to Carmel; in his reminiscences he described the meeting—Weston, he said, was very generous with his praise for his two most recent photographs. They were "in the mood and spirit of the kind of work that he did—they were sharp and clean, and had great depth of field."[1] In an interview, Van Dyke pointed out how Weston "picked those [two photographs] out too. He said that he couldn't teach me anything, but if I wanted to come down and play around, why fine. So I went out and hocked my car or something and got an 8 × 10 view camera. Of course, that's what he was working with."[2]

Van Dyke had just committed himself to Weston's influence in ways that he could not imagine, and he would learn things about a way of life that would remain with him forever. Imogen Cunningham, a new friend of Van Dyke's and an old friend of Weston's, described Weston and his work in an excerpt from a letter she wrote to Weston himself in 1920. This extraordinary letter provides wonderful insight into Weston and reveals the depth of Cunningham's wit and intellect, beyond her famous blunt exterior. Even though it was written nearly a decade before Van Dyke's visit, it offers a timeless peek into Weston's work and persona:

Dear Edward Weston:

Do you know that from a very indefinite and uncertain personality you emerged into a very vivid one for us up here? Roi [Partridge] and I have often said since that it was seldom given to anyone to make such a fiery strike, such vivid and warm impressions. . . . I'm thinking of you and your work now and who in heaven's name could offend you by calling you sentimental. It is pure brains and intellect spread all over the photographic surface. This recalls your latest effort brought to us by Mr. Hagemeyer. I think so many things about this "Ramiel in the Attic" that I can't say them all at once as I feel them and should like to say them. Of course it is clever, you know that, but it is much more. If that doesn't make old near sighted Stieglitz sit up and look around for and at someone beside the seven constellations, I don't know what could. It has Paul Strand's eccentric efforts, so far as I have seen them, put entirely to shame, because it is more than eccentric. It has all the cubistically inclined photographs laid low.

… I know why I pour all this in your ear, just as I did when you were here, because like animals and children, who intuitively recognize their friends, I felt at once that you understand and appreciate what and why the "Rune of Women" is. Why is all this as it is and when will it not be so? . . . I see you just conquering worlds in a new environment. It is what we all need at some time in our lives.[3]

Cunningham's remark about the "Rune of Women" refers to an ancient Celtic alphabet (c. 400 A.D.) that was used to devise secret or magical messages by whoever constructed the message. It was also a way of divining the essence of one's internal powers. In this case Cunningham was probably referring to the prejudice against and oppression of women in the arts. She, like Mather, Modotti, Brigman, and other women photographers of the period, were strong personalities who found in Weston a sense of appreciation for them as artists.

When Van Dyke returned to Oakland, he made arrangements for a friend to cover his job for two weeks. He rushed back to Carmel with his sleeping bag eager to sleep on the floor of his new mentor's studio. He accompanied Weston to Point Lobos and the beach on Sundays and whenever the days were especially sunny. On bad weather days he worked with him in his darkroom. But the initial experience for Van Dyke was anything but promising:

> That first week was absolute hell. Because here was a monster of a thing [the 8 × 10-inch camera]. And every time I tried to set up the tripod, it was like a W. C. Fields act. One leg would slip out in one direction and then the other one. I wouldn't get the legs tightened up and so it would collapse forward. For years he [Weston] laughed about that in his sympathetic kind of way.[4]

Van Dyke, however, soon became accomplished with his new camera, which opened his eyes to a new aesthetic vision of his own. The approximately one hundred works that he produced during the years he knew and worked with Weston reveal that he was greatly influenced by Weston but also that he had his own special way of treating landscape, architecture, and human-made objects. Van Dyke's work was more about formal isolation and the abstraction of his subjects, where Weston's was about the subject itself, as he wrote in his daybooks:

The approach to photography must be through another avenue[;] . . . the camera should be used for a recording of *life*, for rendering the very substance and quintessence of the *thing itself*, whether it be polished steel or palpitating flesh.[5]

Van Dyke described his own work as being about the narrative qualities of a subject. But he also emphasized visual pleasure, a pleasure born of edges and shapes engaging in a geometric abstraction of the subject. The notion of straight photography, as it was later articulated by Van Dyke, was a combination of both visions. He described his first week with Weston as follows:

We'd get up in the morning, both of us being fairly early risers, about 6:30 or 7 o'clock, as soon as it got light. . . . Then Weston would always have coffee and a cigarette. . . . We would talk a little bit, I'd have a cup of coffee, and then we'd go to the beach or to Point Lobos, or to some place close by, and he would just walk around with the camera, and he'd see a rock or a tree or a curve of the shore or something of that sort, and he'd photograph it. I would watch him and try to absorb what was going on in his mind, but keeping quiet all the time, and I'd occasionally make a photograph myself.

Then at noon, sometimes we took sandwiches with us, more often we'd drive back to Carmel, which was only a couple of miles, and have a very light lunch, usually grapes or some other kind of fruit and Triscuits. Triscuits he loved. And we'd have a glass of milk usually, and dried fruit and Monterey Jack cheese. Then we'd go back and take a short break, and then go back to work again until the light got lower in the sky and it was too dark to work. Often I'd gather mussels that were clinging to the rocks. We ate simply and lived simply, and talked photography almost all the time.

Lots of times we would go through photographs that I hadn't seen before in reproduction—packages of photographs that he'd take down off his shelves and open up. . . . If he went into the darkroom to work I'd work with him. But if the weather was at all good he would make negatives, and then if we got another bad day he'd make prints, and I would watch and be with him while he was doing that. . . . I'd mix up the developer and the hypo or something of that sort. . . . [T]here was no routine.

Weston never tried to teach me in a formal way. I watched him work with his camera in the field and with his negatives in the darkroom. His apparatus was simple and so were his formulas. His way of seeing was something else again. Some photographers dominate their subject material, crushing or twisting it into a mold that suits the artist. Weston seemed to be concerned with sharing with other people the things he saw through straightforward use of his camera. The pictures were Weston's way of showing what he had found: they didn't proclaim the artist's cleverness. They were perceptual, not conceptual.

I felt as though I had been blind before seeing his work; it seemed as though everything around him was filled with beauty and he was finding a way of capturing it with his camera. He seemed endowed with a power to reveal the special qualities, the beauty of form or texture, of the rocks of Point Lobos, vegetables, plants, household objects and clouds.[6]

From their first meeting and for the rest of his life Van Dyke referred to Weston as his spiritual father. Weston became a model in every way; Van Dyke even absorbed Weston's views on art, literature, and politics. He introduced Van Dyke to the writings of Kandinsky, Roger Fry, Thomas Wolfe, T. S. Eliot, and Henry Miller. His independence from all forms of social convention and mores merged with Van Dyke's own needs. Weston's quiet assertion of independence regarding all matters in life, his rejection of bourgeois materialism, and his implacable devotion to the primacy of his art made a lasting imprint on Van Dyke. In 1932 Weston wrote his working philosophy in his exhibition statement for a show at the Delphic Studios in New York:

I have no unalterable theories to proclaim, no personal cause to champion, no symbolism to connote. Too often theories crystallize into academic dullness,—bind one in a strait-jacket of logic,— common, very common sense. To be directed or restrained by unyielding reason is to put doubt as a check on amazement, to question fresh horizons, and so hinder growth. It is essential to keep fluid by thinking irrationally, by challenging apparent evidence and accepted ideas,—especially one's own.[7]

Many of Van Dyke's accomplishments and failures throughout his life are tinged by the closeness he felt to Weston. Certainly, respect and admiration for each other was a part what bound them together, but their common desire for sexual adventure and gratification with many women became a prominent feature of their respective lives. At a most impressionable age, Van Dyke saw how Weston's art and life were inspired by passion and how numerous sexual relationships were a part of what made life as interesting as art for him.

In his memoir Van Dyke recalled a story that Weston had told him about an experience he'd had in making a photograph. When Weston was living with Tina Modotti in Mexico (1923–26) he observed that the toilet in their apartment had flowing sculptural lines and shapes that were as beautiful as any of the objects he was then photographing. A prolific reader, he had possibly read about Duchamp's submission of a wall urinal as a satiric found sculpture to the Armory exhibition in 1915. He had also been photographing Mexican folk sculptures and objects of everyday life for some time. In any case, he spent a day exploring the toilet's pristine white sculptural form with his camera. The next day he found it filled with flowers. The woman who cleaned their apartment had seen him at work and accepted the idea of its beauty—to her it was like a large vase—so she filled it with a bouquet from the local market.

Van Dyke also included in his memoir an entry from Weston's daybook, which had been "expurgated," in his words, by the editor of the published volumes. He made no attempt to provide a transition from one story to the other. He simply introduced the love scene between Weston and Modotti as if it was a continuation of the same concern expressed by Weston in photographing the sensual forms of the *excusado*:

> . . . She called me to her room and our lips met for the first time since New Year's Eve—she threw herself upon my prone body pressing hard—hard—exquisite possibilities—. . . and so it was that she leaned against a white washed wall—lips quivering—nostrils dilating—eyes heavy with the gloom of unspent rain clouds— I drew close to her—whispered something and kissed her—a tear rolled down her cheek—and then I captured forever the moment— let me see f.8, 1/10 sec, k-1 filter, panchromatic film—how brutally mechanical and calculated it sounds—yet really how spontaneous

and genuine—for I have so overcome the mechanics of my camera that it's [sic] functions are responsive to my desires.[8]

Van Dyke scoured the pages of his copy of the first edition of Weston's two-volume set of the *Daybooks*, edited by Nancy Newhall and published in 1961, for relevant meaning to his own life. He wrote notes in the margins of the pages commenting on various aspects of the content (WVD estate). He seemed to be especially interested in Weston's sexuality and the historically contested meaning of his relationships with Ramiel, himself, and other male friends, especially given their many joint exploits with women in the late twenties and thirties. On page 3 he wrote the following concerning a passage in which Weston described going to a party dressed as woman, at which, as he said, he had a chance to burlesque the ladies:

> Weston to my personal knowledge never had a homosexual experience, yet he was always attracted to transvestitism. Did he ever have a relationship with a woman that was as meaningful as those with Ramiel, Johan, and even with Brett?

In Van Dyke's files there was also a copy of Weston's handwritten entry in his journal from 1923 in which he described going to a party at a gay bar with Margarethe Mather:

> After the concert we desired a corner to sit and smoke and sip coffee—but to the shame of Los Angeles we could think of hardly a place but deadly respectable ice-cream parlors with smug people—sickening sweets—noisy clatter—commercial haste—and most likely bad music—Margarethe, ever curious had heard of a Greek coffee house near L.A. Street where sailors gathered—There had been a murder committed there and fights were a nightly occurrence—So we went—and though not favored with a murder or fight, had a sufficiently exciting night—yes a fascinating night—a room full of sailors, with here and there a collarless, nondescript—but mostly those not in uniform were that type of effeminate male who seek the husky sailor to complement their lacking vigor—.... Sailors danced together with biting of ears and open caresses—some sprawled over their tables down and out—every one had a bottle on the hip—while officers of the law amiably overlooked the

18th Amendment—. . . . Margarethe was the only girl in the place besides the waitresses—But we were too differently dressed—too conspicuous and I wonder we did not land in the street—I should like to go again under different circumstances.[9]

Ben Maddow's biography of Weston detailed numerous other parties in which he dressed as a woman and "put his energies on display." Maddow also explored the possible reasons for his interest in dressing up, photographing nudes, and having one love affair after another. He suggested that among the artistic milieu of the twenties and thirties in California cross-dressing was not unusual; it was a form of entertainment as well as a form of social rebellion. But he also suggested that Weston might have been driven by a psychological desire to reclaim the intimacy he had had with his mother, who died when he was four. He also attributes his boast about his lovemaking and his claims of conquests to a distrust and contempt for women. But nowhere does he explore his relationship with men, especially Ramiel McGeehe, as anything other than friendship or as instances in which he was loved by them but did not love them back in a romantic way.

Some historians have suggested, based on oblique passages in his day-books like the one just cited, that Weston may have been bisexual. But the evidence is weak and doubtful. Weston was very sensual and sexual, as was much of the community in which he circulated. And no one has suggested that the numerous Hollywood comedians who cross-dressed in their performances or, for that matter, the dozens of other actors in film and television who have done the same are bisexual. In this vein, Maddow's thoughtful analysis of Weston's sexuality is also probably inaccurate. Weston simply rejected all forms social and cultural restrictions for himself and his art.

In the seventies Roxanne, my spouse, and I attended numerous parties hosted by Weston's sons in Carmel; some were for holidays, some for birthdays, and others just for raucous fun. We talked about their father's love for parties with friends and his converse dislike of social functions outside the trusted circle of friends and family. These parties in the seventies were a continuation of the Weston tradition, and I would not have been surprised to see Weston come walking down a staircase in drag just ahead of the member of his family who at one party was wearing only shaving cream between his legs. There was also the woman who came dressed as a man, wearing sufficient makeup to obscure her identity even though we

all knew her. Whenever she reached forward to shake hands, her fly would spring open and out would pop an erected penis, perfectly crafted from flesh-colored cloth.

There is ample evidence to suggest that sexuality was not a taboo subject among the Weston clan, and that Edward's love for the sensitivity of gay individuals like Ramiel, Margarethe, or other close friends was just that, a deeply felt love. Weston's sexuality is of interest only because he was such an influence on Van Dyke and his life as an artist. In an interview with Ben Maddow in 1971 when Van Dyke was preparing to work on his memoir and Maddow was writing his biography of Weston, Van Dyke summarized his youthful impressions of Weston:

He was interested in art, but not all art; he was interested in photography, but not all photographers; he was apolitical, but liberal in his outlook, he was a conservationist by conviction and out of his own close observation of nature and its beauties; he liked music, but only a limited range of music, primarily Bach. He liked women, but he was impatient with them. No, that's too strong . . . impatient isn't the word. I think he liked women as companions and sexual objects. His numerous affairs are legendary. He found each new sexual adventure vastly stimulating as far as his work was concerned. I had a feeling that perhaps he was somewhat unsure of himself in many areas and needed the assurance that he was loved and wanted the satisfaction of knowing that women were attracted to him and satisfied by him. . . . My feelings about him changed as years went on. I became less adoring and more respectful. . . . I came to realize that he was very self-centered as many artists are and that was a necessary part of his make-up. I think we all realized that when we were with him, what he needed and what he wanted took precedence over anything else. He was not insistent about that nor was he petulant or childish, but it was recognition on the part of everyone around him that he was unique. . . .

I think I would sum it up by saying my feeling for Edward went from awe to respect and from adoration to friendship to a realization that he was an extremely important creative artist, but as a human being, he was just that—a human being with all of the marvelous things a human being can have, but with faults as well. His loyalty to friends was without any restrictions. When he made

a friend, that person was a friend always or as long as he wanted to be and he fiercely defended those loyalties and friendships.

He was impatient with the self-styled Marxist who wanted him to take an active position in relation to art in the service of revolution. His feeling was that he was against formula of any kind, whether it was in art, in politics, or in human relations. He hated the idea that Marxists would feel that art could only exist in the service of social change. . . . The atmosphere around Edward was one of quiet, of peace. But when he was at rest, you almost had a feeling that it was like a spring getting tighter and tighter, waiting to be let loose to work again. His whole life centered around photography.

There was not very much else except, of course, his love affairs. My trips to Carmel were eagerly anticipated by me and they were the most important thing to happen during that period of my life, a period of trying to decide what kind of a man I was going to be and whether or not I was going to be an artist. His respect for art, his understanding of the nature of artistic life, his desire to keep everything simple so that nothing could interfere with his life as an artist, were things I learned and respected, that focused me.[10]

During the remainder of 1929, following his two-week stint with Weston, Van Dyke worked on informing himself about photography and the art world like never before. On Weston's recommendation, he studied the work of Charles Sheeler, Morton Schamberg, and Charles Demuth whose precisionist visions embraced the "machine age" and broadened the abstract potential for straight photography. Van Dyke's photographs during this time incorporated new subjects, including industrial sites and close-ups of man-made objects: petroleum storage tanks, industrial sites with towering smoke stacks, and cast-iron machine parts. But he also now worked daily in making photographs of landscape, adapting his love for adventure and travel as a means to distance himself from the sculptural images of shells, vegetables, and rock formations that preoccupied his mentor. In his memoir he described his now feverish way of working:

I always carried my large view camera with me in the back of my car and one night, just before Easter, I was returning from work at

the gas station at the end of the night shift when I passed a butcher shop with its lights on. The juxtaposition of the dressed chickens hanging from a rack over a vase of calla lilies struck me as extremely incongruous. Those flowers were often used as symbols of death, and the association of the Easter Holy day impressed me as something I had to get on film. I hurried to set up my camera, made a guess as to the exposure time and clicked the shutter. Just to cover myself, I decided to make a shorter exposure, but I was too late, the store lights went out. I was frantic because I was almost sure I had overexposed the image. I hurried home and although it was after ten o'clock at night I developed the negative. On the edge of being hopelessly overexposed and just barely printable, it nevertheless is one of my favorite images.[11]

The following spring, in 1930, Van Dyke reenrolled in the University of California, having dropped out of college in 1925. He returned to take courses selectively, only those that appealed to him, without the intention of earning a degree. Weston, Cunningham, et al. were all older than he and had the benefit of greater life experience and knowledge. Even though most of them were self-taught, they were all widely read and sophisticated in their awareness of historical and contemporary issues in art and literature. His return to college was part of an effort to broaden his knowledge of the world so that he could compete on the same level. And once again, the fates favored his self-confidence and gregarious personality, bringing him into contact with a new friend from the university who he would become closer with than his own family for the next several years. He described the meeting in his memoir:

It was during this period that I met a man who saw things much the way I did. He was very important to me. . . . A student in one of the courses happened to see a few of my photographs in a local bookstore, found out which of the callow young men I was, and introduced himself. His name was Preston Holder. We became close friends, drank wine together, and read Hart Crane and Robinson Jeffers. Of course, we both had blue-papered covers of James Joyce *Ulysses* and carried them everywhere in a kind of adolescent protest against the Philistines. The book had been banned in the United States and the blue covers were proof that the copies we carried had been printed in Paris and smuggled into our country.

We both had courses with Professor A. L. Kroeber, a great teacher and a practicing anthropologist, and with Professor Benjamin Lehman. These two men, Kroeber and Lehman, had profound influences on our lives. Lehman was a friend of Robinson Jeffers, who lived near Weston in Carmel. Jeffers' poetry was moving in its content and its rolling rhythms lent sonority to our youthful voices as we read it aloud. Lehman helped us to find other levels that we had only sensed existed in the works. Kroeber's teachings reaffirmed my belief that all peoples are capable of equal achievements, regardless of creed or color, and I also began to understand all art a little better as a result of Lehman's passion for writers and their work. Holder acquired a camera, and for a few short years we were inseparable, taking photographing trips together, discussing art and drinking new red wine from grapes grown on the rolling sensuous California hills.

. . . Preston with his eager inquiring mind, always excited by a new piece of insight, was the first person my age that was unabashedly enthusiastic in his praise or condemnation. He had been a telephone lineman, a lumberjack and a habitual rider of freight trains. He usually had no money, but if he did, he refused to pay for transportation that he could get any other way. He loved poetry and photography and talk.

We learned about an old Frenchman, whose name was Georges Cornac. He lived in the Livermore hills south of Oakland and had a side-hill vineyard. He was not averse to selling a gallon of good red wine to a couple of young men who didn't look as if they were revenue agents. It cost a dollar and you had to bring your own jug, but it was good and it was safe to drink. Not like the bootleg whiskey that probably contained a high proportion of methyl alcohol.

I had an old Chevrolet roadster that I had bought for ten dollars. In the early spring we often visited M. Cornac. The California hills at that time of year are green and gold with new grass and poppies. The sun is warm. A fine time to lie on your belly and read Hart Crane or Allan Tate. Or maybe Hemingway. And when you felt the wine warming your insides, it was good to sit up and talk.[12]

Van Dyke and Weston continued to visit each other regularly, although by 1931 they were taking fewer photographic excursions together. Van

Dyke's attending college and holding down a nighttime job meant that he, Mary Jeannette, and Preston were more often photographing together and sharing their experiences with Weston by letter. The growing friendship between Van Dyke and Weston took in their respective families from time to time. Mary Catherine (Wanda), the older of Van Dyke's two sisters became enamored with Chandler, eldest of Weston's four sons. The relationship lasted until about 1937 when Weston wrote to Wanda, warning her about Chandler's lack of dependability:

> Why do I write these details? Because I know that he has not written to you! I did not ask, I just *know*. It's the same old story, Wanda. . . . he can work and work hard, when he gets going; but to get him started is an almost hopeless task. You should know the worst— undoubtedly do. One thing I can assure you, he is not coming back to stay with me for any length of time—nor does he want to. He knows that now it's up to him to sink or swim. God knows I don't believe in dull routine, but I do believe in some *order*. And one must *earn* the *right* to freedom.[13]

Even Van Dyke's father was welcomed into the fold. He suggested that he would be happy to produce a reading of Weston's horoscope, a talent not widely shared in any of the family correspondence. It may have been his own sly "frontier" means of smoking out more about this older person who had so captured his son's heart and admiration. Van Dyke passed on the offer to Weston who replied as follows:

> Dear Mr. Van Dyke:
> Willard tells me that you offered to put up my horoscope. I appreciate this, and am greatly interested. However, I do not know and cannot get my hour of birth, which I realize entails much extra work on your part: so I will not be disappointed if you give up! Or do not wish to start!
> I am writing down a few of the most important events of my life—dated, for you to work from, and general characteristics:
> Born March 24, 1886, at Highland Park, Illinois, near Chicago.
> Mother died when I was four.
> Father gave me first camera (my life work) August 19, 1902.
> Came to California about 1905–06.

Married at 23—4 children, boys.

Sailed to Mexico, July 1923, remaining 3 years.

Height 5 ft. 5-½ in. Weight (about) 133 lbs.

Brunette—eyes brown—hair brown medium—complexion medium—Inclined to Freckle.

Have considerable nervous energy—controlled and directed.

Have been a vegetarian a great part of life, starting as young as 15, building up my health from a rather bad beginning.

Many women have entered my life, but never at the expense of my work—Photography—around which my life has been built.

Marital relations unsuccessful, but my four boys have been very close to me.

I hope the above will be of some value—E.W.[14]

No response concerning the proposed horoscope chart for Weston is to be found in Weston's letters or in Van Dyke's. Either it was never produced or the record of it has not survived. In any case the information supplied by Weston is a rich and blunt survey of his life up to 1931. He had not yet met Charis Wilson, a twenty-four-year-old free spirit, who Sonya Noskowiak introduced to him as a potential model in 1934. She soon moved in, and Sonya moved out. Charis, indeed, became his most famous nude model and they were married in 1938. Weston could still have made the claim after his second marriage that "many women have entered my life, but never at the expense of my work" because they were divorced eight years later in 1946. The Weston family was not unhappy to see her go for a variety of reasons according to Van Dyke's memoir. The primary reason was that she represented competition for their father's attention, since she was about the same age as the sons and Van Dyke.

Van Dyke experienced some of the same concerns with Brett Weston who was resentful and jealous of the relationship between Van Dyke and his father. Since the age of sixteen he had been his father's colleague in photography and exhibitions and just as Charis had moved in, so it seemed to him had Van Dyke. In an interview in the seventies with Ben Maddow, Van Dyke described his relationship with the Weston brothers:

Brett was envious of me. I remember the very first time I was in Carmel and Brett had done quite an extraordinary series of photographs of a singer, a Russian baritone who lived there and

subsequently lost his voice through cancer of the larynx. He had done these very nice heads against the sky, the man singing Russian songs—quite nice. Edward said that he would like to do some of the singer too and I asked if I could go. Brett made it clear that the singer was his property and he couldn't tell his father no, but he certainly didn't want me to be included in any photographic expedition of that kind. I certainly understood that Brett was much younger and was struggling against the thing that we all faced, which was the fact that Edward could take an idea that someone had explored and then develop it and bring it to fruition [in a way] that was beyond the capacity of the rest of us.

Neil had all the gentle sweetness of his father and tried to go his own way. He is the only one that wasn't caught up in photography in one way or another. Chandler, at one point came and lived with me and my family[;] . . . he was talking about marrying the older of my two sisters. He had a job in Oakland, but every morning it was a problem for Wanda to get him out of bed and to his job. He was the one that was probably hurt the most by the divorce from Flora. He was the eldest and understood more clearly what was going on.

I liked Cole. He was much younger. I respect what he has done with his life. In many ways he was the most secure of the boys. He's the only one that went to college and had a career in theatre, before photography.[15]

In the spring of 1930 Van Dyke and Preston Holder took a trip to Death Valley to make photographs. It was a long trip to make considering their limited resources, especially since the country had just entered the Great Depression. Howard Zinn characterized the state of the nation as follows:

After the crash, the economy was stunned, barely moving. Over five thousand banks closed and huge numbers of businesses, unable to get money, closed too. . . . By the end of 1930, almost half the 280,000 textile mill workers in New England were out of work. . . . In Oklahoma, the farmers found their farms sold under the auctioneer's hammer, their farms turning to dust, the tractors coming in and taking over.[16]

Almost a decade later in *The Grapes of Wrath*, John Steinbeck wrote

about the rural poor of middle America who made their heartbreaking journey to California, where they had heard there was work for the willing and where providence had created an oasis protected from the winds of human devastation. California at that time was indeed a haven for the little enclave of artists in Oakland and Carmel where Van Dyke and his friends were eking out a modest lifestyle. Though they were not unaware of the country's mounting problems, neither were they preoccupied with the events of the day. Van Dyke described their attitude as follows:

> It was a time of unrest and poverty, but for many West Coast artists the stock market crash of 1929 brought little change to their ways of living. The climate was mild, and a log or two, burned in the fireplace as the fog rolled in at dusk, was enough to drive away the evening chill. Many of our homes and studios were simple and rents were low. Our needs were simple and few of us had ever owned a share of stock. The East Coast, with it breadlines and apple sellers seemed to be a faintly heard rumor. Few of us knew of the soup kitchens in San Francisco. There was a world of natural beauty around us; beauty to be found in plants, in rocks, in the human body, in vegetables for dinner or in the majesty of Death Valley, the Sierra Madre, and the long rows of an artichoke farm. Even in the urban decay of abandoned houses and storefronts.[17]

Carmel, where Weston lived, is known to this day as "Eden by the Sea." But the Depression deepened and in the coming years it would change everyone's lives, including Van Dyke's in dramatic and lasting ways. In the meantime, Van Dyke had committed himself to being an artist, and for him that meant immersing himself in the natural wonders of the California coast, where his socialist tendencies were happily muted in the shadow of Weston's apolitical stance. When he and Preston arrived at Death Valley, several hundred miles south of Oakland, it was not the great expanse of desert or the towering mountains and exotic plants nor the crackled earth that caught Van Dyke's eye; it was, rather, the subtle waves of white, delicate sand dunes, which to him had all the sensuality of a woman's body. He made one photograph of the dunes that day, which was to become a catalyst for coming changes in his life.

Among his circle of friends who had photographed all over California, no one before him had seen the potential of the dunes as a photographic

subject. Van Dyke claims that when he later showed his photographs to Weston he suggested they make a return trip so that he too could photograph the dunes. When they did, Van Dyke had problems with his camera, while Weston made one astounding image after another. Van Dyke believed for the rest of his life that he ruined his negatives in a subconscious drive to not compete with his mentor. At the same time he also felt a strong, uncomfortable urge to claim the dunes as his original vision, and the conflicting thoughts made him physically ill. By now, he loved and admired Weston intensely and felt guilty about the emotions he was experiencing over the making of the dune images. Van Dyke claimed that his feelings of jealousy and the sense that he was competing with Weston over the dune photographs were what sparked the fire within that would later contribute to his decision to leave photography and take up film. The issue was, of course, much more complicated than that, and over the next several years a series of personal developments and the increasing intensity of the Depression would coalesce in a way that would slowly erode his commitment to photography.

Van Dyke was becoming a perfectionist, and photography offered ample opportunities to support such a tendency. From childhood he had been encouraged by his mother to believe he was special and that he had an obligation to control his fate as an artist. This trait, which manifested itself as a need for control over everything and everyone, was becoming his dominant means of relating to the world. An early example is apparent in this story of his and Preston Holder's return trip from Death Valley:

After making the photograph of the sand dunes, we found ourselves on our way home, late in the afternoon, near a fence post. Its barbed wire strands were broken, but provided a graceful line contrasting with the stolid upright post. . . . After driving more than three hundred miles, I arrived home, developed my negatives, and found that the fence post was hopelessly overexposed. It was late at night. I slept a few hours and then drove three hundred miles back, corrected my exposure, and drove home again. I call it my thousand mile negative.[18]

By 1931 Van Dyke's studio and living quarters at 683 Brockhurst had become a regular safe house for parties with wine and alcohol in spite of prohibition laws:

There were vineyards where one could buy grapes by the basket or truckload. In the Italian neighborhoods, shops sold presses, oak barrels, bottling apparatus and bottles. Wine was plentiful. Usually our parties were accompanied by wine . . . but sometimes we prepared a drink that was far more potent.

Among our friends were two Georgians, Papashvili and Matakashvili, who knew how to prepare a drink they called a "five star final." Papashvili wrote reminiscences of his mother country and Matakashvili, a bull of a man, roared at the stories and bent quarters with his teeth. I had a source for pure grain alcohol—a doctor gave it me so I could dry my negatives more quickly. Matakashvili took five limons and squeezed their juice into a gallon jug, added an ounce of glycerin, filled the jug half way with distilled water and topped it off with alcohol. After aging it for about twenty minutes, it was ready to drink. . . . After an evening of drinking some of this, I made one of my better known pictures of Ansel; it was taken as he drank coffee to sustain himself until he got home.[19]

In the following year, on a warm sunny afternoon, Van Dyke and Preston Holder were returning on a ferry to Berkeley from "a wine-filled" day in San Francisco. They talked photography and philosophy with a verve that was only slightly less coherent than many of their other deeply felt discussions about art and life. They railed against Mortensen and pictorialism, professing their superiority in understanding the modernist trend in art. The conversation turned to how they might strengthen the impact of the work of Weston, Adams, Cunningham, and themselves. Holder suggested that they form a group of like-minded artists and Van Dyke responded, "'Yeah, and let's call it U.S. 256.' He [Preston] said, 'that's a great idea.'"[20] Late in life the two friends disagreed about who came up with the name, but it was of little consequence because at a subsequent party Ansel Adams provided the actual name that was adopted, Group f/64. Van Dyke said that he chose the number "256" because that was the smallest aperture on his lens, which provided the greatest detail and depth of field, the hallmark of those promoting straight photography. About that afternoon, Van Dyke said:

I was excited about the idea; it appeared to me that this would be an opportunity to make a statement about our work—how it differed from the pictorialists. . . . Also I know that I, for one, felt that

it was time that the eastern establishment acknowledged our existence. I knew that Stieglitz had been patronizing to Weston when they met in 1922. I was young and eager and I was proud of the work being done by my friends.[21]

In August, a short time after their initial conversation about forming a group, Van Dyke put together one of his frequent parties, this time because Weston was visiting and would be staying at 683 Brockhurst. He invited Ansel Adams, Imogen Cunningham, John Paul Edwards, Preston Holder, and, of course, Mary Jeannette Edwards. Holder and Van Dyke brought up the idea of a group, and all except Weston was enthusiastic. Weston did not like groups or clubs of any kind, but he agreed to be part of the concept, at least for a while. Adams pointed out that the lens system that used 256 as it smallest aperture was going to be superceded by the "f-stop" system and it would, therefore, be prudent to use f/64, which was the new system's equivalent. He then drew a flowing "f" in lowercase script to show how it would offer the potential of great graphic identity. With the stroke of Adams's pen there was consensus and the group was formed. In 1938 Van Dyke wrote a short article for *Scribner's* March issue that summarized the outcome of the discussion that formed the group:

> The group was not started as a cult, nor did it function as one. Around the fireplace at 683, over coffee and food from the corner Mexican restaurant, they found they had certain things in common. All of them believed that photography must use its own peculiar powers, acknowledge its own limitations, and that it should never be influenced by painting, or any other graphic art. . . . In order to achieve their ends through the most photographic means, members of the Group used large cameras, usually making prints on glossy papers, from negatives that were sharp in definition and brilliant in tonal gradation. . . . They believed that everything in the picture should be in focus, and to achieve this they used small lens openings, with their cameras on tripods, because of the necessarily long exposures.

Immediately after the party Sonya Noskowiak and Henry Swift were invited to join. Because Stieglitz and his group in New York were highly political and because communist and socialist influences in art, literature,

and industry were spreading, Van Dyke in the same article described everyone, including himself, in terms of their political points of view:

> I would say politically, it [the Group] ranged from Imogen Cunningham, who was a non-practicing anarchist, but who just thought all government was terrible. But she was an iconoclast in every way, a wonderful woman—It ranged from her to Henry Swift, who was an investment banker and who was as conservative as anybody could be. Ansel was apolitical. Weston was sympathetic to labor but wanted no active part in it at all. Sonya Noskowiak had no position. And I was left of center, but I didn't belong to any political organization.

Less than a decade before he died, Van Dyke described more fully each of the original members of Group f/64 for an exhibition that re-created their first show. His text reveals his own extraordinary rise from a young, aspiring amateur photographer in 1929, taught by his girlfriend's father, to the motivator and equal of a group of photographers who became historical icons in the history of photography. His mentors John Paul Edwards and Edward Weston became within four short years his peers in the search for an original vision and aesthetic. And when he describes himself, he reveals the equally rapid departure he made from that success, his abandonment of what was the most important thing in his life at the time for an altogether different medium of expression, film. The pressures and events that led to such a seemingly dramatic shift in his thinking and loyalties is told in the remaining years he devoted to photography, between 1932 and 1935:

> Each of the members of Group f/64 was a distinct individual with personal elements of style, even though we were united by a common aesthetic. Imogen Cunningham's way of life, for instance, was as simple as my own, but Imogen's camera was often pointed toward the succulents, flowers, and cacti of her own garden and often the pictures were close-ups that did not reveal their domestic settings. She kept a home for an artist husband and three growing boys. Her subject material was close at hand, by necessity if not by choice. She was unable to roam widely in search of objects she could make beautiful with her camera, and like each of us she worked within her own limitations. Personally she was admired for the sharpness of her wit and her disdain for artifice and pomposity.

John Paul Edwards had a long and respected career as a pictorial photographer before he cast aside his Karl Struss soft focus lens and began to look at elements of the world around him in the clear, clean, simple way that marked a dramatic change in his style. Had he been a New Yorker his early works would have entitled him to a place in the pantheon Stieglitz called the Photo-Secession, but the eastern photographic establishment provincially scorned any work that was not anointed by the high priest of 291 Fifth Avenue. Edwards came to straight photography late in his career, he was a master of the bromoil and soft focus lens, but his later pictures and his article in *Camera Craft* in 1936 [1935] showed clearly that his association with the other photographers in Group f/64 was a liberating influence in his work. . . . Unlike some other members of the Group, he was a "Sunday artist" who earned his livelihood as the buyer for a San Francisco department store. His daughter, Mary Jeannette, was a talented photographer in her own right and helped manage the gallery at 683 Brockhurst in Oakland where the Group was formed and exhibited its work.

Sony[a] Noskowiak shared a studio with Edward Weston in Carmel and made exquisite contact prints with a four-by-five camera. Her subject matter was broad and ranged from beautifully detailed rivulets in sand to an explosive view of a pile of boards in a lumber yard. Her struggle to maintain her own artistic identity while she was so close to such a powerful figure as Weston is a tribute to her personal strength and her independence in seeing freshly, with a minimum of influence by the rest of us.

Henry Swift was another part-time photographer. His work is original in concept, and though not rooted in direct observation of nature it nevertheless has a feeling of dexterity and a cleanliness of execution that is always delightful and sometimes touching. . . .

The unquestioned giant of the period was Weston. Older than the rest of us, his simplicity of technique and approach was deceptive. He rarely failed to make an important statement every time he released the shutter. . . . His Point Lobos work has a timeless quality that sets it apart from everything else done in the thirties, and perhaps his whole lifetime. The mystery inherent in these photographs far transcends anything else done during that period, and it is indeed a poor spirit that is left untouched by them.

Ansel Adams' understanding of the Western landscape stems from the work of the early pioneer photographers such as William Henry Jackson, but goes light years beyond. His photography certainly is not confined to the majestic "long shot," even though some of his best known images have been made in Yosemite Valley, the Owens Valley, the High Sierra, and New Mexico. . . . But his delicate, sensitive images of objects within the landscapes are joyful celebrations of discovery. Pine cones, grasses, eucalyptus leaves, gravestones, as well as the Wagnerian landscapes composed of clouds and mountains, and trees, help us to see the wholeness of his concern for nature. Without ever shouting it, without ever using the word, he is a supreme ecologist, a true lover of our earth.

And so we come to myself, to the youngest member of the Group as it was originally constituted. How does one evaluate his own work? Let me try. First of all, I knew from the age of ten that photography was to be something that I would do. . . . When I saw Weston's work in 1928, although I had already been photographing for several years, I knew that there was a path I had not perceived before. At first I followed his way, but too slavishly. Then I began to become aware of the problems of the immediate world around me. Of soup lines and men and women out of work. I walked the poor streets of Oakland and Berkeley. I began to be as fascinated by the abandoned storefronts just as much as I had been by the clean forms of a ship's funnels or the sensuous curves of a sand dune. I saw the itinerant workers and the dignity in their faces as well as the holes in their shoes. Dorothea Lange's photographs startled me and I wrote about them and showed them at 683 Brockhurst. I began to want to use photography to help make a better world. I attempted to use my 8 by 10 view camera, but it was the wrong instrument or perhaps I was unequal to the challenge and I turned to film.[22]

Van Dyke was given a solo exhibition at the M. H. de Young Memorial Museum in San Francisco at the beginning of 1932. This was an important moment for him because both Weston and Adams had had exhibitions at that distinguished museum. It was a moment of validation, encouraging him to be himself, to demonstrate his independence from Weston, but at the same time to promote the vision he and Weston shared. Weston,

true to his loyalty to his friends, made the trip to San Francisco to be with Van Dyke and to celebrate at 683. A few months later the director of the museum, Lloyd LaPage Rollins, offered to hold the first show of Group f/64. The group was delighted and invited Brett Weston, Alma Lavenson, Consuelo Kanaga, and Preston Holder to show with and to join the group.

Rollins was leading the way for museums in the region to accept photography as an art form and to include its artists in regular scheduling of events. The exhibition opened on November 15, 1932. Three galleries were devoted to the work, which both shocked and excited the public. While the group continued to meet and publish their ideas about photography, they showed together only one more time, a few months later, at the Ansel Adams Gallery, which he had opened in San Francisco. His gallery was short lived and he eventually turned it over to a partner. Sigismund Blumann wrote a review of the first show in the leading journal for photography, *Camera Craft*, in the May 1933 issue:

> The name of the organization was intriguing. The show was recommended to us as something new . . . [and] specifically aimed at exploiting the trend. We went with a determined and preconceived intention of being amused and, if need be, adversely critical. We came away with several ideals badly bent and a few opinions wholly destroyed.
>
> . . . The f.64 Group have shown that there is something to say in a 1933 way that still may react on the cultivated senses as expressive of the beautiful. . . . They are not trying to forcibly revolutionize this, that, or anything whatever but are doing what it pleases them to do without thought of the past, present or the future.
>
> . . . For a listener to enjoy Stravinsky he must dismiss the Chopin mood and prepare with a course of raw meat diet. The f.64 prints are like that. Black, oh, very black and white! . . . These pictures do not sing. They shout.
>
> Sentimentalists that we are, we shall never forgive these fellows for shattering our pet traditions. On the other had, we are grateful to them for chastening our over-sure spirit.
>
> The Group is creating a place for photographic freedom.

In 1933 Van Dyke and Mary Jeannette decided to turn his studio and living quarters at 683 Brockhurst into a gallery for photography and other

media. He chose the address as the name of the gallery, a way of mimicking and mocking the name of Stieglitz's gallery, "291" at 291 Fifth Avenue. The 1933 issue of *Camera Craft* described the gallery as a charming little studio and gallery and quoted Mary Jeannette who said:

For a long time we have felt that the Pacific Coast is a particularly fertile field in its photographic activities; that here are many of the finest photographers and that their work should be shown. "683 Brockhurst" seems to fill the need for a suitable gallery, not only for the showing of exhibits, but for a discussion center as well. We hope that all who are interested will consider it as such.

The gallery became a regular meeting place where Weston, Adams, Cunningham, Van Dyke and others met for talk about photography and for parties. Van Dyke was interested in poetry, especially the works of Hart Crane, T. S. Eliot, and e. e. cummings. At one of the parties he read aloud from cummings's works, which shocked the group. They questioned the relevance of his social concerns in terms of their own interests in art, which were reflected in a paragraph of a letter that Weston wrote to a critic for *Experimental Cinema*; the critic, though supportive, did not understand his work in a contemporary social context:

Propaganda is necessary for the moment, art forever. I am in every way sympathetic with the Russian experiment,—though I cannot believe that this country will have or need revolution. More logical here will be a conversion,—slower, maybe very slow, but with a stronger basis. Prohibition of any kind must fail, brings reaction, divides a people, generates individualism. If Russia dictates to its artists, after the period of necessity, forcing them into the narrow groove of propaganda, the revolution will fail, die from crystallization. "Art for Politics Sake" is worse than "Art for Arts Sake." To limit art with social *duty* is a bourgeois attitude (but then many radicals are bourgeois under a thin skin), comparable to the idea that art can be used to further the destruction of card playing or the demon rum. A pedantic premise,—that art is subservient to ethics. Only by working for himself, can the artist fulfill his reason for existence and directly or indirectly serve mankind: he is not as some assume a little god apart from humanity, but he is the

spiritual core of the whole plan. Social solidarity rests upon a base of individuals,—the few supporting the inchoate mass. The artist can neither serve the plutocrat nor the proletarian—he must be free from all but self imposed obligations.[23]

Weston periodically used the studio/gallery/living space as a place for trysts when he was in the Bay Area. On one such occasion, as a gesture of passion, he took off his watch and threw it away to impress a woman he was then seeing secretly behind the back of his housemate, Sonya Noskowiak. The event was referenced in letters between him and Van Dyke as a symbol of the meaninglessness of time in moments of great passion in art and life alike. Van Dyke described 683 Brockhurst in the following manner:

I started it as a place first to show my own work and for possible sittings. But then I became very zealous about the idea of straight photography, rather than manipulated photography—manipulated in the sense of William Mortensen . . . [who] would start with a photograph, and then etch away parts of it and draw in parts, and do all kinds of things to change it, usually around sensational subjects, such as witches or the Crucifixion, or something that would allow him blood and gore, and I thought it was a perversion of photography. . . . I wrote an article for a magazine called *Camera Craft* about this trend in photography, and it attracted attention, and photographers from all over the country wrote to me. So I organized a series of exhibitions of photographers' works that expressed the spirit that moved Ansel Adams, Edward Weston, and me. I had exhibitions that would last six weeks, say a photographer, and then I would have a painter or a lithographer or an etcher or someone of that sort, to make it clear that photography was part of the mainstream of art.[24]

Among the artists other than photographers that he gave exhibitions to were Jean Charlot, Henrietta Shore, and Adolph Dehn, who were friends of Weston. He also gave Roi Partridge, Imogen Cunningham's husband, an exhibition. The photographers whose works he showed included Edward Weston, Ansel Adams, Imogen Cunningham, Sonya Noskowiak, Henry Swift, Consuelo Kanaga, Alma Lavenson, Mary Jeanette Edwards, and himself.

Mortensen's cheesecake nudes in predatory, narrative poses became a rallying point around which Weston, Van Dyke, Adams and other photographers launched a virtual war of words in the literature of the time. To them Mortensen represented cheap, pictorialist sensationalism. Mortensen was a target because he was teaching his methodology and having success in publishing his work. Those who objected to him viewed him as a mortal enemy of serious photography who had the potential to trivialize the medium as an art form. In the 1934 issue of *Modern Photography* Van Dyke wrote a personal statement in which he made the following observation:

I think photography is being rapidly split into two well-defined groups—one group doing work which is influenced by painting and the other section making photographs, which are the result of legitimate photographic practice. In the former group most "pictorial" photography will fall. This group usually justifies its manipulatory [*sic*] methods by saying that it makes no difference how the result is achieved. The end, not the means, is important. My own aims and beliefs are with those workers who think that photography is another means of expression to be added to painting, sculpture, etc. I believe that photography has its own virtues and limitations and that a photograph can achieve art value only if it exists strictly within the possibilities of the medium.[25]

On July 28, 1933, Van Dyke and Mary Jeannette opened their gallery with Edward Weston's first retrospective exhibition. Weston's statement that appeared on the wall of the gallery stated that the exhibition covered a thirty-year period and showed his growth and change of approach:

My earliest work of 1903—though immature—is related more closely, both in technique and conception, to my latest work than are several of the photographs dating from 1913 to 1920; a period in which I was trying to be "artistic."[26]

Weston's comment about being "artistic" is very curious, though completely sincere. It was that issue that Stieglitz and Strand had discussed following Weston's visit in 1922. Among friends, particularly Van Dyke, he promoted the worst aspects of Stieglitz's personality, but privately he clearly used the unpleasant comments by Stieglitz as a learning tool. The work he

produced in Mexico and after, which involved what he called "the thing itself" and "significant representation," led the way to a modernist vision for him and eventually Group f/64. Stieglitz could not understand that Weston had absorbed more than he intended to give and that like the best of artists he had borrowed without being influenced.

With the opening of his gallery and the formation of Group f/64 Van Dyke grew closer to Ansel Adams, and the two of them shared ideas and aspirations for the medium. Shortly after the formation of the group he and Holder visited Adams's studio in San Francisco. The phrase, "Joy of Friends," was carved over the mantel of a grand fireplace, which was a perfect reference to Adams himself. He prized his friends, was gregarious, and loved humor. He was the most sociable of the group and in many ways the most intellectual. He had a scholar's grasp of the history of photography and spent his life embedding contemporary photography in American institutions, including museums, universities, and archives. Next to Van Dyke, he was the most enthusiastic about the potential of their newly formed group. Van Dyke, bowled over by the studio, described his visit to it with awe:

> Outside the window we could see the Golden Gate Bridge, still under construction, drenched in afternoon sun. Ansel showed us his photographs and some by early photographers, who had worked in the west, men such as Timothy O'Sullivan, Carleton E. Watkins, and William Henry Jackson. He talked glowingly about these pioneers of our craft as he introduced us to pictures of landscapes made with an enormous camera. . . . We saw Yosemite Valley as it appeared before roads were built to it, and magical Canyon de Chelly. . . . Later in the afternoon as the daily fog rolled in across the Golden Gate, Ansel sat down at the piano and after a bit of Mozart he began to play a Bach fugue. His mastery of the instrument was breathtaking. . . . I was deeply moved. A few moments after the piece was finished, I regained my composure and told him how magnificently I thought he played. With a wry laugh, he said: "My musical friends all tell me what a fine photographer I am, and the photographers all love my musical efforts."[27]

Van Dyke and Adams wrote to each other often about Group f/64 between 1932 and 1934 and throughout their lives. Van Dyke was clearly the leader and responsible for organizing the events and activities of the

unofficial body. Shortly after their inaugural exhibition they commenced writing the following series of letters. Adams wrote first:

I have been thinking a lot today about the *Camera Craft* article that Blumann promises us. I do not worry very much about the text, as the illustrations will hold their own. But I do think we should ask him to have the statement on Group 64, which is on the wall of the museum, printed along with the article. Either that statement or another that we could put together. Then, you see, whatever happens to the text, we would have a clear position in the eyes of readers.[28]

Adams was just a few years Van Dyke's senior, but he had over ten years' more experience with photography than him. As a result he pushed Van Dyke hard on making the group a more formal entity, but without success. Van Dyke knew that Weston was only marginally interested in even the loose association that had been created, which put him in the middle between his mentor and Adams. When at one point Van Dyke suggested that perhaps the group should grow its ranks and publish an annual of photography, Adams responded with great enthusiasm:

Damn Good Idea! Your mind is by no means unproductive; in fact, I think it ought to be controlled by the Fed. Govt. Naughty Inventiveness Routs Apathy. Or Carefully Controlled Calamities. But I must be serious. It is very interesting, but I have been entertaining a similar idea for quite a little time; I have intended writing to you about it, but we always seemed too occupied and rushed. But, all honor to you for formulating it in a good plan. While it is something that should be discussed long and carefully, I feel I can offer an associative suggestion here. (But by all means keep it mum until ready to announce. The intellectual wolves are all too numerous). My idea is this: 1. To form your group throughout the country. (Your Pure Salon is a swell way to sound it out). 2. To carefully define the program—just what is to be done, and how. 3. To consider the enlarged Group, not only a print-contributing membership, but the Membership of an Institute of Pure Photography (I think we can dig up a better name.) The Institute would publish the annual among other activities.[29]

Adams went on to describe a total of ten points, including an aesthetic code for members, exhibitions, lectures, and an expanding organization. None of Adams's suggestions were adopted, and they probably intimidated Van Dyke, not because they were complex but because of the sheer energy that would be required to carry them out and the implication that he would bear the brunt of the effort. He had, after all, intended that the group be only an informal artists' association, not a full-time job. Within two years of the formation of the group, Van Dyke was already feeling more affected by the state of the world and began to investigate outlets for his innate socialist views. Even Adams closed one of his letters during this period with a sense of the changing times:

Whatever comes to pass, keep a stiff upper lip and remember your Scout training. That is what has kept me in constant view of my ideal. Home, family, country, and rugged Americanism—those things are the foundation of our life. Let us remember Washington (and trust in Pyro) [a chemical for developing prints].[30]

Adams had mentioned Van Dyke's "Pure Salon," which was one of the events organized by him in mid-1934. It was to be a juried exhibition, open to the public, but only to photographers who did not technically manipulate the medium and who printed in black and white. The exhibition was held at 683 Brockhurst and received modest recognition. Weston found the title especially humorous. He thought the word "pure" could be easily interpreted as referring to puritan morality, and most members of f/64 represented anything but puritan values. Van Dyke felt that the salon was an acceptable effort, but his heart was not in it. Too much had already begun to change in his life and outlook.

In 1934 John Paul Edwards wrote the final article on f/64 for *Camera Craft*. Van Dyke had already departed for New York and Weston had silently resigned from the group. Edwards attempted to put the short-lived group in perspective, repeating its artistic motives. But he also included quotes from Van Dyke, Adams, and Cunningham that revealed the pressure they felt from the social crisis that now engulfed the entire country. Van Dyke said:

I believe that art must be identified with contemporary life. I believe that photography can be a powerful instrument for the

dissemination of ideas, social or personal. I believe that the photo-document is the most logical use of the medium.

Adams, whose work had progressively grown to be about the great landscape vistas of California, also tried to find relevance in his work to the times:

Our work has been basically experimental. In our desire to attain a pure expression in our medium we have made powerful attacks in various directions, stressing objective, abstract, and socially significant tendencies. These phases of our work should now be taken from the laboratory (along with our technical attainments) and functionally applied. I have always disagreed with an *obvious* approach to such phases: I have argued that a basic aesthetic motivation was sufficient in all forms of art, and that this motivation, when applied to a definite functional problem, became in itself socially significant.

Cunningham was succinct:

Photography began for me with people and no matter what interest I have given plant life, I have never totally deserted the bigger significance in human life.[31]

During much of 1932 Van Dyke and Weston discussed making a trip to Taos, New Mexico. Mabel Dodge Luhan (an heiress of the Dodge fortune, who had married Tony Luhan, a Taos Pueblo Indian) had made a visit to Carmel to see Robinson Jeffers, poet and close friend of Weston. She invited Weston to visit her that summer in her compound in the artist colony where she regularly hosted well-known writers and artists, including D. H. Lawrence and Paul Strand. Weston eagerly accepted her invitation but with the condition that Sonya Noskowiak and Van Dyke also be invited. Van Dyke owned a car and neither Weston nor Sonya could drive. It offered the opportunity for them to make a photographic excursion together, larger than any they had embarked on to date. In March Van Dyke wrote:

As nearly as I can tell by the detail maps I have here, our trip to New Mexico will cover about 2625 miles round trip. This is about

300 miles less than we figured while I was there in Carmel. The Death Valley trip would be a little less than half as far.

I still have hopes even tho things are not so good here. Mary J. and I almost feel like casting good judgment to one side regardless of consequences. Perhaps we could find some place to settle there. I am tired of this damned city. I'm tired of worry and grubbing for a few lousy pennies. The whole thing stinks too loudly of futility. More and more my thoughts return to the time when I was a kid on a little farm in Colorado and how swell the days were to me then. There's much to be done and the time is sliding swiftly by.

Thanks for the letter. I shall lay aside my camera for a time. The most thrilling time I ever had was the week I spent with you in 1929. The very air was filled with your energy and vitality. Perhaps we shall capture it in New Mexico.

Please excuse this disjointed letter, written with the smell of gasoline in my nostrils.[32]

Van Dyke was addressing a couple of frustrations in this letter. He had invited Mary Jeannette to go on the trip to New Mexico with them, but her parents forbid it. Even though they were engaged and had bought their silver, they felt it was not a good idea from the standpoint of appearances. When her parents asked if she and Van Dyke were already sleeping together and were told that, yes they were, the Edwardses were furious. Mary Jeannette and Van Dyke decided to abide by her parents wishes, and so she would not go on the trip. When he said that he would lay his camera aside for a while, he was referring to intimate discussions he had shared with Weston about his growing unrest as an artist and the internal struggle he was having over his desire to do something more direct and constructive about the state of human suffering and political injustices. Weston responded, and though he seems to have missed the real thrust of Van Dyke's unhappiness, his counsel that Van Dyke act on his own advice and "cast good judgment aside" unintentionally accelerated Van Dyke's departure from photography:

Dear Willard:

You are after my own heart—"tired of worry and grubbing for a few lousy pennies"—it "stinks too loudly of futility." Very early, in my twenties, I made my choice. I knew that I could make money—I refused to pay the obvious price. I have no regrets. My

generation, most of them, have lost everything: they have no more than I have, after their slavery. At least I have had a rich life—

Of course with dependents there is always some compromise. My present studio, overhead, is one. But I am waiting for the first hunch, opportunity to shake it all off! A few friends, a few books, a chance to play, and to develop oneself, what more! Of course the setting—for me—must be somewhere with soil and sky—no pavements, (we may allow one good highway) no sad faced people canned in dreary rows of dusty houses. I don't know when or how, but I feel it's coming,—some change.

It's a thrill, and right to throw aside *good* judgment, to disregard consequences. I did when I left the "unlovely level of 10,000 *good* people"—who were giving me a good living—and went to Mexico. These *good* people were scandalized, I had "run away" with another woman! Bah!—the woman was incidental, I was escaping their own suffocating breath. But I returned and did my finest work to date in their midst. After all, it's the gesture that counts, that strengthens.[33]

In the meantime Van Dyke remained excited about the trip to New Mexico. In June 1933 Van Dyke, Weston, and Noskowiak left Carmel for Taos, New Mexico. They camped along the way and photographed much as they had done on numerous shorter excursions. They did not know what to expect from Mabel Dodge Luhan; all they knew was that she was a patron of many artists who were their friends. Although they did photograph along the way, it was more of a forced march than any one of them would have preferred. The distance was far greater than they had calculated, and the two weeks they had allotted was barely sufficient for the trip. In his memoir, Van Dyke described the scene in Taos and the surrounding area with cryptic detail:

Taos was a small town then: dirt streets, huge cottonwood trees, horses and wagons, and many Indians dressed in the picturesque Taos fashion. Just outside the town was the beautiful Taos Pueblo. The much-photographed church at Ranchos de Taos was just a few miles away. Most of the buildings were made of adobe or built in the same style, although a few in the center of town were of Territorial style. . . . I was delighted to be there with my friends

and I looked forward to a period of work with my camera in an atmosphere of intelligent dedication to art.

Mabel's house was in a compound surrounded by smaller dwellings for guests and servants. Though comfortable the houses had no particular distinction. We had our evening meals in the large house, but otherwise we were left on our own. Most evenings were spent in our quarters while I read aloud from Thomas Wolfe's *Look Homeward Angel*, a work that moved Edward deeply. Most days were filled with sunshine, blue skies, and photographic sorties into the country—the surrounding small Hispanic villages of Truchas, Cordova, and Chimayo and into the mountains.

We visited Dorothy Brett, a painter and writer who had been a friend of D. H. Lawrence on his visits to Taos. Edward photographed her with the ear trumpet she called Toby. We spent an afternoon with a young man named Spud Johnson, who published a literary magazine, called *Laughing Horse*. . . . [Today the Laughing Horse Inn in Taos is an expansion of Johnson's original nineteenth century adobe. According to promotional literature for the inn (Laughinghorseinn. com/history.html) Johnson came in Taos in 1924 with a hand letterpress to be with friends, including D. H. Lawrence and Dorothy Brett. His magazine, printed in his living room, "started as a learned barb against the faculty and administration of UC Berkeley. The magazine was famous for its stand against censorship and bombast."]

. . . I made two negatives at the Pueblo. One was a nice positioning of three ovens used for baking bread and the other showed Sonya on a trash heap behind the pueblo photographing a magnificent cloud formation.

Photographers, intent upon their own work are sometimes quite boring and I think Mabel was not amused by us. One night she called for dessert before Edward had finished his main course and when someone called her attention to this her reply was that Edward did not want dessert. That night we decided to move on and the next morning we bade goodbye to a relieved hostess and drove to Santa Fe, where we had been invited to stay with Willard Nash and his wife, Edith.

Willard was a good painter, a charming host, and a great raconteur. He and I were comfortable with each other at once. We both had done some amateur boxing and we both were passable

marksmen. When the weather was not suitable for photography, we shot at tin cans in the desert.

Edith was a very attractive woman dressed in Western fashion, her slim waist accented by a magnificent concha belt. She and Willard seemed very happy and we all enjoyed our times together, meeting other artists and photographers of Santa Fe. Among them I especially remember Andrew Dasburg, whose paintings and sketches were reminiscent of Cézanne, and Ernest Knee, a photographer whose approach and sensibilities were consistent with ours. Witter Brynner [sic], a poet whose work I had studied in high school, gave a party for us one night, which was one of the most memorable events of the trip.

It began to rain late in the afternoon and continued into the evening, making the dirt roads slippery and Brynner's [sic] yard very muddy. I let my friends off at the front door and drove on to find a parking place in the yard, which was crowded with cars. I went back and rang the doorbell, which was answered by a young woman holding a martini. She said: "You must be one of those photographers from California. How about you and me going upstairs and having a quickie with our clothes on before dinner?" I wasn't quite ready for the question or for the action she suggested, so I proposed that we consider it after dinner.

The living room was crowded with people who seemed to have been drinking heavily. Brynner [sic] was pleasant, introduced me to his secretary, a personable young man named Bobby Hunt, and suggested that we proceed to the buffet supper. It was an enjoyable meal with good wine and lively conversation. The young woman who had greeted me so cordially at the door was not at the table. She had passed out upstairs.

. . . It was time to return to California. I had hired a man to take my place at the filling station while I was gone, so I was not earning anything. We made a few photographs on the way home, including one I made of the Indian Village at Laguna, New Mexico. We arrived at Flora Weston's home in Glendale tired and dusty after I had driven 630 miles that day. Mrs. Weston was Edward's wife and mother of his four sons. They had not divorced even though Edward had lived with a number of other women, including Sonya. We stayed the night there and although the atmosphere was not entirely

relaxed, Mrs. Weston received us with grace. The next day we paid a short visit to Margarethe Mather who had been the subject of many of Edward's early photographs and who had been an important photographer herself. Edward said that she had been the first important artistic influence in his life. She was very heavy and seemed ill when I saw her. The next day we arrived in Carmel, glad to see the sea and the fog, glad to be home.[34]

Back in Oakland, Van Dyke returned to his job at the Shell gas station and to pursuing his photography again, having been renewed, at least temporarily, by the trip to the Southwest. But his wayward eye for women had begun to unravel his relationship with Mary Jeannette. He had begun to see Mary Barnett, a friend of theirs. As early as 1933 she and Van Dyke were developing a serious relationship, and when he would travel they would write love letters to each other, sometimes mentioning their concern for Mary Jeannette. A few months later, by the end of the summer, things came to a head. Van Dyke and Mary Jeannette agreed to break off their engagement and their relationship. Mary Jeannette then began dating and later married Norman Donant, another friend they all had in common. A number of years later, in the late thirties, Van Dyke and Mary Barnett would marry. In interviews late in life, Van Dyke described his parting with Mary Jeannette but did not mention that the reason was his infidelity to her. Instead he described the cause in a way that revealed his unrelenting competitiveness, which drove his friends, lovers, family, and colleagues alike to distraction:

The reason that Mary Jeannette and I didn't get married is that she absolutely adored me and I couldn't do anything wrong, and that she just turned her whole life over to me, and my slightest wish was her desire, and it was not fair to her to accept that kind of relationship. And it also made her less interesting than she would have been if she had continued doing her own things instead of, well, becoming a photographer because I was a photographer.[35]

But the real reasons were tied up with his dissatisfaction with who he was at that time and what he was doing with his life. At about that time he wrote a poem or perhaps copied one from an unknown author on personal letterhead; it was not addressed to anyone but seemed written more as a means of attempting to purge himself of strong feelings—words are crossed

out and others inserted as if to improve the image. Among the phrases are the following, which reveal the psychological burdens he continued to carry from childhood and the darkening clouds of the Depression:

> The shadow of my head upon the rocks
> Can tell me more than all your ticking clocks
> (Though we never know our fathers nor
> the sons we leave behind us)
> Of whence we come and where we go
> Why we live we never know . . .

> . . . In the quiet and the peace
> where all but earth shall cease
> Remember this when your sons have grown
> to manhood
> And the wind whines cold in the desert
> At sundown
> Tell them this:
>> That once there were men who knew in the night
>> the warmth of the earth's great arms
>> In the day the beating of sunlite on leaves
>> And the grass growing out of the soil
> O, tell them that man has not always been blind
> Nor the wind blown dry from the barren hills
>> Nor the day without light
>>> Always

> Tell them
>> But there are no words
>> No signs to be carved in the stone
>> And now we are lost here, watching gaunt herds
>> Seeking water
>>> Waiting for rain
>>>> Dying alone
>> Oh, remember these things
>>> In the hot days
>>>> In the parched winds
>>>> In the chill nights[36]

In Weston's writings there exists a pre-1920s entry in his daybooks, a two-page handwritten note that bears a striking similarity to Van Dyke's poem in both tone and character:

And how ironical that we waste our lives in feverish haste and fitful sleep to acquire comforts! We sweat and groan that we may buy tickets to have some other person dance for us when *we* should dance—or sing when *we* should be singing—we stiffen behind counters or cramp on a ledger—stool for the price of a book to learn how others live—we acquire dyspepsia or ptomaine poisoning for the privilege of buying canned abominations—a short cut to cooking—automobiles are ours and along with them obesity and tuberculosis—blue coated criminals with clubs and guns we hire to knock our heads and pick our pockets if we don't mind laws formulated by grey—hoary—disintegrating old fossils whom we also hire to think for us—if our neighbor steps out of the beaten path in some amorous adventure we look askance—but when the billboards read "Tonight—Rudolph Valentino—the World's Greatest Lover"—the box office is stormed by the secretly desirous ones—expecting some vicarious thrill—We are a lost and degenerate race living by the clock and thermometer and resting that we may work again—for what?[37]

In both Van Dyke's and Weston's writings there is a strong resonance with the Socialist Party agenda of the twenties and thirties in America. During the thirties in particular, the fervor of socialist demonstrations and labor strikes rose dramatically and aggressively. The International Workers of the World and the teamsters had been striking against unfair labor practices and working to raise awareness of the plight of the unemployed and the growing ranks of poor and destitute across the country since the end of World War I. The Communist Party infiltrated public demonstrations to recruit for proletariat rebellions against big business and the capitalist system. But for Van Dyke all of the social issues coalesced in the 1934 San Francisco general strike.

The International Longshoremen's Association called a strike in May, which continued until July 19. During that period there were bloody confrontations with the police and the National Guard, which inspired nearly every other union in San Francisco and down the coast to join the strike.

Two of Van Dyke's close friends, Dorothea Lange and Paul Taylor, recorded the strike; Lange took pictures for herself of the soup lines and demonstrations; Taylor, an economist, covered the strike for the socialist journal *Survey Graphic*. Van Dyke's own social consciousness had been fermenting since 1932 when he had reenrolled at the University of California, Berkeley:

> I went back to college . . . and there I ran into some other people who were [influential]—there was a radical professor that I got to know and there were some young men who were close friends and we talked politics and social change and so on. And I got to know Ella Winter and Lincoln Steffens; and Weston was not interested in politics. He was apolitical; and I was not particularly interested in politics, but I was interested in social change. And I learned that the uncle for whom I was named [his mother's brother] had run for Mayor of Denver on the Socialist ticket in about 1880, which kind of got me interested in all this too.[38]

Artists were generally sympathetic to the battle calls and slogans of socialists and communists alike: to support the workers of the world, to end economic and political injustice, and to bring a hoped-for revolution to the attention of the world. But for Van Dyke and many others, sympathy for the strikers and the socialist rhetoric was also manifested in their work. Van Dyke said throughout his life that his motive in becoming a socially conscious filmmaker was to "change the world," an ideal he found to be completely compatible with Roosevelt's programs and his New Deal administration:

> Here was an aristocratic gentleman who spoke with a voice that was eloquent on behalf of the disinherited. There was a feeling that the New Deal was a bridge between capitalism and socialism. The bankers and the ruling class felt that this was true, and were scared to death by Roosevelt's policies. He was hated virulently by his own class, and that made us gather around him.
>
> Roosevelt saved us from a revolution that would have been devastatingly premature—which would have been put down brutally and which would have precipitated a reactionary backlash inhibiting a progressive thought or action for a long time. He united us, and in a way that made it possible for us to destroy fascism in Europe.[39]

Van Dyke began to drift from a love of art for art's sake to a more active social expression in his work. In early 1934 he met another photographer who became very important to his evolving life as an artist. Dorothea Lange had begun to receive recognition for her photographs of the affects of the Great Depression on the people of San Francisco. Van Dyke gave her an exhibition of this work at 683 Brockhurst. Although they were not anything like the work of the members of Group f/64, they did capture Van Dyke's interest through their intensity and compassion. To accompany the exhibition he wrote an article for the 1934 issue of *Camera Craft*. In excerpts from the article it is possible to see the changing philosophy that now imbued Van Dyke's own photography; he now took pictures of decaying storefronts and makeshift shacks symbolizing the depression, pictures that displaced his earlier work of smoke stacks and urban scenes that bespoke a thriving industrial society.

> She sees the final criticism of her work in the reaction to it of some person who might view it fifty years from now. It is her hope that such a person would see in her work a record of the people of her time, a record valid of the day and place wherein made, although necessarily incomplete in the sense of the entire contemporary movement.
>
> . . . Neither does she encompass her work within the bounds of a political or economic thesis. She believes and depends more on a certain quality of awareness in her self. . . . She is not preoccupied with the philosophy behind the present conflict, she is making a record of it through the faces of the individuals most sensitive to it or most concerned in it.
>
> . . . Miss Lange's work is motivated by no preconceived photographic aesthetic. Her attitude bears a significant analogy to the sensitized plate of the camera itself. For her making a shot is an adventure that begins with no planned itinerary. She feels that setting out with a preconceived idea of what she wants to photograph actually minimizes her chance for success. Her method is to eradicate from her mind before she starts, all ideas which she might hold regarding the situation—her mind like an unexposed film.
>
> . . . There is no attempt made to conceal her apparatus. Miss Lange merely appears to take as little interest in the proceedings around her as is possible. She looks at no individual directly, and

soon she becomes one of the familiar elements of her surround-
ings. Her subjects become unaware of her presence. Her method,
as she describes it, is to act as if she possessed the power to become
invisible to those around her. . . .

. . . We ourselves are too poignantly involved in the turmoil of
present life. Much of it is stupid, confused, violent, some little of it
is significant, all of it is of the most immediate concern to every-
one living today—we have no time for the records, ourselves living
and dying in the recording.[40]

Paul Taylor, a professor of economics at the University of California,
was a frequent visitor to Van Dyke's gallery. In 1934 he and Van Dyke sub-
mitted an application to the Guggenheim Foundation to document the exo-
dus of farmers from the Dust Bowl and their migration to California. Their
application was rejected, but five years later, Taylor and Lange did pub-
lish a book on that very subject, *An American Exodus: A Record of Human
Erosion.* By that time Van Dyke was no longer involved with photogra-
phy, having become completely immersed in film. But his friendship with
both Lange and Taylor bore other fruit. He introduced them to each other,
which resulted in many years of collaborative work and marriage. They first
worked together when Taylor invited Van Dyke, Lange, Holder, and others
to make a trip with him to photograph a cooperative lumber camp in the
high Sierra called UXA (Unemployed Exchange Association), one of the
many bartering groups that had sprung up during the depression.

UXA was a cooperative of down-and-out souls, former forestry and
lumber workers who were riding out the depression making shakes and
shingles. Taylor wanted to see how well they were doing and to document
their work. The workers lived in large tents like those used by the military
in First World War. Each tent held two men and had two army cots and a
wood-burning stove as a meager defense against the high altitude and win-
ter winds of November.

Van Dyke, Taylor, Lange, and other members of their party slept in
tents, ate in the mess hall, and photographed from sunup to sundown. Van
Dyke shot film as well as photographed but none of the works from that
trip survive; they were probably destroyed by Van Dyke in one of many
attempts to eliminate the earliest of his efforts in both mediums.

Earlier in March 1934 Van Dyke was given an exhibition at the Denny
Watrous Gallery in Carmel. It was his last one-person show in the thirties,

and his exhibition statement reveals an attitude of summation rather than excited anticipation of work yet to come, which would have been more typical of such a statement from him a few years earlier:

> The commercial and documentary uses of photography have long been familiar to the public, but the legitimate use of the medium as an art form is comparatively new. The knowledge that photography can record surface texture and tonal gradation better than any other medium, has led to the use of pure photography as a means for personal expression.
> . . . These prints, then, represent my use of pure photography to record what I consider to be the significant or the merely beautiful aspects of the American Scene.[41]

Weston published a small piece in the local newspaper in which he described Van Dyke as "one of America's most promising young photographers" in "his ever sensitive reactions to life." He also plugged 683 Brockhurst for showing the best workers in straight photography and bringing to public awareness new contemporary photographers. But there was something missing in his praise as well. He clearly admired Van Dyke's work but seemed to pull back from the kind of declarative statement he might have made if he were not aware that Van Dyke was shifting his commitment elsewhere.

Others of the Group f/64 also clearly sensed that things were changing in Van Dyke's outlook. Ansel Adams wrote a long letter to Weston that included the following reference to Van Dyke:

> Both you and I are incapable of devoting ourselves to contemporary social significance in our work; Willard is gifted in this respect. I come to think of him more as a sociologist than a photographer. His photography seems to be turning into a means to a social end, rather than something in itself. I will regret it if it becomes that entirely, for he is too damn good a photographer to submerge it in anything else. I still believe there is a real social significance in a rock—a more important significance therein than in a line of unemployed. For that opinion I am charged with inhumanity, unawareness,—I am dead, through, finished, a social liability, one who will be "liquidated" when the "great day" comes.

Let it come; I will try to adapt myself. But, Goddamnittohell, I refuse to liquidate myself in advance.[42]

Weston did not respond directly to Adams's comments about Van Dyke. Instead he wrote about the nature of the times, referring indirectly to Van Dyke as among those who must choose their own reality:

There is so much talk of the artist getting down to the realities of life. But who is to say which are the realities? Obviously they cannot be the same to everyone. All arguments are futile which do not take into consideration the fact—(fact for me at least) that persons differ in *kind*, not just in degree; differ just as horses and elephants do.

But we all have our place, and should function together as a great fugue. And the tension between opposites is necessary; the two poles, feminine—masculine, radical—conservative, etc. What would the poor red do without his conservative to play with! He would have to invent one. Likewise the conservative.

I have the greatest sympathy, even understanding, for those who have gone sociological (politically). They had to,—granted they are honest. If I saw an interesting battle between strikers and police I might be tempted to photograph it,—if aesthetically moved. But I would record the fight as a commentator regardless of which side was getting licked.[43]

As Van Dyke began to explore a different motivation for his photography and gave serious thought to what he was doing and why, he inevitably searched introspectively for answers to his disquiet. His childhood memories of excitement over film, his acting classes in high school and college, and the films he continued to see all merged in 1934 to reinvigorate his interest in that medium. He and Preston Holder were regular patrons of the Boynton Film Society in Berkeley. Because they were both increasingly interested in the socialist point of view concerning a world society, they were especially interested in films from France and the epic Soviet Union masterpieces. They became familiar with names like Sergei Eisenstein and Dziga Vertov, who were great Russian social propaganda revolutionaries and early masters of montage. Eduard Tisse was Eisenstein's cinematographer, and it was his use of extremely low camera angles, which dramatized

his human subjects against the sky, making them heroic, that most inspired Van Dyke. He said that at the time he naively thought that great film was a series of individually seen single images. But later after making his own first film, he realized that "a series of beautiful frames tires the eye of the spectator and does not move the action forward." They saw works by Fernand Léger like *Ballet Mécanique* and Ralph Steiner's *Surf and Seaweed*, a film Van Dyke referred to as "a rhapsody of images that came to life on the screen."

Steiner had been someone that Van Dyke was interested in as early as 1929 when he and Weston talked about his and Walker Evans's works reproduced in *Hound and Horn*. They were among those who he appreciated before he developed an interest in Lange's documentary photography. The fact that Steiner was known to Van Dyke at this time as both a photographer and filmmaker greatly inspired him to try his own hand at film.

Inspired by the surrealist nature of some of the films they were seeing at the film society, Van Dyke and Holder decided in 1933 to make a 16-millimeter work of their own, which they titled *An Automatic Flight of Tin Birds: An Experimental Surrealist Film*. The scenario was written by Holder, and Van Dyke did the filming, but they both invented the gory scenes meant to shock the viewer. The film contained three sequences: "Midnight Shakes the Memory, News papers from Vacant Lots," and "Dust in Crevices." The primary props were a rubber glove, several sheep eyes from a local slaughterhouse, and a straw figure tied to a cross on a hilltop. Holder came up with the title, which Van Dyke claimed he never understood the meaning of, but then the images of the film itself defied all but the most surreal of meanings. The following is a selection of scene descriptions from the original script:

> glove fills frame, slowly collapses until fingers droop over palm—
> Dummy topples stiffly to ground, cross slowly tilts backward, falls over hill out of sight—close-up of canvas dummy face crudely & precisely painted filling frame—camera moves to eye, filling frame, dummy eye becomes closed living eye, eyelids slowly open to very wide, staring blankly, becomes naked eyeball resting on black surface, eyeball is punctured, slowly collapses—. . . thick lipped wet mouth, full length portrait of nude woman "still" with face whited-out as in medical journal—. . . with camera in position

shown, plate glass is held in front of lens. As shot ends water or oil is poured on glass, blurring image at the same time lens is racked out of focus.[44]

Van Dyke readily admitted in later life that he was happy that the film did not survive. He felt, probably correctly, that it was an immature gesture born of imitation and youthful energy. It did, however, represent an opportunity for him to rent equipment and to get a feel for the process of the medium, which he had begun to believe would fill the void that had replaced his recent passion for formalist photography. He was always fascinated by the process of whatever captured his interest, whether it was the push-pull of reality in acting, the planned search for unexpected adventures in travel, or the mastery of demanding technical requirements to be an artist with a camera; it was the process that he loved as much as anything else.

Good fortune came his way, yet again, and just at the right moment. In the fall of 1934 a friend of his, Winslow Carlton, visited him at 683 when he heard of his involvement with film. Van Dyke had written to Weston boasting about his foray into film but received only a bland acknowledgement. He no doubt sought an audience in the Bay Area, but, again, he must have received less than enthusiastic responses. In any case, Carlton visited him to enlist him (clearly without having viewed his surrealist venture) in making a film about the human face of the Depression. Van Dyke and Holder accepted the invitation enthusiastically, if naively. Winslow Carlton was a New Yorker with strong liberal politics and had substantial financial resources. His father was chairman of the board of directors of Western Union Telegraph Company. Carlton explained to the two novices that he was deeply moved by the problems faced by the unemployed and that he felt that the cooperative movement, which had numerous outlets in California, might provide additional solutions to existing government's programs like the Works Progress Administration (WPA), Civilian Conservation Corps (CCC), and other make-work efforts.

Van Dyke borrowed a more professional camera from friends at a local newsreel and industrial film company. It was an Akeley (named after its designer who developed it for his exploration of Africa), which was the standard news camera of the day, made famous in 1922 by Paul Strand when he photographed it as a precisionist icon with sculptural qualities. It was also his camera of choice for a time. Hand cranked, the Akeley was

geared for smooth, steady action that helped to compensate for the operator's hand movement. It was a wonderful sensory experience in Van Dyke's hands, and he rushed to a nearby lake and filmed the movement of swans, analogous to the sleek, gliding movement of the camera's internal workings. The process seemed ridiculously simple to him. He was used to a long focal length lens with its imposing weight and the inexactness of figuring proper exposure when light had to travel though the long tunnel of an extended bellows on a cumbersome 8 × 10-inch view camera. The Akeley film camera was compact, had relatively small short lenses, and most importantly did not require static subjects. It could flow with time; an operator could reveal his or her vision in sequences of observation rather than having to attempt to visually eulogize a single perception.

So armed with a wholly new visual enterprise and the excitement of new conquest, Van Dyke and Holder took up Carlton's challenge, accepted his financial backing, and went back to the UXA camp they had earlier photographed with Dorothea Lange and Paul Taylor. The shingle makers in the high Sierra, living in tents, bartering in part for their livelihood, and braving the winter seemed like a noble subject for a positive message in the midst of so much human suffering. But after eight months of shooting the result was an unmitigated, boring failure. In his memoir Van Dyke described this first attempt not so much for the sake of detailing the failure as to lay down the basis of his filmic vision for his forthcoming career as a social documentary filmmaker:

> We had no understanding of how unprepared we were to make a documentary film. We certainly knew how to expose a negative, and what a print should look like, but the knowledge that movies were not just a series of still pictures strung together had eluded us.
>
> It was a sobering time when all of our UXA camp shots were cut together: the effect was boring beyond belief. But in making it I learned a number of lessons important for my future.
>
> . . . Strand's photography is certainly among the greatest ever done, but his cinematography in THE WAVE is static, slow, and inappropriate. The film indicates that he, too, saw and was influenced by the photography of the Russian, Tisse. Each single shot is exquisitely lit and the relationships of the forms within the frame are impeccably arranged, but they are quite obviously arranged. The scenes are not convincing.[45]

Van Dyke's first finished film may not have been a coherent or interesting work, but the process, by great coincidence, presented him with a unique opportunity to learn from one of the masters of film. The raw footage for Van Dyke's film was being processed in the same laboratory as footage for a film by Sergei Eisenstein about Mexican culture and the revolution. When Van Dyke went to the lab to screen rushes for his film, the lab was already screening footage for Eisenstein's film, titled *Que Viva Mexico*. The film was never completed by him but was, sadly, taken over by Upton Sinclair, who financed it. He turned it over to Hollywood, which recut it and released it as *Thunder Over Mexico*. On several occasions Van Dyke sat through the afternoon watching unedited reels of the film, probably before Eisenstein had seen it and before it had been abused by Hollywood.

The UXA film did not launch Van Dyke's career as a filmmaker, but it did encourage him to concentrate on something positive in the mix of a number of dramatic events that laid the framework for a rupture in his personal life. These events eventually prompted his departure from photography and his beloved California. Van Dyke had now worked at a Shell gas station for several years, which was an entirely different enterprise from such establishments today. Then the gas station was about comprehensive service for the customer. The attendant had to appear in clean uniforms, and it was a job with career potential; one would train to own a franchise station or even advance to work for Shell Company itself. Van Dyke, of course, had valued the position for his daytime freedom to photograph.

For a couple of years Shell had offered him better positions, which he turned down, claiming he needed his freedom to attend law school. The claim was bogus, but it allowed him to maintain a status quo with his job. Finally in 1930 Shell offered him a position as district manager for northern California. He knew in his heart that he did not want such a career, but at the time he was engaged to be married, and he felt conflicted. He visited Weston to seek counsel and reinforcement for his decision. Weston told him, when asked what he would do, that it was not a matter of what he, Weston, would do, but what Van Dyke should do. He reminded Van Dyke that he had talent but that it would be a very long time before he would make enough money as a photographer to support a family or be able to do the kind of work he would want to do in photography. He ended by asking Van Dyke if he thought he could be happy by doing a job that he knew he could do but that did not interest him just for the sake of money. Van Dyke turned down the offer from Shell and when Weston gave him a copy

of his first book, he inscribed it "For Willard, who endeared himself to me because he spurned the bitch goddess, success."

Van Dyke's decision not to seek a secure financial future probably also affected his relationship with Mary Jeannette. It was then that he began to secretly explore liaisons with women introduced to him by Weston. Confronted with the prospect of life as an artist, he also started to lose his bearings when the Depression began to take its horrendous toll on life itself. He began casting about for other jobs both as a photographer and at other stations. He received a note from Ansel Adams that curiously recommended against him trying to make a living as a photographer:

It's none of my business, Willard, but I am going to express myself and take the consequences. But, I guess you won't get sore at an honest opinion. If that other Service Station job is available, I would certainly take it for a while. It is going to be quite some time before photography will be a paying proposition—especially for new people in the commercial fields. Honestly and confidentially, if I did not have one small contract for the year, I would be in a Hell of a fix, and looking for some kind of janitorship. The whole set-up is in the lap of the Gods—it looks like it will go through all right, but it's going to be a struggle. As I said, I have a heap of connections and strings and contacts—and I have had only one small order since I came back from Yosemite on the 8th of January. I certainly don't want to make you discouraged about it—and there may be a fortunate break for you right away, but I am a bit scared myself, and if I were in your shoes I would be more so. You're a damn good photographer—one of the best going (I mean it) but for Krisesake don't put yourself in the breadline on account of any impatience. I am confident the times are going to be better—but not immediately.

Let's get together and talk it over some time. I have a few ideas that may be of a little value. But Hell—wait until you try the commercial fields—a few phases are swell but most of it is absolute bunk.[46]

Adams was able to be helpful through his contacts and arranged for Van Dyke to become enrolled as a photographer for the PWAP (Public Works of Art Project) in northern California. This New Deal program hired

photographers to photograph works of art and murals produced by painters. The famous Farm Security Administration (FSA), which hired photographers to photograph rural America under the sociologist Roy Stryker did not yet exist. It began as an official government program late in 1935. The government-sponsored jobs were not exciting, but they helped Van Dyke make his decision to quit working at the station and try to make his living as a photographer. But the final straw that persuaded him to abandon his job at the station came during the general strike in San Francisco. Union-busting goons began to patrol neighborhoods with baseball bats, stopping cars and asking for identification, in their search for scab infiltrators. Van Dyke felt the anger and violence every day on his way home. Scabs delivered gasoline to the station, which annoyed Van Dyke. He attempted to form a union among some of his friends who were also service station workers. Shell threatened him with his job. One of his friends was beaten by Legionnaires, his leg broken, and threats of worse to come spread throughout the industry. Van Dyke told the story as follows:

They called me down and the district manager said, "we've offered you several jobs, haven't we?" I said, "Yes." He said, "Well, what do you think you're going to get with your union, what is all this?" And, I said, "Well, I just figured that if we all got together and sort of talked things over, then maybe we could get together on telling you fellows what our problems were." He pushed a buzzer, and his secretary came in with a pile of papers about so high, threw them down on his desk and went out. . . . And he said, "You know what those are?" I said, "No." He said, "Those are applications for your job! I don't think you're going anywhere with this union. We control the industry, and the only way to stop our stations from operating is with the Teamsters, and we've had them in our pocket for a long time." Well this kind of opened my eyes to some facts of life that were more than rocks and shells and peppers. I became a militant young radical at that point.[47]

Van Dyke quit and started taking freelance photography jobs; he worked for Mills College and local museums, and he photographed a private jade collection for half a year. He soon found out for himself that the requirements of commercial work were dull and demanding, just as Adams had warned him. It was also a strange time for his relationships with the

women in his life, who remained friends in spite of the musical chairs they played. He also could not shake his mother's ever-present grasp on his life and activities. She wrote him every few days when he and Weston visited Mabel Dodge Luhan and whenever and wherever he traveled outside of Oakland. But it was a codependent relationship, one that he both needed and abhorred. He was his mother's firstborn and the favorite, as she all too often reminded him.

Word about Van Dyke's burgeoning interest and involvement in documentary film and photography began to reach the professional community. After Winslow Carlton's visit to 683 Brockhurst came a visit from Nina Collier, a staff member of the Agricultural Adjustment Agency. After reviewing his photographs and film she told him she would be interested in receiving a proposal from him to make a film about the Dust Bowl and migratory workers. He diligently put together a proposal and script outline and planned a trip to Washington, D.C. He bid good-bye to friends, lovers, and family with a certain finality, which at the time surprised even him. Somehow he knew he would not be returning—ever.

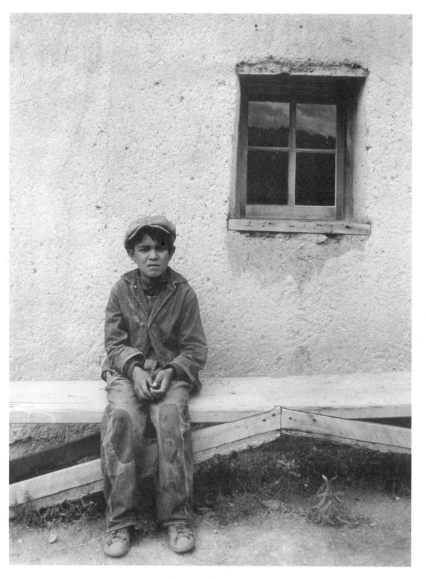

10. Willard Van Dyke, "Boy, New Mexico," 1937

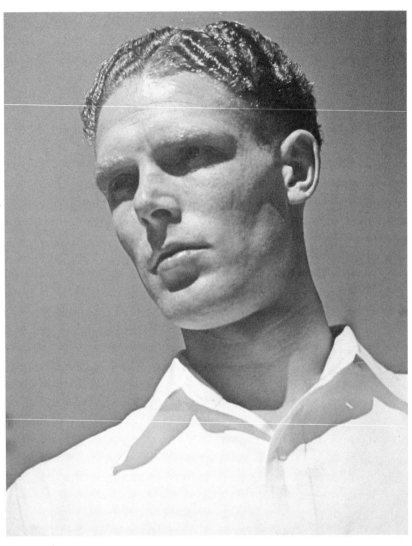

11. Willard Van Dyke, "Athlete," 1932

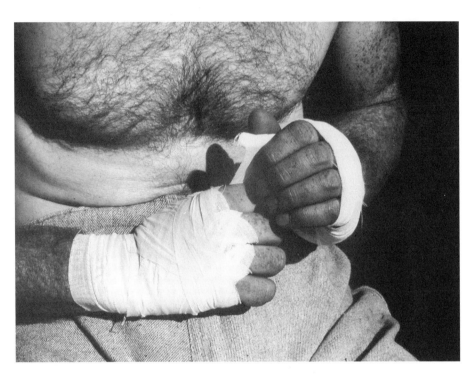

12. Willard Van Dyke, "Boxer's Hands #1," 1933

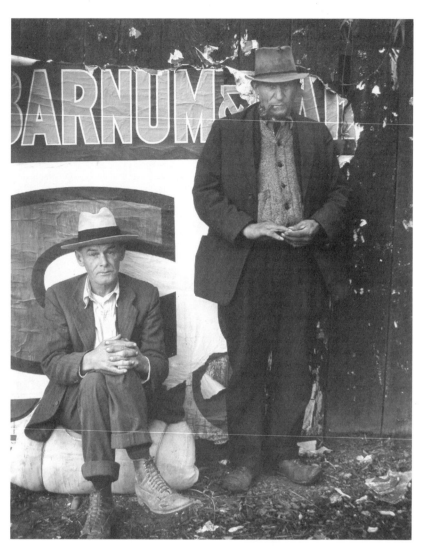

13. Willard Van Dyke, "Itinerant Workers," 1934

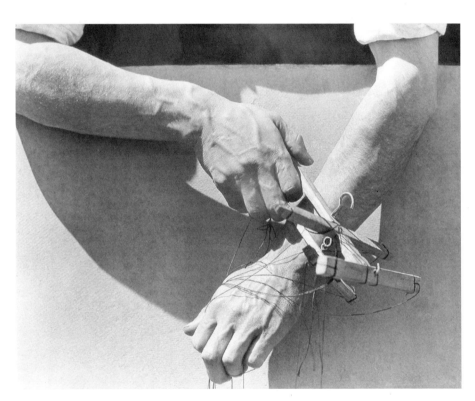

14. *Willard Van Dyke, "Puppeteer's Hands," 1933*

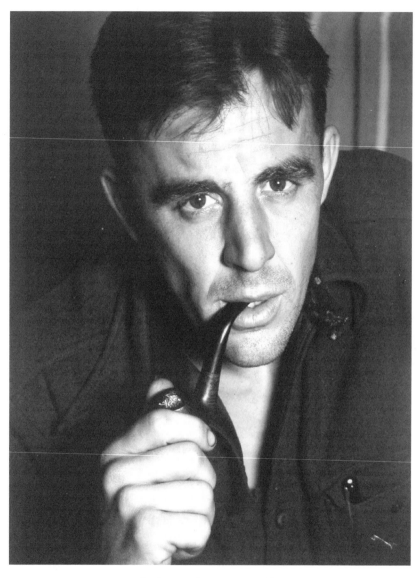

15. Willard Van Dyke, "Preston Holder," 1937

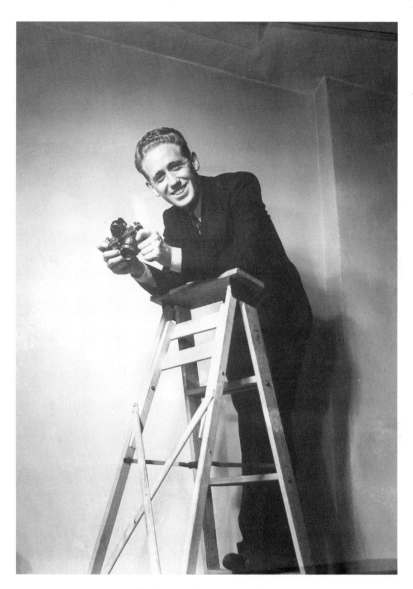

16. Willard Van Dyke, "Peter Stackpole," 1937

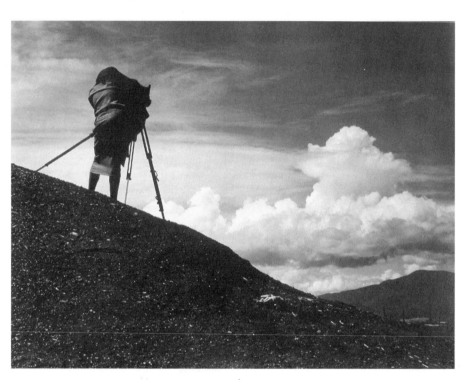

17. *Willard Van Dyke, "Sonya Noskowiak," 1933*

18. Willard Van Dyke, "Ansel Adams at 683 Brockhurst," 1933

19. Willard Van Dyke, "Sonya Noskowiak [left]
and Imogen Cunningham at 683 Brockhurst," 1932

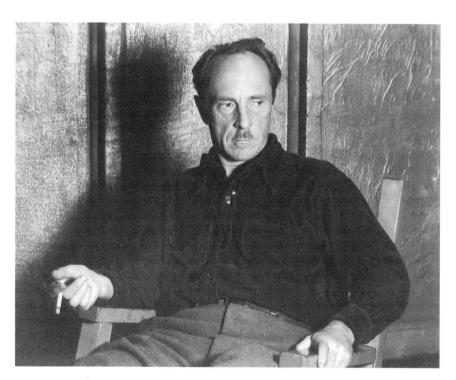

20. Willard Van Dyke, "Edward Weston, Carmel," c. 1930

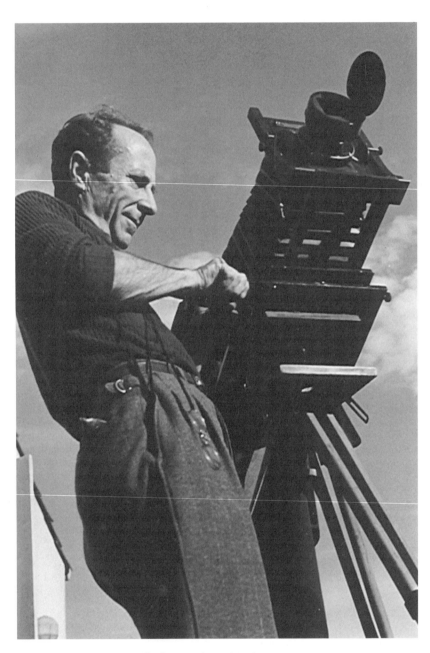

21. Willard Van Dyke, "Edward Weston," 1933

22. Willard Van Dyke, "Abandoned Logging Camp, North Coast, CA," 1937

23. Willard Van Dyke, "California Farm," c. 1934

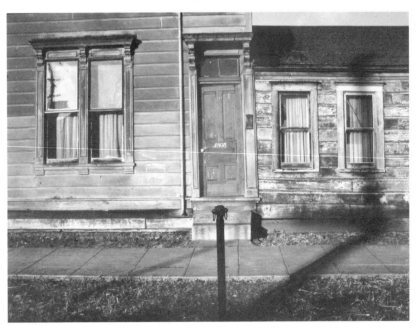

24. Willard Van Dyke, "Hitching Post, Berkeley, CA," 1933

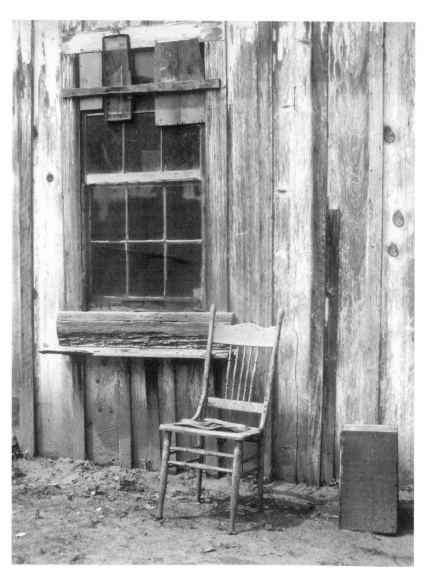

25. Willard Van Dyke, "House and Chair, Monterey, CA," 1933

26. Willard Van Dyke, "Virginia City Interior," 1933

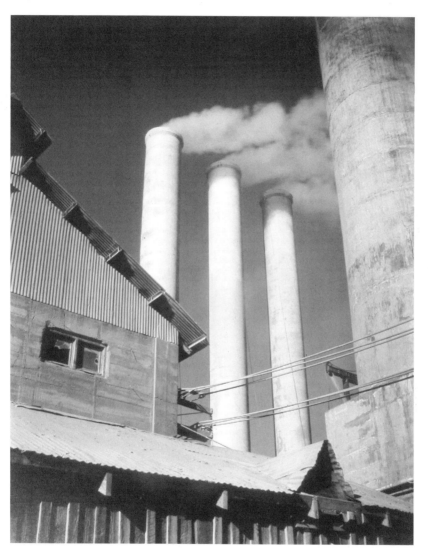

27. Willard Van Dyke, "Monolith Factory," 1929

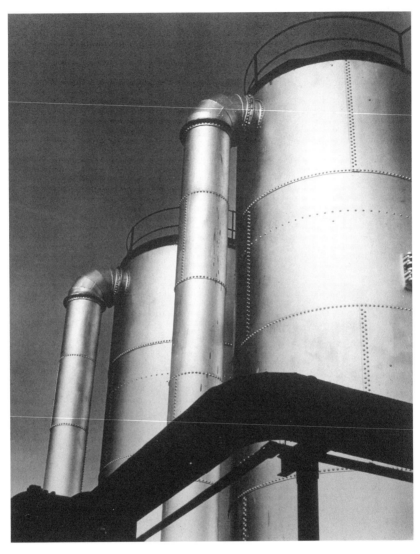

28. Willard Van Dyke, "Gas Tanks, CA," 1929

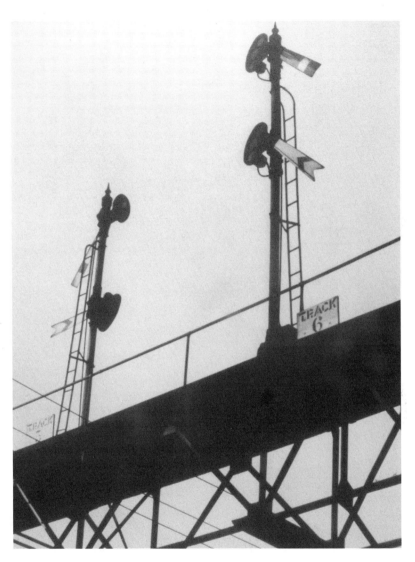

29. Willard Van Dyke, "Railroad Semaphores," 1929

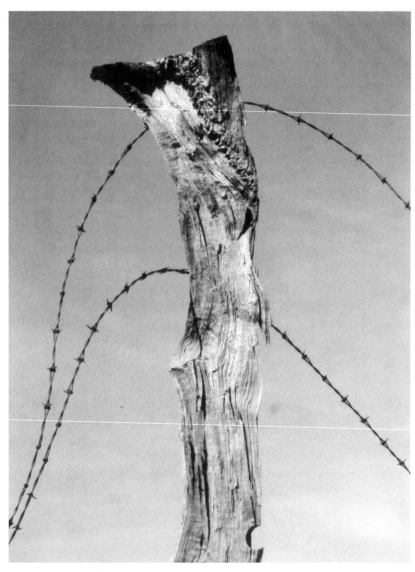

30. Willard Van Dyke, "Barbed Wire and Fence Post," 1930

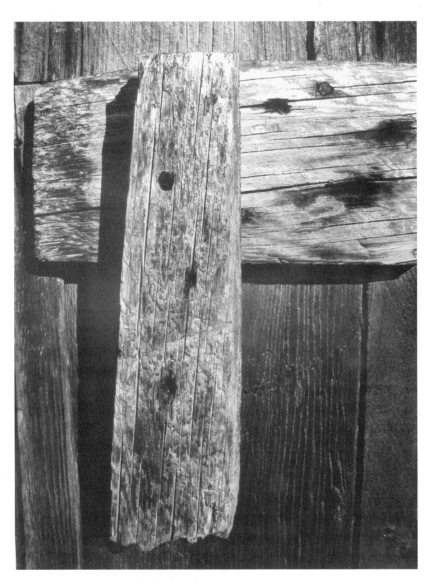

31. Willard Van Dyke, "Barn Detail," 1933

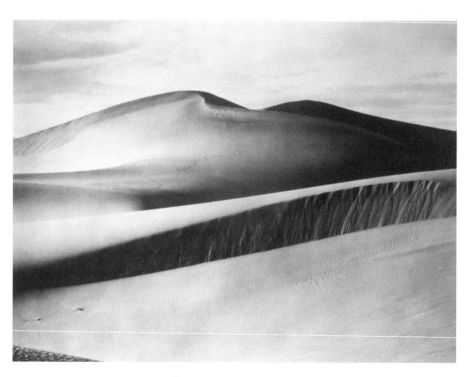

32. Willard Van Dyke, "Death Valley Dunes," 1930

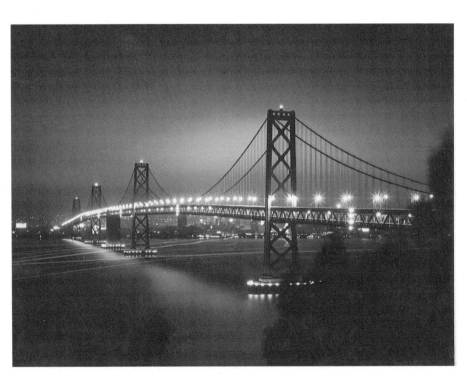

33. Willard Van Dyke, "San Francisco Bay Bridge," c. 1927–29

4

Reinventing the Artist

✦ EARLY IN 1934 VAN DYKE TOOK A TRAIN TO WASHINGTON, D.C.,
to show his UXA film to the Agricultural Adjustment Agency. Caught up in
the moment of his newest adventure, he convinced himself that the agency
would be able to see beyond the film's structural deficiencies and judge his
proposal on the basis of his cinematography, which he believed was "good
enough." But as his little silent film flickered on the screen in the sterile gov-
ernment viewing room, he could see that scene after scene displayed a pain-
ful lack of drama. Displaced unemployed craftsmen hacked away at logs,
splintering off thick shakes for roofing, while some fellow workers smiled
for the camera in front of their tents and cooking fires. Only the darkness of
the room softened the roar of polite silence from the faceless viewers. Then
came a voice from somewhere near the front of the room that said, "Well,
we haven't got the government appropriation yet. We'll let you know."

Van Dyke knew that he had probably not impressed his potential
sponsors, but it was too soon into his journey for him to feel the emptiness
that comes with rejection. Besides, before he left Oakland, he had accepted
an invitation from the most unlikely of sources to make a six-week trip to
the USSR and Europe. The family friend that he accused of abusing him
during his childhood and early teen years had said he would meet him
in New York and pay all of his expenses on the proposed trip. Although
Van Dyke's acceptance might seem to throw doubt on the credibility of his

earlier claims, it is also possible that their friendship had survived beyond the point of crisis and that their differences had been settled. In his memoir this is what Van Dyke claimed took place at age seventeen. He was a complex person of extremes, and he may have been given to elaboration and enhancement of his memories, but at the core he was excruciatingly honest. Therefore, in the absence of proof to the contrary, his claims that the two reconciled must be assumed to be true. This does not mean that the psychological scars did not continue to haunt him but only that he had devised a means of living with them, at least to the best of his ability. Throughout her life, Van Dyke's mother regularly wrote him with news of the family friend, who seemed to have genuine affection for the family in general, describing his accomplishments and noting his continued support of their financial needs.

The trip was to be an opportunity for the friend to see firsthand what was happening musically in Europe, and Van Dyke was especially eager to see and learn more about Russian film and theater. He had seen many Russian films back at the Berkeley Film Center and thought he might have a chance to meet their creators—filmmakers like Eisenstein, Dovzhenko, Vertov, and Pudovkin. He had also read about Stanislavsky and his unique form of teaching and directing actors. Van Dyke and his friend first made short visits to England, Scotland, Norway, Sweden, and Denmark, but there is nothing about their visit to these countries in Van Dyke's letters and notes that document who they might have visited or why they were there. His first recorded memory of the trip describes a visit with the great environmental composer, Jean Sibelius, at his home in Finland:

Sibelius greeted us courteously and offered us coffee. He had a young assistant who spoke more English than his master, and all of us spoke a little German, so communication was no problem. . . . It was a memorable day for me as I watched and listened to two artists speak in the language they understood best [the piano]. I remembered the many Saturday afternoons in Los Angeles when I had listened to artists such as Kreisler and Heifetz [with his friend], but I had never seen him with one of his fellow composers. I gained a new respect for him. We were silent during the train ride back to Helsinki. I was sorry that my nature did not permit me to return the love he felt for me. He was a good friend and a kind man.[1]

Van Dyke's last sentence is a good example of the kind of glazing over of unpleasant experiences he often engaged in when presenting his life for public consumption. If he experienced trauma in his childhood, his adjusted memories nevertheless became his reality. This charming, precocious young boy, who became addicted to attention, carried into adulthood the extremes of these memories, and they formed the basis for his attitudes toward all relationships.

Van Dyke and his friend arrived in Leningrad in June and spent the majority of their time attending the theater and ballets and visiting museums. When he wrote of these experiences in his memoir and shared a draft with filmmaker friends he was surprised at their shocked disbelief that he had not visited the leading filmmakers and revolutionary artists of the time. There was a hint of anger in their comments that suggested they thought either he was hiding something or had not made the most of the trip. Van Dyke responded by saying that he was young (twenty-eight at the time) and inexperienced and that he was just as interested in theater and acting at that time as he was in film—in fact, maybe more interested in them than in film. He had just begun a personal journey to find out what kind of artist he might yet be. He was convinced that all that was left of his life as a photographer was shards of fragmented memories, and he apparently made no attempt to make photographs on the trip.

Within the first week in Leningrad he drafted a letter to send to friends. He indicated that it would be the first of a series of letters. It appears, however, that no other letters were written and that even the first was never sent. The letter reveals interest in and empathy for the socialist lifestyle of the workers, in spite of the limitations on their freedom. It contained a running description of hotels and of visits to revolutionary sites and other points of interest permitted by the controlling government Intourist agency. In stark contrast, his memoir, which was written nearly four decades later, projects a brusque and negative mood and only occasionally mentions positive experiences. The following excerpt from the letter suggests that he was clearly testing his socialist perspective but in a more touristy rather than serious professional or creative fashion:

Our first day in Russia provided a glimpse into a very different world. We arrived in Leningrad a little late for lunch, having pushed our way through a group of furtive beggars, and went directly to the dining room. The waiter was sullen and the bread roll on my

plate had the rear legs of a cockroach protruding from it and spears from an ear of wheat. . . . That night we went to see a play about whores being reformed in a work camp on the edge of the Artic Circle. . . . As I understood it the idea was that once the women understood the aims of the revolution and were offered jobs . . . they would abandon their profession and become more productive members of society. It did not ring true for me, nor did the paintings that I saw the next day. Stalin was discouraging experimentation and innovation; as a result, the State had come to support what was known as Social Realism, a highly idealized representation of farm workers, mechanics, machinists and soldiers. This was one of the greatest of the many disillusionments I was to receive during my visit.

We went on to Moscow where we saw model factories, a showcase collective farm, and a marvelous performance of "Swan Lake" danced by the prima ballerina Ulanova. I never saw Pavlova, but if she danced more beautifully than this woman, I think I could not have borne it. I was deeply moved, as I often am by art in any form. . . .

Unfortunately, all of the film people we had hoped to see were out of town on location for the summer. There was nothing our guide could do about this, of course, but knowing that we were disappointed, she rather reluctantly introduced us to two American men about my age. They had come from Russian Jewish families who had left Russia for the United States in 1905, and the young men, in an excess of chauvinistic fervor, had returned and relinquished their American citizenship so that they could help build a socialist society. . . .

I learned that my new friends had been in the country for two years, had jobs in a factory, and slept on park benches because apartments were very scarce and under state control. They hoped to get more comfortable accommodations soon. I sensed a desire to be loyal to their adopted country, [but] suspected that they felt they had relinquished their American citizenship too hastily. As they led us back to our Intourist hotel, we took a short cut that led through an alley. I was appalled to see there dozens of ragged, dirty children sleeping against the walls. These were the kids that I had seen portrayed in a Soviet film called "Wild Boys of the

Road"—children who had been uprooted by five years of war and famine following the 1917 revolution. But this was 1935. My new friends loyally assured me that these were just farm kids who had come to Moscow for excitement in the summer and who slept out doors because it was so warm. Perhaps, but I felt that a socialist society should be able to do better by its children. . . .

It had been only eighteen years since the revolution and already it had begun to be betrayed. Dissidents like Trotsky had been exiled, later to be murdered. The purges had begun: Kamenev and Zinoviev, two staunch followers of Lenin, had been executed, but more important to me than these crimes was the suppression of the artists.[2]

Following the trip to Europe and Russia Van Dyke returned briefly to New York. He called Washington to ask about the progress of his proposal and was told that although the funding had come through, they had decided to give the grant to a filmmaker by the name of Pare Lorentz to do a film on soil erosion under the auspices of the Resettlement Administration (later the FSA). (This film by Lorentz, *The Plow That Broke the Plain*, was released in 1936 and became a classic.) Although not really surprised he was not selected, he decided to return to New York to take stock of the situation. He walked the streets of Manhattan for a few days soaking up the surprisingly welcome chaos of a constantly moving throng of independently driven minds. With the oppressive Russian socialist system fresh in his mind, he reacted as if he had awakened from a bad dream. He instinctively recognized that his desire to "change the world" meant having an impact and that that meant enlarging his immediate world. He visited the Julian Levy Gallery where he saw an exhibition of photographs by Henri Cartier-Bresson, whose work reinforced the idea that photographic works of social concern could stand equally among the work of painters and other artists. He checked out what acting classes were available and explored various ways of making a living, such as through freelance commercial photography. At the end of a week he returned to Oakland, unsure of why he was going back, but feeling there were loose ends to tie up (with Mary Barnett, for example). After he and his family friend said good-bye in New York, it appears they never again had contact with each other.

He arrived in California to find that everything now seemed to be slow moving and lacking the "artistic ferment" that had captivated him in

New York. He did discover that a theater union had been formed, like one in New York he had visited, to recruit actors and directors for politically left productions. But even their efforts could not turn his head from the inspired days he had spent in New York. He also visited the office of the San Francisco Film and Photo League, which he said in his memoir he had attempted to organize before leaving for Russia. Like its namesake in New York it was to be composed of photographers and filmmakers who would record the Depression and the growing labor movement, but in his view, it had made no progress since his departure. His statement suggests that he had been far more involved with activist social issues in California than he previously admitted, making Ansel Adams's letter to Weston about him seem all the more reasonable.

In Van Dyke's personal papers was a copy of the constitution of the San Francisco Film and Photo League and a copy of the January 7, 1935, issue of the New York Film and Photo League's newsletter, *Filmfront*, which he had picked up in New York on his return from Russia. It featured an article by Dziga Vertov with excerpts from a lecture he gave in Paris in 1929 on the kino-eye, a method he had developed for making films of strong socialist content in a nontheatrical manner. Vertov's works, including *Man with a Movie Camera*, as well as Eisenstein's *Potemkin*, both of which set artistic standards for new documentary film movements, were already familiar to Van Dyke. In his article Vertov claimed kino-eye was an attempt to develop "a language proper to cinema, special methods of shooting and montage which are not those of enacted film. The language of the film has become absolutely distinct from theatre and literature. We have created the conception of Documentary Cinematography."

The remainder of the issue was devoted to diatribes against the U.S. government's League of Decency, which, in the league's view, was attempting to censor films and control the film medium. The league also attacked what it saw as hypocrisy in the Hollywood machine and its lack of concern for reality, especially for the suffering of humanity. Of additional interest to Van Dyke would have been a list of members of the board of "sponsors," which included Ralph Steiner, who was at that time showing his film H_2O, Lee Strasberg who taught acting, and Erskine Caldwell, author of *God's Little Acre* and *Tobacco Road*, whose writings on the injustices of class and poverty in the rural South would have hit close to home for Van Dyke. There can be little doubt that the article by Vertov spoke to the kind of cinematic expression in film that Van Dyke was seeking. It is also possible to

see Van Dyke's thinking, if not his hand, in aspects the San Francisco Film and Photo League document:

> We want to seek then, most of all, subjects that are powerful and representative factors in the present struggle of social forces. We want bankers, workers, farmers, rich and poor, white collar workers, policemen, politicians, soldiers, strikers, scabs, wandering youth, stockbrokers, and so on and so on. We want to see them in relation to the things they do, where they live, how they work, how they play, what they need and what they think. In other words we want to see them as they are—in their most significant aspects. This means seeing them in their relation to each other. We want this most of all because in this period of economic crisis the whole population is shifting into groups with equally uniform demands. In this shaking down of people into more and more clearly defined classes lies the prospect of vast social change. If this is true then it is the most significant factor in all human activity and our work must be fundamentally influenced by it.

As a part of Van Dyke's effort to organize the San Francisco Film and Photo League he made a trip to Los Angeles in 1934 with Ella Winter, wife of Lincoln Steffens, who wrote about corruption in cities and politics. Winter wrote on women's issues in the Soviet Union and was known for her bombastic manner. She was to have helped Van Dyke recruit "socially minded" members of the movie colony to support the league. Both Steffens and Winter were social revolutionaries, had visited Russia, and were strong influences on Van Dyke's strain of socialist thought. He loved telling the story about how, on one occasion when Steffens was visiting Weston in Carmel, he walked up and down the streets calling out "Vote for Hoover, Vote for Hoover." When a puzzled Weston asked why, Steffens is reported to have said, "If we elect Hoover, the revolution will come all that much sooner."

When Van Dyke went back to visit 683 Brockhurst, he found it had completely disappeared in the few months he had been gone. It had been replaced by a parking lot. It seemed to him that everything he had left was either gone (such as Group f/64) or frozen in time. He once again said his good-byes and left for New York. The first person he contacted in New York was Iris Barry who he had been told was setting up a film library at MoMA.

Synchronized sound for film had been used by Hollywood for six years by 1935, and Barry with the support of her patron, John Hay Whitney, was approaching Hollywood studios and asking them to deposit their silent theatricals at the museum. Barry welcomed Van Dyke and shared her enthusiasm for the history of the young medium of film. She and Van Dyke became close friends in the ensuing years, but in the meantime she provided him with an introduction to Ralph Steiner.

Van Dyke had determined that this was a person he must meet because Steiner was both photographer and filmmaker, and he had featured in Van Dyke's self-taught education on influential leading photographers. Even Walker Evans, who Van Dyke had come to admire, had paid tribute to Steiner's influence on him. With Barry's urging, Van Dyke called Steiner and asked for an appointment to meet him. To his great relief he found Steiner, then in his mid-thirties, accessible, warm, cheery, and welcoming. He knew nothing of Group f/64 but was interested in seeing Van Dyke's photographs.

Steiner was making a very good living as a commercial photographer but relied on his participation at the Film and Photo League to keep his sanity. The league was founded in 1930 in association with the Workers' International Relief, a communist organization that sponsored films in Russia and several European countries. In 1934 socialist and communist factions within the league split over political differences and disagreement about the mission of the league. One group, which included Steiner, formed a new branch of the league called Nykino (New York and the word for "cinema" in Russian). The new group was interested in more than documentation of class struggle and the communist agenda. Nykino was to make films about broad social issues and expand the use of the documentary approach to address narrative (acting) issues.

Steiner's loft consisted of one large room with a high ceiling and bathroom that doubled as a darkroom. Van Dyke felt at home and Steiner's legendary sense of humor made for a quick transition from acquaintance to friendship. Steiner could see the talent in his young colleague's photographs of California and on the spot offered to share his commercial clients with Van Dyke. They discussed film and the social crisis, which prompted Steiner to offer to introduce him to his film colleagues at the league. Steiner was left of center, perhaps a socialist, but essentially apolitical. Like his new young friend, Steiner believed that communists were far too dictatorial. In his book *A Point of View* he wrote:

About this time I was to teach a class in photography at a Communist-dominated photo league. At the end of the second lesson I was fired from the job. This is what I had done; at the first lesson I asked the students to leave their cameras at home but to take paper and pencil to record what they saw in the seventies and eighties on fashionable Park Avenue. Then they were to do the same on Park Avenue near Harlem underneath the New York Central Railroad elevated tracks. There, for block after block, pushcarts with food and clothing were lined up. There the poor did their buying. At the second session of my class one student after another read almost identical notes: "Along expensive Park Avenue live the capitalist rich in unearned luxury and elegance. Under the railroad the downtrodden victims of the rich live in misery."

"Yes, but what did you See?" I asked. So I read them what I had seen and taken down on paper. The monotonous rows of expensive apartment houses seemed a city of the dead. The windows of the rich looked out, front and back, on dull facades and unimaginative architecture. Visually and functionally it was what architects were calling "a high-class slum." The sidewalks were almost deserted. Every so often a taxi would draw up, and a woman would scurry into the black hole of the doorway. Once in a while a small boy in his St. Botolph's private school uniform would be herded home by his nanny. But uptown, under the railroad, life bubbled. Children chased each other under pushcarts. Mothers screamed at them and went on bargaining for merchandise. Two boys with sticks and garbage-can covers dueled like knights of old. I was finished—fired—kaput because I could not see the two Park Avenues through a thick volume of *Das Kapital*.[3]

At the league's headquarters, Steiner introduced Van Dyke to Strand, which was a monumental moment for him. If there was anyone Van Dyke admired as much as Weston, it was Strand. He had also seen Strand's early film *Manhatta*, which he had made in 1921 with Charles Sheeler, and may have seen *The Wave* (1934), a film about a fishing village in Mexico that was struggling for its very life. Henwar Rodakiewicz wrote the script for *The Wave* and had, interestingly enough, wanted to be part of f/64 but had been rejected by the other members. But whatever direct experience Van Dyke had had with Strand's work, here was another photographer and

filmmaker legend to reinforce his most recent life decision—that a photographer could also be a filmmaker of social consequence. Van Dyke would also soon learn that Steiner and Strand represented two sides of the socially conscious coin: Steiner was closer to the socialist ideal and Strand demonstrated more interest in stronger leftist position.

In the early fall of 1935, after a period of getting to know each other, Strand invited Van Dyke to see his photographs at his loft. It is not clear how much Van Dyke may have told him about his role in Group f/64 and his closeness to Weston, but at this meeting there was no mention of Van Dyke's past. Van Dyke described the evening and his perceptions of Strand as follows:

Strand lived on Ninth street, just across from my studio. . . . So I climbed the three flights of stairs and entered his sparsely decorated apartment. There were very few pictures on the walls, but one of them especially interested me. It was a painting on glass, something I had never seen before. The subject was a weeping willow tree, its branches flowing over a gravestone. Kneeling in front was a mourning woman in a long dress, her hair falling forward from her bent head. The name on the tombstone was that of a man; the dates indicated that he had died quite young. It was a melancholy piece but very moving. The picture was from New England as were the simple chairs that lined the wall. A table, a pine cupboard and a painted chest were all that Strand owned.

Paul asked me to sit down, pulled another chair in front of me, went to the chest and took out a photograph. He placed it on the chair before me, produced a large pongee silk handkerchief, and carefully dusted the print. I couldn't see any dust, but the gesture spoke of care and respect for the work he had produced. The image was a Mexican landscape, a contact print about five by six and a half inches, slightly brownish in color. Paul had the platinum paper he used especially coated by the Platinotype Company of London. After exposing the paper to the sun in a simple printing frame, he developed it. When it was dry, he coated it with a thin coat of linseed oil. The result was a rich-looking image with lustrous shadows and clean highlights. I had never seen a more beautiful print. Paul left it in front of me for what seemed like a long time, but I was grateful for that. The longer I looked at it, the

more impressed I was. . . . Strand was a man for whom photography was part of a life that was simple and respectful for art wherever he found it, whether in a chair, a table, a photograph.

Everything one did, he said, should be a part of a whole. It was just as important to scramble eggs properly or sweep the floor thoroughly as it was to paint a picture or make a photograph. Everything must be approached with respect and perception. He quoted Clifford Odets: "Life should have some dignity."

One day . . . Paul asked if he could use my darkroom, explaining that it had been many years since he had made a silver print and that a darkroom was unnecessary for the platinum process. Of course, I agreed and was flattered when he asked me to help him. The subject was a skeleton lashed to a large Nazi swastika, shot against a dark, dramatic sky. It was intended for the cover of a left-wing magazine. The magazine used the best paper that it could afford, but that was still not very good. Despite the fact that the reproduction would at best be crude, Paul was still determined to make the best possible print from the negative at hand. The problems were not very great; it was desirable to have detail in the white cross and in the skeleton, but as far as I could see, whether the sky was a shade lighter or darker didn't matter. There were minute variations in the prints he made, but they were so minute that it was difficult to see what difference they would make, considering the kind of paper that would be used for the cover. I offered Paul a fresh box of one hundred and forty-four sheets of eight by ten inch photographic paper when he started. When at last he was satisfied, there were three sheets left.[4]

Within a few weeks after Van Dyke had begun working with Steiner on commercial jobs, Steiner invited him to join Nykino at the Film and Photo League. Noted members of the group included Leo Hurwitz, Paul Strand, Ralph Steiner, Ben Maddow, Henri Cartier-Bresson, Sidney Meyers, and Irving Lerner. These aspiring leftist filmmakers, musicians, photographers, and editors got together in the evenings to write scripts and on weekends to shoot their films. Their work was largely self-financed and produced as volunteer efforts. Strand, Steiner, and Hurwitz were making a film with Elia Kazan about unemployed young men who used the resources at a city dump to rebuild junked cars. Kazan later became one of Hollywood's

greatly admired directors for films like *On the Waterfront*, only later to be ridiculed and treated with contempt for his alleged role in naming names during the McCarthy hearings.

After Van Dyke joined Nykino he immediately became one of the cinematographers for a two-part, left-of-center film known as *The World Today*. It was to be a series patterned after *The March of Time*, a Time, Inc., production (1935–51) of short subjects shown at the Capitol Theater on Broadway, which aspired to make cinema more effective as a form of journalism. *The March of Time* combined newsreel, documentary, and dramatic reenacted presentations, and although based in fact, the shorts were largely fictional reenactments; often the actual subjects were not featured, and there was no attempt to portray reality.

Nykino's films, on the other hand, were to be wholly documentary, based in reality, at least from the leftist point of view. But these pioneers of socially conscious film understood the word "documentary" in a conceptually different way from that of photographers in the first half of the twentieth century. Photography was expected to be a truthful, if aesthetically persuasive, "document" of an actual event or subject, without interference of any kind from the photographer. To manipulate the subject in any manner was considered unethical and unacceptable. But some filmmakers considered directed performances of the actual subjects or scenes to be a major tool for getting to the heart of an issue. For filmmakers, then, documentary expression was about having a point of view, an opinion, of a subject and then working with the actual scenes, situations, or persons to create a dramatized version of reality. By the time Van Dyke was a mature filmmaker in the late thirties, he said he didn't believe any film could be objective; every filmmaker, he observed, has an attitude and a responsibility to express himself accordingly.

The line that separated *The March of Time* from *The World Today* was very thin—the difference was primarily the sort of politics each promoted and the extent of the propaganda each contained. The first part of *The World Today* dealt with the Black Legion in Detroit, which was a white supremacist organization equivalent to the KKK in the South, and the second part dealt with a rent strike in Sunnyside, Long Island. Both films were recreations of events and exhibited a strong leftist point of view. The Black Legion film, for example, was not filmed in Detroit but in the woods of New Jersey. Van Dyke would do his freelance photography jobs in New York during the daytime. He would then drive madly to New Jersey to

shoot through the night (the scenes were lit by flares and bonfires) and go back to New York the next day.

Although all of the Nykino filmmakers were artistically involved in what they were doing, Van Dyke soon learned that what they chose to do was driven entirely by their politics. He knew that some of the members were communists, but the majority, he felt, were young people who were disturbed by the effects of the Depression and were using film as a means of making social changes within the system. This was an important issue for Van Dyke because he felt that socialism was compatible with Roosevelt's policies and ideas but that communist aims were not. In an April 14, 1985, interview with Alan Artner, a reporter for the *Chicago Tribune*, he recalled the tenor of Nykino at the time:

> All my life I felt that if we go about it right, we can change all that is necessary by democratic means. I have never, ever, felt that revolutions were the answer. It was interesting, though. The intellectuals [at Nykino] had a different view. Henri Cartier-Bresson, who was not only an intellectual, but a maverick, used to go down to Wall Street so he could find a Rolls Royce or a Cadillac to spit on. Well, that didn't change much. It was intellectual. I went to one [Communist] party meeting and was disgusted by the rigidity, but nobody cared. As long as I was a cameraman who could get everything in focus and make the pans smooth, that was fine.

Van Dyke was a little naive, as was much of the arts community at the time. He was walking an artistic tightrope because communist literature, like the *Communist Daily Worker*, was aimed at the middle class and artists and intended to inspire an unseen revolution. The *New Masses* and *Partisan Review* were other magazines with similar agendas aimed at intellectuals. The notion of being a sympathizer or an activist was not, initially, an issue in Van Dyke's mind since he believed they were all broadly working toward social change, which he described as follows:

> Social conditions gave rise to the political movements that developed, and I think that those same social conditions were things that affected us. But there was another very important element in it, I think. With the coming of Roosevelt, there was a hope—indeed, an evangelistic belief—that it was possible to effect important changes

through government and orderly processes in relation to the government—all you had to do was make people aware of things that needed changing. All you had to do was to move them emotionally. Changes would require political action, but the awareness we created would prepare the ground. . . . We were operating with a great spirit of optimism.[5]

The cultural ambience of New York in the thirties was, indeed, markedly left and much of its art was produced in the spirit of the New Deal. Marc Blitzstein produced *The Cradle Will Rock* at the Federal Theater; there was the WPA Theater, the Group Theater, and the Living Newspapers, which was funded by the government as a theater production. Joris Iven's films were shown at the New School, and Clifford Odets produced *Waiting for Lefty* about strikers, starring Elia Kazan. Everywhere one turned there seemed to be respected playwrights and screenwriters focusing on ordinary human beings and the tragedy of their desperate situations.

Van Dyke, Strand, and Hurwitz enrolled in acting, directing, and screenwriting classes with Lee Strasberg, one of the founders of the Group Theater who employed Stanislavsky's method acting and theatrical approach. Van Dyke credited these classes with having had the foremost impact on his filmmaking vision throughout his career. He was eager to share his excitement for the socialist cause and his own artistic efforts as well as those of his new colleagues at Nykino with his friends back in California. He wrote and sent copies of the league's literature and some of the new little socialist/communist magazines to Weston and Adams. To Weston he wrote:

So here I am in New York, for how long I don't know, but surely until October first, and probably until next year. My future is most indefinite. I am very happy here, and working very hard. I am a member of Nykino, a small group of enthusiastic people producing movies. Strand and Steiner are also very active members— Strand only recently so. He went to the Soviet Union with hopes of working there, received a great deal of praise for his work especially from Eisenstein and Dovzhenko, but found out, as I did, that they are no longer relying on foreign talent or guidance, and it is very difficult to go there to stay unless one wishes to become a Russian citizen, and even then it is not so easy. So here he is,

and it is our gain. Anyway, we have ambitious plans for the future including full length sound productions. More on that later.

In addition to this, I am taking a course in Play Analysis, and learning a very great deal. There is certainly a lot that I don't know. But here one could keep learning indefinitely. There certainly is opportunity. I can't understand why New York was so distasteful to Ansel, and yet I say that knowing well why it was.

And to make a living? Steiner has been more than swell to me, and I am now working with another friend of his, sharing the same apartment, working together. We do a lot of work for *Harper's Bazaar* . . . under the names of NYphoto or Van Dyke—Trubov. Also we have a great deal of work from William Lescaze, the modern architect. So we will probably be able to make a living—in fact we are already doing that, and have a couple of dollars left over for making films. . . . And I am forgetting my bourgeois need of a car, as we use the subway in the city and on the weekends we hitchhike out into the open country. We got back last night from a trip about 75 miles north, where we spent the weekend. In a couple of weeks we'll take a few days off and hitchhike up to Maine. It is rather an easy thing to do here. The only thing is that one usually has a lot of feminine competition. All of the young women who work in offices, spend their weekends that way if they haven't cars.[6]

Weston's response was to continue encouraging his young friend and to invite him to return and stay with him as soon as he could. He was not without some sympathetic interest in Van Dyke's new cause in life and would in fact write a letter to one of his sons during World War II in which he said he did not wish to sidestep the issue of the proletariat, the "little people." He expressed equal disdain for New York intellectuals and their brand of communism. But on the other hand he felt that the ideal of communism was "almost too high to shoot for in this present world."[7]

Ansel Adams had a very different response to Van Dyke's propaganda. At the end of February 1936, he sent Van Dyke a metaphoric summary of his view of what he observed about him:

Van Dyke: Brilliant bewildered backwash with a strong tide coming in. Lots of Marxian Flotsam floating around since last storm. The Flotsam goes round and round in a pool and hasn't come out

anywhere yet. Extremely talented and suspicious, but shouldn't be so damned careful. Never mind. There will still be ample and expansive junk-piles in the USSA. But there may be trouble getting really good movie film. Swell guy who will get a second helping of destiny. Psycho-simplification due any time now.[8]

Adams's comments were partly tongue in cheek and partly his personal assessment of Van Dyke's artistic abilities. His perception about "a second helping of destiny" was ultimately proven accurate since Van Dyke did go on to have a second career as a filmmaker.

In his letter to Adams, Van Dyke had said he thought Stieglitz was full of "baloney," and he personally had no use for or interest in him. He had visited Stieglitz, which only confirmed his dislike of the man and his treatment of Weston. Adams rebuffed Van Dyke's negative attitude about Stieglitz in the same letter with the following:

Stieglitz: Continuous transformer-hum. Translating, God knows what voltages, into directional and non-directional activities, chiefly intellectual and egocentrically charitable. Supreme artist who knows something is wrong, but can't see it due to smokescreen of convictions (which are denied in the flesh). Can intermix the I and the not-I, like nobodies business. Has done no end of good for photography, but is hated for it on account of its intangible success. I remember photographs where I do not have to remember print-quality, style, social significance, form and composition—for all these merge, without pushing, into a very simple and aggravating perfection of thought and feeling, which, after all, may be the essential surface of the personality. Stieglitz never goes beyond human things. Neither do any of us, but we try to out-complicate the breath and the coursing of the blood. Stieglitz would have been dead forty years ago if envy could poison. When he IS dead—envy will disappear. No one envies Atget or Hill now. But we can't scorn the solidity of seventy years. The shield is quite untarnished. The mote is full. The bridge drops down occasionally and somebody crosses over. Yes, perhaps it's a bit Feudal, but something beautiful is always happening—something surprising, provoking, irritating perhaps—but always beautiful. And Stieglitz isn't afraid of being called Baloney, because he often makes himself baloney just to find out the kind of

baloney in someone else. When he is dead he will be remembered for some extraordinary photographs among other things. How many of us will be able to have that said about us? Stieglitz gets fresh air at Lake George.

Van Dyke responded, almost immediately, on March 2, eager to tell Adams where he stood on the issues Adams had raised, especially how he felt about Adams's observations of him. In this letter he revealed for the first time one of the most important reasons why he had abandoned his photography. He had given a number of reasons at the time and in later life, including that he had not wanted to compete with Weston and that he had become more radical in regard to social issues. But in this letter he added that he felt he had become simply "imitative":

> Thanks for the two letters—the one from Chicago was a scream, the later one more serious—more self revelatory. It is a platitude to say that by one's reactions to a thing he reveals himself, but, of course, platitudes have a way of being true. And so by this letter I feel that you show yourself to be a very facile and brilliant judge of people. I don't quite understand how you do it, but you certainly do.
>
> . . . About Van Dyke, I am less sure than the others. But I do know that about the Marxian, you may be quite wrong. Here I feel that you are expressing an opinion that is hardly based on knowledge. Whether or not I am confused on this issue is something that you will better understand after you have spent a little time familiarizing yourself with the concepts of Dialectical Materialism. Doesn't it seem possible, Ansel, that the confusion you feel may be in your own mind. Suspicious I am. I am suspicious because I have been fooled too often to let it sneak up on me without my knowing it. Talented? I am very much inclined to doubt it. If you were to say "imitative," then I should agree. About the possibility of getting good movie film under a socialist America, again you are wrong—we have good film now, and the executives don't make it. All the technical workers will still be with us, only then they will have an opportunity to give free rein to their talents and no new invention will ever be held back because they might lower market prices and cut the profits of the manufacturer. And I surely wish

the "psycho-simplification" would hurry up, because I am pretty tired of feeling the way I have for the last few months.

We have talked about Stieglitz before. You know how I feel. I respect your feelings. . . . The talk about fresh air is only to say that the outdoors means a great deal to you. It doesn't mean that it is necessary for all photographers or all people. It would be nice if people could be out in the country more often, but I doubt the emphasis you place on it.

Edward will always remain to me one of the great and fine things in my life. One of the few people whom I love; nothing could take that from me—that and the memories of days spent together in the sun and wind by the sea. But be sure that I feel no offense at the letter. It was a swell one, and I am terribly glad to have gotten it.

I hope that you won't think me a crusader if I offer to send you a left wing magazine for a few months? If you don't want it, say so and I'll refrain. . . .

<div align="right">Best luck and a straight road for you.

W.[9]</div>

Two weeks later, Adams wrote a long follow-up letter, which took him three days to complete. Typical of his thoughtful way of looking at controversial issues, he presented a lucid, convincing argument for his arms-length distrust of socialism and wrote extensively about his political, social, artistic, and emotional views. Adams belonged briefly to the Film and Photo League, but his involvement was on his own terms as an artist, and when the red-baiting purge began in the late forties, although it pained him greatly to do so, he disassociated himself from the group. Adams wrote the following on March 16, 1936:

A few days ago I received a very welcome package containing some copies of USSR in Construction. I imagine they came from you and were the "left" magazines you so kindly offered to send me. I appreciate it; they are remarkable and very provocative of that kind of thought, which may be labeled "social."

. . . I have wanted to write you or talk to you seriously about my interpretation of your tendencies and about whatever tendencies I have myself towards a social rehabilitation. Why are you so

far to the left—and why am I quite a bit further in that direction than even you might suppose? And why do I argue about it and express what you undoubtedly think a conservative viewpoint?

I don't know. I am anxious to advise you that I am really miserably impatient and worried over the conditions of contemporary life. I grant the basic logic of the Marxian doctrines (although I frankly am not in a position to discuss it clearly, as I do not "live" in it, as you and others do). That, perhaps, is my fault; I should make myself more aware of impending change—more aware of the admittedly universal thought. However, I can explain that (I believe). My training has been introspective and intensely lonely. I have been trained with the dominating thought of art as something almost religious in quality. In fact, it has been the only faith I have known. As I look back on it, now I realize a certain "unworldly" quality about the point of view that was drilled and dynamited into me; I existed only for the quality of art in relation to itself; the production of beauty without other motivation. I have not achieved anything comparable to what my training implied, but again—that's my fault. This training has become part of the physical and emotional body and it is hard to manage it in relation to other directions of thought. However, for quite a few years I have been fully aware of the fact that something was missing—something of supreme importance. The "contact with life" you may call it. It has been apparent to me that there is no way out in a system such as ours, but I have been unable to visualize within my mind an acceptable alternative. I am not a sociologist—any more than I am a Roman Catholic. I simply do not understand the philosophic basis of Marx and I cannot accept in my mind something I do not understand. But I am frankly willing to say that if the understanding of it should come to me I would completely accept it. I am not negative to it—I am negative only to what I do not understand, and only negative in myself and not in relation to you or the entire left group.

. . . I don't dispute Marx as expressive of an intellectual philosophy, but I feel that Marxian elements bear the same relation to the humanities as basic chemistry and physics bear to photography. I think it would be unsatisfactory to exhibit a print for its chemical and physical properties—although the better understanding of

these properties would augment the force and message of the print. And the same applies to the social "exhibition." In other words, I would work down from the surface, rather than work up from the bottom, and the problem is not isolated in space, but floating on the ocean of the "status quo."

. . . For me, art is a means of interpretation of things which possibly cannot be interpreted in a "practical" dialect. When it attempts expression of "practicalities" it seems as futile as a mathematical analysis of a nude. Art is limited; so are philosophy, mathematics, sociology. I think the intermarriage of these classifications of human activity can easily produce shallow bastard-expressions that never clearly resolve the problem. However, any form of interpretation can reveal, if sufficiently complete and intense, a clear conception from its own specific point of view. And on this conception another form of interpretation may find an easier and more complete development. . . . In other words, I frankly admit that a complete understanding of Marx would assist in a better production of a film such as Chaplin's—but it would not imply the necessity of obvious inclusion of any of the visible "surfaces" of the Marxian principles. These principles would work within; fully conscious of them, the artist would use them as part of the *intuition*. Their use would not be intellectually; it would act as governor to the intuitive complex mental and emotional machinery, which in art determines the appropriate relationships. In exactly the same sense I mean that if I knew something of engineering I could make a better picture of the Golden Gate Bridge; not because I would express engineering in my picture, but, because certain formal significances would be better revealed to me. Without these significances the resultant photograph might very well be said to have only a "two-dimensional" emotional quality. The reason that I do not photograph many subjects is only because I know the result will be "two-dimensional" instead of the possibly achieved "three dimensionalism" of an expression which is based on a deeper understanding.

That is why I distrust the power of Propaganda in Art, or the power of Art in Propaganda (in the obvious sense, of course). But I don't distrust the power of Propaganda as Propaganda. And more power to those who are working for a betterment of the social

order. My argument concerns the artists who I do not think have achieved awareness of the immense force of comment based on understanding and who are satisfied with the representation of the superficialities of doctrine. To me, a large part of contemporary art is adulterated with the products of confused conceptions and motivations. I think it is just as bad to approach economics emotionally as it is to approach emotion economically.

. . . All I have been talking about is the problem of the direct relation of the artist to any doctrine. I realize how hopelessly involved the foregoing argument is and how many contradictions appear in it.

Of all the arts I feel that photography admits the least departure from reality. No matter how rotten the final print may be there is always something there—something *seen* by the operator. There is, of course, that also which is not-seen (which may be just as revealing). This which is seen honestly, intensely, and with due appreciation for itself and the ultimate aesthetic result should be enough. The Pictorialist attempts to plaster it with hazy painting-school manners; the Beatons [Cecil Beaton, English photographer of the rich and famous] discolor it with the stinks of plush-and-French-plaster drawing rooms; the extreme propagandists mix a little of the grime of industrial alleys in their developers. And I freely admit that the "purists" work in an icebox and get their beards frosty [a reference to himself].

Anyway, thanks for the magazines (and I guess for the copy of the *New Theater* that just came as well). Wish I could get back to New York soon. I enjoyed it—it woke me up.

Just for your own digestion—the Beard [Adams] is thawing out a bit. The Contax seems to be applying the heat.

Good luck and my warmest regards to Strand, Steiner, and Trubov. . . . Yours,

A. A.[10]

Van Dyke accepted the differences between Adams and himself. He had always admired Adams as a photographer and liked him as a friend, but these recent letters made clear that they would never see eye to eye on politics. Weston's attitude about social issues was much closer to Van Dyke's.

The year 1936 was becoming an important time of change for Van Dyke in general. His new friends in New York were the polar opposite of those he had left back in California. He was turning thirty years old and was finally finding his own footing. Although no longer making photographs for himself, he continued making a living as a freelance photographer for *Architectural Forum, Harper's Bazaar, Life,* and *Scribner's* magazines. At night he worked on film sequences for Nykino, gaining recognition among his friends and colleagues for his hard work and cinematic eye.

He had continued to correspond with Mary Barnett, back in Oakland, but like Weston who put his work before his relationships, he concentrated his efforts on laying the groundwork for his new life and career. Barnett, however, won a scholarship to study at the Neighborhood Playhouse in New York. She had been teaching speech, acting at a women's private school in Berkeley, and acting with a theater group in San Francisco. She had decided that New York was the place to perfect her skills. In time she was given a teaching position at the Elizabeth Irwin High School, where her productions attracted the attention of such luminaries as Arthur Miller. When she first arrived in New York she moved into a boarding house, and Van Dyke lived in his studio. But within a few months she and Van Dyke were living together in a combined studio and living space on West 9th, rekindling their relationship.

During these early months of 1936, Van Dyke and Steiner had been asked by Elia Kazan to organize a small group of youth in a settlement house called the Lavenburg House on the Lower East Side into an amateur theatrical company. Steiner was not interested, but Van Dyke jumped at the chance since it would put him in a position to get closer to Kazan and would allow him to try his hand at directing, which he had been studying. The amateur youth group wrote a play called *A Place in the Sun,* which was about sit-down strikes. At the end of the year, it was performed several times in their makeshift theater, and to Van Dyke's great excitement Elia Kazan attended on one of the evenings. At the same time Van Dyke was "hanging around" the Group Theater learning directing from Harold Clurman and watching Kazan perform. At one rehearsal, Van Dyke took particular interest in Kazan's portrayal of a homosexual. On the surface, those memories were far in the past, but they still must have tugged hard at him for him to remember this performance of the performances he saw:

He played the gangster in "Golden Boy." All through rehearsal he played it as a homosexual. And then he threw away that characterization just before dress rehearsal. But there was enough of it left. . . . You could feel underneath some strange thing that was not there on the surface. And so when he came on the stage and said, "I want to buy a piece of that boy," . . . you know he wanted to buy a piece of the fighter, but there was another thing that he was saying too that made it extremely menacing.[11]

Van Dyke and Mary Barnett did not apparently become involved in each other's theater activities. By the mid-1960s Mary was teaching at the American Academy for the Arts, and in the 1970s she became a professor in the theater department at Yale University. There is no mention in Van Dyke's memoir of her sharing in his experiences. Rather, his theater work came through Steiner, who introduced him to various individuals and attended performances with him. It seems that Van Dyke expected Barnett to make her own way, which she did. In any case, the little theater group that Van Dyke was involved with eventually disbanded and he happily returned to film for his creative outlet.

The WPA approached Pathé News about making a film that would help the agency portray how government money was being used to put the needy to work, especially manual laborers. The head of the news agency gave the assignment to Steiner and Van Dyke, who had submitted a script for a film to be shot entirely of hands telling the story: in the film, a WPA check was handed to someone; the check was then handed to a grocery store clerk; then the hands picked something off of a shelf and put the purchased items into a cart; then the hands were shown doing the initial work to earn the WPA check, and so on. The film ended with a hand poised over a pool of water and as it dropped a rock, and a line of commentary moved across the screen saying that a small amount of money spent in this manner spreads out like ripples through the whole of society.

The film was quite short, just a few minutes long, but it was shown as a short in theaters across the country, and the attention it received gave Van Dyke his first step up in film. The mildly socialist message it contained also fit with the attitude that Van Dyke and his friends at Nykino had about documentary film:

The attitude of most of them [Nykino members] was that they wanted to use their craft to make a better world, to change the aspects of the world that they felt could be changed or [to hasten] the change . . . by the use of film; that they were missionaries or proselytizers or would-be revolutionaries. But the purpose was to change.[12]

From 1935 to 1937 Van Dyke was all over the place, trying to find a replacement for the photography he had left behind. He explored theater, propagandistic film, and commercial photography. But nothing seemed to command his total commitment, not even a newly revived love affair. Then something happened that brought all of his emotional and professional yearnings into focus. Steiner introduced him to Pare Lorentz, the filmmaker whose film about soil erosion had beat out his UXA film in the competition for government funds to make a film about the Dust Bowl and migratory workers. At first, it was only a casual meeting, since it was his friend Steiner who was being solicited by Lorentz to help make the film. But for Van Dyke the chance meeting was in time to have consequences that would change his life and career.

Lorentz had in addition solicited Paul Strand and Leo Hurwitz to be his cameramen on what was clearly to be a government propaganda film about the causes of the Dust Bowl. Steiner accepted and kept Van Dyke informed about the process of making the film, especially the difficulties that arose as a result of the dramatically mismatched politics and personalities of the parties involved.

Ralph Steiner was one of the founders of Nykino, which for him was about attempting to elevate the medium to an art form rather than using it just for political purposes. Although a socialist at heart, he was essentially apolitical. One of his assistants on freelance photography jobs was Hurwitz. He became a member of Nykino but had stronger political views than Steiner. Shortly after finishing his film in Mexico, *The Wave*, Strand, who also had strong political views, was likewise invited to join Nykino, and during this period in fulfillment of his political convictions he leaned more toward communist ideals. These three artists agreed to make a film to be directed by Lorentz, who had never before made a film. But that was the nature of Nykino, where raw talent was welcome and everyone was free to experiment.

By the time Lorentz made contact with Nykino and his three prospective cinematographers, he had been a professional writer for ten years and had been a film critic for eight of those years. In addition to writing film reviews for *Vanity Fair* and other media, he had written a book with Clare Boothe Luce titled *The Roosevelt Year: A Photographic Record* about the first year of the New Deal. Lorentz was also well informed about the music world and excelled at communicating with administrator types, whether editors or politicians. He had convinced Rexford Guy Tugwell, the first administrator of the Resettlement Administration, that the government should be making films about the state of the country, which could compete on a quality and entertainment level with the best of Hollywood. That idea may have flattered his supporters, but it was far from reality for documentary film.

Well aware of Lorentz's background as a strong supporter of Roosevelt, the three hardened, socially conscious artists accepted his offer and by the end of 1935 were working in the high plains of Wyoming filming the results of poor farming practices and drought conditions with no more than an outline of a script.

It was not long before Strand and Hurwitz rebelled against Lorentz's sketchy outline, which was greatly slanted toward Roosevelt. They also objected to his long absences from the shooting sites. Brazenly, they drafted their own substitute script in the field, one with a distinctly socialist bent and sent it to him with the proviso that either he accept the script or they would quit. He returned immediately to the filming location and told them they would be fired unless they agreed to continue with his original outline and instructions. Reluctantly, they agreed but said they would disavow having any connection to the film. Filming continued; Strand and Hurwitz shot undefined farm footage, while Lorentz and Steiner completed the scenes Lorentz was interested in. Steiner described the event as follows:

My big film moment on Broadway came when the Copland-Sessions Concerts commissioned Colin McPhee and Marc Blitzstein to write music for three of my short films. The music was not recorded, but was to be played by a sizable orchestra in synchronization with the films.

. . . One happy result of the Copland-Sessions concert was that Pare Lorentz, a film critic, attended. He was about to embark on a film about the dust storms for the government. He hired me as cameraman. I suggested that two men with cameras would be

necessary, and recommended Paul Strand as the other camera-man, plus Leo Hurwitz to assist. Since Lorentz was out in the field with us for only a very short part of the film making, I think I can say that Strand and I were "director-cameramen."

. . . I learned a lot from Strand while filming the vast, open, almost featureless vistas of Wyoming grass. He made compositions out the darks and lights of the valleys and hillocks. . . . During the period when we had no film, Hurwitz, perhaps feeling that he had too little function in the film, decided to rewrite Lorentz's script with the help of Strand. I kept out of the rewriting project. It may just be that I had sense enough to know that the producer-writer Lorentz would not wax enthusiastic over the rewriting of his script by his employees. Anyway, since the script was to differ politically with Lorentz, and since I was (and still am) hardly a political ani-mal, I rented a twenty-two rifle to shoot tin cans while the others rented a typewriter.

When Lorentz finally arrived with raw film stock, he went into a rage about the "bettered" script. Imagine Beethoven dis-covering that a small-town bandmaster had added another note to the awesome beginning for of his Fifth Symphony. Lorentz sent the two men away with a list of various shots he wanted. I stayed with Lorentz to complete the film. . . . He was a genius at pulling a visual and unifying concept out of a mass of economic, political, and sociological facts. And he was a master at writing commen-tary, editing film, and working with a composer.[13]

The Plow That Broke the Plains was screened at the White House in March 1936 and then shown throughout the country. Ironically, over time, the art world erroneously identified the film as one of Strand's important film achievements. But the same was true for Van Dyke and Steiner when they served as cinematographers or directors or producers for particular films. It is the nature of film, which requires many hands and minds, that it is the child of many parents, and this fact about it is especially appar-ent when individual contributions lend strength of unusual proportion to the whole. Nevertheless, it was Lorentz who history recorded as making the first socially conscious documentary film in the United States. England and Russia had made earlier documentary contributions, but none, as Van Dyke described it, with the force and directness of Lorentz:

The film depicted a national disaster with dramatic force, a combination of a fine musical score by Virgil Thompson, Lorentz's commentary read movingly by Thomas Chalmers (a Metropolitan Opera baritone), and a fine editing of film footage supervised by Lorentz.[14]

Reaction to the film was varied. Some congressmen from the states where scenes were filmed demanded that Tugwell be fired and all copies of the film burned, claiming that it damaged the image of their states. The public was more sympathetic, though not heartened by such a depressing view of the country in the midst of hard times. Within a couple of years the film was withdrawn from distribution by the government. Lorentz was undaunted, and during the spring and summer of 1936, he began preparing to try to secure his next film commission from the government. With no small measure of flamboyance and persuasion he convinced Tugwell and Roosevelt that it was essential to make a film about the Mississippi River, which he insisted affected a majority of Americans one way or another. He provided an outline that geographically started in Minnesota and followed the river and its tributaries all the way to the Gulf of Mexico. The film was to reveal that annual episodes of erosion and flooding resulted in major human and economic losses and that broad support for getting control of the river could be won with the persuasive drama of a documentary film.

Lorentz was more confident about his new effort. Through King Vidor, a leading Hollywood director who had helped him with contacts in making *The Plow That Broke the Plains*, he set about this time to hire professional, commercial cinematographers. He was able to engage the academy-award winning team of Horace and Stacy Woodard, who made nature films, and Floyd Crosby, who had won an academy award for *Tabu* (he would also later win an academy award for the classic western *High Noon*).

The Woodards worked hard and well but also had difficulty in working with Lorentz's preference for an outline rather than a script. They worked from October 1936 to Christmas and then out of frustration returned to Hollywood, first one and then the other (Horace returned after only forty-five days on the job). Crosby joined the film crew when they left. But Lorentz, nudged by his love of the arts, also invited Ralph Steiner to join him in making the film. He apparently wanted an artist involved because he knew the power of the artist's eye, and he had had a good experience with Steiner.

Steiner was, however, involved in making a film with Strand and Hurwitz for Nykino, who strenuously objected to Steiner even considering the project, saying that his departure would compromise their film. True as that might have been, they also had no use for Lorentz after their experience with him. Steiner, being the elder statesman of Nykino, relented and agreed to honor his commitment. He recommended in his place his young friend, Willard Van Dyke.

Van Dyke was elated beyond imagination. He knew Lorentz's first film and may have seen *Nightmail* (1936) by John Grierson, the British master of early government documentaries. He also knew the work of Robert Flaherty, whose film *Nanook of the North* (1922) was the first feature-length documentary to be widely distributed. Both Flaherty and Grierson were as influential worldwide in their genres as were Vertov and Eisenstein in theirs, and they all had enormous impact on Van Dyke's eye for cinematic vision.

Van Dyke wanted to be one of the cameramen on Lorentz's film more than anything. Nothing had inspired him with such intensity since that day so many years ago when Weston had invited him to come to Carmel. Van Dyke wrote to Dorothea Lange to ask her to write to Lorentz on his behalf. She happily did so, and her letter must have been especially persuasive given her participation as a photographer of the rural poor for the FSA. In addition she had assisted Lorentz during the shooting of *The Plow That Broke the Plain* by helping him get access to migrant workers. Van Dyke also urged Steiner to push a little on Lorentz; Steiner obliged, arranging for Lorentz to see Van Dyke's camerawork in *Sunnyside* for Nykino and *Hands* for the WPA. Van Dyke also showed him his photographs from his years in California, which Lorentz was particularly taken with. Van Dyke pestered Lorentz for weeks until finally, shortly before they were to begin, he agreed to hire him. At twenty-five dollars a day with a five dollar per diem, this was not only an opportunity of a lifetime, but a real living as well.

Van Dyke, with his deep love and passion for landscape, was well prepared for the making of *The River*. While working with Weston, he had honed his ability to capture dramatic form, to treat details and vistas alike that were otherwise hidden from the average person's awareness. He also had begun to articulate a philosophy based partly on his knowledge of how Flaherty had made films about man's struggle to harmonize with nature. At the same time, he was eager to test his current more skeptical view that natural forces were more likely a problem because of man's self-interest and exploitation of nature.

In late October the film crew and Lorentz assembled in New York, packed their gear in a couple of cars, and drove to West Virginia where they set up shop to begin filming. Lorentz had provided everyone with a one-page outline. He hired a university film crew to make stock footage in Minnesota, while he and his cameramen began at Tygart Valley, near Clarksburg. Van Dyke and Lorentz concentrated on power lines and evidence of presence of the Tennessee Valley Authority (TVA). Each cinematographer worked according to his own ideas drawn from a brief summary provided by Lorentz about what the film should be about. Van Dyke had hoped to gain experience by working with the other cameramen, but since Lorentz had everyone working on different things, he had to rely on his own instincts. He soon learned that Lorentz liked what he was doing and not only did that prove satisfying but it also set him free to trust his own talents and vision.

He filmed his assigned subjects with a special appreciation for the aesthetic qualities of nature and in the process was able to experiment with imagery that did not dominate the subject. Lorentz had told him that there is no such thing as a good river in nature. Even without the presence of humans, a river would periodically go on a rampage and become destructive. It was up to human beings to tame the river through reforestation and by building dams. Van Dyke understood the message on Lorentz's terms and believed that great dramatic effect could be achieved by building the film from small details to a complex whole, like the few notes that grow into a great crescendo.

Both Van Dyke and Lorentz were well acquainted with classical music, and Lorentz took a guitar with him wherever he went. Lorentz avoided film jargon or technical language when he talked about film, speaking instead in terms of themes and great fugues. He believed, like Flaherty, that making a film consisted of shooting mountains of film on the greatest variety of subjects related to a film's topic and then refining it through editing. Commentary and music would do the rest. Van Dyke began by filming little drops of water that formed rivulets. The rivulets grew into streams, the streams into rivers, and all the tributaries together formed the great Mississippi. In the background the cameramen knew that Virgil Thompson was going to create the score, which gave them a certain security that the drama they wanted their scenes to convey would indeed come through. Lorentz had likened the making of a documentary film to that of making an opera. The action and music would be inextricably intertwined.

Van Dyke was given thousands of feet of film to shoot with, so when he filmed a subject, like the cultivation of cotton, which had slowly worn out the land, he filmed it from every conceivable perspective and camera angle: being picked, bailed, hauled by mule, loaded on steamboats, and unloaded. He shot a TVA dam like a great monument to the pharaohs, a twentieth-century pyramid in his words, which he believed was evidence of man's ability to conquer the natural elements.

During the filming of *The River*, from October 1936 to February 1937, Van Dyke wrote nearly fifty letters to Mary Barnett. Like his mentor, Weston, who wrote personal letters from Mexico to his wife Flora to save for future use in his daybooks, Van Dyke wrote to Mary about the events that were unfolding before him on a daily basis. The running commentary was all about himself, his exploits, and the human condition before his lens. There is little intimate interaction in the letters. He left loved ones behind for extended periods of time through all of his relationships and both marriages, even after having children. Although he professed great love for his children and their mothers, they would probably say that he had loved film more. In the 1960s an interviewer asked him directly why he traveled around the world to make films. His answer revealed just how much making films was a personal journey for him:

I think that one thing that might be said about me is that I am wide open for any experience at all and that I welcome new experiences. To travel around the world, to see different people and work with different people, is another way of experiencing new and exciting things. And also, more important, perhaps, it is a way of verifying one's own philosophy, position, ideas, concepts—whatever you might want to call that. Because the more you get to know primitive people, for example, the more you realize the nature of yourself; the more you work with strangers, the less of a stranger you are to yourself.[15]

Some of the letters he wrote to Mary while working on *The River* were published in the spring 1965 issue of *Film Comment*. Harrison Engle, author of the interview that accompanied the letters, said that they should be read within the context of the great social change that America faced during the Depression and World War II. This is true, but the excerpts from the original letters also reveal that Van Dyke was writing about his personal quest

to reinvent himself as an artist while at the same time engaging in his love of storytelling.

In a letter from Knoxville, Tennessee, Van Dyke enthusiastically described his rapidly growing relationship with Lorentz and dreams about his own debut as a director. It was at this moment that he began to realize what was missing in the earlier part of his life as a photographer. Producing work for its own sake had not been enough for him no matter how accomplished he was or how much critical praise he received. Certainly Weston and Adams believed he had every bit the eye required to be a photographer on their level. But even when he was working with Weston, he very quickly put his camera aside to organize and "direct" Group f/64. For a variety of reasons he had always found comfort in managing and guiding others. He was a perfectionist and took satisfaction in his unusual ability to facilitate the talents of others as much as his own. At its best this quality found a natural outlet in film, which is dependent on the creative efforts of many individuals, all devoted to a single product or work of art:

So far Pare and I have gotten along famously. He trusts me to do this job in the South without him, and he has indicated he has a lot of faith in my work. It is too early to say anything yet, but I have a vague suspicion that this will not be a completely bad picture from any point of view, which is another way of saying that I think he knows more of what he wants than he has been given credit for. If, as I said before, you can translate what he is saying into visual terms, you're okay. Of course, it isn't always easy.

. . . A conference with Pare just finished tells me I go to Huntsville, Ala.[,] [t]omorrow[,] and I will be there or thereabouts for the next week. It is very hard to say what the chances are for the future in this thing [the film]. One can't know what the people in Washington are thinking. It seems that Pare gets along swell with Tugwell, and that Tugwell is interested, at least, in this picture, if not in a permanent program. I feel that if this one thing is good, it will mean a big step toward the ultimate establishment of a film producing section in the government.

. . . Pare has told me quite a lot . . . and isn't very close mouthed when he is tight. But one thing you can be sure of—if there is a permanent program, and if there is a guy named Lorentz connected with it, there will be a cameraman who will soon be a director and

whose name is Van Dyke, also connected with it. I have him sold on my ability to direct people (he hasn't any ability himself) and that is why I am down here alone to do this job. If he were along he would feel it incumbent upon himself to direct them—and he can't do it, so he isn't here. I will have to do it, and he will get the credit. Not that I feel that I know anything about directing yet—you know I don't feel that, but I do more than he does.

I have had long talks with him about Faulkner, Dos Passos, Caldwell, Farrell and the rest of the boys, and I find that he has a very clear critical analysis ready for all of them. . . . In other words I really like the guy quite a lot, and I think that he only needs a little adroit handling to make him do whatever you want him to do. But if nothing ever happens in the future, the gold and red of the trees, the somber quiet skies and the feel of myself traveling over the earth will be a memory I shall cherish.[16]

A letter from Alabama suggests that his relationship with Mary was either very solid or that he felt he had to display his independence. He and Mary Barnett were living together and certainly they had had discussions about a commitment to each other. In fact, in his memoir, he had written about how much he looked forward to being with her when she moved to New York. And back in Oakland, her letters to him had been touching love letters. Therefore, this letter from Alabama about going to a house of prostitution seems a bit odd for him to have written. It may have been an attempt to reinforce his unchanging adherence to a life of independence and adventure. He claimed not to have participated in the evening's activities, that he was just accompanying a friend. His recall of the details of the surrounding environment was astounding:

Yesterday was a bad day—rainy, stormy, cold. So after a frantic and miserable day sitting around . . . [a friend who accompanied the film crew to ensure budget control] decided nothing would do but he must visit the local cat-house to get himself laid, and nothing would do but I must go along to see that he didn't get rolled for his cash and watch. So we went out on a quiet night covering the town after the rain, to a place at the end of a side street with the porch light burning. In answer to the ring, a kindly faced woman, about fifty, asked us in and we entered into a long hallway,

off which doors opened on both sides. We went into a bare room that had a bench in it, a player piano, and an electric (nickel in the slot) phonograph. We explained that only [the friend] was in search of entertainment, so the madam called a small, medium, and one large heavy girl. [He] took the medium one, the little one left, and the big one said, "Don't you all want to go to bed honey?" I said no and so she said, "Well, you all come into my room where it's warm and wait for your friend." It sounds so damned sordid when I write it, but I seemed to be outside it completely. I couldn't believe that these girls were there to lie with men. It was inconceivable that anyone would be attracted by one of them. The big girl led the way into a room that had a bed, a fireplace that was closed off, a dressing table, a chiffonier, a magazine stand, and a bridge lamp on it. In the center was an oil stove with a pan of water on it. "Why didn't you all want to go to bed, honey?" And to my answer: "Well not wanting to is as good a reason as any, I guess." And then the subject was dropped as we talked about how cold it was, and how the election had gone. On the mantel was a picture of William Powell. Next to the dressing table was a horseshoe that was made out of some sort of white plastic, and had "Good Luck" written on it. Over the bed was a picture of the girl herself taking off her stocking, tastefully colored. On the chair was a copy of love stories, a pile of *True Romances* stood in the magazine stand. The room was spotlessly clean. There was a bed spread embroidered in large red flowers. The wallpaper was pink. A single small light burned above the bed. She called it her work light. It was green. On the dressing table, in a silver frame, was a small picture of Shirley Temple. She told me about being in a house in Detroit, about her father who was now ninety-two years old and who lived on a farm. She couldn't stand it on the farm, so she went on the town. Her other two sisters left home with her. One of them committed suicide. The other is in a house too. Her brother works on the Wilson dam. She explained the ethics of her business, and explained that a girl who wasted as much time as Jack's girl was in talking with him would never make any money, and that any other girl in the house would have had him "out" in ten minutes, and that a lot of madams would only let a girl entertain a man for ten minutes and then if she wasn't through with him, another two

dollars was demanded. She said a girl couldn't make any money if she only took on three men a night.

A few days later, Lorentz sent Van Dyke to film a large water control project in the form of the Pickwick Dam in Tennessee. His letters from Tennessee constituted a kind of running commentary on the politics of the TVA and the local poor who were largely sharecrop farmers. Van Dyke seemed to delight in describing their personal habits and traits, enjoying that even more than the filming process. He was bored by the TVA subjects but irresistibly drawn to both the endearing and profane aspects of the victims of poverty and social oppression. He was finally in the midst of what he believed were the social ills and injustice that drove the Depression. He had seen the same in Russia where he thought the government was incapable of dealing with poverty and its devastation of the population. But here in the United States he believed he could make a difference by documenting conditions of the underprivileged because Roosevelt had demonstrated the government's concern for its people through a number of self-help programs like the CCC and WPA.

Everything written about the sharecroppers down here is underestimating the poverty and squalor. Yesterday was Saturday, and everybody from miles around came to Corinth for the day. And everybody met in the square in front of the courthouse. I have never seen such a collection of poor, half starved, badly clothed, dirty people in my whole life. It depresses me every time I see them—not only for the way they have to live but because they appear to be so complacent about it all. Of course, that may be on the surface only, and I am sure that there is a stirring social awareness underneath it all, but how can they stand it so long?

Liberal and conservatives in the thirties crisscrossed many political lines, often with surprising results. Tolerated by the establishment in politics and commerce, both communism and socialism were seen as far left politics but not the threat they were seen as in the fifties. Therefore calling a communist a "red" would have been about the same as saying liberal today with a capital "L." And the term "pink" was a vague term for being a socialist. Van Dyke was deeply embroiled in the social issues and causes connected with socialism and communism through Nykino but to

find the same issues in rural Tennessee was more than a little surprising for him.

> [A government information officer for TVA] considers himself a pinkish red, actually he is a confused liberal who believes the only way out of our mess is for a Constitutional amendment giving the President the power to enact social legislation. A more complete missing of the point could hardly be imagined. When the TVA library was thrown open for the use of the surrounding territory, he refused to list Margaret Sanger's book, or Redon's "Life of Christ," on the grounds that the TVA would be attacked as Reds, atheists, advocates of free love. Maybe he is right, but I don't believe it, because I believe if people are being benefited by an organization or a group, then the old names that are slung around will not be very effectual.
>
> The TVA is already attacked by the utility men and their hirelings as Reds, but the people don't pay any attention, because if Reds are going to give them cheaper power and electrify their homes for them, then Reds aren't so bad after all.

When Van Dyke was sent to a hospital for a brief stay while in rural Tennessee, he found himself in the midst of captivating personalities, the very "people" who he was trying to understand. He was bedridden with five other men in the same room. He appears to have had a relapse of malaria or perhaps a case of food poisoning. Bored as he was with the TVA assignment, his time in the hospital gave him an opportunity to enjoy his favorite pastime, writing about various dialects and the cultural expressions of those who were far from his own background. This period of storytelling and letter writing would eventually contribute greatly to his scriptwriting style in future films.

> There are only two private rooms in the hospital. I'm in a ward of five other men. One man is almost completely covered with casts. He fell off the dam. In the bed next to him is a man with an infected foot, which he had tried to treat with glycerin and rosewater. Next to me is the newsboy of the village who has a nasal infection. The fourth man has a boil on his behind. And finally, the local geometry teacher, who has a bad chest cold. The guy with the cast is an engineer and the man with the boil is a worker. The engineer reads

"Red Book" and "Cosmopolitan," talks about the football games he's missing and about the local bridge club. The worker reads "Field and Stream," doesn't talk much, but when he does his language is richly flavored with similes. Speaking of a boss on another job he said. "That man's so mean he could skin a flea for the hide and tallow'em, then run his skinnin knife over the bones." When the newsboy spoke about needing a shave he [the worker] advocated "a little sweet milk and a cat." He told about a farmer in Corinth who walked up and down the main street, on the day following the election cursing Landon [Alf Landon]. Someone asked the farmer if he didn't think the man hadn't been "hu'milated" enough. The farmer said "doggone if he didn't believe he'd been a sucker, here Landon only got 8 votes and he'd given him one of them."

. . . The people down here are of almost pure English extraction. Names like those in the ward here are the rule: Barton, Clark, Steward, Bond, and Tippit. Once in a while there will be a Welsh or Scotch one. My doctor's is Derryberry. Once in a while the curly hair and broad nostrils of a citizen will hint that miscegenation is not just a word. Soon we will be going to Mississippi, and there we will see the real decadence of the south.

. . . Yesterday, [now out of the hospital] while cruising up and down the river on the "Mary Lou," the local boat-of-all-purposes, I asked if there were any rich-looking fields with farm houses that come down to the water's edge. I was told by the Capitan: "Hell man, they ain't no farmhouses around here—the biggest thing in that line is a shack just big enough to fight, fuck, and fry fish in."

And that just about circumscribes the economic and domestic situation of the South.

One of the Woodard brothers had already returned to Hollywood and the other was to do the same in a short time. Lorentz was also relying more and more on Van Dyke. As they traveled across the rolling hills and meadows with old growth trees in full fall color they were constantly reminded of the human failure to care for the land. Due to either ignorance or the circular nature of poverty itself or both, Van Dyke was equally appalled by "the ubiquitous holes that people live in, all over what was virgin timber land thirty years ago." Lorentz sent Van Dyke to film eroded hillsides where he struggled to document nature's revenge on human indifference, to film

the landscape for what it was and not as elegant form, pleasing to the artist's eye. It was a difficult mission for Van Dyke because he found great beauty in nature's tortuous chaos, whether in California or Tennessee. It was no small realization when he discovered as a cinematographer that he could lead the viewer through a real-time sequence without isolating his sense of the aesthetic but instead use it to give drama to its destruction. Where he had previously found security in the abstract qualities of his photographs, now he came to love narrative film and its ability to harness beauty as a fragile reminder of the social contract with nature and humanity alike.

> Today I went out and shot some more eroded hillsides, having found some wonderful material yesterday. It is hard to believe these people could let their soil wash away like they have without doing something about it. Yesterday we went way back into the hill country, found some rare scenes, and talked to some rare people. . . . [Lorentz] said he had seen the rushes, and that my stuff was magnificent. . . . He said he had never seen anything of cotton before that was anything nearly as good. The water stuff he dubbed "superb."

Lorentz had indeed realized that he could depend on Van Dyke to be the artist he had initially desired when he had invited Steiner to be his cinematographer. But Lorentz also recognized in Van Dyke his unusual talent as a director and motivator of people. He told Van Dyke that he was going to put him in charge of the film crew while he returned to New York to deal with a problem in laboratory production of the finished film rushes. Van Dyke was elated not only because it showed that Lorentz clearly had confidence in him but also because it put him in a position to guide the members of the film crew into a more cohesive unit while maintaining their creative independence. His experience at 683 Brockhurst had come full circle.

In late November Van Dyke and the crew moved filming and production to Nashville. Even though he had earlier talked himself into being able to work with Lorentz and had, in fact, come to enjoy his company, Lorentz's chaotic directing style was finally beginning to frustrate Van Dyke, no less than the rest of the crew:

> We have been out on a boat most all day photographing Wheeler Dam, from every conceivable angle, with the water coming over, with the water stopped, with power lines, without power lines,

with a transformer, without filters, and with them. . . . I hope this is the end of the dams for a while. The other cameraman is disgusted. All this talk about "motifs, song of the river, symphony of cotton" and all the rest of the phrases Pare uses to cover things up, mean nothing at all to him. He doesn't savvy, and all he can see is that Pare has no clear idea of what he wants to do, and as long as that is the case it is boring to him to shoot thousands of feet of film on a sequence that could be done in five hundred, simply because the cutter will have to have something to cover with. . . . I can't blame him at all, I know how he feels, but after all I am in a little different position than he is. He has won two academy awards for the best one reel picture for two consecutive years—expects to win it this year again, so his reputation is made and he needs no more experience. . . . He does everything in a very workman like manner with no attempt at faking or showing off. He makes no pretense of knowing anything about aesthetics. He only makes a shot because it has a place in a series of shots that build up to tell a story. In other words he is a craftsman of the highest order.

But this picture is a stepping stone for me. I must try to make Pare's fumbling words have meaning. It is up to me to translate his ideas into film form, put them back into his mind so that they come forth as his own ideas, newly clothed. He likes me, likes my work, but I have been a little less than patient with him a couple of times the last few days, yesterday and today in particular. Finally I told him that a lot of his ideas were literary ones, not translatable in visual terms. He got a little upset, but took it alright. There is one thing I have noticed about him. He has an almost uncanny ability to judge people, to size them up in a few minutes.

. . . So the days go by, with good sunshine, mostly, cold days infrequently, a refreshing goodness about the touch and smell of earth, and a fine feeling of blue sky overhead.

By early December the crew was in Greenville, Mississippi, and the weather had definitely turned nasty. The new location was also depressing owing to its stronger and more cynical segregationist culture. With so much time on their hands because of the chilling rain, they spent many hours and days indoors and not on location. In this next long letter Van Dyke pondered the plight of the poor, especially the "Negroes." He was also

treated to story after story from Lorentz about his life in the demimonde world of New York and his association with Strand, including the intimate, bitter details of making *The Plow That Broke the Plains*. Previous critical accounts in film literature about the dispute between Strand and Lorentz have been antiseptically attributed to politics and working methods. But it appears it was also the product of a thundering clash of personalities:

> The alluvial rains have set in. There are usually few good days between now and May first. Winds are high, floods are the order. So, we champ, waiting for the sun. From here Pare and I go to New Orleans, take a boat out to the Gulf. I've tried to tell him there is nothing to photograph there, but it does no good. . . . The country here in Mississippi is entirely different from what we have been seeing. It is worse. Here there is the highest illiteracy rate in the country, the fewest telephones per capita, the poorest roads, the highest proportion of Negroes. In this small city there are ten percent of the houses without connection. Over twenty deaths per 1000 each year result from Malaria. Amoebic dysentery has not been stamped out. One bathes in river water even at this hotel. I drink bottled water entirely now. The sale of Coca Cola is tremendous. People are to be seen drinking it before breakfast. Negroes live like animals, speak only when spoken to, are quick to say, "yas suh!"—even the poorest wayside food stand has two entrances, one marked "Colored" the other "White." Today I sang the *International* [a global Marxist song, written by Eugene Pottier after the fall of the Paris commune in 1871]. Wished they knew it too.
>
> Our place of shooting has been about forty miles away the last two days. Coming home last night there was a glorious red sunset, then the greenish afterglow on the bayous and swamps. We took a back road to get back to the hotel. It led through miles of territory inhabited only by Negroes, their houses have only candles or at best kerosene lamps for illumination. They were getting water from ponds. Stagnant, dirty water, undoubtedly infested with every known kind of filth and germs. Sanitation is unknown. Where there are wells, they are within a few feet of outhouses, and the wells are very shallow, because they have to go down not more than ten feet before they strike water. Even the water here at the hotel is always yellowish in color, from the mud they don't get

out of it. Such a terribly miserable country. Why do they stand for it? The only hope in the whole mess is the Southern tenant Farmer's Union. There is one thing that does stand out here though—the people are friendly. The rude discourtesy one finds continually in New York just doesn't exist.

[That night at dinner] Pare talked incessantly. First it started with the Strand, Steiner, Hurwitz thing. I don't know how to recapture the feeling I had from last night's talk. I will try to be objective and then perhaps it will come over. He told me about a call from the manager of the ranch where they were staying, saying that he [Pare] had better come and get his men, before they got in any more trouble. A cowboy had beaten one of them up pretty badly. When he got to Denver they were there. Strand had a cut over his eye. They said nothing about the brawl. Neither did he. Then the conversation changed. . . . So I listened to story after story about New York's nether world. . . . Where gangsters came for recreation. Where dope peddlers hung out. About beautiful show girls being ordered around by gorillas. About guys whose hands no longer looked as if they had joints, having been broken so often. . . . Suddenly he became very serious. Seemed suddenly sober. Asked me what my connection with Strand was. I tried to explain about Nykino. . . . And then back to Denver where he gave the men [Strand and Hurwitz] the alternative of doing just the photography, or of leaving two days later on the Golden State Limited, their salaries to stop when they hit New York. Otherwise they were to report in the dining room at six-thirty in the morning, ready to go to work. When he came down to breakfast they were already there, and as he entered the room they sang "Good Morning Dear Teacher" in unison. He thought they had been sincere when they said they couldn't shoot his scenario. That Strand had formed a really vast and great philosophy of life. Sincerely believed in it. Would rather quit than capitulate. From that time on, he was bitter. He sent Paul and Leo away for a few days to shoot some stuff, he and Ralph [Steiner] stayed, did the sequence of the little kid in the sand, the plow and the dust, the man looking at the sky, the woman sweeping the porch. The whole essence of the picture. And when Leo and Paul came back, they brought beautiful pictures of grain elevators, glorious still things that he tried to cut into the picture several times. Couldn't fit them.

. . . And then finally, the time came when the picture was finished. The narration had been done. The music was scored. A combination of the work of Ivanow, Murnau, (wheat scenes) . . . went on the screen. He asked them if they wanted their names on it. They didn't know, held meetings, finally asked to see it. Decided yes. And then when the preview was given at Pare's expense, with Sidney Howard, Benchley, Benet, and many others drinking his champagne, sherry cocktails, they—precious trio—sat in a corner reading newspapers. Strand told him that it was a pretty picture, but that it didn't mean anything. That the guts had been taken out of it.

And how much the story in New Theatre rankled after he had prepared the press releases on the photographers—the press and all of the rest of them giving the photography a big hand, saying little about the rest.

And as I went to my room at four-thirty the phone rang and a jovial voice asked me if I thought Stacy Woodard had written the scenario for this film. I laughed, hung up, knocked on his door, told him I didn't think I had written it either, went back to my room. The telephone rang and he said, "I haven't written it yet either."

The next few letters briefly dealt with a down period for Van Dyke in which he described the trip as having "gone dead." He had begun to feel that the material they were shooting was not of any real value to the film or to his career. In the meantime his friendship with Stacy Woodard had grown. Stacy invited him to make films in Siberia, but Van Dyke declined because he would have had to leave the country for nearly a year, and at age thirty he felt that such a long absence would be detrimental to the ambitions he now held for becoming a director. He repeated a phrase at the end of one letter that conveyed just how ambitious he was: "What a lot there is to do in the short time there is left." By mid-December the strained situation was more and more evident in the attitudes of Van Dyke and Woodard. Lorentz obviously thought a pep talk was in order for both men, so at dinner one evening he offered the following assessment:

And then we heard about how he [Lorentz] had made two guesses and how they had come true: One, that Stacy had a long time investment in dependability, that he had to turn out pictures to meet release dates, that he had had to deal with bastards, and held

his head up. The other, that I had been close to a couple of men [Strand and Hurwitz] who had spent their whole lives trying to find out what a picture can do, and who perhaps are the finest and most sensitive technicians in the field. And that these men would never be really great because of their personal and psychical difficulties. That these men wouldn't have had me around unless I was good. Because friendship was unknown in their league, and that when they said I was a capable man, that meant more than it said, and that I was young, ambitious, obviously reliable. So when the thing [the film] worked out as he thought it would, he knew that he would have a great picture, and that this picture is going to make news as a new form, as a great picture, as a finely organized piece of work. And with a pat on my shoulder, a handclasp for Stacy, he was off to New York. And he left with us a few notes for the most important shooting of the whole picture. The whole Mississippi River footage. . . . But it has made me write a few things down on paper, has made me more impersonal than ever, has taught me disciplines, and given me great experience. Going into the last lap of it, I know this—that given a few interesting pictures, a good narrator, a fine musical score, the picture will have a big impact. And that this picture, having as it does, over a hundred thousand feet of negative to choose from, to make a three thousand foot release, will make a place for itself along with the best documentary films.

By the end of December, Woodard had had enough and returned to Hollywood. Lorentz found another academy-award winning cinematographer to take his place with the help, once again, of the great Hollywood director King Vidor. Floyd Crosby arrived in New Orleans on New Year's Eve. Lorentz and Crosby went immediately to the Gulf of Mexico to film and Van Dyke stayed in New Orleans to film levee construction. Although he knew Crosby's work and held great respect for him, Van Dyke was more than happy to have the time to work alone. He had the full confidence of Lorentz, and with the project entering its last lap, he was eager to shoot as much good material as he could. The first days of shooting a crew of black laborers building a levee was inspiring, even though he loosened them up with a quart of whiskey. While they worked they sang hymns, and they were not intimidated by the close-up camera work. In one of his first letters of the new year, 1937, he assessed what he believed he had captured on film:

I was dreadfully tired last night. I guess being director, camera-man, and assistant cameraman to myself was a little too much. I went to bed at eight-thirty and got up at nine. Needless to say I feel a lot better. Anyway, I shot twenty-two hundred feet of film on the levee work, and he surely can't use more than two hundred and fifty, so that is ten for one. And I know that some of it is wonderful. There is one scene in silhouette against the most marvelous sky you could imagine, all of them wheeling their wheelbarrows across the top of the levee, another of their singing faces coming right into the camera, details of the barrows being dumped against a bank of cumulous clouds. And shots of mules that make them look like the noblest animal that God ever wrought. In fact everything has a swell singing quality, with nice movement in space and nice tempo. I feel more sure of it than anything I have ever done. Alone it would make a very lyrical little film. So the whole trip gains meaning by one sequence well done. Meaning for me, I mean. Pare is still down at the Gulf and much as I would have liked to take a trip this chance to work alone was better.

His next letter, which he had saved and had inserted in the midst of a package of saved letters from Mississippi, diverged from the central theme of his successes and failures in helping to make the film. It was about his reaction to a review in the *New Masses* magazine and a controversial book on dance in America. The *New Masses*, a Marxist publication, was in circulation from 1926 to 1948. It published authors like Upton Sinclair, Max Eastman, Eugene O'Neill, and Theodore Dreiser. He might have thought of the letter as one that would demonstrate to future potential readers of his "daybooks" that he was well informed on a broad array of the arts. It does reinforce his claim that when he moved to New York he had as much interest in the performing arts and theater as in photography and film. But it also reveals his distaste for segregating popular arts from the avant-garde as well as his "western" belligerence toward what he saw as New York's provincialism.

By this time in his life he had a fully developed sense of egalitarianism concerning society and the arts alike. The inclusion here of this brief letter helps to further illuminate the hybrid social agenda he was developing for himself. His photography in California had excluded popular aspects of the medium. He and his friends had completely rejected "pictorialism,"

which was then practiced by all of the amateur camera clubs. In fighting for photography's role in the arts the message was that only the "purity" of art for art's sake was allowed, as was evident in Van Dyke's "Salon of Pure Photography." When he converted from aestheticism to socialism, however, the common man and populist ideals were merged in an emotional blur, which caused him and other artists to devote their work to subjects that dealt with labor, justice, and other pressing social issues of the thirties:

The controversy between Agna Enters and the apostles of la Graham seems to be reaching something of the proportions of the debate between Isadore Schneider and Farrell. The current *New Masses* has a letter from Sophia Delza (Leo's sister) in which she criticizes Enters (rightly) for not sticking to the subject of Spain in her article. And the *New Masses* promises more articles on the subject. I have read reviews of *America Dancing* by John Martin. The book sounds sickening to me, and in fact, it makes me more than a little mad. To me, speaking of "pure dance," Fred Astaire approaches it as closely as or more closely than Graham and there is a place for Powell in any study of AMERICAN dancing. Who says that Graham is the greatest speaker in the dance for America? Is New York America? And all this business of kinesthetic reaction is being over worked. There is at least visual reaction also. And in some dancing there is also an aural response. But to make such a statement as, "The dance has been able to place itself at the top of the American arts," especially when most of the popular American dancers have been disregarded, is utterly ridiculous. Such a limited medium—Well any way the whole business is a little precious, like most of New York, but I don't think such a book can be fair, good, or honest, when such a specious statement is its foundation.

The crew moved on to New Orleans in January, which was cold, wet, dreary, interfering with the crew's shooting schedule. The pouring rain kept the crew indoors much of the time and Lorentz in New York. Van Dyke was now able to get to know Crosby, who unlike most of the crew drank in moderation, was antifascist, modest, unassuming, and a complete professional. They developed a mutual, but distant, respect for each other: Van Dyke admired Crosby for his disciplined accomplishments and Crosby Van Dyke for his youthful, inspired, creativity.

The downtime from the weather gave Van Dyke time to clean and maintain his equipment. He used several different cameras including a Model L Parvo, which was his favorite because it was used by Eisenstein and because its viewfinder allowed simultaneous viewing of what was being shot. But all of the cameras were hand cranked, and the speed at which one cranked affected the exposure of the film—the slower one cranked, the more exposure. Normal speed for both action and exposure required somewhere between sixty and seventy-five feet of film per minute or about sixteen frames per second. Van Dyke's method of maintaining natural, lifelike scenes was to hum "Stars and Stripes Forever" and crank in time to the song.

Inclement weather made it extremely difficult to attain acceptable footage, so when *The River* portrays dramatic atmospheric effects, it evokes special admiration for the physical stamina and concentration of the cinematographers. Van Dyke and his colleagues may have played hard, but they worked even harder.

On one evening when he was fighting boredom and a growing depression over his time in New Orleans, Van Dyke entertained himself by writing a letter to Mary that took the form of a short piece of fiction imitating the style of famous writers. The letter, he said in his memoir, was a pastiche of his friend from Carmel days, William Saroyan, and two of his favorite authors, Ernest Hemingway and Thomas Wolfe. In the final paragraph of his letter, he used a line from *A Farewell To Arms*:

> He was a tall man, with black curly hair, and people looked at him as he walked into the restaurant. The waiters were more than usually attentive, and I heard him say that this was to be his last meal in New Orleans, and he would like to make a little occasion of it. He said that he was going back to New York, and he didn't know when he would be back in New Orleans again. People had been very kind, but he had to get back to work. He hadn't been in New Orleans, he said, since he had been brought there by his mother when he was very little. She had brought him from North Carolina, where he was born, to see the fair.
>
> He ordered a shrimp remoulade, bouillabaisse, and a bottle of Graves. While his food was being prepared, he talked to the headwaiter about New York, about the good places to eat there, about Sherry's and Luchows, and about how he didn't want to go

back on a Pullman because he was such a tall man and the berths were so short.

I had almost finished my dinner by this time, so after a helping of Brie, I walked over to his table, begged his pardon, told him that I noticed that he was alone. He graciously asked me to sit with him while he ate.

I introduced myself and told him what I was doing in New Orleans. He asked: did I think anyone had ever photographed America, really? He said he thought that freight cars sitting on a siding were really very American. He had tried to explain this to people and they had been very polite. He told me about a film of Berlin that gives one the essence of that great city from dawn to night—Walter Ruttman's "Berlin Symphony of a Great City." He spoke about a new German film called "Triumph of the Will," and how it could only have been possible to make it under a dictatorship. Of course, he hated what the current regime in Germany stood for, but he had heard it was a very wonderful picture. Did I think that the Government here would ever make any really good pictures of our country?

I said that I knew Saroyan, and what did he think of Saroyan? He said that it was awfully easy for little dried-up guys to laugh at Saroyan, only they never wrote anything themselves. And he said that pretty soon Saroyan was going to have to take his writing and get Bill Saroyan out of it. Of course, one could only write about oneself, but it was only when one took some guy like Bill Green or Tom Smith (who was really the author) and wrote about *him*, with the implications of a larger thing, society itself, that his writing began to mean anything. Yes, he thought that Saroyan would be all right some day, but he had to get that fellow Saroyan out of his writing. He had written Bill a long letter one time, and then never sent it to him.

Did I know the country around Asheville? He said that the people in the hills back of Asheville had lived there for a very long time and maybe they were just about as American as one could find. He said that he had been all over America except the Pacific Northwest, and that America was a very complex country, only it wasn't at all disconnected the way some people said it was.

Then the waiter asked him to have a drink on the house, and because I was sitting with him, they asked me to have a drink on the house, too. After a while I went out and walked back to the hotel in the rain. I kept thinking about "the singing and the gold" and about "this most weary unbright cinder, lost." About *Look Homeward, Angel.* And that is how I met Thomas Wolfe.

In this simple little story, Van Dyke is really writing about his thoughts and ideas concerning America and, more specifically, New Orleans. Although he does not dwell on the fact that he spent a couple of years of his childhood in that city when writing any of his letters, he did follow this story with a note that harkened back to the dark shadows of his later childhood:

New Orleans had now ceased to be the place where I lived for two years when I was a little boy, and is now a composite of us and a picture ["The River"]. Only in memories can I see the house I lived in then. When I think about the place as I saw it that day with Jack, it is just another house on a street. And it has made me realize that to go back to Fort Collins would be rank folly. I want to keep the thoughts of my childhood there unsullied by any later, less good pictures.

Van Dyke and the others thought that they would finish their shooting for the film in New Orleans and on the gulf soon, but on about January 15 they received an urgent call from Lorentz, who was in Washington, D.C. He told them that they all should pack up and head for Memphis, Tennessee. The Mississippi was beginning to flood and it appeared it was going to be a national catastrophe. The crew threw their equipment into their 1935 Ford station wagon and left in a driving, freezing rain. The windshield wipers on the car had to be operated by a hand crank on the inside, while they bounced and slid over muddy roads, taking a three-hundred-mile detour to avoid washed out and closed highways. In one day they drove through four states, including Louisiana, Texas, Arkansas, and finally Tennessee. As they crossed the countryside they began to get a sense of the growing tragedy: vast expanses of farmland under water, rivers swollen level to the tops of their banks, levees piled with sandbags, and cities boarding up and evacuating.

When they arrived in Memphis in the dark of night, they learned that a nearby levee was about to be breeched by the river. Adding to the terror

of the moment, they saw farmers on each side of the river piling up sand-bags along the banks of the river to protect their stretch of land. But they were also standing guard to prevent each other from crossing over and dynamiting the levee opposite their farms, which would force the flooding waters to rush onto the opposite farmer's land. In the desperate chaos of the night the crew went to the levee and with the use of flares began shooting a sequence of attempts by small local WPA crews in overcoats and rubber boots with freezing hands, trying to repair the damaged wall holding back the raging river:

> Oh, Christ it was miserable[;] . . . the drama was tremendous because there were guys patrolling it with shotguns to keep farmers from blowing the levee so that their land wouldn't get flooded—and there were the WPA workers who were there, in this freezing cold, improperly clothed, and they had sacks and they would fill the sacks with frozen earth, and they would take them over and pile them on the levee, and jump up and down to get them into place. We had to work with flares, which would give you just three minutes of light. Magnesium flares. That amount of light. You had to shoot, hopefully, so that the smoke wouldn't come across the screen—and the camera kept freezing up, it was so cold.

When they finally arrived at their hotel it was filled with people listening to shortwave radio reports from across the affected area. Van Dyke, recalling his work with Nykino for *The World Today*, which covered news situations with reenactments for dramatic effect, suggested that they do the same for the flood. Crosby would have none of it and declared that they would shoot it like newsreel material, purely documentary. Van Dyke agreed but silently felt that straight newsreel-like material would not offer the "punch" that the flood and its human toll were bound to offer. He sensed that the film had just taken a dramatic turn and that it was likely to make all the previous months of shooting make sense. The crew filmed the flood from mid-January to mid-February and Van Dyke's letters during this period chronicle an astounding adventure and American tragedy.

> This morning we left Memphis to come here, to Blytheville. Nearby the levees have given way, and more are expected to break tonight. All the way here we fought sleet and snow and a bitter wind. . . .

In a few minutes we will leave the lake into which the river flows, do some shots by flare light. There are five inches of sleet on the ground and more is coming down. It won't be a picnic.

In spite of the cold, the country looked beautiful. Every tree was a crystal thrill. Loaded with icicles against black barns, that tempted me to stop many times. We called the engineers; found that men were working twelve miles away to try to keep the levee from breaking. . . . At the bridge twelve miles from town the water had reached a new all-time high. In several places it was trickling over the levee. Men were filling bags with earth and piling them at points of danger. The ice was six inches thick on the tops and sides of the levees, and the temperature was twelve degrees with a bitter cold wind blowing spray over the men. For eight miles down the levee men were stationed at one mile intervals to prevent anyone from blowing it up. At seven o'clock they came off shift, and as number six and number seven mile men came in, they found number five man down in the snow unconscious. They sent word on ahead, and a doctor came by boat and revived him and took him to a hospital. Number eight man failed to report, there was no way to reach him except by wading eight miles, but at twelve they sent a search party, who found him at four o'clock. He was dead.

. . . Today Blytheville prepares to assist eight thousand refugees. A hundred box cars will be placed on a spur track just outside of town—soup kitchens will be established in the armory and the city hall. Last night we saw flat wagons with a crude framework nailed to them, over which canvas had been thrown. Extra mules were tethered behind them. Inside a lantern burned for warmth—around it were huddled women and children.

Back in Memphis, Van Dyke hired a pilot from the local airport to fly him over boiling, swollen, muddy river. He witnessed the river turning into "an angry, powerful force, which whirled and eddied" as it slowly, massively flowed like great brown lava toward the Gulf of Mexico five hundred miles away. He saw whole farms washed away and houses floating and bobbing along like toys in a stream.

The water was filled with debris, floating firewood, broken wagons, logs and a few animals. We dived to about three hundred feet,

as I breathlessly gave instructions to the pilot, and shot magazine after magazine of film. I had to hold my breath to keep the camera still. As I held it against my chest and we came out of the dives at a hundred and fifty miles per hour, it seemed to weigh a hundred pounds. But all of my preoccupation with my job was not enough to stifle my surprise at the extent of the flood, and the obvious damage it had done in just this tiny sector. We were flying over the levee now and suddenly I saw a place that was dark in the snow covered side of it. Water was running over the top for about a hundred yards, staining the snow for a mile or more, as it wound an irregular path over the farms. And then ahead I saw our goal. There, with men vainly trying to stop its inexorable rush, the River had broken through, washing a terrific gap in the levee and widening the breach perceptibly as we watched.

Two days later, he again took to the air for aerial filming over Cairo, Illinois, and then on to Paducah, Kentucky. He saw what looked like a miniature town set in a vast expanse of destruction; he was sickened by it, at times unable to keep the film rolling. Now thirty-eight thousand people were homeless. All communication was lost, looting and pillaging was rampant, but worst of all the danger of typhoid was mounting hourly. In Louisville he knew the catastrophe was even worse with the lives of three hundred thousand people at stake. As the devastation began to take a toll on his emotions he wrote to Mary that he did not like the numbness that he was beginning to experience as a member of the team. He had begun to feel that he was shooting "news" footage more than getting at the real drama of the sorrows, losses, and heroic moments of all those on the ground beneath his plane.

A few days later Lorentz returned and helped to give form to the enterprise, which the whole crew felt was lacking owing to the arbitrary way they had been shooting, first one subject and another.

Across the lowlands, not flooded as yet, with refugee wagons going in the opposite direction, we came at last to this little riverfront town. Pare and Floyd went on a boat, upstream. Jack and I are here to do shots of levee work. Tonight we went to the local bar to have a drink before dinner. The place was jammed with workers, but in spite of the amount of liquor being sold, every one was very orderly and quiet. All of the stores are boarded up; the theater is

closed. The hotel is almost the only place in town still open, except the saloon. There isn't much danger here except in case of a strong wind, and even then we would be safe on the second story of this hotel. But over the whole place there is the feeling that twenty miles out there is an enemy army and one doesn't know how long the friendly forces can hold it away. Two doors away from the hotel is a funeral parlor. Inside, in a room with no furniture, are five coffins. Five men, black faced in death lie in them. Yesterday a barge sank, plunging a hundred men into the icy river. Twenty-two are still missing, probably never will be found. The temperature is eighteen degrees outside and the sky is clear. That means frozen feet and pain, but it also means that the run-off will be slowed up, no more water added to the swollen tributaries, and in turn to the main stream.

. . . Cairo is suffering great anxiety tonight, as the crest approached. Geysers of water shoot from the manholes and "sand-boils" (water breaking through the earth like springs) are appearing all over the levees. Six thousand men work night and day to hold back two rivers; the Mississippi is on one side, the Ohio on the other. Five more bodies of men who drowned came in tonight, frozen stiff. They were stacked like a cord of wood on the prow of the little boat. Even now, the one Negro was separated from the four Whites.

Several days later, while driving in Arkansas, Van Dyke wrote about listening on the car radio to a Russian program of music presented by General Motors. Igor Stravinsky conducted the orchestra, which deeply moved Van Dyke as he recalled his time in Moscow. He reminisced about how much he loved the finer things of life and felt the weight of being away from "cultural things" for so long. The next morning he rose at dawn and wandered out onto the landscape, just as he and his good friend Preston had done so many times when they were at Berkeley, and the light and air gave freshness to being alive, transporting him far from the exigencies of life.

Van Dyke and the crew completed their work in February 1937, and now the tens of thousands of feet of film that they had produced was being sent to New York where Lorentz and his assistants would begin cutting and pasting to create one of America's first landmark documentary films. From the beginning it was to have been a kind of political propaganda that would help

Roosevelt and the Agricultural Adjustment Agency advance conservation programs that would save lives, land, and the future economy of the United States. But it ended up more than that because its cinematographers saw the rawness of the disaster in light of inspired imagery. And for all of Lorentz's faults it was he who understood the vagaries of working with artists, including Van Dyke himself.

In his final letter while still on location, Van Dyke pondered where he would go and what he would now do with his career, and he recalled the suffering he had seen, which would remain with him to the end of his days. Death itself had finally surfaced as a reality, too; it was no longer just the last hour on life's clock, a conception of it that until then had driven his ambitions in the face of passing time. He now recalled an exchange with his friend Preston at the time of the formation of Group f/64 and the moment of its grand idealism, a conversation in which they took the verblike quality out of death and saw it for the first time as a noun representing self-realization.

It seems hardly possible that this hotel [Lewisburg, West Virginia] was out of service two weeks ago, with water almost to the top of the lobby doors. . . . This is the place where the bellboy caught the fish in the lobby. The basement was full of catfish when the water went down. All of the windows on the street show the line of the water, because a paint factory nearby caught fire, and a layer of paint and oil covered the water for blocks around. . . . In the residential sections, citizens are still disgustedly trying to clean up the mess, porches are piled with household effects, clearly showing the effect of the water. It rose a foot an hour, until it was ten feet deep one night, so very few people had a chance to get anything out. The confusion and haste was so great that many families were split in several sections, and sent to refugee camps in widely separated parts of the country. It must have been a nightmare. And now the Ohio is below flood stage, peacefully, almost shamefacedly flowing between well-defined banks.

And now fast comes the end of this period of my life. . . . All in all it has been a good four months and a necessary part of my growth. I wouldn't want to do this sort of thing always, nor again soon, but I certainly am happy to have had it at this time. Now to choose the right way to go forward. I know now what

Preston meant one time when I was talking to him about "things." I remember that I said something to the effect, that why did we try to do things at all, why were we trying to find the meanings behind the earth and the stars, and the people, there was only this day, this minute, and perhaps never again another moment, but only blackness and death for all time—only oblivion. And he said that he guessed that there really was good in everything, that life was good if we *were really alive*, and that death wouldn't be bad if we were really alive all our *living* days. That to live fully and gaily and to work with earnestness, toward some goal, was really the thing that would make death good when it came. Only if there had been no striving, emptiness, and decay in life, would death be bad.

For the next six months Lorentz worked on editing the film and adding music and narration. The finished film was thirty minutes long and the music, like the documentary style of filming, broke new ground. The film premiered on October 29, 1937, in New Orleans to rave reviews and then later in Minneapolis and finally in Washington, D.C., in December. The film was a deeply moving experience for a broad audience and immediately was recognized as a new form of documentary in the history of American film. Paramount Pictures picked up its distribution and booked it in theaters across America but only as a short to be shown with a third-rate Hollywood film called *Scandal Sheet*. The irony was that the government gave the film to Paramount for free, and Paramount would only let *The River* be shown if theaters rented *Scandal Sheet*, which would have otherwise bombed at the box office.

Lorentz received critical acclaim for *The Plow That Broke the Plain*, but *The River* received both critical and popular acclaim, which provided the much desired and needed national circulation. The acclaimed British documentary filmmaker Paul Rotha wrote in his book *Documentary Film* that the film "did more than to secure the popular recognition of the documentary film in America than any other picture. And, above all, it played its part in the expression of the awakening need for social reconstruction in the United States."[17] The film's cinematography was described as "drama and poetry and excitement" by Jay Carmody of the *Washington Star*.[18] Lorentz went on to make several more films for the government and to set up its short-lived department of film known as the U.S. Film Service.

Van Dyke received just the kind of "stepping stone" accolades he hoped for and was now considered a seasoned cinematographer with a place squarely in the forefront of the American documentary film movement. He returned to New York to work with Nykino and to reinvigorate his freelance commercial photography commissions. But he could not just pick up where he left off. He no longer could muster enthusiasm for just shooting film footage for *The World Today*. He had developed a taste during the past several months for being his own director and for the possibility of making films that could "change the world." But he would have to wait a while longer.

5

Changing the World

❧ WHEN VAN DYKE RETURNED TO NEW YORK FROM WORKING WITH
Lorentz, he found that Nykino had hardened in its leftist mandate. There
was a zealous effort to concentrate more than ever on "racial barriers, mil-
itarism, imperialism and jingoism, all of which had succeeded in bring-
ing us to the brink of another world war."[1] This statement was included
in a brochure at the beginning of 1937, which announced that Nykino had
evolved into a new independent nonprofit film organization, Frontier
Films. Strand was to be president, Hurwitz and Steiner, vice-presidents.

In spite of his professed uneasiness about the rigidity of the new
mandate, Van Dyke contributed to both the evolution of the new organi-
zation and its name. According to William Alexander, Van Dyke "posed
a rhetorical question then familiar to people of many political persua-
sions: How, in a country of 'scheming merchants,' was one to 'recreate
the vision of the pioneer?'"[2] This quote came from one of Van Dyke's let-
ters to Mary Barnett. If it contributed to the idea of the name, Frontier
Films, by way of its reference to pioneers, it would have been because
Van Dyke shared either his rhetoric or some of his letters to Mary with
Steiner. In any case, his feelings about the new organization were ambiv-
alent, at best.

Unlike the free-spirited, loose organization Nykino had been, Frontier
Films was a hard-line, all-too-Communist-inspired, businesslike organi-

zation with a board of directors. Van Dyke knew that John Howard Lawson, head of the board, was the "Hollywood commissar" of film and a member of the American Communist Party. The link to Russia was now direct, and Van Dyke had already made clear his disenchantment with Moscow after his visit in 1935. In addition he was an ardent supporter of Roosevelt even though most of the other members of Frontier Films were not. He continued to profess a desperate need for change, to profess the ideals of the Socialist Party, but was adamant that that could not be accomplished by replacing the current system with a Russian model.

He was offered a temporary diversion from dealing with the issues of Frontier by a visit from an old friend from Oakland, Peter Stackpole. During the days of Group f/64 Stackpole had been a frequent visitor to 683 Brockhurst and a close family friend, often mentoring Van Dyke's younger brother in photography. After Group f/64 had been fully established, Stackpole and a few others, including Dorothea Lange, had been made members. Even as a member of Group f/64, Stackpole used a small 35-millimeter Leica camera. Van Dyke often chided him that it was not possible to make enlargements from the Leica that could equal the quality and detail of a contact print made from an 8 x 10-inch view camera.

Now working in New York, Stackpole was a *Life* magazine photographer on regular assignment. He finally felt secure enough to challenge Van Dyke and proposed that they make a trip across America, photographing with their respective camera formats on assignment for *Life*. The idea would be to illustrate the most effective use of each camera and what their differing negative sizes might accomplish. In the background of the plan was Stackpole's desire to see his fiancé and Van Dyke's longing to see his family and friends. The editor of *Life*, Wilson Hicks, thought the idea had merit and the two men were given two months of travel, photography supplies, and a comfortable stipend from the magazine.

Van Dyke had only just returned to be with Mary in New York in March and was now preparing to go on the road again in June. Whatever difficulty this created for their relationship was suppressed for the moment. Mary was successfully developing an acting and teaching career, and Van Dyke's ventures were not, in any event, negotiable. When he professed love for someone, he no doubt felt it deeply and sincerely, but the emotional triumph he felt in just being able to love someone was inevitably shattered by the realization that such love came with expectations and demands he could not meet. His behavioral models, especially Weston, gave him permission

to separate love and sex. When he was on the road all of the tension of dealing with the needs and desires of a formal relationship were diminished. Writing letters and making films allowed his more successful intellectual side to fulfill what he believed intensely were his good intentions.

On this trip he again wrote detailed, diarylike letters to Mary, but this time they were softened, however slightly, by periodic inquiry into and comments on her personal interests. As before, the letters largely took the form of storytelling; he related his adventures, using narrative to illuminate and explain the meaning of art to himself.

On June 5 the two photographers climbed into their car and headed for Virginia. The first letter Van Dyke wrote was on June 7 and it contained a wonderful visualization—a photograph in words—of their first evening in Harrisonburg:

> Two days of long hard driving ended last night at eleven when we arrived here. The first night out we stayed in Harrisonburg, Va. The trip was pretty un-eventful the first day, except for a stop in a small country town, which was alive with activity on a warm Saturday night. We went into a sort of restaurant, sweetshop and bar and had a plate supper. In the booth behind us were two CCC officers, and in nearly every other booth were boys and girls having sodas or Cokes. At the soda fountain was a boy about twenty, who was really wonderful. He wore a straw hat, well back on his head, light trousers of some nondescript material, and a coat of a slightly darker shade. It wasn't his appearance that was so extraordinary, though, but it was the fact that he stood drinking glass after glass of water, speaking to people who came in, nodding to acquaintances and leaning against the counter. Every movement was as if he were in a saloon—he rested his foot against the marble baseboard, which jutted out slightly from the front of the counter, he held his glass in the certain way one holds glasses like ours with the heavy base, and he tasted the water at the back of his mouth. He even created the illusion of a spittoon at his feet. If he were a Group Theatre actor, one would have said he was doing a fine improvisation. Pretty soon his pal came in and he turned his back to the counter, leaned against it and draped his arm lightly over his pal's shoulder while he talked earnestly to him.[3]

His next letter, a day later, was a lengthy prose description of the rural poor in the Smoky Mountains. His observations on their language and folklore recalled the style of his diary from his high school graduation, when he took his trip to mining towns of the West. He steeped himself in the sound, look, and feel of the people and places he visited, practicing, it seems, for scripting the kind of films that were growing inside his head, preparing to share his vision of America. The descriptive detail of his prose was very much in harmony with and analogous to the infinite fine-grain details and wide-ranging values in the black and white photographs that he had come to love when he and Weston were making their pictures with their big cameras. He continued to gently urge Mary to be confidant and happy in her indirect role as his assistant on the home front while making it clear that the current letter was also potential article material for *Life*:

Today was one of the most satisfying and exciting days of my life. We started early, Peter, three local men and I, to see the Great Smokies, and to try to pick up some shots of primitive ways of life in the foothills and mountains. . . . They contain the highest peak in the Appalachian range, and the second highest East of the Mississippi. . . . Early pioneers, arriving in America from England and Scotland, made their way westward from Carolina, and per-haps Georgia, and when they reached the cool slopes of these mountains they were content to stay. Their descendants, retain-ing many of the pioneer qualities, as well as the speech of these people, have never left the slopes. They call themselves mountain people. To them an outsider is a "furriner." They say "hit" instead of "it" in a sentence that may also contain the word "it." Euphony governs their choice of words. "Hit" is an old English form, but whether they use that word, or whether they say "it" depends upon how it sounds to them. They may say "nestes" instead of nests, but Chaucer formed his plurals that way too. Much maligned in the story and cartoon, the fact still remains that they live a primitive life in the midst of an industrialized country.

. . . As we came closer to the mountains, the people as well as the scenery changed. They became leaner and more silent, and they didn't often return our waved greeting. . . . As we went ahead, we saw a house surrounded by a picket fence. On almost every picket

there was a fruit jar, turned bottom up. Of course, that made a picture, so we stopped, asked permission of the woman who came to the door in overalls, and made several negatives. I asked why she put her jars on the fence and she said, "I don't know, but my ma always used to do it, and I wouldn't think of puttin' up no fruit without I'd sunned my jars good." Of course, there is a good reason for what she did, only nowadays we boil our fruit jars to kill the bacteria that might cause mildew or mold. Overhead there were wires stretched with two pieces of white cotton cloth. That was to "keep the birds from the biddies," she told us ["biddies" being newly hatched chicks]. And beyond the barn was a sapling with two crosspieces to which had been tied four gourds with holes in them. "I wouldn't be without Martens, they keep the hawks away."

. . . Up the road, now with pictures secure on film, to find an old gristmill run by water power. And the old miller who ran it was a fine, sensitive old man, whose beautiful barefoot boy, perhaps eighteen years old, helped him run through the bit of corn he needed for his corn pone. Not many people bring grist to the mountain mills any more, and they are rapidly disappearing. And still further into the mountains to try to put on silver, the elusive charm of these peaks and valleys, to try to show other people why the pioneers just "sat down, for a piece" and remained two hundred years. And, of course, I never can, for now there are roads through the hills, the Cherokees are gone, except for a few pitiful ones on a reservation, the mountain people are being taken from their homes, and their homes are being destroyed or occasionally turned into museums. You can't pick a bit of moss, or a fern or a flame azalea now, because if you do you'll be fined twenty-five dollars. And if you were to shoot a squirrel, they'd put you in jail.

In another letter Van Dyke wrote about a conversation with a little eleven-year-old girl. Her world, that of the hill people around Knoxville, was simple, direct, and mired in a cultural mindset that had never known anything but poverty. Doing without most of the simple pleasures of material well-being, she had developed endearing survival skills, which included lightning quick logic, maturity beyond her years, and keen powers of observation. The effect on Van Dyke was immediate, arousing his desires to change the world so that all the little girls like her might someday

have the food and clothing they deserved, as he promised to himself at the end of the letter:

> While I was working a little girl with red hair and greenish eyes came up to me and asked what my camera was. I explained to her, and she stood by and watched me work in silence for a while. Then she said: "Whatever you see through that thing must be awful purty, because every time you take it down from your eye, you look mighty pleased." I laughed and showed her how things looked though the finder, and then she asked me if I wasn't there to take pictures of the farmers. I told her that I wasn't, but that I had to make some pictures for a magazine called *Life*. She asked me if they wanted pictures of vegetables and I laughingly said that of course they did, because vegetables helped to sustain life. "Why don't you take pictures of the ground," she said, "the ground is the most thing."
>
> She asked me if the camera could see light in the dark, and I said that it couldn't, and she said that a cat made light in the dark, "leastwise his eyes do." Her name is Edith Dailey and she lives in East Knoxville. She doesn't have shoes and she wears overalls. She is eleven years old and is in [grade] 6b. She earns money, a few pennies a day, by attending to the goods of the merchants if they have to leave their trucks or cars. She says she wants to save up to buy a car, someday, but right now her money goes so that there will be food on the table at night.

By mid-June Van Dyke and Stackpole were back in the region of the TVA. In the following letter, Van Dyke displayed an unusually strong surge of affection for Mary. But even when he professed that he wanted to be with her always, he qualified it with the word "probably":

> Your dear sweet little note that was in with the letter on the new typewriter brought sudden tears, and a quick reaching for your hand. I love you, Mary darling, and I need you to be by me for probably always.

Van Dyke's letters about the mountain people he encountered described their desperate poverty and ignorance. He was ever the compassionate

observer and used his natural charm to win their confidence, a quality that won him a great deal of romance and numerous positions of influence throughout his life.

Tuesday morning the movie camera came, I bought batteries and started out. I went to the top of a mountain a few miles from Norris Dam, to a coal mining village. There I wanted to get some mountain houses. These were not in bad repair as some I had seen, but they were bad enough, and the people were most co-operative, one of them carrying my tripod for me, and having his wife pose for me with the baby (whose name is Franklyn D.) and letting his ten year old boy hoe a hillside potato patch for me. Incidentally, the youngster smoked a hand-rolled cigarette, as a matter of course, while he hoed. . . . As we drove back to Norris, a couple of young girls hailed us. They were dressed in slacks, tight sweaters, and sailor caps. As we drove by, the TVA forester who was with me told me that the county doctor told him that eighty percent of the girls under twenty-five in that county were infected with syphilis. The girls, as soon as they are old enough, begin hanging around the bootleg dives that line the highways on the out skirts of the mining towns, and pick up what change they can by selling themselves to traveling salesmen as well as the miners. That way one girl can infect a whole community with syphilis before they are even aware of its presence.

From Kentucky and Tennessee Van Dyke and Stackpole drove to Missouri to photograph the French Quarter in Sainte Genevieve, known as the oldest French settlement in the Middle West. When they arrived they found that there was little of interest because not much was left of French influence. The region was mostly a hybrid culture, a mix of French, Dutch, and German influences. Van Dyke wrote to Mary that although this part of their journey was not inspiring, he had observed that the midwesterners looked like his relatives and spoke with the same accent. His own accent, he admitted, had been softened by moving around the West and by living in New York. But most of the letter was about the people he was photographing and his feeling right at home in the culture because of his time in New Orleans. He also wrote about a growing lack of patience with his friend, Peter Stackpole. The competitiveness between them that had inspired the

trip had begun to make it difficult for them to tolerate each other in close quarters day in and day out.

Van Dyke complained that Peter depended on him to make all decisions and arrangements for every photographic venture. He, not Stackpole, had to do all of the talking to engage those they dealt with, whether it was winning over the subjects of their photographs, negotiating with the mechanics at the garage who serviced their car, or speaking with the clerks responsible for making hotel accommodations. He was offended when Stackpole would enter his hotel room without knocking while he was writing Mary. He expressed his anger at being shackled to someone else, but the anger was unwarranted and was really an expression of his desire to not have to accommodate Stackpole's different vision and ideas when it came to what to photograph on the trip. He never showed his belligerence to Stackpole, and in fact he turned on his charm and kidded Stackpole out of their petty combativeness. There was still a long way to go, and underneath it all they were friends.

Van Dyke had become addicted to drama and high adventure both from his exploits growing up and, more recently, from his Mississippi River filming adventure with Pare Lorentz. The current trip had become a blur of normality without much excitement. Without realizing it, Van Dyke struck out at his friend because he was bored and was having withdrawal from the rawness of life he had come to crave. He missed the energy and process of making films. He also saved a little of his temperamental feistiness for Mary and his brother in the same letter. He went, with no transition, from complaining about Stackpole to complaining about his brother Lou, who he had been trying to help get established in New York as a photographer and technician. He paid Lou to process film he sent back from the trip, but realized he could not depend on him to meet deadlines. He then admonished Mary that she really needed to learn to read negatives so that she could help him with his efforts. And in the next breath he pleaded with her to have patience with him for not wanting children for the time being. The last comment was curious considering that they were not married at time. It must have been on his mind and a part of their discussions, because in a few months hence, Mary would return to California to visit her mother. According to Van Dyke she did not intend to return to New York, unless she could announce that they were getting married.

From Missouri, the two photographers drove through Oklahoma, the upper part of Texas, and then to their final destination, Santa Fe and Taos.

Along the way they did not make an effort to do much photography. They had finished their journeymen work for *Life*, and they were both intoxicated by mystery and excitement of the exotic Southwest. During the few days it took to make this leg of their journey, Van Dyke wrote a letter to Mary, which included a paragraph that he used in his memoir as a summation of his life in photography and that I quoted in the introduction to this book. Romantic to the core, and written by a thirty-one year old idealist, the statement mimicked the writing style of William Saroyan, one of his friends from his Weston days. He closed the letter by showing a rare concern for Mary's needs:

> Goodbye now, Witto, thank you for all the letters, all of the good help. I hope that you are finding what you want, and that the way will soon open for you to do the things you want to do, and which you so richly deserve. Love Willo.

These romantic endearments were used in letters they wrote to each other during the period when they were first dating, back in Oakland. The push and pull between loving care and biting chauvinism persisted throughout his life. His marriages were more complex versions of this push and pull that is revealed in these letters.

Just before arriving in Santa Fe, Van Dyke wrote to Mary that there were many things in the Ozarks he could no longer bring himself to photograph. He had already seen so much of the same kind of poverty, which he believed was a state of mind as much as a physical condition. At the same time, the desperate ignorance of the rural poor and the lack of opportunity for even basic education energized his activist zeal against the injustice of it all, preparing him for the documentary films he would make in coming years and the political causes he would champion when he returned to New York and Frontier Films.

> We got some pretty local color, and some of it I didn't have the heart to photograph—like a fat girl in a rose print voile dress, with a slip made of flour sacking that stuck out at the shoulders and neck, with her shoes full of holes, standing forlornly against a wall making little bubble-balloons out of a piece of broken balloon she had found. And the fine looking farmer, whose felt hat was pressed into the tri-cornered cocked hat shape of the revolutionary times,

but who had infantile paralysis and who walked with a terrible limp. There was a woman who carried one child, led another by the hand, and she was pregnant.

When Van Dyke arrived in Santa Fe and visited Taos and villages in the region, he soon felt a sense of disappointment and disdain for what he found. Subconsciously, he was making a journey into his past but had not anticipated just how unsettling the experience would be. In part, his feelings were mixed up with a confused nostalgia for his life as a photographer with Weston and his f/64 colleagues a decade earlier. He had also traveled with Weston to Taos in 1932 and his memories from that trip, which included wild parties and freewheeling good times, were now seen in the shadow of the Depression and events leading up to World War II.

Van Dyke's strong socialist idealism, which had led him to give up photography, was strengthened by his film work on *The River*; this brief reentry into photography for documentary purposes was a disappointment and so likewise reinforced his commitment to filmmaking. He also saw the laid-back life of his former friends and acquaintances in the Southwest as "decadent and fascist," whereas in the past he had regarded them as leading rebellious creative lifestyles.

His letters to Mary from Santa Fe and Taos were bitter and critical of everything he experienced. In a way this part of the journey should have reminded him of the book he used to read aloud to Weston while they were staying at Mabel Dodge Luhan's compound in Taos. It was Weston's favorite novel, *Look Homeward, Angel*, in which Thomas Wolfe proffered that "you can't go home again." It took this trip to finally make real that his lack of desire to make photographs had all the finality of death itself. He would make one last brief photographic sojourn with Weston later in the year, which would bring to an end that part of his life.

Excerpts from the Santa Fe letters written during this period also reveal Van Dyke's struggle between his driving passion for social justice and his inner need for the arts. Frontier Films had moved so far to the left that he knew he could not return to it as it now was. The making of *The River* had enormously boosted his self-confidence as a filmmaker and had opened new doors for him. The two months he had taken off to work with his friend on the current trip had only increased his need and desire to continue making social documentary films—on his terms, however, as director and cinematographer. He was no longer interested in the genre of the documentary for its own sake.

Andrew Dasburg, one of the really fine artists of the community is afflicted with Addison's disease, and will probably die soon. The woodcarver at Cordova, the penitente village, is dead. . . . Bynner has heart trouble, and has written a bitter book of sonnets called, "Guest Book," in which he cleanly and beautifully lays bare the stupidities and vulgarities of the people of the town. And the Indians, dressed in tribal costumes, but wearing Keds on their feet, sell silly little bows and arrows in the tourist camps. . . . The old Santa Fe is dying—has been for a hundred years. There is time for a revaluation and new life here. . . . So, as you have seen, either Santa Fe has changed or my orientation to the world has changed.

. . . Of course you know without my telling you how happy I am working once more, but somehow using a still camera is a different thing to me now than it ever has been before. There is no longer any residue of the feeling of getting a lot of swell prints for a portfolio, but rather that I am saying something with a camera. Before the action was to be an artist. Now it is to tell a story. And even though that story is as yet a very personal one, still I feel it is a logical step in my development. I feel as if I wanted other people to see the things I am seeing, to thrill with me at the beauty of life, and to laugh with me at its foibles—and more important, to become indignant at some of its inequalities. . . . I keep thinking of things I want to get into silver, and there are so many of them and I get a little scared every time I think of how old I am [age thirty-one] and how little I have done. And then the headlines in the papers scare the hell out of me. . . .

. . . Day before yesterday I started into the Don Fernando to call Becky Strand [Paul Strand's ex-wife] when I saw a woman with white hair down to her shoulders, a black Stetson, jeans, and short cowboy boots, so I introduced myself and saved a phone call. I told her what we wanted in Taos—that we wanted to know what Taos was, who people were, and to show the thing in pictures of LIFE. She asked us to come up and have a drink—it was ten in the morning—and she'd tell us anything she could.

Her studio is on the second floor of the old adobe, full of light and with several of the delicate sensitive feminine things she paints on glass. We sat and talked for a while, while Peter shot her, and then she brought out a very remarkable series of photographs. Her

father's name was Nate Salsbury, and he was Buffalo Bill's man-
ager. He first took the Wild West show to England, and he was an
actor and a barnstormer from the time he was a boy. Well, anyway,
these photographs were of Cody, Wild Bill Hickok, Annie Oakley,
Billy Baxter, Ma Wilkinson, and innumerable other people of the
western world at that time whom I have heard my father speak
about many, many times. Her mother was an actress and when the
show was in England, Becky was born.

 . . . The next morning, yesterday, we started for the ranch
where Frieda Lawrence [widow of D. H. Lawrence] and Lady Brett
live. It threatened rain all the way out, but held off for us. Brett
was very cordial, "looked in the tins" for lunch, admired our cam-
eras, showed us her paintings, walked up and down stairs for us,
and even went to the brook for water. She remembered me from
before, she said, so as usual I led the conversation while Peter got
the good shots.

 Then we went to Frieda's ranch, a couple of miles away, where
she lives with her lover Angelino de Ravagli, an ex-captain in the
Fascist army, and where the shrine to Lawrence is situated. They
were just about to eat lunch, so de Ravagli told us to look at the
shrine, and then come down for coffee. The Aldous Huxley's [sic]
are staying there too, and as we all sat around drinking coffee
made by Mrs. Huxley, the story of why they were there came out,
and again we were treated very well, and told to photograph any-
thing on the place that interested us. I did a couple of 8 × 10's
of the inside of the shrine, where his ashes are, and then to make
things easier I did three photographs of paintings that Ravagli had
done. Interesting primitive things they are.

 . . . We did some pretty good things, I think, and an excep-
tionally good break was having Huxley, for he romped on the lawn
with the dog and was very un-self conscious. Frieda was wonder-
ful, a big lusty German Frau, who lived a good life with Lawrence,
and saw no reason why she shouldn't have a good *animal* life when
she could no longer have him. Angelino tills the ground, cuts the
hay, feeds the cattle, and paints lustily until two in the morning,
and they are happy with the whole Taos Valley laid out before
them in a hundred mile vista that is beautiful beyond description.
And here are the intellectual bases of fascism, without anyone

suspecting them. Lawrence and his "blood thought," Brett with her Mysticism, Frieda telling about how differently Napoleon's soldiers talked when they were hungry and when they weren't, and Ravagli and Frieda calling their black pig Haile Selassie. Significantly enough they butchered him and are now enjoying his hams. . . .

. . . And it was good to hear . . . that Frontier Films had gotten to work. Whether I shall be able to shoot the picture for them or not remains very doubtful. I hope it is not spot news or documentary stuff. I am not interested in doing that right now.

Van Dyke wrote in his memoir that on leaving Santa Fe he realized how much had happened in just four short years. He had broken all ties with his Oakland life at 683 Brockhurst, had been to Russia, had established himself in New York, had been the cinematographer for much of an important documentary film, and was on his way to photograph once again with Edward Weston. After the final *Life* assignments in Salt Lake City and Lake Tahoe, Van Dyke and Stackpole separated to visit their respective friends and family in the Bay Area. Van Dyke stayed with his family until the first week in August, and then he accompanied Edward Weston and Charis Wilson on a trip to photograph along the coast of northern California. Weston had received a Guggenheim, the first for a photographer, and he was happy to be able to once again go photographing with his young friend. Together they set out with sleeping bags, several boxes of Triscuits, some figs, and a wheel of Monterey Jack Cheese, which represented the dietary preferences of Weston. Van Dyke wrote in his memoir that "what followed were days and nights of talk and long sentences, sunshine and fog, friendship and love, and above all the joy of working with our cameras."[4]

Weston invited Van Dyke to bring along a friend, meaning a female companion, which he did. The few letters Van Dyke wrote to Mary on this trip of a couple of weeks were consistently about two subjects: he wrote to her about their love and compatibility (all the while he was sleeping with his unnamed companion) and he wrote about his loss of interest in Weston's kind of work and for photography in general. Whoever was his traveling companion on the camping trip was there for pure pleasure. At least for now, he seemed to realize that he wanted and needed something more, which he described in letters to Mary. During the past two years, they had now been apart more than they had been together, but when they were apart, they did share in their letters much about their interests in art

and life, even if he did not speak often to her activities. Several days later his attention turned to the remoteness he now felt from his past and for photography itself:

Last night we camped on a beach covered with great bleached logs, and enormous jagged rocks. Of course it is exciting material for Edward and he is busily at work on it. Charis and I have cleaned camp, and now while she writes in the day book, I have a chance to write my Mary.

Yesterday, for four and a half hours Edward worked with details of old stumps, while I lay in the sun. I cannot understand how anyone can hammer away, year after year at the same subject material. It is almost as if he felt that if he could just keep his head under the black cloth, resolving problems of form on the ground glass, he would never have to look at the larger world of humans and their problems. But he is a sweet person and I certainly mean no criticism of his way of working. It is one that I do not understand.[5]

Van Dyke's comments about Weston reveal a complete reversal in his attitude about photography. Less than five years earlier he was approaching life and art in the very same manner as Weston, who he idolized. In a similar manner the letters written on the trip for *Life* reflected Van Dyke's growing distance from everyone around him, including former friends and even Mary. Nevertheless, he at the same time professed a deep love for Mary and for Weston. It is as if he needed to separate art from life and sex from love.

Some of these changes in his outlook were surely due to his nature, but they were also likely influenced by the sad condition of humanity, made all the more intense by the ravaging effects of the Depression and Hitler's growing campaign in Europe. Life and its social exigencies had drawn him away from the life as art artist in 1935. His engagement with socialism had evolved from a largely uncritical embrace of ideology to a heart-pounding emotional struggle. In a confused partitioning of his feelings, like when he was a child and suffered trauma, he now seemed to have convinced himself that his old world was crumbling and the new order of things would be life and love as he would define them anew.

When they returned to Carmel and Oakland, Van Dyke found an urgent message from Frontier Films waiting for him, which said that it wanted him

to film its most ambitious work to date. Under its new structure, which was further left than before, Frontier wanted to make a feature-length film to be called *Native Land*. Van Dyke returned to New York in late August and began filming in October but under what he called disastrous conditions. The film was to be a prolabor film "based on the U.S. Senate's la Follette Committee findings concerning union busting and the tactics of massive corporate labor spying" as described by historian William Alexander.[6] Van Dyke described his efforts as follows:

> The location was a farm belonging to one of Leo Hurwitz's relatives, located more than two hours outside New York City. We left before sunrise in order to have as much time to work as possible. The weather was cold and rainy and my camera was driven by batteries that lost much of their power at low temperatures. Michael Gordon, who had been chosen to direct the film, had been trained in theater. I felt that his talents were not appropriate to the filmic and demanding script. I know that my photography was not up to the best I had done, either.[7]

When the first rushes of the film came in Strand stopped all work on the film. When filming began again some eighteen months later, Strand became the primary cinematographer. The film was not finished for another nearly five years. Just as Strand went through one hundred sheets of paper to make one photograph, so he went through an enormous amount of film to make *Native Land*. The finished film was first shown to the public several months after the attack on Pearl Harbor. By that time the public was not interested in seeing or hearing the left's criticism of America, regardless of the subject. The film received no recognition and quickly faded from view.

What Van Dyke did not mention in his memoir was that this film represented the last straw in his association with Frontier. Both he and Steiner had become disenchanted with the political views that dominated the filming agenda and what they believed was communist control of the content of Frontier's films. To make matters worse, according to Van Dyke, Hurwitz completely changed a sequence that Van Dyke and Steiner had shot in an earlier film (*China Strikes Back*) without consulting either of them. Then when Van Dyke was taken off the shooting schedule of *Native Land* without explanation and the film was stopped altogether, Van Dyke made his

decision and told Steiner. Other disagreements over films followed for a short time, and finally both Van Dyke and Steiner resigned from Frontier.

Accusations flew, and there were arguments about the influence of the Communist Party on Frontier, which enraged Strand. But Van Dyke and Steiner continued to insist throughout their lives that their belief that the company was under communist control was the primary cause for their departure. Hurwitz simply believed that they were afraid of the controversy and the growing power of the political right. In reality, both reasons no doubt played a part in their departure (although it seems unlikely that Van Dyke and Steiner were "afraid," since that would not have been in character for either of them). They did see the extremism of Frontier as unwise and offensive to their strong beliefs in democracy and Roosevelt's public programs.

Historian William Alexander described the climate of the times at that moment in Frontier's history as one in which the views of its members reflected the views of many people in the United States, communist and anticommunist alike, including Van Dyke and Steiner:

All the members of Frontier Films (including Van Dyke) shared with the party a commitment to a Loyalist victory in Spain, a Chinese victory over Japan (although interest in the eventual control of China by the Red forces would vary among members), the growth of the militant trade unions, and other general domestic struggles against social inequality. Because of this commitment, the party valued the work of Frontier. But the same commitment was also shared by many anti-Communists (like Van Dyke) who also valued the films. Although party member John Howard Lawson's name was on the Frontier roster from 1936 to 1941, so was Archibald MacLeish's. The fact that the films were not hardline politics and the fact that they were admired by a wide spectrum of people on the left suggests that the relevance of Hurwitz's statement that, at the time, the party seemed to offer the best grasp of the world.[8]

Still, there was also another matter in the background that bothered both Van Dyke and Steiner. It was Strand's enormous ego, which in their minds made any film that he participated in his film, not the director's, writer's, or other cameramen's film but his film. Van Dyke and Steiner were

not without their own egos, but they knew that Frontier now belonged to Strand. Van Dyke described the problem as follows:

One of the interesting things about . . . [*Native Land*] is that Strand and Hurwitz get the credit for the film. That sequence [the opening sequence] was directed by Bill Watts. The two sequences, which I think by general consensus, are the poorest were directed by Strand and Hurwitz—the labor spy, and the burial [of the] worker. The burial of the worker was directed by Strand, and the labor spy was directed by Hurwitz. Now others were directed by a man named Al Saxe, and [also by] Bill Watts. They are never mentioned in connection with the film and they receive no credit. It's one of those incredible stories. It's like Strand's THE WAVE—well Fred Zinneman directed the THE WAVE, and Henwar Rodakiewicz wrote THE WAVE. . . . Al Saxe was involved in the guerrilla theatre of that period, Theater of Action, set up on street corners, some place, any place. As a matter of fact, what I like best about the film is the opening sequence, which Strand did [shoot], and I think that's absolutely stunning. It's when they got into dealing with people that I felt there was something lacking.[9]

The first few months of 1938 brought significant changes to and opportunities for Van Dyke on a number of fronts. Just prior to his resignation from Frontier he and Mary were married. Without much fanfare or ritual they were married on January 2, 1938, at the parish house of the First Presbyterian Church on Fifth Avenue. Still living a hand-to-mouth existence, the couple's attendant celebration was limited to a buffet supper with a few friends.

Van Dyke also received a letter from Weston at this time that helped to crystallize the real meaning behind the surprising comments he made about Weston's work in letters to Mary. Weston wrote a long letter to withdraw himself from a book that was in the works about f/64. He was frustrated by the text that was to introduce the photographs. Weston vigorously said he believed that the author of it was a twit without the slightest understanding of his work. The book was a project Van Dyke and Weston had conceived of together, but Weston had been reluctant from the beginning. In his letter, he reminded Van Dyke that he did not like groups, that he had attempted to resign from f/64 shortly after it was formed, and that he did

not like the idea of being lumped into a group in the proposed book. In addition, he took a swipe at the prevalent critical consciousness of the time about photography, something that indirectly helped Van Dyke to understand that perhaps he had been too quick to condemn Weston's persistence of vision. The result would become evident in Van Dyke's films to come in which he would no longer deny aesthetics as a persuasive tool for social documentary film.

Years later, just after World War II, he wrote an article for the *Hollywood Quarterly* in which he said that the best documentary films were always notable for their cinematography because many of the best cameramen were still photographers, "who left that medium because they felt it was too limiting a vehicle to carry on complex ideas . . . the better the artist, the more completely the film image interprets the script."[10] He listed Steiner, Strand, Hurwitz, and himself as examples. Weston's contribution to that train of thought came from the comments in his letter about social significance in a work of art:

It seems so utterly naïve that landscape—not that of the pictorial school—is not considered of "social significance" when it has far more important bearing on the human race of a given locale than the excrescences called cities. By landscape I mean every physical aspect of a given region—weather, soil, wildflowers, mountain peaks—and its effect on the psyche and physical appearance of the people. My landscapes of the past year are years in advance of any I have done before or any I have seen.

I have profound interest in anyone who is doing a fine job of photographing the "strident headlines," but to point to it as the only way in which photography can be "faithful to its potentialities" is utter rot. There are as many ways to see and do as there are individuals—and there are far too few of them.[11]

In May 1938, according to Mike Weaver, film and photography historian, Van Dyke participated in the second annual membership exhibition held at Wanamaker's store in New York City.[12] Van Dyke showed two photographs in the show, which was the maximum allowed. Barbara Morgan was on the national executive committee headed by Stuart Davis. Eliot Elisofon was on the exhibition committee. Berenice Abbott and Margaret Bourke-White had been in the organization since its beginnings in 1936.

Strand was a member but did not participate in the exhibition. Van Dyke, among so many distinguished colleagues, was selected to present a paper on "What Art Means To Me." In this paper he publicly sorts out the question of his move from photography to film:

This is the first time I have seen photographs on the same walls with paintings in an exhibition. It isn't the first time that it has happened. Alfred Stieglitz first did it at "291" many years ago, and it is a customary procedure with the American Artists Congress, but I am new to New York. It is especially thrilling to me, however, to see that here photography is considered equally important with the other arts. There are two reasons for this. In the first place, all over the world today artists have found that ideas are more important than the method of presenting them. Every available means of conveying the idea of progress and social advancement is important—whether the artist uses paint, marble, metal, pencil or lens, the end product remains the same in that each practitioner hopes to convey an emotion or an idea. The second reason is that in the motion picture we have seen the successful wedding of all the arts[,] and painters, who so long opposed the idea that the photographer could also be an artist, have come to see that the camera is also an important medium for the re-assembling of natural objects into a new sequence which will convey the ideas of the creative technician.

Melville said that Arts are tools. In the world today, filled with new wars of conquest, and the renewed flaring of old hates and prejudices, the artist has the age old problem of bringing order to the chaos of reality. There is a long tradition of functional use of art in this country. During the Civil War, Mathew Brady made a series of photographs which were as stirring an indictment against mass slaughter as anything ever written or painted. He worked with the primitive apparatus of his time, sensitizing his plates immediately before exposure in his portable darkroom, developing them immediately—often in the midst of battle. The work of the United States Resettlement Administration—both in still photography and in motion pictures, has been a work of no less importance. And that brings me to the subject which is closest to me. For ten years I was a still photographer. I photographed the world of the West Coast, making hundreds of negatives with a large view

camera. Because of the nature of my equipment, and because still photographs are made to be seen individually, I felt cramped and limited. Perhaps this was because I wasn't great enough to master the problem of conveying all of the elements I saw in the world in stills. In other words, whether the medium of movies is more flexible, or whether I didn't have the patience to master the inherent problems of stills, I am not prepared to say, but at any rate in 1934 I started on my first motion picture. I had the job of showing[,] in a two reel film, the work of the California co-operatives. I thought at first in terms of a dramatic work of the people who had banded together to trade their labor for commodities. But the task was too big for such an approach. I found that a sort of short hand had to be devised. And so before I had ever seen any of the British documentary films, I found myself engaged in making one. It wasn't a very good movie, because the problems of the medium were too multiple for me to solve with my limited experience, but I did see that motion pictures had the potential of being a vital creative force in the dissemination of social ideas. And that is justification for me to consider film as an art form.

Art today can serve many functions. To make living more gracious has many implications. For paintings to decorate a wall is important, but those paintings must also reflect the social struggles of their time—even though only by implication. Society makes the artist, and conversely the artist—being always in the vanguard time—influences the world around him. The photographer, because of the very nature of his medium, can be more objective than other artists, but that is not to say that his own point of view should not enter into his work. As a matter of fact it must, because therein lies his creative power. The motion picture maker carries this one step further, because in his combining of visual images in a temporal sequence, the individual shots partake of each other, modify each other, and in their sum total create a single final impression which was not complete in any single scene.

Art means to me the possibility of men who can write, paint, draw, photograph, working together with a common aim, each within the framework of his own medium, toward a common goal of a better life for all mankind. Art is international, and I believe that the artist can do much toward furthering understanding

between all peoples. Primarily it means to me the chance to under-
stand my own people, and to explain them to themselves.[13]

In an undated draft for a presentation before the American Artists' Con-
gress, founded in 1936, Van Dyke delivered a much more strident polemi-
cal statement. The American Artists' Congress was formed in response to
a call from the American Popular Front, a coalition of leftist, antiwar, and
antifascist groups. The call was to form literary and artistic groups against
the spread of fascism. Among the founders were Stuart Davis, William
Gropper, Peter Blume, and Moses Soyer.

In his speech Van Dyke aggressively presented his socialist agenda for
the arts and he titled it "What Art Means to Us" rather than "Me" as in the
Wanamaker manuscript. He finally seemed to be getting it all together. He
had made a commitment to marriage and presumably a monogamous rela-
tionship, he was fully at peace with his abrupt departure from photography,
and understood how his socialist ideas could be manifested in the arts. The
ideas presented in the American Artists' Congress presentation served as a
kind of manifesto for where he would go next in his film career.

The artist today has descended from his ivory tower to discover
that there is a world of real people around him—a world richer in
material for his brush, pencil, or lens than he ever dreamed of. The
artist today has found the real meaning of the term that art is a way
of life. He has found that the tools are only the means of express-
ing work in terms of art for the people, rather than for a few con-
noisseurs. The past few years have seen an increasing number of
artists painting and drawing and making photographs for the peo-
ple, rather than catering to the decadent tastes of aged collectors.
The result is that with Federal Art Projects, organizations such as
the American Artists Congress, inexpensive reproductions of liv-
ing art, there is a new breath of life in American art.

Painters, for the first time in American history, have united
with photographers . . . and all other artists to define for them-
selves—and for the world, the issues that confront all men today.
For the first time artists have realized that photography is the
real folk art—the art of the masses, and that in the hands of such
skilled craftsmen as Edward Weston, Ralph Steiner, Berenice
Abbott, Walker Evans and Paul Strand, it can be made to speak

as eloquently—and perhaps more clearly than any other art form. There is merely the difference in the tools used, because today art speaks in terms of ideas, and form is not divorced from subject material. They have realized their pictures are telling testimonials against the demagogue, the dictator, and the war maker. Photographs can be, and must be, used to expose social injustices. Photography is essentially a recording instrument, and what the photographer records tells us a lot about the man behind the camera, as well as a great deal about the world he photographs.

The photographer—and every other artist—today has a terrific task before him. He has seen paintings, sculpture and books destroyed by fascist hoodlums who were afraid of the power of art. The artist knows that if he wants art to continue for him as a way of life, integrated with his daily existence, he must fight to preserve the democracy that is the bulwark against reaction. He knows that a lone fight is not enough, and so he has banded together with other artists to work toward the things he needs to make his way of living complete. Ivory towers are not powerful enough to withstand the power of high velocity projectiles and delayed fuse bombs. He has seen the artist in Spain take up arms against foreign invasion, and he wants to stop the possibility of such a fight here. Because of the work of such organizations as [t]he American Artists' Congress, the artist knows that in every country in the world today there are artists who feel as he does, and who stand shoulder to shoulder with him in the fight to preserve democracy so that men may walk in peace and dignity upon the earth.[14]

After Van Dyke and Steiner left Frontier Films, they formed their own company, which they called American Documentary Films, Inc., and opened an office on West 42nd. Van Dyke wrote to Weston about the new venture:

I am no longer connected with Frontier Films, Ralph S. and I have formed a corporation to produce educational and instructional films—any films "in the public interest."

We are associated with a group of men here who are doing publicity for foundations and universities, and they furnish us with offices and get us jobs. In turn they take a small percentage of the gross. Paul Rotha, the great British documentary film maker, is

our consulting producer. It is our hope (and the expressed intention of the foundation) that we will get a Rockefeller subsidy starting next year to last for three years to make it possible for us to make many documentary films. That, of course, is most certainly not for publication. But the foundation has said that if there is a producing unit ready to be subsidized, they will give two hundred thousand dollars for production over a three year period. That would more than put us on our feet.[15]

Just before Steiner resigned from Frontier, he had been contacted by Clarence Stein and Lewis Mumford, members of a planning committee for the theme of the 1939 World's Fair. They asked Steiner to make a film for them about the plight of cities in America. When Steiner told them he was resigning from Frontier, they told him that the project could move with him wherever he went. Steiner accepted and asked Van Dyke to codirect and coproduce the film with him. The sponsoring group for the film would be the American Institute of City Planners, which had obtained a grant of fifty thousand dollars from the Carnegie Corporation. The film they made, *The City*, over the next ten months was subsequently acclaimed by critics and historians. Richard M. Barsam wrote in his book *Nonfiction Film: A Critical History* that *The City* became the link between "the politics of Ivens, the poetry of Lorentz, and the nonfiction films of the 1940s." Van Dyke's involvement in the film was, he said, "marked by two distinguishing characteristics: an interest in experimentation and an instinctive feeling for the poetry in common ordinary lives and events. Van Dyke excels when depicting the virtues in individual lives[;] . . . [he] works with the incisive skill of a great photographer for whom the image is all."[16]

At long last, Van Dyke had an opportunity to be more closely involved in the policies and programs of social change being implemented by Roosevelt. He and his colleagues who made up the handful of documentary filmmakers of the thirties believed that their efforts could actually change the world. They had been inspired by the revolutionary Russian films of a decade earlier, and they were admirers of the grit and directness of British documentaries, especially those by John Grierson. The Depression and a Second World War in their lifetimes gave urgency to their passion for social action in America.

Roosevelt was promoting the concept of greenbelts for cities through Rexford Tugwell, head of the Resettlement Administration, which was also the government umbrella for the FSA and its program of documenting the

rural poor, which photographers like Dorothea Lange and Walker Evans had participated in. The greenbelt concept, a means of humanizing the congestion and decay of large cities, was at the heart of the film Steiner and Van Dyke had agreed to make. In a letter to Weston in February 1939 Van Dyke outlined the film:

We start in New England, sometime after 1791—maybe about the middle of the last century. It is a peaceful place, men go about their work in fresh air and sunshine. They meet together in mutual discussion, they work alone, with their hands they build a life. This is the way of life, planning for winter, for the spring, but not for the years and the times that their children will live through. The blacksmith works in his shop, the miller grinds his meal, the boy wanders through the graveyard with his dog, reading the tombstones and looking at their quaint and primitive carvings. We come closer to the blacksmith and his work, and as the hammer rings on the hot iron, out of the flying sparks and the smoke, the industrial city is born. Smoke from a thousand chimneys, funnels of smoke pouring dirt and filth into the coves, into the lives of the people. Great ladles pour molten slag onto a seared landscape, children play on railroad tracks, beside scabrous houses—sores and welts on the once clean earth. Where is the clean grass now? Where is the scythe flashing in the sun? What have we built? Why? Where does this steel go? Now we understand; steel to build a thousand cities, steel over steel rails to push skyscrapers into the blue sky that once knew only the church steeple. Is this what all the smoke is for? . . . Who cares? The lox-on-pumpernickel at the beanery on the corner is waiting. Who can wait for the fire engine to pass? There is coffee to be snatched in a few minutes before they return to the machines. Thousands of slices of bread. Hundreds of pieces of ham, countless gallons of coffee, and always the hungry mouth. . . . Back to the constipation of a great city. Street after crowded street, children play in gutters, play at their war games on tenement stoops, swim in the open sewer that is called a river. Why? Because a few people didn't plan for their children a decent place in which to live and work. . . . But now there is an airplane propeller turning slowly against the sky fleecy with clouds. A sleek silver plane takes off, and there far below us is a different kind of city. Surrounded by green trees, by a green belt

of leaves and grass, lies a little town. Far away, but reached quickly by this plane, or by the fast divided highway, lies the metropolis. Here children play close to nature. Here man may dig again in the earth, and a tree is a thing to be known and loved. This is the thing we wanted, and it is not too late.

This very sketchy outline will give you a rough idea of what we have tried to do. I think we have succeeded. I think it is a good thing we have done.[17]

In November Van Dyke sent Weston a copy of the film for his personal viewing, which he viewed with a large number of his friends. Weston wrote back that they all loved the film. He said that he had never been so moved and completely held by any film as *The City*. But he, like many others, found the ending a little too saccharine, although he said he would have voted for the solution they had opted for nevertheless. John Grierson wrote in a review that "Van Dyke, an old villager himself . . . seemed to have forgotten the smell of the fish and chips," a reference to the final suburban scene.

Throughout Van Dyke's outline of the film there are descriptions of the poor and destitute, which recall his experiences in making *The River*. His desire to become a director to help change things for those who could not change it for themselves is also evident. Although he had a superior eye as both photographer and cinematographer, he had begun to lean toward the idea of directing and producing films. Steiner once told him you can either do it or get credit for it, but not both, meaning it is the director that gets the majority of the credit. Van Dyke wanted both and for a while worked as a director/cinematographer, including on *The City*.

His background of growing up in the West, close to nature, also had a significant impact on the theme of *The City*, especially the opening sequence where a young boy is followed by the camera running through the woods. Van Dyke's and Steiner's passion for the project grew to such an extent that when the money ran out several weeks before completion, they worked for no pay and paid for parts of the finished production out of their own pockets. But the genius of the film came from the collaboration among all of those brought together by Van Dyke and Steiner for their unique talents.

Congress abolished the Resettlement Administration and the FSA in June 1938 because it feared that Tugwell was much too far to the left and that the proposed greenbelt project of "resettlement" was socialistic, if not downright communistic.[18] Lorentz had become the director of the U.S.

Film Service under the Resettlement Administration and had been asked by the American Institute of City Planners to produce a film about America's decaying cities. He produced a partial outline, but when Congress killed the two agencies his outline was left unfinished. Van Dyke and Steiner asked Lorentz to join their team and to rework his unfinished document to provide them with a brief outline. From their experience of working with Lorentz on America's first two social documentary films, Van Dyke and Steiner knew that his literary background and critical overview of events and situations gave him a special ability to provide snapshots of complex ideas for scripts.

Lewis Mumford, who was on the original planning committee for the World's Fair, was invited to provide commentary for the narration of the film. Mumford was reputed to be procommunist and had written and lectured for years on the plight of cities in relation to the human condition. But he was internationally acclaimed for his writing on urban planning and social issues, especially his book *The Culture of Cities*, published in 1938. When Steiner and Van Dyke received his commentary for the narration, it was far too inflammatory even for Steiner and Van Dyke, and they knew they would have to have someone in addition to Mumford write the actual narration.

They invited Henwar Rodakiewicz to return from Hollywood to work on the film. He had written the script for *The Wave*, working successfully with Strand, so they were confident that he could flesh out Lorentz's outline. This he did and more. In later years Van Dyke credited him as an associate director and an inspiration for the film as a whole. Rodakiewicz wrote to a film student in 1951 about why he thought the film was so successful and affected such a broad range of people in the thirties:

As to our ethics in getting to the heart of Pittsburg, knowing we were treading on toes, in fact shooting the steel mill stuff first, and being aware that news gets around fast through local police, and that caught shooting housing first would probably deny entry into any plants—that, I consider intelligent operating. I suppose it can be called responsibility to society. We had a slight brush with the police anyway, nothing serious or delaying, but those instances were more common in those days than now—and I think the reason is innocuous subject matter of films, not an increase in kindheartedness or liberalism.

Then too, we purposely shot the entire sequence in subdued light, or on overcast days, and in the fall, when there were no leaves

on the trees, in contrast to the preceding New England pleasant-
ness. It did not make it any grimier than it really was, but it had
its effect on the screen. I consider that good ethics, not a case of
distortion. I think that is revealing the essence of the place, seeing
the heart of it through your own eyes, and translating it onto the
screen by using the techniques of your medium.

 . . . There is for instance the first use that I know of, of the
integrated combination of unstaged and staged materials in such a
way that they are indistinguishable.

 . . . The whole business of imagery and sound was given a
tremendous amount of thought throughout. Everywhere it is an
additive process, not merely being a supplement to the other, or
sound just for the sake of some activity on the track. . . . What they
come out of, of course, is a unified concept of the film as a whole.
And that you can have only with an extraordinary team working
together, or one guiding all the way through.[19]

Rodakiewicz was a screenwriter who had started out as an imagistic
filmmaker like Van Dyke and Steiner. But he eventually developed a pas-
sion for writing, which took him to Hollywood for several years until he was
rescued by Van Dyke and Steiner. The few silent films Rodakiewicz made
caught the eye of Alfred Stieglitz, and one of his untitled silent works, some-
what akin to Steiner's H_2O, was screened in Stieglitz's gallery, 291. He became
good friends with Stieglitz, unlike Van Dyke and Steiner, and through expo-
sure to avant-garde ideas of the Stieglitz group he was able to infuse the
film with a rawer aestheticism than it might otherwise have had. He was an
iconoclast of the first degree, who could blend frank and truthful ideas with
a wry sense of humor, not unlike Steiner. For example, in the same letter just
cited he also wrote about his involvement in film of the thirties:

 At times my Quaker American half has had rather tough sledding
 for in addition to those malevolencies lurking above, I pack other
 pet abominations: fine print spawned by lawyers, conglomerates,
 franchises, percentages, noise, and those who cross picket lines.
 I've shuffled on quite a few, but never walked across one. . . . I've
 learned that "no" can be a potent positive statement. I must confess
 to some misgivings about academia (both parents had Heidelberg
 PH.D's). Better to shelter trivia than clutter the mind with data

available in reference books. Then there is "by committee" which to quote Ada Louise Huxtable, means decision born of compromise and fatigue, eliminating excess of error and excess of brilliance.[20]

Van Dyke and Steiner then added a group of young committed film-makers to the production team. They hired Roger Barlow as an assistant to shoot various sequences. Barlow had been trained as a cameraman in the Navy on the USS *Langley*. They also hired apprentices to work with both of them, including a young graduate from Sarah Lawrence College, Caroline Nielson, who several years later became Steiner's second wife. Edward Anhalt, a young aspiring filmmaker, was given a spring-loaded camera and the freedom to shoot anything on New York streets that interested him, the result of which became short clips in several of the film's sequences. Steiner and his young assistants were responsible for bringing a sense of humor to the film in, among other scenes, a diner sequence in which people were filmed pushing food into their mouths impatiently at an incredible rate of speed while kitchen machines automatically sliced bread and made pancakes and toast on an assemblylike line that kept the eaters supplied.

Morris Carnovsky, a member of the Group Theater, had a dramatic, character actor's voice, and so he was hired to narrate the film. He was a friend of most of the group, and he had a strong commitment to the theater. Van Dyke had taught there and recruited his students as extras for the film.

But one of the great achievements in putting the team together came when Steiner invited his friend Aaron Copland, a young aspiring composer, to write the music for the film. Copland brought a piano into the cutting room, positioned it in front of a moviola to view film footage, and worked directly to compose music that related to what he saw and felt. For six weeks he worked in the cutting room developing the score. Van Dyke described Copland's process as follows:

And a horn gets stuck on a car and people gather around and try to get the horn unstuck. Finally the jam breaks and there is a series of shots of wheels starting up. And that gave Copland a cue, and so he starts out a piece of music that indicates wheels starting, and then just takes off on a kind of joyous, symphonic song that gives you a sense of freedom, of openness, of space.

. . . In a way Lorentz was right. It was more like an opera than working for a Hollywood film. The action and the music were very

closely intertwined in the documentary. Now that meant you had to have a composer who didn't overdo that. . . . And since Copland was . . . in the process of changing his whole style, this was a chance for him. Copland felt that he had been writing for other composers, and that his music had become dry and sterile, and he wanted music that people could listen to and enjoy, but at the same time, they were going to have dignity. The chance to do the *The City* came at exactly the right time for him, because we were not going to hamper him in doing good music.[21]

The City opened at the World's Fair in May 1939. It was shown three times a day to rave reviews. *Life* magazine gave it extensive coverage and the *New York Times* said the following:

It is not merely excellent as a documentary on housing, with its graphic depiction of planless squalor and planned comfort, but it contains one of the most bitterly hilarious sequences of the year—a deft montage of city life as millions of uncomplaining New York cliff dwellers know it.[22]

But when the planning committee, who had funded the film, initially reviewed the finished work they did so with dismay. They complained that Van Dyke and Steiner had treated a serious subject with humorous satire and that they had wasted the Carnegie Corporation's money. But immediately thereafter, when the reviews gave the film high praise, they fell silent. The film ran daily, several times a day for the next two years. Van Dyke had now made his debut as a force in social documentary film, and he would soon find that there were backers attentive to his accomplishments, supporters who would show interest in his future films. In his analysis of the film Van Dyke said:

As the film maker shoots, his subject begins to talk to him. If he listens, he can begin to understand the shape his film must take. Every film has its form hidden in the subject matter. It is up to the film maker to make the form visible to an audience. . . . When the film was finished I never saw New York, or any other city, with the same eyes as before.[23]

The City was heralded by critics and historians as a classic of docu-

mentary film. Following its showing at the World's Fair, it toured to public theaters for several more years. When it was eventually acquired by MoMA, it became the most requested and rented film in the collection for the next forty years. The *New York Post* set the stage for appreciation of the film with the following review by Archer Winsten on May 23, 1939:

> People who have never cared for Documentary pictures, even when they were as impressive, eloquent and meaningful as *The Plough That Broke the Plains* or *The River*, will have to revise their opinions when they see *The City*, that extraordinary documentary arguing for city planning. It will be shown several times daily at the Little Theatre of the Science and Education Building at the World's Fair beginning this Saturday.
>
> If there were nothing else worth seeing at the Fair, this picture would justify the trip and all the exhaustion. . . .
>
> It contains more thrillingly genuine shots of life in New York City than all the feature pictures ever made, and this is merely one section out of five. It is filled with tragedy, magnificence, ugliness and sheer cinematic genius. It will be a revelation and an education to the public. For the benefit of Hollywood one could hope it would be the same to the West Coast treadmill athletes.
>
> One lesson should be emphasized: the enormous effectiveness of the actors who don't act, or as in this picture, amateurs. This seems very hard to learn. It must be learned over and over again. The living theatre is constantly sending its stage-trained folk into motion pictures, a different medium, though many have trouble believing it. *The City* is a rich demonstration of things that can be accomplished on the screen with images and music and commentary. These unique effects cannot even be approximated in any other way. . . .
>
> No one should do himself the injury of missing *The City*. Probably it won't be shown outside of the World's Fair until late in autumn. That makes the World's Fair a "movie must."

Van Dyke had been the lead director of the film, coordinating the entire crew with site directors like Rodakiewicz and working hand in hand with his friend Steiner. *The City* had brought him critical acclaim as cocreator of a landmark film, and he was now ready and excited about making social documentary films on his own.

6

Social Documentary Film

⁂ By 1939 VAN DYKE HAD BECOME A HIGHLY RESPECTED FILMMAKER and was working in what history would later record as the golden era of American documentary film. By age thirty-three he had achieved his goal of being recognized as both a cinematographer and director of films. Also during this period he and Mary had their first child, Alison, born in 1939. Alison was special to Van Dyke, and letters reveal that they developed a very close relationship during her early childhood that they maintained throughout her adulthood. She also developed a career in theater arts, eventually becoming a senior lecturer and director of undergraduate studies in the department of theater, film, and dance at Cornell University.

In 1941 they had a second child, a son, Peter, who eventually became a well-known sound engineer and had a distinguished career in film, even working with his father on some of his films. During the three years before he and Mary married, Van Dyke had expressed a desire to have children only after he was able to offer what he felt would be a financially secure home, something he had not enjoyed as a child. Emotionally, he was deeply dedicated to his new family. However, psychologically he had not changed, and within a few years his old habits and desires overcame his hope for the perfect family.

Success with *The City* dramatically increased his opportunities to make films in remote areas of the globe, which kept him away from home for months at a time. He continued to arrange liaisons with other women, and

in less than a decade his marriage began to unravel, the final stage of a cycle that he had established as a young man. He became convinced that his wife was at fault because she demanded more of him emotionally than he could give. They divorced in 1950, which was extremely hard on the young family. Sons from his second marriage, who grew very close to their half siblings, suggested that Van Dyke and Mary Barnett had an intense, passionate love for each other, but one that was constantly under stress owing to their competing careers as well as to the unrealistic personal demands each one placed on the other. Letters between the two suggest that the real tension, more often than not, was Van Dyke's extended absences from home.

Following the critical acclaim of *The City*, Van Dyke and Steiner began to look for ways to advance their company, American Documentary Films. They unhappily experienced a severe drop in support for documentary film. By the end of the summer of 1939 they had made only two promotional films for a bank and realized that the effects of the Depression would be a continuing deterrent to their commercial ventures.

The stress of trying to make ends meet and remain creative began to affect both artists, straining their friendship. Also at this time Steiner married, and his new wife, a graduate of Sarah Lawrence College who eventually became a recognized art historian, initially helped manage the failing company. She and Steiner wanted to expand and bring in several more filmmakers and expected to retain 51 percent of the company. Van Dyke, whose own ambition lay in true documentary film and not the kind of commercial work they were producing, rebelled at the prospect of doing even more promotional films in order for all of the participants to make a living. He withdrew from the company, knowing that in all likelihood that the two friends would no longer make films together as intuitive, artistic ventures. Van Dyke and Steiner soon became competitive in the small world of independent film, and a rivalry set in that finally led to complete estrangement. It was not until after World War II that the two would reconcile. After their reconciliation they never again talked about the differences that had led them to go their separate ways for a few years.

In 1940, a year after *The City*, Van Dyke entered the most prolific period of filmmaking of his life. In that single year under the name of his own new film company, Documentary Film Productions, Inc., he produced five films: *Valley Town*, a social documentary about the human devastation brought about by automation in a small steel-producing town; *The Children Must Learn*, a film about the impact on society of ignoring the educational needs of children in

general and the importance of trying new experimental educational methods to improve literacy, presented in a vignette of a Kentucky mountain village; *Sarah Lawrence*, a brief biographical sketch of a typical student at Sarah Lawrence College; *To Hear Your Banjo Play*, a film about Pete Seeger and the history of folk music for the banjo, which was an attempt by Van Dyke and Seeger to increase appreciation for folk music in general; and finally, *Tall Tales*, a study of three songs performed by Josh White and Burl Ives.

All five films were directed by Van Dyke but photographed by other cinematographers who he had worked with in the past or whose worked he respected from other films. For *Valley Town* he served as the primary writer of the script and was the sole director, a goal he had written to Mary about back in 1937 when he was cinematographer for *The River*. This need to have control and be the sole authority on whatever creative effort he undertook was intrinsic to his personality, and it was in evidence from as far back as his leadership of Group f/64 in 1932. He continued to enjoy being behind the camera in making films when he could, but in the end it was his desire to be independent at all costs that made being a director of film the perfect outlet for his creative drive.

Among the films he made in 1940 the most important to his legacy is *Valley Town*, which allowed him to experiment with the medium as an art form. The film gave him license to put into practice his reformed socialism with the goal of bringing to the world's attention its failed contract with the poor. He was strongly influenced by friend and fellow filmmaker Joris Ivens, who came to the United States from Holland in the late thirties to work with Pare Lorentz. Marc Blitzstein scored the music in one of Ivens's protest films, *The Spanish Earth* (1937), and Ivens used real people rather than actors in his film *Borinage* about Belgian miners in 1933. Van Dyke likewise hired real people and Blitzstein to score the music for *Valley Town*, a film that he believed was his greatest contribution to the history of film—in part, no doubt, because it was the one over which he had the most control artistically and intellectually. He attributed the essential form of the film to the following influences:

In *Valley Town*, it seemed, I was very interested in Marc Blitzstein and *The Cradle Will Rock* and *No for an Answer*, and the way in which he used recitatives and songs. Then the problem was, who is the person who is looking at this? Well, there was a radio program in which the mayor of a town was played by the man, whom I chose

as narrator, and it was one of those soap opera kinds of things, but he had this commanding, sympathetic voice, so I conceived of the idea of the mayor talking about the problems in his town. It came directly out of radio soap opera.[1]

Van Dyke's account of making the film is his best-written description concerning process and content; it is better even than that of critics and historians. Although written in retrospect, it reveals his thinking at a crucial point in his career:

I was sure that I wanted to make films more than anything else, but I was also sure that I wanted to expand the documentary form beyond the boundaries set by Lorentz. My love of the theatre led me to believe that more control over form and content as well as greater use of actors could result in [a] more effective production. The didactic theater of Bertold Brecht and Kurt Weill in Germany, the productions of the Theatre union and the Theater of Action, the Federal Theatre's *Living Newspaper* and the musical plays of Marc Blitzstein in New York were all opening vistas and breaking boundaries. I saw no reason why films should not do the same. . . .

Both *The Plow* and *The River* had been sponsored by the Federal Government. *The City* had been funded [by a grant from the Carnegie Corporation]. Other foundations timidly followed the Rockefeller Foundation into the field, including the Twentieth Century Fund, which sponsored a small film attacking the use of sales tax as discriminatory. The most ambitious project, however, was begun by the Alfred P. Sloan Foundation, which in 1939 established a production organization under the auspices of the New York University Film Library. A young economist, Spencer Pollard, was appointed to head a group of writers and researchers. They were charged with developing a series of films to dramatize the economic principles underlying our society. The first film to be made was about unemployment, specifically technological unemployment in the steel industry. Now that the Great Depression was beginning to subside, it was only logical that some of its causes should be closely examined.[2]

The Sloan Foundation solicited a critique of its proposed film program from Van Dyke. He wrote a long detailed analysis, which called for a less

didactic approach to films and more freedom for filmmakers from writers and sponsors. He warned the foundation against requiring a basic format, "because then the work would become propagandistic." He suggested in his report that documentary film was analogous to a novel in its aim to produce a progression of images leading to a climax. The Sloan Foundation was impressed with Van Dyke's report and selected him to be one of several filmmakers to help launch its new program. The following lengthy description of *Valley Town* in Van Dyke's memoir provides a rich portrait of the working process and the inner workings of his imagination:

I was chosen to produce and direct the steel film [*Valley Town*], so in the fall of 1939 I went to Pittsburgh. The Steel Workers Organizing Committee was in the process of researching all aspects of the steel industry prior to setting up a drive to unionize steelworkers, and their office in Pittsburgh offered an impressive amount of information. It was there I learned that Newcastle, Pennsylvania would provide the exact location and situation I needed for the film.

The town was dependent upon a mill making tinplate, a material used in all the canning factories of the country. The mill had been shut down and a new high-speed strip mill built not far away. It seemed likely that such new mills would replace all of the old mills that had once employed so many workers. For every thirty men needed by the old methods, the new mills required only one worker. As a result, two-thirds of the families in Newcastle now received welfare assistance in place of paychecks. No smoke rose from the stacks of the mill that had once dominated the town. Although the names on the gravestones in the hillside cemetery were proof of the foreign workers' contributions to American Labor, their children and grandchildren were now the victims of technological change. There was an expression of bewilderment on their faces; their lives seemed beyond their control. I was determined that my film would be no sterile explanation of economic theory.

. . . I knew that the film would be very different in form from anything made up to that time. For example, at the time and up to the Second World War, it was virtually impossible to record dialogue outside a studio. The big motion picture cameras that were quiet enough to use with recorded synchronous sound were very

heavy and required a source of two-hundred-twenty volt, three-phase current, which was also used to drive the sound recorders. Thus a specialized source of electricity was necessary. The sound was recorded on 35mm motion picture film running at exactly the same speed as the film in the camera. This was the way that the two elements, sound and picture, could be combined. To add further complications, the sound film had to be developed and printed before anyone knew whether the recording had been successful. For a number of reasons, then, location sound recording was out of the question. The other films I had worked on had solved this problem by using an impersonal narrator, a kind of voice from heaven. I wanted a more personal approach, so I decided to characterize the narrator and make him the mayor of a fictitious town. I also decided to use thought-speech, the thoughts of the workers spoken on the sound-track, and post-synchronized dialogue. I wrote words for the workers to speak, photographed them speaking, and then recorded their words spoken by actors in a New York sound studio as they watched the film.

Since I had been trained as an actor and director, it seemed only natural to me to control the actions of the people in the film, the people of the town who became "actors." To gain their confidence, however, required a long period of preparation without cameras. I was fortunate enough to have the services of two union organizers, Jack Gritty and Steve Wheel. They had lived in Newcastle all their lives and knew almost every worker in the mill. They were essential to my plans.

With their help, I spent almost every evening in the pool halls and other workers' hangouts. I was soon a familiar figure to everyone upon whom I might be dependent. I learned the names of dozens of unemployed men and many of their families. I became a creditable bowler and drank almost as many beers as my friends, but I was careful to remain myself. It would have been disastrous if I had tried to imitate their speech or behavior, for they were quick to reject falsity of any kind. Instead I experienced as much of their lives as I could without intruding. When I had the outlines of a film firmly in mind I returned to New York.

Spencer Pollard and his associates discussed the plans with me and agreed on my principles: the structure of the film should be

dictated by the elements of the situation and the environment; it should arise naturally out of what the filmmaker perceives, it should never be artificially imposed. They made one suggestion that I rejected: for me to live in a worker's home. This problem solved, I gathered my crew, made arrangements for editing and music, and returned to Newcastle with my old friend, Roger Barlow, for camera operator, and Bob Churchill to do the stills. Irving Lerner, a great editor, would review my exposed film and report on its image quality and make suggestions for changes. When we were farther advanced, Marc Blitzstein would begin composition of the musical score.

As always it was satisfying to begin photographing. Though the preliminary work was essential, I always felt I was on more familiar ground when the camera began to roll. We began shooting in a nearby tinplate hand mill that happened to be still operating. It was November and very cold. Standing on the steel floor with great drafts of outside air pouring through the openings in the shed, we were quickly chilled, but we had permission for only one shooting session and we had to push on.

We used two cameras, one on a tripod driven by an electric motor and the other hand-held, driven by a spring. Lighting was a problem in the vast darkness; even a fully equipped Hollywood crew would have been unable to light that interior fully. By professional standards we had most inadequate equipment, but both Roger and I had experience improvising under circumstances such as we then faced. The first problem was to give some sense of the size of the plant. At its far end was an enormous flywheel that provided power for fifteen or more sets of rollers used by the workers to gradually squeeze the thick steel plates down to tinplate thickness. Behind the flywheel was a curtain of steam, exhaust from the engine that provided the power to turn it. We lit that white steam, thereby silhouetting the spokes and the rim of the wheel. Then we lit the first pair of rollers in the foreground and one other steam exhaust halfway between.

We now had perspective plus dramatic lighting. Film buffs may remember that cinematographer Greg Toland used the same method in lighting the interiors of *Citizen Kane* [1941] and achieved the deep focus that was an innovation in that picture.

Although this section of *Valley Town*, as the film was finally titled, was shot and edited in a conventional documentary manner, much of the rest was controlled. I used the workers as I would actors, but I directed them quite differently for the most part—for example, the section where an unemployed worker returns to his house for lunch. We first see the man coming along an alley, passing by the rear of his neighbors' houses. His face is impassive as he glances at some of the men with whom he had worked, but on the soundtrack we hear his voice, with music as in the recitative of an opera. "What am I goin' home for? What the devil am I goin' home for?" He was told to walk at a steady pace, looking to his left at the people and the backyards as he passed. There was to be no emotion, no change of expression. Intercut with his passage were two men fixing a flat tire, a woman carrying trash to a pile in her backyard, a man going through a basket full of bottles, a man tearing a board off his shed for firewood, and a man carrying a plank into his house. The "actor's" voice is heard from time to time with music behind it, commenting as he looks at the men fixing the tire: "Pete and Joe, we used to work together, workin' at the mill. Now I can't stand to look at their faces. They're thinkin' and I'm thinkin', when is that mill gonna open again?" And as the woman empties the trash: "Mrs. Kovanky, and Jack Kovanky way out in Pittsburgh, tryin' to find a job there."

The emotions felt by the audience are not the result of "acting," but rather the combined effect of the man's face, the things he sees and his voice set to music. The result is quite as I wanted it. In an effective but concise way, we hear him look backward to the time when he was working and asks himself why he is going home. The scene continues in the kitchen as the man with his wife and child sit at table eating a meager lunch. Now the woman's voice is hard in song: "You add up the pennies, knowing there's always not quite enough. So far we can eat and over our head is some kind of roof. Is he scared, too? Look how soft his hands are from not workin' so long." The sequence ends as the worker exits with a toaster under his arm, presumably to see how much he can sell it for.

The following sequence finds a group of men running to the street leading to the mill. A man with a welding torch is on the roof cutting down the [smoke] stacks and as each stack falls we cut

to a close-up of the men's faces. We read their expressions as sorrow, or perhaps dismay. We know they have lost all hope of the mill opening again.

No one who sees the *Valley Town* sequence suspects what really happened. The stacks were cut down on a factory ninety miles away, a fact unknown to my actors. The men were asked simply to look at a specific stack on the mill in their town, a factory that was still standing, and concentrate on it. The audience who sees our scene never doubts that the men are seeing and reacting to the stacks on their own mill coming down. The theory behind the way I shot the sequence was derived from an experiment performed by a Russian filmmaker named Lev Kuleshov in the early twenties, before there were sound films. Kuleshov used a famous Russian actor named Mosjoukine and six strips of film. First he photographed Mosjoukine looking straight ahead without changing expression. He then cut this into three pieces. He spliced one piece with a shot of a coffin, another with a plate of soup, and the third with a little girl. He then showed the film to various audiences and asked for reactions. In almost every case the shot with the coffin was identified with grief, the plate of soup with hunger, and the shot of the little girl with various emotions. In all cases Mosjoukine was praised for this great acting ability. No one realized that his expression had not changed.

The final sequence of the film begins with the men leaving the scene, the stacks lying in ruin on the ground. At an old abandoned factory the men build a fire for warmth and discuss their problems in a dialogue between themselves and the Mayor. The men speak their lines and the Mayor-narrator replies off-screen:

1ST MAN: But why, we're all good men here, we know our jobs, why are we finished?

2ND MAN: Because the strip mill can make the steel cheaper.

1ST MAN: They can make it cheaper and faster and better. That's what these new machines are like.

3RD MAN: But what good are the machines if they put us out of work?

NARRATOR: What good are the machines? You can't blame the machines. They do what they are told to do and they benefit a great many people in a great many towns, but why

should some people in some towns have to pay the whole price? Why should these men be thrown away as if they were obsolete, as if they were broken machines?

We asked ourselves how we could film what it means to be out of work for three years? How does it affect a family? What does the workman think when he sees his hands grow soft? When he begins to lose his skill? We knew well enough what he would say, but that wasn't enough. We'd have to find a way to let his thoughts speak for him.[3]

Behind the scenes and what Van Dyke left out of his description in his memoir was a circumstance in making the film that revealed the complex nature of his own psyche; one in which anger over the treatment of a child led to his own cruelty, which he justified on the grounds that he had done what was necessary to get the right emotion in a scene. He had been trying to film a scene in which a steelworker came home to tell his wife that he had lost his job, and whenever he would deliver his line the woman would laugh. These were not actors but the very people who were living through the hell of a dying town and livelihoods. The woman was timid and shy, so in fear and anxiety of the moment when her husband would speak, she would laugh nervously. Finally, out of her own frustration she angrily told her son to go away or she would put him in the basement with the spiders or in the boogie man's sack to be taken away. It seemed that there was plenty of cruelty to go around. Van Dyke, angered by what he heard and wanting her to cry in the scene, took her aside and told her that she was going to warp the boy forever, that he would grow up to hate her and to hate black people, because he knew she meant blacks when she said "boogie men." The woman began to cry. He turned to Bob Churchill, his cameraman, who looked up, turned the camera toward her and got the shot that Van Dyke wanted. He said he didn't know how else to reach her.

The Sloan Foundation did not find *Valley Town* useful for their purpose of educating the public about economic theory, but Pollard supported Van Dyke's right to make a labor film as he envisioned it, and the foundation continued to support Van Dyke in making future films. A crucial moment came when the finished film was reviewed by Alfred P. Sloan, who funded the foundation. He objected to a line in the dialogue in which one of the actors pined for a "far away land of hope and joy." He thought that

Van Dyke's friend and leftist scriptwriter Ben Maddow was trying to sneak in communist propaganda. Van Dyke convinced him that was not the case and that the line simply referred to somewhere other than Newcastle.

Critical reviews were mixed. Some could not appreciate the operatic nature of the music and dialogue, which was partially sung. Others found it a masterful, inventive piece. But the film received very little coverage and even fewer showings in theaters, largely because America was coming out of the Depression and preparing for war. Unemployment was decreasing as a result, and the public was not interested in labor issues, which paled in view of what was coming. In addition the operatic style of the film and the use of real people to tell the story was just too avant-garde for the time. But later critics were much more receptive to the film. In a review of the film the *Chicago Reader* in 1985, Lisa Katzman wrote:

Van Dyke developed his concern with the dangers of capitalistic industrialization in *Valley Town*, a story of the effects of automation on a small Pennsylvania steel town. Classified as a documentary for its use of real people rather than actors, *Valley Town* diverges radically from the standard documentary form. Not only do the "real people" in the film not speak for themselves, they don't speak to each other. While they speechlessly play their roles, their internal thoughts are represented by professional actors as a narrative voice-over. *Film Comment* magazine has called *Valley Town* a "Brechtian poem to the common laborer," alluding in part to the film's embodiment of the principles of Brechtian epic theater. By stressing the characters' alienation from one another, Van Dyke's ingenious narrative device engenders the distance between the viewer and the spectacle that, for Brecht, was essential in leading the viewer to examine the circumstances under which characters function.

Such inventive departures from what has become standard documentary form by one of the genre's founders should serve to remind us that in its inception the documentary was essentially an experimental form. By begging the question of the documentary's identification with an objective point of view, Van Dyke's films suggest that the prevalent view that documentaries and experimental films are mutually exclusive genres is as misguided as the objective/subjective polarity it's based on. Who knows, maybe in 20 years film historians will be arguing that the work

of "experimentalists" such as Bruce Baillie and Stan Brakhage owe as much to the documentary tradition of Willard Van Dyke as to more obvious experimental sources like Maya Deren.[4]

In May 1940 Van Dyke took his family and the family nanny to Chicago and Los Angeles for viewings of both *The City* and *Valley Town*. In Chicago he showed *Valley Town* to the members of the Steel Workers Organizing Committee, and although they were perplexed by the film's style they felt it was a true representation of the issues and problems. But when he showed the films at the Academy of Motion Picture Arts and Sciences, a few weeks later, he faced reality of another kind. Walter Wanger, a Hollywood producer, told Van Dyke that although *Valley Town* was a great film, he should shelve it because it was too depressing and would not find distribution.

While he was finishing up *Valley Town*, the Sloan Foundation invited Van Dyke to make a short film about an experimental program to change the curriculum in three rural mountain schools in Kentucky, which the foundation and the University of Kentucky hoped would improve the children's literacy. The aim of the film was to capture the conditions under which the children were learning in the schools before the new curriculum was introduced. The goal of the foundation was to replace an irrelevant urban curriculum with one that matched the needs of a rural school system. But the story behind the making of the film revealed Van Dyke's competitiveness, often at the expense of others' interests and concerns. Van Dyke revealed the story only once in his life, to an interviewer in 1980:

So I felt that I had overcome the first real problem, which was the influence of the men[.] . . . I had I felt that the first time that I did that was with Weston in still photography; I overcame his influence, and I became my own photographer—I was not imitating Weston. And in *Valley Town* I overcame Steiner's influence, and I went on to do the same thing with a minor film which was shot in a week called *The Children Must Learn*. It had another quality that I have . . . a sense of bitterness or anger, or an ironic outlook toward things that our society says "you can have this too." I mean the idea that any boy born in this country can be President—that kind of concept made me laugh.

Well, *Valley Town* was full of ironic touches. From the very beginning in the graveyard, all the different nationalities, ending

up with a tombstone that had carved on it a steel mill, and this was the tombstone of a mill owner, who carried that thing to his grave. . . .

Well, the story [about *The Children Must Learn*] was that one of the activities of the Sloan Foundation—which as you will remember put up the money for the Educational Film Institute at New York University . . . started to make some other films. One of their activities was to help, on an experimental basis, the state of Kentucky to provide curricula for various sections of the state, which had different sociological backgrounds and possibly different hopes for the future.

. . . Well, while I was busy working on *Valley Town* another crew was sent to do a film on that subject, and word began to come back to New York University that there was dissention among the members of the crew, that they were not getting the material, that they were shooting material which was inappropriate for that subject, that it was dealing with things that had nothing to do with that subject.

Spencer Pollard, who was the director of the Institute, became worried because here his first two films were being shot, and certainly *Valley Town* was not the film that he had had in mind, but he was willing to go along with the idea. But then to hear that a quite simple film was running into trouble in the Kentucky mountains, he began to get nervous and asked me if I would go to another area and make a film along the same lines. I could do my own script, shoot it as I saw it, but that was the result he wanted. What did it look like? What did it feel like? How much sophistication was there?

The other crew was very hard to contact. . . . I didn't really try very hard to contact them to find out whether or not that was the case. I was competitive and I was also perfectly willing to drop *Valley Town* for a couple of weeks—I had been working on it six months—and go off and make another film, and then come back and pick up *Valley Town* again.

The fact that this other crew, some of them were my friends, and that I was showing lack of faith in their ability to do the job that they had been given to do without even discussing it with them—it wasn't fair to them, and it was—to put the very best face on it—thoughtless from my point of view to do that. . . .

But in any case I did—I went to another area, made the film, came back, cut it in a hurry, and went back to work again on *Valley Town*. The other crew came back several weeks later to find that I had already shot a film very similar to theirs, and they weren't very happy about it, and for very good reasons.

Subsequently I became partners with the director who was directing the other film [John Ferno] and we became close friends. . . . But it was a thoughtless and unworthy gesture, and I learned something that was very important to me from that, and it was that in a way it was the crew against the sponsor. . . . So from then on all my feelings went with the filmmakers, and if that stepped on the sponsor's toes, well, that's too bad.[5]

There was another revealing part to this story that concerned attitudes toward women, which Van Dyke hoped to correct by telling all in this interview. Self-confession of past transgressions, a strategy he used throughout his life, allowed him to forgive himself without directly asking for it from someone else; no one knew this better than his two wives. He loved women and exploited them, something that was reinforced by his generation's discrimination against women. Addressing his profession's discrimination against women as professionals, he concluded the story with comments about a woman who was on the other crew:

She had a German name . . . and she worked for Pollard, and was out with the crew on location. I think the crew resented that, and I think that's where a lot of trouble came from. They felt that she was there reporting back to the boss, and she had great ambitions to be a filmmaker, so I have no doubt but there was dissention there. And there's no question but what there was an enormous amount of male chauvinism among motion picture filmmakers. The fact that there were only two or three women directors in the whole history of Hollywood is indicative of that.

But somehow we took pride in the fact that the cameras weighed a lot, and that we wrestled those things around and we'd get the pictures. And, of course, they literally were too heavy for women to be carrying around. . . . We resented having women on the crew. There were some other reasons for that—part of them were sexual. You were away on location sometimes for six months

to work, and if there were four men there and one woman, there was bound to be some jockeying around to see who could get her into bed. . . .

But fundamentally the reason was that the men wanted to do it themselves. They wanted to keep the women out of the picture. . . . It wasn't a pretty picture . . . and I am almost positive that in this particular case a great deal of the trouble arose because there was a woman there on the crew. Just her very presence would have set up tensions that would not have been there otherwise.[6]

In the fall of 1940 the Sloan Foundation offered Van Dyke a new and different kind of commission. It invited him to make a film in South America about aspects of trade relationships among Latin America, Europe, and North America. The intent of the film would be to acquaint audiences, especially in the United States, with foreign trade and the economic structure of South America. Even though he would be working through an organization called the Foreign Policy Association, a think tank for the State Department, he was not worried about the potential for intrusive propagandist influences. He had turned *Valley Town*, a film the Sloan Foundation had sponsored to educate Americans about economic policies, into an artistic expression involving a new cinematic form with socialist overtones. The Sloan Foundation had encouraged his freedom and trusted the outcome in spite of misgivings about the usefulness of the film to its agenda. Van Dyke was confident that a film about South American trade could be turned to the same ends.

Many of the films he had made since marriage had taken him away from home for weeks or months at a time. But now with one child at home and Mary pregnant with their second, Mary broached the topic of whether he could find another way to make films to support their needs. But Van Dyke was unbending and began preparations to make the South American film. In his memoir he said that when he recalled the decision to make the film, he was ambivalent about the project because of his family situation. In the end, however, he felt that he could not turn down the Sloan Foundation support. He also said that the wife of a documentary filmmaker knew that long absences were part and parcel of the marriage contract. For Van Dyke the film offered not just a unique opportunity but adventure as well. So it was with no little excitement that he contacted his old friend Ben Maddow, who in the 1950s became a successful Hollywood screenwriter.

During the last part of 1940 and the first six months of 1941, Van Dyke

and Maddow worked on the script for their film, which they titled *The Bridge*. Their research led them to a new understanding of the geographical, social, and political differences among Brazil, Columbia, Argentina, Chile, Venezuela, Ecuador, and Peru and yet also made clear certain qualities of interdependence among them. The landscape ranged from deserts and jungles to large urban centers to formidable mountain ranges. Natural resources were abundant and in some cases (vanadium, tin) unique. Transportation and roads were primitive by European and North American standards. Air transportation was out of the question, since most of the continent was not yet served by airlines or small chartered craft.

Van Dyke decided to keep the crew to a minimum, so beside himself and Maddow only a technical assistant by the name of Fred Porrett would be a part of the adventurous troupe. In an act of courageous desperation they decided they would drive the intercontinental route of their filmmaking quest, which would take them the length and breadth of South America. The length of time the adventure would take was of little concern, so they bought a new Ford station wagon, removed the back seat, had the suspension system reinforced and filled it with clothes, camping gear, cameras, and film. They booked passage on a Grace Line ship for departure from New York to La Guaira, Venezuela, on December 20, 1941.

Earlier that year, on June 2, Mary had delivered their second child, Peter, but Van Dyke was not present, because he had been deeply involved at the time in preparations for his coming trip, a fatal mistake as far as their relationship was concerned. In July Mary took the children to live in New England where she was engaged to act in several plays at a summer theater. Van Dyke continued his research and put his love of detail and process to work, discovering that the American Automobile Association had in the past planned a road race from Buenos Aires to Caracas. A test driver had covered the route and prepared a sketchy document with page after page noting landmarks. Van Dyke obtained a copy and this became the primary "map" of their initial route.

Mary returned in the fall, and the Van Dyke family drove together to visit friends in the country outside Manhattan on December 7, 1941. When they returned they learned of the attack on Pearl Harbor by the Japanese. Van Dyke assured his family and crew that the Japanese were committing suicide and that America's entrance into World War II would last no more than about six weeks. He never questioned whether or not they should continue with their plans for the film.

On December 20 they sailed from New York harbor, the last vessel to leave America's shores carrying civilians until the end of World War II. The filming of *The Bridge* did not go as well as Van Dyke had hoped. It did not become another *Valley Town*. The pressure of the war and the inadequacies of their preparation for the obstacles they would have to surmount on the journey left little energy for creative effort. The final film released in 1942 was a document filled with maps and graphics introduced to fill gaps in unobtainable footage. It was in the end, ironically, the kind of film the Sloan Foundation desired.

Van Dyke did not refer to the film with pride, although he conceded there were some beautiful pictorial scenes that were unavoidable in the interior of the continent. The film was never shown publicly and was bought by only one client—Iris Barry, director of the film library of MoMA in 1943. After that it was immediately forgotten. Yet, the ordeals that Van Dyke and his crew suffered in making the film would have themselves made an exciting documentary.

During the first leg of their voyage they set sail for Venezuela. With the war now reaching around the globe, the ship proceeded under radio blackout and set an evasive course that eventually landed them in Puerto Cabello on December 25, a day later than they were supposed to arrive at their original destination of La Guaira. Even though it was Christmas the film crew saw no celebrations or festive reminders of the holiday in the city. They spent the day in a rundown port loitering in a shabby café with strange food, waiting for the ship's captain to tell them when they might continue on to their intended destination. That night they were back on the steamer heading for La Guaira with running lights blacked out and portholes covered with black paper. Inside, in a grungy mess hall they ate turkey and plum pudding, a welcome reference to the all but lost holiday and a reminder of the long absence from their families ahead of them.

On January 3, 1942, after days of haggling with visa officials and preparing their overloaded station wagon, they set off on a reasonably good highway to their first stop—Táchira, on the border of Columbia and Venezuela. The arrangement with the State Department provided that the customs authorities on each side of the border were to be notified in advance that they were approaching and that when they arrived they were to be granted free passage. But in Táchira the officials had never heard of the venturesome crew, and there was no way to phone or send a telegraph. The next mail delivery was not due for three days. The postal agent said that perhaps

the documentation would come then. They had no choice but to go to the only hotel and wait with hope and anticipation. Eventually, Van Dyke and the border official found the needed documents in a file in the office and they were once again on their way.

Their next stop was to be Quito, Peru, but they had first to travel for several days through the Andes on narrow, winding roads. Day after day they had mishaps with their station wagon, including a harrowing accident in which they got stuck in a rut on the inside curve of a passage too humble to be called a road. With a precipitous cliff on the other side they struggled for most of a day to free the heavily burdened car, ever aware that certain death was just a few feet away. They finally wound down to a jungle-covered valley with a river in the distance. On entering a small opening just a short distance from the river, the road abruptly ended. A primitive little house stood not far from the river. Almost immediately after they stopped and got out of the car they were approached by a man from the house, who Van Dyke described in his memoir.

He had dark skin but his features were not Indian or Hispanic. He wore a belt with a holstered revolver and around his neck was a sweat-stained, fringed, yellow and white Turkish towel. In Spanish almost as bad as ours he asked us what we were doing there and, when we told him, he smiled and told us that there were no accommodations in Playa Montalvo, the road ended where we had stopped, and that he was prepared to give us a simple meal and provide shelter for the night. . . . He said his name was Cherki Yasbek and that he had a plantation that produced cacao and cattle. His country of origin was Lebanon.

His house was about two hundred meters away on the bank of a river that flowed into the Gulf of Guayaquil, a one room structure on pilings surrounded by a wide porch where the cooking and eating took place. The enclosed room contained an iron white enameled bed with an orange coverlet and a mattress on the floor beside it. . . . He suggested that we get our bedding before nightfall, so we returned to the car and returned with sleeping bags, mosquito nets and folding cots. A chicken stew was in preparation and a bottle of Arak, a crude brandy made in the Near East, sat on the table. A steel oil drum filled with brown river water stood in one corner of the porch and our host handed us a well worn cake of soap and invited

us to wash. When we had finished he offered the towel from around his neck. Politeness overcame distaste and we dried ourselves and gratefully accepted the offered liquor. After the bottle was empty we felt considerably better and even enjoyed the small portion of tough stewed chicken and a vegetable resembling potato.

We set up our cots on the porch and Ben and I rigged our mosquito nets but Fred said he was too tired and pulled his sleeping bag over his head and went to sleep. About an hour later I was awakened by something hitting my net. The flashlight revealed several bats circling around our beds and when I tried to awaken Fred our host appeared in the doorway with a flashlight. He told us that the intruders were vampire bats, but that they rarely molested human beings and lived off the herd of cattle resting in a clearing not far away. Fred slept on until morning.

The next morning the crew learned that they would have to walk to the nearest village, a few kilometers away. There they could wire to Guayaquil, the nearest city, to send a barge to haul the car down river. They soon learned that they would also have to carry the battery from their car to the village to power the telegraph. They were able to procure a barge for the car, and all went well as they were slowly towed down the slow, muddy river. But just before reaching their intended port the barge nearly sank when it suddenly swung sideways and floated down river out of control. Quick action by the captain of the barge saved the day; he used the towboat to block the barge and bring it under control. Everyone was able to disembark safely, but all had begun to have second thoughts about continuing overland through Peru on their way to Santiago, Chile. They decided to give the car and themselves a rest by boarding a steamer, car and all, to make their way to Lima. Once there, they began driving again, heading for the Cerro de Pasco mines high in the Andes northeast of Lima. Along the way, Ben Maddow noted the following vignette of Andean life in his diary:

We saw four teams of oxen plowing a hill. We stopped and climbed up to photograph them. An Indian was driving one of these teams twisting his wood plough about in the small field and his son was there with a pick loosening the stones in the ground. We paid them in cigarettes and so they drove themselves for some time— until noon. The Indians said they were tired and wanted to take a

rest. We were through by then, so when he and the boy went to rest under a boulder, I came up with my Leica to take some stills. From the hollow at the bottom of the stone the boy took a fur bag of pelts made from two small animals and I thought it was an odd way to carry a meal. But it was nothing but a mass of dried green leaves. Father and son took a wad of these small leaves and rolled them into their cheeks squeezing them against the gum to suck out the juice. This was their substitute for food—coca. Coca is simply the plant from which cocaine is derived and the wad of leaves moistened in the mouth and smeared every so often with a piece of lime or taken with a little cigarette ash, liberates the drug, deadens the pain, deadens fatigue and cold and hunger. It's very cheap and stupefies the mind and up here it is used by men, women, and children. Here is the cycle of Indian degradation, in the Andean Highlands—poor land, hunger, fatigue, pain and coca, which allows them to endure that which otherwise could not be endured.[7]

As they continued on their trip up the Andes they suffered blackouts and exhaustion from high altitude only to find that at the top of the mountain there was little of interest to film. Van Dyke experienced a kind of altitude sickness from lack of oxygen, which caused colorful visions and euphoria. He recognized the symptoms and began hiking back down to the others. Maddow was already passed out in the car, and Porrett was trying to revive him. They spent the rest of the day descending slowly, taking in oxygen as if it were poison. As they acclimated to a normal level of breathing again, they felt that the cure was worse than the illness.

They drove on to Cuzco, where they rested for a few days, and then proceeded to Santiago, Chile, where they shipped exposed film back to the United States. After a few restful days (which included a quick affair for Van Dyke with a Scottish office worker) in one of the most beautiful European-inspired cities in South America, they loaded their car on a train and traveled to Argentina. Roads across the Andes, a familiar challenge, had been washed out and blocked by landslides. At the border, customs officials did not recognize their official documents, and they were assessed a tax on all the film they were carrying. They were required to post bond at the rate of ten cents per foot of film. They refused and were briefly detained in jail at gunpoint. Van Dyke described the intensity of the moment when confronted by a belligerent policeman:

I was put into a very large room with a marble bench against the wall on four sides. The seat was too cold to sit on so I paced the floor. Some time later I heard Fred calling to the birds in the tree outside his cell, and I shouted to him. The door to my room opened, and a police sergeant entered, with his saber drawn, yelling to me in Spanish to shut up and sit down. He used the familiar form of address that is reserved for servants, children and other "inferiors." I told the man to address me correctly and I would obey. He was furious, repeated his command, and approached me with his saber waving. I took a chance and held my ground. He hesitated, lowered his weapon, and motioned to the bench. I sat down. It would have been foolish to do anything else, but I was very angry. After a few hours, we were released with the command that we either leave town before nightfall or face arrest.[8]

After one more stop in Brazil, the unhappy trio returned to New York. It was June 1942, and they had been gone for six months. In a few short weeks they edited the film and presented the finished work to the Sloan Foundation. Van Dyke knew that this time he had stretched the limits of his family's understanding. From this point on their relationship would never be the same. Van Dyke, unable to change his ways, continued to put all of his energy into his work.

The next few months brought other kinds of changes because of the escalating war. Maddow was drafted into the Army and assigned to the motion picture unit of the Signal Corps, but Porrett did not pass his physical and was not drafted. Van Dyke was given a deferment because he had a family, but he could see the writing on the wall and knew that in time of war even those with deferments could be called, and he had no desire to be a foot soldier. He dissolved his film company and joined the Office of Inter-American Affairs, which was going to be making films about the United States for distribution in Latin America. Within a couple of months, however, he recognized he had made a mistake and the group would not be making films at his level of interest. In 1943 he joined the Office of War Information (OWI) and the Bureau of Overseas Motion Pictures. The war changed everything, including Van Dyke's career as a documentary filmmaker. His muses had led him down a path that was as uncertain as it was inevitable.

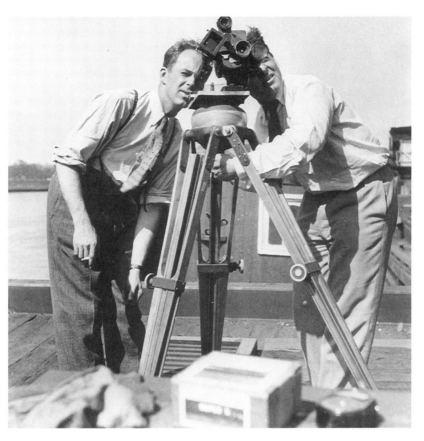

34. Willard Van Dyke (left) and Ralph Steiner shooting The City, 1938

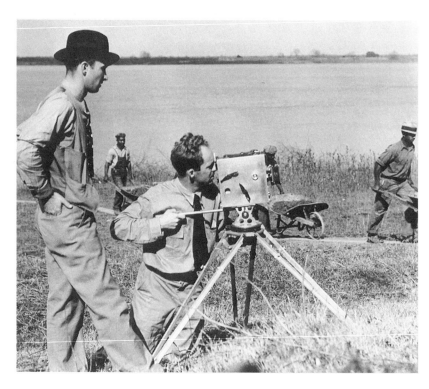

35. Willard Van Dyke shooting *The River*, 1936–37

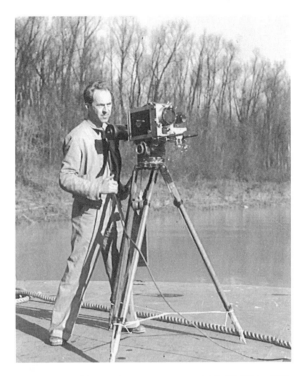

36. Willard Van Dyke
shooting *The River*,
1936–37

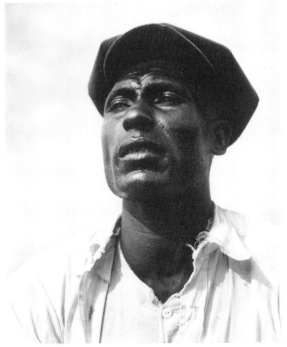

37. Willard Van Dyke,
"Black Man Singing,"
photograph shot
on location of
The River, 1936–37

38. Steelworker at wheel in *Valley Town*, 1939

39. Steelworkers in *Valley Town*, 1939

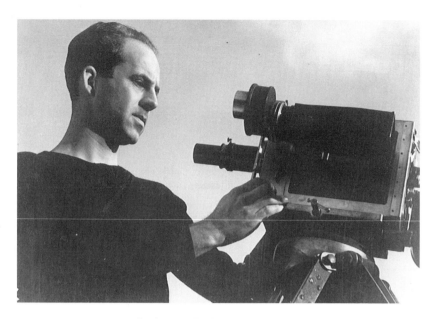

40. Willard Van Dyke shooting *Valley Town*, 1939

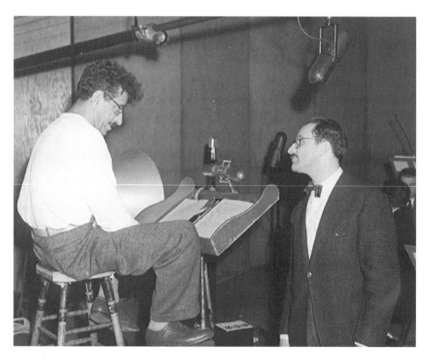

41. Marc Blitzstein (left) and Alexander Smallens recording *Valley Town*, 1938

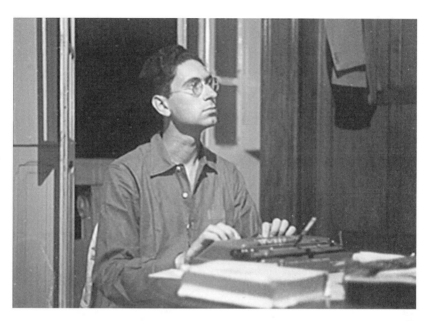

42. Ben Maddow, working on the script of the *The Bridge*, 1940

43a–f. Willard Van Dyke and film crew of The Bridge, Peru, 1940

44a–d Willard Van Dyke, Edward Weston, and film crew of *The Photographer*, 1947

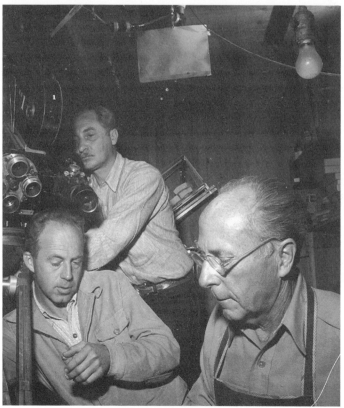

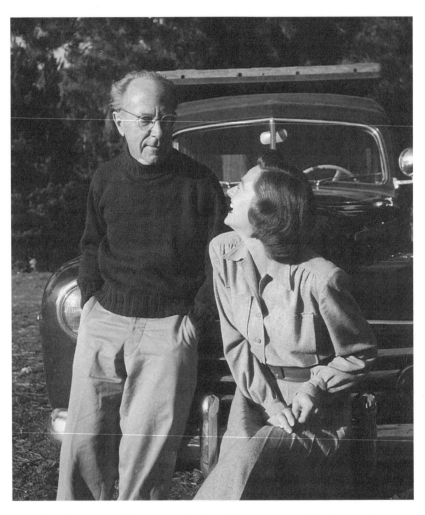

45. Edward Weston and the actress who played his assistant in *The Photographer*, 1947

7

Lost Years

⁓ BEGINNING IN 1943 VAN DYKE'S CAREER CHANGED DRAMATICALLY. Social documentary film, as he had known it, gave way to the exigencies of the war and the government's need to make military orientation and information films about the American way of life. The small cadre of American artists who had been leading socially conscious documentary filmmakers during the thirties became the government's eager propaganda merchants during the forties. Van Dyke, among them, proudly proclaimed that he was an ardent propagandist, because, he said, he so hated the Nazis. And following the end of the war there was little interest in socially critical films, since the nation's economy was improving and an air of optimism seemed to be everywhere.

The films Van Dyke and others made for the OWI and other agencies were largely uninspired, saccharine, sanitized portraits of American communities and culture. They were made with the intent of influencing foreign countries' views of America and providing disinformation to the enemy. Industry was portrayed as productive and benevolent; ethnicity and race were made to appear as harmonious havens in the land of immigrants; and small town America became the symbolic representation of all that was good in the American way of life.

By 1943, when Van Dyke went to work for Robert Riskin (*It Happened*

One Night) and Philip Dunne (*How Green Was My Valley*), both Hollywood screenwriters, at the OWI, there was a desperate need for filmmakers who understood the nature of information or "fact" films. In the orientation branch of the military, Frank Capra and John Houston made films that would familiarize soldiers with a wide range of weapons, the enemy, and the power of the American military. Van Dyke became a producer for OWI and made films about American life and industry on the cultural side of the agency.

Many of his friends and fellow filmmakers (Alexander Hackenschmied [later Sasha Hammid], Irving Lerner, Irving Jacoby, Roger Barlow) from the documentary world joined OWI to work with him as cinematographers, writers, and technicians. Van Dyke described himself and his documentary colleagues, some from his Nykino and Frontier days, as "premature anti-fascists."[1] Documentarians, he said, had foreseen the menace of fascism from 1935 on and had made films about it in and out of America in an attempt to awaken the public to its dangers. The government, therefore, was hiring some of the most powerful messengers possible.

At the same time other filmmakers from the same background but who were known communists were prohibited from working for the government. Van Dyke and those who worked with him protested that such discrimination was unfair because those rejected filmmakers were, after all, advocates for the policies of one of America's strongest allies, the Soviet Union. But the distrust of anyone who was not 100 percent American was already manifest, in ways that would reach a climax in the fifties with the McCarthy hearings. Van Dyke's fellow filmmakers who worked with him at OWI against the fascists became his partners in a film production company known as Affiliated Film Producers, Inc., after the war.

Among the films that Van Dyke produced and sometimes directed for OWI were *Oswego* (1943), a narrative view of an American city as seen through the eyes of French visitors; *Steel Town* (1943), a portrait of the life and work of American steelworkers; *Pacific Northwest* (1944), a film about the importance of Oregon and Washington to international trade and transportation; and *San Francisco* (1945), a film about the creation of the United Nations during the first meeting to establish membership.

Following the end of the war, Van Dyke realized that documentary film was in need of revitalization but found that his prewar support structure had changed policies and direction. He appealed to the next best source, which was the lone surviving cultural division of the government, the U.S.

Information Service, later know as the U.S. Information Agency (USIA), which funded a couple of his films, neither of which attained the level of quality of *Valley Town* and earlier films. Most of the foundation support he received was commissions; that is, foundations were funding projects in which they had vested interests. Ever the idealist, Van Dyke convinced himself that he could find creative opportunity in a new kind of documentary film within the new funding structure of corporations and public institutions. But in reality he was retreating from his life as an artist. He spent the next twenty years making films for the commercial market in health and education. Audience interest in documentary films of all kinds had waned, and Van Dyke ceased speaking about films in terms of art and began using the word "craft." As a way of justifying his decision to leave creative film, just as he had left still photography, he began to write articles for professional journals about the history and importance of documentary film. He became one of the medium's most regular apologists. In an article for the *Bulletin of the American Library Association* he wrote an essay on the history and nature of documentary film from which the following is an excerpt:

We are no longer helpless in our efforts to deal with nature, but sometimes our outworn prejudices, our crippling anxieties and our uncontrolled fears stand in the way of using techniques that science has ready for us. The problem is an individual one and the solution to it lies in the emotional reactions of individuals. Today our films must appeal to our audiences through their emotions, as well as through their minds. The form and content of the documentary film is changing. In the future we will see more personal stories, more synchronous dialogue, more attention to the individual and his problems.

Already there are a few films that point the way that documentary is to take. *The Quiet One* [a fictional dramatic film about a mentally disturbed boy in Harlem by Sidney Meyers and James Agee, so authentic and perceptive that it was labeled "documentary"] has shown the imitators of the documentary approach how moving truth can be in a feature-length film. Its influence will be widely felt.[2]

In 1946 Van Dyke had entered psychological therapy at his wife's urging, so when he speaks of "anxiety and uncontrolled fears," he is speaking

from experience. It is also more than coincidence that he and his production company, Affiliated Film Producers, developed an interest in mental health films. Writing became his creative outlet while he made films that largely bored him about medicine, marriage, the changing face of New York, and other informational topics. He often produced, directed, or codirected these films and only once—when he made a film about Edward Weston—did he return to being the cinematographer.

In various interviews late in life Van Dyke referred to this period as the "lost years" during which he inexplicably forgot who he was and suppressed his artistic drives, convincing himself that the primary reason he did so was to support his family. But that claim rang hollow, because even in this commercial period of his life he never stopped satisfying his compulsion for adventure, which meant long absences from his family.

The last film Van Dyke and his crew made for OWI, *San Francisco*, was about the international conference held in San Francisco in the spring of 1945 to create an organization of member countries, later known as the United Nations, that could arbitrate world conflicts in order to maintain and enforce international peace and security. For the film, they shot public sessions and debate, conversations and meetings on the street, and the life of delegates outside of conference rooms. But they could not film the inner sanctum, where various countries' leaders met and hammered out policies for public presentation and discussion, which is why Van Dyke described the film as "dead." He was prohibited for example from filming the argument over whether or not Argentina would be allowed to become a part of the United Nations. The United States wanted Argentina in and the Soviet Union wanted them out. He knew there was a real battle taking place behind the scenes, but he could not get access. In frustration he and his crew decided to fill their time by shooting stock footage of the city of San Francisco, one of the most photogenic cities in America. In the process Van Dyke found a couple of diversions that were more important to him than the film.

On one occasion the Navy lent the crew a blimp to obtain aerial views of the city. Several years earlier, Van Dyke had flown with friends in the Navy and learned the basics of flying a training plane used to teach dive-bomber pilots. His air time had given him experience in the maneuverability and timing of a highly responsive aircraft. As he and the pilot of the blimp discussed the differences between trainer planes and blimps, Van Dyke pumped up his own abilities. When lunchtime came the pilot

turned to Van Dyke and told him to take over the controls and left to go to the galley to make lunch. Before Van Dyke could protest, he found himself piloting the blimp over San Francisco. The response time of the blimp to its various controls was dramatically delayed by its whale-like size and its completely different shape and configuration from an airplane. Van Dyke had difficulty keeping the blimp level to the horizon and the giant ship bounced around the sky like a child's balloon. Finally, with lunch prepared, the Navy pilot returned and in a most unconcerned manner said that he was pleased that Van Dyke had worked things out.

Van Dyke continued searching for new outlets to relieve his boredom with the United Nations film project, which took three months. And it was not long before he turned to satisfying his other most persistent personal need—the bed of a woman. This time he met a ceramicist who lived on Telegraph Hill in a place with a romantic view overlooking San Francisco Bay. He said in his memoir that they fell in love, that is was more than just a one-night stand. He took up residence and used her apartment as a meeting place for his crew. They relaxed before the warmth of the fireplace telling stories and sharing meals like one big happy family. Van Dyke believed he was really in love and gave no thought to his family back in New York and the day when he would have to make a decision about returning.

In the meantime he made several trips to Los Angeles to meet with the Hollywood Writers' Mobilization group, which had been formed to assist government agencies by preparing scripts. The group, composed of the best writers in Hollywood, was also among the most liberal left in the country. The famous Hollywood Ten, who were subsequently persecuted by Senator Joseph McCarthy during his Senate hearings on un-American activities, were all members of the group. Among them, Van Dyke worked directly on the U.N. script with John Howard Lawson, Albert Maltz, Richard Collins, and Leonardo Bercovici. In time their membership in the communist party would come to haunt them in tragic ways and Van Dyke as well for his association with them. Ironically, at the end of the war the government sequestered all of the OWI films and censored their viewing by the American public, for fear of accusations that the government was competing with private enterprise, including Hollywood. Van Dyke believed it was because there was a desire to hide the fact that taxpayer money had been used for such blatant propaganda, the propaganda likely to be especially apparent if seen in subsequent times when the frenzy of the war was diminished.

When Van Dyke finally had to make a decision in September 1945 about whether or not to stay in San Francisco, he chose to treat his new love as an interlude and returned to New York. When he arrived home his wife confronted him with the growing personal distance between them, the long silences, bitter arguments, and his never-ending absences to be on location. She asked him pointedly about whether or not he was having sex with other women; she had probably known intuitively that he had been having affairs since before they were married. He answered her bluntly and told her that in San Francisco, "I enjoyed the company of two women." So it seems that he had been secretly seeing yet another woman behind the back of his new love in San Francisco.

As terribly hurt and dejected by his admission as Mary must have been, she told him that if he would seek help, perhaps their marriage could be saved. Although she would never forget, she could forgive, and she attended his memorial service in New York in 1986. Van Dyke agreed to her request and remained under treatment for nearly four years. But by the middle of 1949 he withdrew, and he and Mary began proceedings for divorce, which was granted in 1950. Van Dyke believed in later years that his time in therapy only exacerbated the problems that he and Mary were experiencing. Yet, even during his years of treatment he continued to see women on the side, and then he married for a second time within months of his divorce.

As the pressure from his dissatisfaction with himself as an artist built, his first marriage deteriorated, and unresolved issues about his childhood were brought to the surface by therapy, Van Dyke began to develop a temper. Inside the charming demeanor that was so attractive to women and sponsors alike was enormous turmoil, which contributed to a series of heart attacks over the next forty years.

When Affiliated Film Producers was first formed in 1946, it operated more as a cooperative than a traditional company. Van Dyke had had a taste of working in a conventional business with his friend Ralph Steiner, which ended with the temporary loss of a friend, and he was determined not to repeat that mistake. Everyone who worked at Affiliated could work on their own projects, but they all shared the same overhead and staff. Additional luminaries, including Ricky Leacock, one of the pioneers in cinema verité, became a part of the company later on. Van Dyke hoped the cooperative structure would allow him to operate within his personal constraints. He was independent to the very core of his being and required

a measure of control that was often self-defeating. But his overriding ambition to be a director and producer meant that this time he would have to suppress his personal desire to control and manage. Those who joined Van Dyke included Irving Jacoby, who had made a deeply moving film, *The Pale Horseman*, about postwar relief; John Ferno, who Van Dyke had competed with to make *The Children Must Learn*; and Henwar Rodakiewicz, who worked with Van Dyke on *The City*. They hired Boris Kaufman, the younger brother of the great Soviet filmmaker Dziga Vertov, as staff cameraman. Kaufman eventually became most well known as cinematographer for *On The Waterfront*.

The company's first important production was made for the Department of State. It was titled *Journey into Medicine* and was about the education and training of one man to become a medical doctor. The nature of educational filmmaking had never seen such a powerhouse of talent. But even that was not sufficient to earn the genre of such films a place in history as more than footnotes. For a decade Affiliated Film would make films that were, according to Van Dyke "pseudo-documentary—they were documentary in style, but at the service of something else. They were not allowed to dictate their own shape, and their own form."[3]

The one exception was when Irving Jacoby, who was the primary contact with the USIA in the State Department, suggested that Affiliated Films make a series on American artists, including Martha Graham, Georgia O'Keeffe, Frank Lloyd Wright, and Edward Weston. The State Department loved the idea. In 1947 Rodakiewicz and Kaufman went to New Mexico to begin a film on O'Keeffe. Van Dyke and Jacoby, along with Ben Maddow, prepared to make a film about the life and work of Edward Weston (*The Photographer*). Van Dyke reserved the position of cinematographer for himself, and in July the crew set out for Los Angeles where they were to meet Weston's son, Brett, for the drive to Carmel.

Brett was most like his father in that he had pursued photography as the sole interest in his life from age of fourteen. His brothers Cole, Chandler, and Neil had pursued other careers. In time Cole also became a respected photographer and was his father's primary caretaker during his last years. But Brett, at this time, tended to represent his father's photographic interests. Brett was by nature self-consumed with his ideas about art and spoke with an exaggerated baritone voice, which in conversation made him seem arrogant. He and Van Dyke had not gotten along when Van Dyke was living and working with his father. Brett was five years younger than Van Dyke

but more advanced as a photographer when they first met. They were both quite sure of themselves and competitive, especially for Weston's attention.

Van Dyke found Brett strangely quiet and subdued when he picked up Van Dyke to drive to Carmel but oddly thoughtful about Van Dyke and what was going on in his life. At first Van Dyke thought that Brett's demeanor might owe to the fact that he was now a filmmaker and so no longer was a competitor in photography. Perhaps he was seeing a new side to the man he thought he knew. But Brett finally turned to Van Dyke and asked him to gently break the news to his father that he was sorry they would not be able to make the film together. Van Dyke was stunned. He had no idea what Brett was talking about. Then Brett told him that Weston had Parkinson's disease and that it had begun to advance rapidly in the last few months. Van Dyke was devastated and angry that he had not been forewarned. There he was with a crew, actors (a young woman to play Weston's assistant), and a car full of equipment, not to mention the contract with the State Department.

When they arrived in Carmel the next day, Van Dyke had calmed down but was apprehensive. Indeed, Weston was physically very different from when he had last seen him, nearly a decade ago. Weston walked with a shuffle, and he moved in an exaggeratedly slow fashion in part to try to curb the palsy in his hands. Unaware of Brett's comments to Van Dyke, Weston waxed enthusiastic about making the film, and they talked late into the night about the script. Van Dyke decided he was not going to suggest to Weston that they call it off. They made a few changes to accommodate a different pace and to try to hide the effects of the disease. Van Dyke remembered that when Weston was fifty he had raced two of his sons on the beach and beat them. He was now sixty-three, and though his body was in rapid decline, his mind was sharp and clear.

As the filming proceeded, first in Death Valley where Weston had made many of his most striking photographs, he seemed to regain some of his former vigor. His ability to control facial expression was limited, but he was happy and cheerful to be making photographs again. To inspire Weston, Van Dyke had asked him to return to many of the original locations where he had photographed in the past and to actually make new negatives. The various landscape scenes of sand dunes and Point Lobos were composed in the film to exactly duplicate what Weston had seen when making his original negatives. The film then took viewers into Weston's darkroom on Wildcat Hill, outside Carmel, to film Weston complete the process of making prints from the negatives and to film many of his original prints for later cutting

into the film, which was masterfully achieved by the film's editor, Sasha Hammid. When the shooting was done, Van Dyke returned to New York to begin postproduction and to continue with his commercial business.

In the middle of 1948, Van Dyke ran up against the bureaucracy of the USIA, which said that it would have to have the film about Weston in its hands by no later than June 30 because that was the end of its fiscal year. If Van Dyke could not meet the deadline then he and the crew would not be paid the remainder of the project funds.

The film lacked a music score and they were not satisfied with the narration read by John Carradine, but they quickly recorded a temporary score and sent the first print to USIA. Van Dyke refused to look at the rushed completion of the film until he received new funding from the State Department in their new fiscal year to finish the film properly with a new score and edited narration. But even after the film was redone the way he wanted, Van Dyke still was not happy with the commentary. Weston, on the other hand, overlooked the commentary and loved the film.

The film began its international tour in 1948, and a year later Van Dyke wrote to Weston suggesting he would send him a copy of the film for him to make available to local theaters; perhaps Weston might make a little extra cash this way. During this time he had kept Weston abreast of the difficulties with his marriage and filled him in on his impending divorce, but he also told Weston that he had his eye on the future:

What about having the theater run it along with the regular show for a week and give you a part of the "take"? Surely you would increase their business. You can word the data any way you like, except that I wouldn't mention the State Department. You can just leave the sponsor out of the press release. The main emphasis should be on you. It is, of course, the first film made on an American photographer. It might be news worthy to say that I was an apprentice of yours twenty years ago, and that this is my tribute to my "maestro" as well as to the kind of approach to photography and to life that you taught me to respect. If that sounds high flown for newspapers, you can just keep it for yourself. It is true.

I expect to keep on living and growing. This is a painful period, but life is often painful. I don't look upon this as a tragic event, and I have few regrets. The future looks good to me, and I am full of desire to enjoy it. Someday I'll find a girl who loves me as I am and we'll

make a good life together. If I don't find her, that will be too bad, but I can still like life and work. I have no feeling of self-pity. What we do is usually of our own making, and it never is all good or all bad.[4]

The next time Van Dyke wrote to Weston was in March 1950 to tell him that Edward Steichen, director of photography at MoMA, had seen the film and was delighted with it. But secretly Van Dyke remained unhappy with the narration, which the State Department had insisted on. He believed that it would have been "a very much better film had it had one half the narration. . . . Since the film was made for overseas distribution, it had to carry a lot of information that was obvious to Americans."[5]

In May of that year his divorce was all but signed and sealed and he wrote Weston another letter to make an announcement:

These days are hectic for me, but I must take time for a note to you. There is news. First of all, I am to be married again in June. Her name is Barbara Millikin, and she comes from Evanston, Ill. I met her during the filming of the Marriage films last summer. She is twenty-five, very attractive, and quite mature for her years. [Van Dyke was forty-three.]

The second thing is that I am off for South America early in June to make a film for the State Department. Barbara will meet me in Ecuador, where we will be married. She will work with me down there for three months, after which time we will return here to live. I am very happy and it would be complete happiness if we could visit you. You two will like each other.[6]

Van Dyke and the young Ms. Millikin had met in the spring of 1949 when he was making a film for Affiliated called *Choosing for Happiness* at Stephens College in Columbia, Missouri. When Barbara met Van Dyke and Sasha Hammid (Alexander Hackenschmied) she saw a tall, distinguished-looking Czech and "this short guy," who was dressed and "looked the way a man ought to look." Van Dyke always dressed in harmonious colors and finely tailored clothes, something all of the women in his life commented on. She also liked his laid-back manner of directing the film: "I just liked the way in which Willard was very low key on the set, but he could always explain a scene. I mean these were kind of dumb audio-visual things that all those documentary guys had to do to pay the rent."[7]

Still in therapy for his marital problems, it was no accident that this instructional film was about the fact that one should not choose a mate with the thought that he or she would change favorably as a result of the marriage. Barbara loved theater and film but at the time did not offer any competition in the way that Mary Jeanette and Mary Barnett had with their careers. In time, as Barbara became more sophisticated and as she began to yearn for her own career, Van Dyke's cycle of competition and rejection would once again come into play. But for now he was simply in love with the most understanding woman he had ever met. He was not wrong, even in the worst years of their future lives together. Barbara's understanding would be an ingredient of why, despite future mistresses, they would remain married to the end. In some ways her understanding of Van Dyke's flaws and admiration of his basic nature may have been too close to his mother's oppressive attention, which eventually became intolerable.

As it turned out they were not married in Ecuador but in Mexico, and Barbara did go with him to South America to make a film titled *Years of Change*, based on a speech by President Truman, that outlined three areas in which Latin American countries could expect help from the United States. And in spite of his claim in 1981 that he and other men of his generation did not like having women on film crews, he readily included Barbara as a member of the crew to make the South American film. He may have undergone a change of heart both because by that time the film industry was changing and because Barbara wanted to be one of the crew, not just a tagalong spouse. This venture into South America was also to serve as their honeymoon.

Although Van Dyke professed that his therapy sessions had not helped his marriage to Mary, his dramatic shift in attitude suggests they must have had some effect on his personality. But perhaps Barbara herself accounts in large part for the change in him. Barbara was a faculty member of the Stephens College, serving as technical director for the theater department. She applied for and was given a role in Van Dyke's marriage film as one of the coeds who was unduly wise about choosing a marriage partner in the film. She played her role convincingly, both in the film and in her life with Van Dyke. She had no illusions about her role as the other woman in his life and knew that Van Dyke's marriage was on the skids and would soon end. Even so, she told him in letters that he and Mary should not get divorced because of her. If they did, she said, she could not continue her relationship with Van Dyke. By the end of end of the film's shooting they had become

lovers. But Barbara was more than a pretty young woman with a pleasant voice and self-confidence, which is how Van Dyke described her. She was also very frank, analytical, fiercely loyal, passionate, maddeningly detailed in word and deed and, most important to his ego, an intellectual. Her memory was nearly photographic. Her love for Van Dyke never waned throughout their marriage, despite the fact that the same problems that destroyed his first marriage would come to plague him again: infidelity, excessive drinking, and long absences.

When Van Dyke returned to New York in the fall, he and Barbara wrote almost daily. Between June 1949 and May 1950 Barbara wrote over three hundred and thirty pages of letters to him. No record of his letters to her survives, but it is known that he often telephoned instead of writing. Throughout her love letters, Barbara also offered detailed accounts of her life experiences, her family, and her background. Up front and in the first letter, she addressed their age difference. She was twenty-five and he was forty-three:

> I think love must be a relationship that has no respect for time. I find it difficult to think of you in terms of age. You're just you, and I love you. But I also realize that there is a gap of events and experience between us that covers quite a hunk of time. I can't crowd eighteen years of living into the next few months, and indeed I have no wish to do so, but I can polish off the rough edges of my own growth, and then we can see where we are in terms of this difference.[8]

Barbara had seen *The River* when she was in high school and had been greatly impressed by Van Dyke's reputation in the film world. But she was somewhat naive, having led until then the life of a protected middle-class coed from the Midwest. In the beginning of their marriage this naivety put a great deal of pressure on her. New York itself was a challenge, not to mention the fast-paced and aggressive film world of her new husband. But from the beginning she was intent on sorting out all of the potential problems of their relationship, sometimes with a wry sense of humor. In another letter she sent him a photograph of herself when she was four, reminding him that he would have been twenty-two at the time. It was intended as a humorous little jab, but she also knew that he loved her youth.

Her letters were most often typed, single-spaced, and three- to four-pages long. They were not typical love letters, although she always expressed her love for him, often with poetry. In almost every letter there was serious discussion about topics she felt would affect their relationship as they moved toward marriage, and in her mind, a long life together. Her father had died when she was five, and the letters reveal a measure of admiration for Van Dyke that could be seen as reflecting her need for a father figure. But there was always reference to the passion and sensuality of their relationship in the letters, which meant that their attraction to each other was not just psychological.

Her most loved and admired family member was her Uncle Victor George, who had been a successful photographer of celebrities in New York and later a numerologist. It was he who developed her love of theater and played the role of father in her childhood, introducing her to ballet, music, and the artistic side of life. In one letter she wrote a mini-autobiography detailing the entire history of her family. Another one of her letters in the lead-up to their marriage provides a glimpse of just what Van Dyke had gotten himself into this time. He was soon to learn just how deep the love of his new young spouse could be. He would also discover, in time, that here was a mind that was willing to devote her entire life to trying to help him with his personal needs and to working with him in a variety of capacities on the thing they both loved equally—film.

That they eventually became somewhat competitive is no surprise, especially given Van Dyke's history with friends and family, including his mentor Edward Weston, his film colleagues, and his first wife. But there was something more that was surprising about his relationship with his new wife-to-be. Barbara seems to have been a little bit like Mary Jeanette in her loving commitment to Van Dyke's best qualities, a little bit like his mother in terms of articulating her every thought, and a lot like him in his perfectionism and desire to control as much as possible about life itself. The following excerpt from one of her letters, before they were married, reveals an intensity that follows Van Dyke through all of his exploits for the remainder of his life:

October 14, 1949
. . . The question of religion is something that troubled me for a long time. It's taken me a long time, and a good deal of quiet

agony I might add, to work out my convictions. . . . Religion (and I must confess that emotionally I still shy away from the word) is a funny thing. I think it is a highly personal thing and therefore very difficult to talk about. It seems to me that religion is a quality of living, a way of looking at life, and a way of dealing with other people in terms of that basic viewpoint. I don't think it is necessary to call it religion, but perhaps "religion" is the most convenient handle, and originally the word must have meant something fresh and creative.

I think God is a three letter word that stands for a concept which man has been struggling to define since the beginning of time in an attempt to more fully understand himself, other men, and this strange and wonderful earth planet we live on. I think he has had varying degrees of success in this search, and more than once has taken the wrong turn. Certainly Jesus hit a new high. But so did Gandhi in more recent times, and, I'm sure so have hundreds of other sensitive human beings whose lives were less spectacular.

. . . As I believe religion is a quality of living, so I believe prayer to be a quality of thinking. There are many formal prayers which I dearly love, and the Lord's prayer is first among them, but I must confess that most of the "praying" I do I never recognize as prayer per se. . . . I would rather have the difficulty of discovering for myself, and have that discovery mine, than I would to take the less confusing way, and always get things second hand.[9]

In February Van Dyke asked Barbara to marry him, anticipating that his divorce would soon be final. During the separation phase, Barbara and Van Dyke met in various cities including New York, St. Louis, and Chicago, where he was introduced to her mother and stepfather. Barbara's mother was very conservative and very possessive of her daughter in ways not unlike Van Dyke's mother was of her son. They both decided that they would have to assert their independence and be married in an unconventional ceremony of some kind that would not allow their mothers to be too closely involved. Van Dyke's mother wrote him several letters about his divorce and marriage to a much younger woman, completely absolving him, her favorite child, of any complicity in the failed marriage and praising him for finding a woman who would love him for who he was and especially satisfy his needs for tenderness and love without confrontation.

There were two things he and Barbara had agreed were fundamental to their marriage: no acting and no cats. Mary had been an actor and Weston had had a large number of cats, so many that there was a constant need of cleaning up after them, which had repulsed Van Dyke. Barbara was interested in theater but only on an intellectual level, and she hated cats. They laughingly felt they had solved the only barriers to marriage. When Barbara learned in late May that Van Dyke would be in Mexico City to begin the journey for his South American film, she suggested that they be married there. He agreed, and to their surprise Barbara's parents announced that they planned to attend the wedding. Van Dyke described their wedding day, June 17, 1950, as follows in his memoir:

I was scheduled to make two films in South America that summer, and I planned to leave in May, with Rickie Leacock as my cameraman. If we were married by that time, Barbara would go with us, otherwise, she would join me in Mexico and we would be married in the American embassy. My divorce became final in early May, and Rickie and I went to Mexico City in early June, while Barbara finished her work at Stephens College. Through a great stroke of luck I found an Episcopal clergyman, who recently had been transferred from Honduras where he had held the Bishopric. He was perfectly willing to marry us in the beautiful cathedral in Mexico City, but it must be on Saturday at one o'clock, because he had a date to play tennis later that afternoon. He did not ask about my marital status. Barbara and her parents arrived on Friday, and, at the appointed hour the next day, we went to the cathedral. Rickie [Leacock] was my best man. We were married at the altar, with the ceremony from the Book of Common Prayer. I absolved Barbara from the vow she had taken to endow me with her goods and chattels, and Mrs. Millikin never mentioned the white tennis shoes that peeked below the bishop's black robe, nor the beautiful blue-black color of his skin.[10]

Following the ceremony they flew to Acapulco for a few days for a honeymoon and then flew to Ecuador to begin filming American advisors on education, agriculture, and public health. There they photographed in a rural village where the only accommodations were primitive but not nearly as basic as in Paraguay. Barbara's first experience as a film crew member was

a baptism by fire. Their hotel in Paraguay, also in a rural setting, had rooms over a bar with straw mattresses and noisy wood staircases. Clean water was scarce, and Leacock became ill with amoebic dysentery. When they landed at the airport in La Paz, Bolivia, at an altitude of 14,110 feet, they all became seriously ill with altitude sickness, and Van Dyke experienced the same symptoms as on his first trip to South America in 1943. Their nights were sleepless and interrupted by fitful wakefulness, gasps for air, and constant nightmares. When they finally acclimated a little, they began filming their first location, a weather station at 18,000 feet. They could drive to the 16,000-foot level but then had to hike over a glacier for the last 2,000 feet as described by Van Dyke:

> Our helper began to falter when we had gone about fifteen hundred feet, Barbara was on her hands and knees and Rickie looked pale. I felt wonderful, took the tripod from the Indian and started climbing at a great rate, when I noticed that the snow looked red, the sky was a deep purple, and I realized that I was experiencing the euphoria that precedes blackout from oxygen starvation. After I rested a bit, we all went to the top. The weather station consisted of a locked box containing a barometer and a wind gauge, not very impressive photographically.[11]

They finished their five-month journey through the primitive reaches of Brazil. Sometimes they all slept in the same room. They ate in hospitals when they could, and their final hotel was a converted railroad car. Even their departure became surprisingly difficult when they learned that they could not leave the country without exit visas. The embassy guide assigned to see them off finally offered that his mother was the mistress of the chief of police and that he would ask her to intercede. She did, and they were finally on their way home to New York.

When the newly married couple arrived they found a small apartment on West 116th street, near Columbia University. It was a dreadful little one-room apartment with a kitchen in a hallway. When they tried to entertain Van Dyke's first client for a new film project, all the smoke from the two-burner stove filled the room. Choking and laughing, they spent the evening setting next to and hanging out of open windows. By Christmas they found a real apartment with a small garden on East 46th and lived there through the birth of two sons, Murray Weston Van Dyke in 1952 and Cornelius

(Neil) John Van Dyke in 1954. They lived on East 46th until 1955 when they moved to West 11th street, their family home until the boys were grown and in college. Murray would eventually become a filmmaker and Neil would develop a career in forestry.

Van Dyke continued making commercial films about health and education through Affiliated Films and from time to time would receive lucrative commissions to work for foundations and corporations. In one sense life was better than it ever had been for him. He felt that this time family life would work for him. But as time passed, he missed his children from his first marriage and asked Barbara if she would mind welcoming them into their home on scheduled visits allowed by his divorce settlement. Barbara, as it turned out, was a natural nurturing mother and Alice and Peter became like additional siblings to her two sons. Alice wrote many letters to her father always eager to see and be with baby Murray and later Neil. In 1958 she lived with them for a year. As adults, all four children gathered with their own children in Stowe, Vermont, to be with Barbara the last few days before her death in 2000. Thanksgiving became a time to get the children of both families together, a tradition that continues today.

During the early fifties, Affiliated Films began to feel the effects of a new more conservative America that rejected anything controversial. There was also a new, aggressive and haunting threat of government interest in the personal lives of American citizens. Senator Joseph McCarthy had begun his House Un-American Activities Committee (HUAC) hearings in 1951. The committee, originally formed in 1938 to detect German-American Nazi infiltration in the government, carried out a witch hunt for communists in all walks of life. In 1952 McCarthy wrote and published *McCarthyism: The Fight for America*, which detailed his vendetta against Presidents Truman and Eisenhower, Secretary of State Dean Atchison, the Tydings Committee, the OWI, and anyone else who disagreed with him. In this publication he laid out his hateful campaign to eradicate what he believed was a threat against democracy posed by what he called communist-minded teachers, sex deviates, and communists by association and collaboration.

The Hollywood Ten writers, some of whom Van Dyke had worked with on OWI films, were prosecuted in 1947 because they refused to divulge their political affiliations and were imprisoned because they invoked the Fifth Amendment at the HUAC congressional hearings. But there was also a gray list of individuals who had secretly been observed by the FBI and were known to have associated with communists or communist sympathizers.

Van Dyke's name turned up on that list. By 1951–52 his film work had taken a severe dive. He was barely making enough money to make ends meet for his new family. The reason became apparent when he was working for Bell Telephone.

He had been hired to make a short film for Bell Telephone Company about a military early warning system in Alaska. The filming required him to fly over Mt. Whitney from a strategic airfield laden with bombers carrying atom bombs. When he returned with the footage he needed, he was contacted by Bell Telephone who said there was a problem with security clearance for him and that he could not fly on military planes in the future. Van Dyke had enough footage to finish the film but was still puzzled by the order from the State Department. Bell Telephone could not offer any reasons but had to abide by the dictates of the Air Force.

Van Dyke suspected that it might have something to do with what was going on in the political arena but couldn't be sure. He called a friend who had run for attorney general of New York, and he put Van Dyke in touch with an attorney who he thought could help. The attorney said he could clear up whatever the problem might be for ten thousand dollars. Van Dyke walked out because he could not afford the fee and because he strongly believed that he had done nothing wrong.

He and Barbara let the issue pass for a few months, still struggling for ways to remain solvent. Then Van Dyke was offered a very benign job, but one that he was happy to get. He was contracted to make a series of loop films on America for the Brussels World's Fair. It was lucrative enough for him to hire a number of Affiliated colleagues including Shirley Clarke, Don Pennebaker, and others. When they were almost finished the American commissioner called Van Dyke and said that he had been advised by the State Department that it would be unwise for the fair hire him to be a contractor on the project. The commissioner asserted his right to disregard the State Department's advice but asked Van Dyke if he could shed light on the reason for its taking issue with him. Again, Van Dyke expressed his dismay and ignorance of any possible reasons, noting that he had, in fact, often worked for the State Department since his OWI days. The commissioner then asked if Van Dyke would be willing to meet with the federal investigator who had a dossier on him. Van Dyke described the meeting as follows:

> So they brought this little creep into the room, and he had a thick file. He asked a lot of ridiculous questions. But it began to develop

that when, in 1935, I did a yearbook for Mills College—I did the photography for them—out in California, and there was an undergraduate gal there I got to know really quite well. I became friendly with her and met her a few times in New York. They were connecting me to her. She had turned up trying to smuggle some papers to a bunch of Czech students at the time when the Czech students were in rebellion against Fascists. She lived in Paris. I had not seen her in fifteen years, but I was being connected to her. Then he [the investigator] said, in 1935 you went to the Soviet Union under the auspices of an official Soviet agency. And I said, I don't know what the hell you're talking about. I went to the Soviet Union, I certainly did. And what was the name of the agency? He said Intourist. Intourist was the agency through which you had to buy your tickets; you had to buy them for your hotel room. Sure, it's an official government agency, but I paid $40 a day for every day that I was there and it was not at anybody's invitation. But there it was on my dossier. And I was really getting a little frantic, because there were other accusations.[12]

Van Dyke's membership in the Photo League, his involvement in Frontier Films, and the activities he and his friends engaged in were now being used against him by the McCarthy machine. He had also had a secretary when he worked for the OWI that had later been accused of being a communist double agent. Finally, his file contained a reference to his association in 1945 with the known communist Jean-Paul Sartre, the great French existentialist philosopher. Helen Grayson, a distinguished documentary filmmaker who had grown up France, had called Van Dyke when he was making his film on the creation of the United Nations and told him that she was trying to help some journalist friends of hers who were visiting the West Coast. She mentioned that they were all quite left politically and that one of them was Sartre. She was interested in helping them to meet interesting people in San Francisco. Van Dyke recommended several friends in the arts and told her that they should visit the M. H. de Young Memorial Museum.

All along the way Van Dyke had been clear with colleagues and in print that he was strongly against the communist agenda and that his socialist convictions were humanitarian not revolutionist. He did not agree with many of his friends who held ideals that were embedded in the communist concern for social issues, but he would never have considered avoiding

them because of their beliefs. Such friends included, among a long list, Paul Strand and Elia Kazan. Known by his nickname Gadge, Kazan was very close to Van Dyke and even after he named names at the HUAC hearings, he remained a friend, albeit one who had caused great hurt to other friends who never recovered. Van Dyke and Barbara disapproved of his action but attributed it in part to the hateful paranoia being orchestrated by McCarthyism. Others were less forgiving. In an interview for this book, Barbara recalled a comment by Kazan about warmly greeting a friend on the street with the question, "How are things?" His friend replied, "Gadge, you just did this and you're saying—Oh hello, it's good to see you. Well I hear a man got his tongue cut out in Washington yesterday!"

The great fear and paranoia of the fifties was a growing part of the Van Dykes' daily life. One day, about this time, Barbara was home alone when the doorbell rang just before noon. When she answered the door, a pleasant-looking man politely asked if he could come in because he needed to shave. Barbara was aghast and recoiled in fear. The man then introduced himself as Louis Van Dyke, Willard's brother. Louis Van Dyke had disappeared years earlier after he had been working for one of the first foreign car agencies in Los Angeles. Up to that day, Van Dyke had never mentioned his brother except to say he had been a sweet child. Barbara invited Louis in and showed him the bathroom. They spoke for a few minutes, but he was mysterious and evasive about how he had found their home. What he was doing for a living? Why had he needed to come there to shave? He left as abruptly as he had come without seeing his brother, and they never heard from him again. Both Van Dyke and Barbara believed their phone had been tapped at one point, and they were visited by an FBI agent who purportedly wanted to know all about the activities of their landlord, who was among their closest friends.

Following the accusative meeting with the investigator who presented his case against him, Van Dyke was angry at first but slowly grew more and more depressed. After pondering the event for a while, he finally turned to Barbara and in tears asked, "What the hell shall I do? What can I do?" Barbara, who had maintained a much harder stance about the situation, had already used her bulldog tenacity to devise their next move. She told him to go see their congressman, John Lindsay (later mayor of New York City [1966–73]). Van Dyke protested that Lindsay was a Republican (although he later became a Democrat), but Barbara assured him that he was intelligent and seemed to be a reasonably nice guy. Van Dyke agreed and made an appointment. He described the meeting as follows:

I went to the Wendell Wilkie building, where his office was. And I told him my story, and he said the waste of American talent that this country has indulged itself in is frightful. And he picked up the phone and he called Washington. He told his Washington office, I'm going to be there on Tuesday, and by three o'clock I want to see the State Department security agent with the dossier on Van Dyke, and at 4:30 I want to see the Air Force, and let's see what we can get on this. I never heard back from him. But two weeks later, I got a call from Bell Telephone, and they said, "What the hell happened? We just got a security clearance for you." That was all. It just took a Congressman to ask a few questions. And there wasn't anything in . . . [that file] except a lot of suppositions. And that was the end of it.[13]

In 1953 Van Dyke's mother died. When Van Dyke received the telephone call at 3:00 a.m. one morning, he collapsed with uncontrollable sobbing. Barbara recalled how shocked she was by his reaction in view of how he talked about her for years. Barbara had also come to know his mother's smothering ways firsthand and how she could present herself as deeply concerned about his well-being at the same time that she demanded his absolute love and attention. Her letters continued to flow regularly right up to her death, often shaming him indirectly for not writing more often and for not allowing her to have a more personal role in his life. It was not that she was domineering but rather that she overwhelmed him with her effusive claims of love and that she expected to be a part of every twist and turn in his life.

For the next several years Van Dyke continued to make commercial films. Now in his fifties, the subjects he covered included recreational therapy, labor relations, and things of virtually no aesthetic interest such as the life of molds. Only a film about the construction of a New York skyscraper which he made with Shirley Clarke held any interest for him, and then only because he was inspired by Clarke's extraordinary imaginative editing. But he spent most of his time trying to avoid the utter boredom and depression that had beset him. He began making films for television over which he had virtually no creative control. It paid well and he was determined to provide a good material life for his new family.

He claimed that the film world had changed, but in fact it was he who had changed. The political events of the early fifties had also effectively

robbed him of his drive to change things. He had always been a binge drinker, but now he began to drink more regularly at work and at home. There was always a bottle of scotch in his desk for an afternoon social drink at Affiliated and long numbed evenings at home. He became progressively impatient with his family and took little interest in his boys' school events and personal activities. He barked at Barbara to do something useful and help pay the bills, to stop donating her time to charities and film organizations. He pushed her into getting a job as an associate producer on a film (which she loved) and then berated her for coming home late. By stark contrast, when he was not under the influence, he was supportive and helpful to her in building her own career as a film programmer for various organizations.

His old cycle of love and rejection was once again beginning to surface, but he was married to someone who was determined to help him deal with his problems and to create an environment for him to flourish in the present and a way to cope with his past. They talked about the part of his past with his family and his first wife that continued to haunt him. Barbara insisted that they leave nothing in the shadows because they had agreed from the beginning that there would be no secrets. She even suspected that on one or two occasions he had kept her from making trips with him because he was seeking one-night stands. But she endured and waited for him to confess his affairs rather than forcing the issue, but he never did and even the slightest hint in that direction brought violent denial from him. Barbara continued to arrange things so that all four of his children could grow happily and get to know each other and so that they could have festive holiday celebrations where all issues were put aside for the sake of their children; something that neither she nor Van Dyke had enjoyed themselves as children.

But the sense of malaise that had taken over his spirit persisted. He wrote about it in his memoir:

> I fretted at my boredom. When I was a little boy, my father had given me a rifle and taught me to shoot at tin cans. I bought a target rifle, and Barbara and I sometimes went to a shooting range in New Jersey. Abercrombie and Fitch had a gun department that handled some of the finest firearms in the world. I made the acquaintance of a salesman in that section of the store named Carl Estey. Carl was a big, jovial man who loved to tell stories. One day

a customer asked Carl to show him some shotguns. He wanted one for protection, he said. He rejected the first one he looked at and asked to see a better grade. That went on until Carl was showing English handmade pieces, the finest in the world costing thousands of dollars. The man carefully examined each one and finally settled on a beautifully crafted Purdey twelve gauge. Carl told him that a hundred dollar factory gun would serve his need just as well. Why did he choose such an expensive one? The man was a violin maker and owned a collection of Guarnieri and Stradivari instruments. He could not abide poor workmanship. Such stories fascinated me, so did the fine guns, and I began to spend so much time in the gun department of the famous store that my secretary referred to it as "the branch," and called by telephone if there was anything in my office that required attention. Such was the extent of my boredom with the kind of films available to me.[14]

In 1957 Van Dyke was presented with a new and unusual opportunity that helped both his financial situation and lifted his spirits. He was visited by a former student to whom he had taught film production in 1941 at the College of the City of New York, where he had been a guest instructor for a short period. Milton Fruchtman, his student, had since become a television producer for the Lowell Thomas series *High Adventure*. Fruchtman invited Van Dyke to go to India to make a film about a royal tiger hunt with the king of Nepal. Van Dyke was intrigued but wary. He knew that the Thomas series was looked on as little more than contrived opportunities for Thomas to appear in so-called wild and exotic parts of the world. The first two programs had received very bad reviews. The third program was such a failure that it was never aired and was replaced by old footage of Thomas in Tibet. The sponsor was not pleased, and the producers were frantic.

In Van Dyke's memoir he said that this was a turning point in his life. It was surely that, but not in the sense that he had found a way to reinvigorate his involvement in the arts. For the time being he had sidelined his initial desires and passions to be an artist. The drives and aggravations, which had fueled both his artistic interests and his politics, had been subsumed by his greater need for success in the face of what he saw as a changing world. Ironically, he had spent much of his life wanting to change the world, and now it seemed to be changing in ways that left him feeling alienated. Van Dyke had also grown to enjoy the process of making films for their own

sake, his protestations about the boring nature of the content notwithstanding. He had said early in his life while making *The River* and *The City* that he, in fact, often enjoyed the process of making film more than the finished product:

> I really enjoy the process of making movies, over and above the content. The process itself has always been a very satisfying thing for me. I've worked as a cameraman, obviously, I've worked as a sound man, I've worked as an editor, and I've worked as a writer; there isn't a part of the process that I don't know and know well and enjoy doing. . . . There are things I would like to have done and didn't do, but then who doesn't feel that way.[15]

What this new commission offered was not an opportunity to regain his footing in quality filmmaking but, inevitably, just the opposite. It did, however, present an opportunity for adventure on a grand scale, which would have whetted his appetite. Additionally, his married life was once again filled with stress and long stretches of unhappiness, albeit of his own making. Adventure had always been an escape of one kind or another for him, and here it was being presented to him in a way that no one could object to. Money was tight at both home and at Affiliated. He resigned from Affiliated, and in 1958 formed an independent company called Van Dyke Productions. He and Irving Jacoby, who had been the main inspiration for Affiliated and who had worked with him on *The Photographer*, had grown further and further apart mostly because of Van Dyke's restlessness. In his memoir he wrote about the welcome commission, which served as the catalyst to push him to once again work for himself. In his storytelling manner, he gave the tiger hunt film greater prominence in his memoir than anything else that transpired in his life during the decade of the fifties. Van Dyke's own words best convey the experience of the hunt:

> I had to face the fact that the kind of social documentary films that I had made in the 1930s were not going to be made again. Perhaps the political atmosphere would change, the influence of Joseph McCarthy would probably diminish, but the technical advances in sound recording and camera design had already changed the form and methods of making the independent film. The classroom films were influenced and even shaped by the textbook manufacturers,

cramping the creative input of the filmmaker. They had become boring to make and they must have been even more so to the students upon whom they were inflicted. Industrial films too often plugged the sponsor's message so hard that they defeated the purpose for which they were made, but once in a while the filmmaker had the chance to use an original approach and at least they paid well.

. . . I had heard many fantastic stories about television producers, but I was not prepared for my meeting with . . . Jeff. As I entered his office, he stood up, extended his hand and said, "Welcome aboard, Willard. It's a happy ship." I had not yet agreed to make the film, so I asked what the schedule was and the other terms of the contract. His story was that the King of Nepal was to go on a tiger hunt on the fifteenth of November in the jungle area of Nepal called the Terai. I was to pick up a British-trained crew in Malaysia, proceed to the site, shoot the film and return to New York in time for Christmas—an hour long color motion picture to be shot in 35mm in five weeks without even a script idea in anybody's head. I had never heard of anyone doing that before, but Jeff was adamant and offered a contract with a thousand dollars a day penalty to me, if I was not in New York by midnight December 24.

I persuaded Robert Young to go with me as cinematographer. Jeff and I left for Kuala Lumpur on November 3 to select a unit manager who would accompany us with the rest of the crew to follow. Bob Young would follow with the special apparatus he wanted; large plates of Plexiglas to protect the cameraman from the charge of a tiger, black netting to diffuse the sunlight, all of the color film in refrigerated containers, heavy electrical cable and may other things that we were told were not available in India.

. . . I took a walk around New Delhi and in the late afternoon, Jeff called me to his room. He offered a drink and began to tell a strange story. Five months previously he had met a man in Italy who lived in Nepal and ran a hotel there. The man was named Boris. He was a white Russian who had danced in the Diaghilev Ballet and had run a club and restaurant that had been patronized by military officers and Indian royalty during World War II. He had arranged a previous tiger hunt for the king, providing all the

camping gear and catering the food. He had described the hunt to Jeff as a very colorful and ceremonious event. As he told it, a clearing was made in the jungle and white cloth was draped on the trees surrounding the clearing, forming a large circle, open on one side. The king and his hunters on elephants took their places in the opening while beaters moved through the jungle ringing bells and beating drums to drive all the wildlife toward the clearing. If there were any tigers, they would not go past the white cloth, Boris said.

. . . Boris came to the hotel late in the afternoon. He was still a handsome man, although his once lithe dancer's body was hidden under flesh and fat. I discovered later that he was not to be under-rated. He spoke Russian, French, English, Hindi, and two Nepalese dialects. His knowledge of jungle lore was impressive and he was reputed to be fearless. At sixty years of age he was still fast on his feet and seemingly had inexhaustible energy. I liked him at once.

. . . I felt as though I had been magically transported to Shangri La. The temples and statues, covered with gold leaf, shone in the clear air and the brilliant morning sun. Nepal was the birthplace of Buddha, and while there were many temples devoted to that gentle teacher, there were also some that showed the influence of Tantrism and were adorned with carved wooden figures in every conceivable sexual activity. I tried not to be too curious, but people were watching me and when I raised my Leica to make a snapshot, there were audible giggles.

. . . The day for the hunt came, the nets were spread, the hunters took their places and when it was all over there had not been even so much as a rabbit within the trap. The men wanted double pay to do the same thing again, and I was convinced that a repeat performance would be futile. After three hours of bargaining, Boris persuaded the men to come to the camp of the Maharaja of Cooch Behar if we located a tiger and needed their help.

. . . There were many tigers in the area, according to Boris, although the water buffalo we had staked out for bait had remained unmolested for two nights. . . . The following day a strange Land Rover with two Englishmen came into camp. We made them welcome, offered a cup of tea and learned that they were from a nearby tea plantation. They asked if they could borrow an elephant. Just last evening one of the workers on the

plantation who was chopping wood at the edge of the jungle had been carried off by a man-eating tiger. This was the twentieth-eighth victim, and the tea pickers were threatening to leave unless something was done. The planters hired a Burmese hunter who had much experience during the war as a guide and jungle fighter, but all of his efforts to capture or kill the tiger had been futile. He needed to ride into the jungle on an elephant, find the remains of the unfortunate man, erect a platform in a tree nearby, and wait for the man-eater to return. Of course we were pleased to be able to help, and the next day an elephant and his mahout were dispatched while we went ahead by Land Rover for photographing what we could.

. . . When we reached the spot where the man-eater had carried his victim into the jungle, we found that the terrain was very uneven and the vegetation so dense that one could see only what was directly in front. There was no way an elephant with a man on its back could possibly penetrate the jungle. We decided to go in on foot. Jack Grisham, the hunter, led, Bob and Throckmorton followed, and I took the rear position. Jack carried a large-caliber rifle, Bob the movie camera, and Throckmorton his Nikon, while I walked backward carrying a shotgun loaded with the heaviest charge I had. About fifty yards in we found the man's scarf and a knife lying in the dust, but no trace of his body. Suddenly Jack said, "We have to get out of here, right now." He pointed to the paw print of a tiger. It had rained about ten minutes previously, and the tiger had made the pug mark since then. The tiger was nearby, probably watching us. If he decided to charge, there was little chance that we could get a shot off before he struck. We started back, walking two or three steps, stopping and looking around, keeping this routine all the way back. I have never been so nervous before or since, and I was covered with sweat when we arrived at the clearing.

The only chance we had to kill or capture the man-eater was to get our native hunters, surround the area with nets and hope that we had him within the circle. This was the time to bring Lowell Thomas to the location so that he could be part of the film. We had decided that there was no reason to have him with us until we knew exactly how he would be used. I called New York and he was with us five days later.

Thomas was sixty-seven years of age. He had been a reporter during World War I. He knew the fabled Englishman T. E. Lawrence [Lawrence of Arabia] and had entered Jerusalem with General Allenby, and subsequently made a fortune lecturing about his experiences. He had a distinctive manner of speaking and for many years he did an evening radio news program that was enormously popular, especially in the Midwest.

. . . The elephants gave us a rather ragged performance, but when we got to the end of the shot Lowell made his little introduction, inviting the audience to go with him on an elephant hunt, turned and as the elephant rose and tossed his head he almost slipped off. I said it was a good take and turned away, but Lowell protested that he looked clumsy and that he wanted to try again. The next take was fine and although I thought we had taken too great a risk, I had to admire the courage of a man who could have been seriously injured again. He was a professional, and he took care of his body, skiing well into his eighties. He took two drinks before dinner, never smoked, and took long walks if there was no other exercise to be had.

. . . The object of our search hunted along the edge of the jungle where the tea plantation ended. It was here that the workers gathered wood for their cooking fires. Apparently our tiger was attracted by the sound of their axes. One afternoon shortly after our futile all-night vigil, we were traveling through the plantation on our way to a meeting with the planters when we saw a crowd of Indians near an old tree where the jungle started. We learned that two men had been chopping away at the tree, one on each side, when the man nearer the plantation heard his companion scream. With his axe raised, he looked around the tree to see a tiger with one paw on his friend's shoulder and its teeth buried in the man's buttocks. He brought the axe down on the tiger, which dropped his victim and ran into the jungle. By the time we arrived at the scene the injured man had been taken to a hospital and it was clear that he would recover. The tea workers were very agitated, though, and the planters were desperate.

. . . A buffalo was taken from the area where a tea worker had heard a tiger cough and we decided it was time to go into action. Major Burnett had been rehearsing the tribesmen for several days,

so they went to work with a military precision that saved much time. They surrounded the piece of jungle we had decided upon, set up their nets and braced them with poles, leaving a gap about fifty feet wide.

The camera crews moved portable platforms into position, but I decided to remain on the ground for mobility with my camera and an armed guard beside me. Lowell and several other riders were on elephants; near them on the ground were beaters on foot, ringing bells, striking gongs and beating drums. Enough noise to scare life out of the poor tiger, if he were to be close by.

Then I saw him. Just a glimpse through the undergrowth but he was definitely headed toward the netted enclosure. I moved to a place opposite the opening, my guard close behind. The elephants charged forward, the beaters on foot retreated, the tiger entered the enclosure and the tribesmen quickly closed the gap. It all happened so quickly and with such precision that I lost sight of the tiger, but he was hiding in a patch of bushes in front of me. Someone began throwing lighted firecrackers where we assumed him to be, and he left his hiding place and headed for where I was standing behind the nets. As soon as the camera was rolling and it was clear that I had the footage of the charging animal I shouted to my guard to shoot. Nothing happened so I turned to run. No guard in sight. The tribesmen who had been on either side of me jabbed at the tiger with their spears and one of them struck him in an eye. The animal roared in pain and I called to Boris to dispatch him. Man-eater or not, I was not going to see him slowly killed by spear jabs.

. . . In due course the film was finished and presented in color over the CBS network. It received surprisingly good reviews, due in part to the mediocre programs in the series that had preceded it. There were four more programs scheduled and the advertising agency asked me to direct all of them. I declined, not only because of the work involved, but because it would mean a lengthy separation from my family. Neil was a baby, but Murray had expressed fears that I would either die or return an old man. Barbara was a young woman and it was not easy for her to be alone so much of the time. My absence from Mary and our babies for six months while I was in South America had had a deleterious effect on our

marriage, and here again that pattern was about to be repeated. I needed the money and the amount offered by Thomas was far greater than I had ever earned before, but I settled for signing a contract to make two of the four films with a penalty of one thousand dollars if at the end of the first film I refused to make the second. I did not want to risk ruining our marriage.[16]

Van Dyke made only one of the two films he agreed to undertake, primarily because he did not like the fact that Thomas always had the last word about the editing. He also did not respect Thomas; he believed that the finished versions of the series were little more than Thomas's commentaries in a popular style, which Van Dyke said appealed to a certain nonthinking group of Americans. He felt that even if he could not have pride in the series, he had hoped at least it would represent his abilities as a craftsman. But in the end the *High Adventure* films he made for television were simply soulless.

Van Dyke returned to directing short commercial films for industry, but when he was invited to direct another television series, *The Twentieth Century* with commentary by Walter Cronkite, he could not resist—he would be working with the media's most admired journalist and lucrative pay would accompany the job. He worked with Cronkite on a half dozen programs between 1960 and 1965 covering a range of subjects: contemporary Ireland; Sweden's welfare policies and their impact on national morals; poverty in Appalachia; the Mekong river in Southeast Asia; and the changing nature of farms in America. He enjoyed working and traveling with Cronkite, especially in Ireland. He also worked on a segment for the series about farmers in Laos but with another network correspondent (his filmography lists the program as part of *The Twentieth Century* series with Cronkite, but it was an unnamed correspondent that worked on and produced the program with him). Only the program in Laos offered any of the intrigue of his earlier exploits for television. He described *Pop Buell, Hoosier Farmer in Laos* (1965) briefly in his memoir:

I agreed to make a film in Laos about an Indiana farmer who had reached the age of retirement, had enough money to last the rest of his life, and offered his services to the Agency for International Development. He wanted to help other farmers in underdeveloped countries, he said. I flew to Vientiane, the capital of Laos, where I was entertained by the U.S. Charges d'Affaires, given a "guide,"

who turned out to be a CIA agent, and flown into a remote village called Sam Thong. It was a supply post and hospital for a covert action funded by the CIA. The farmer had no knowledge of agriculture in the area, in fact there was none. He presided over a vast warehouse of medical supplies, a hospital, and a school for Laotian mountain children. He could barely speak English, much less any foreign language. Our evenings were spent around a fire at one end of the warehouse while our farmer and the CIA men discussed why we should bomb Hanoi.

. . . I returned to the United States with the footage I had shot and told of my findings. I assumed that the program would be scrapped and I was greatly surprised some weeks later when I saw it on TV blandly pretending to be an honest report on a caring American who was enduring hardships abroad in an effort to help the poor farmers of an underdeveloped country. Shortly after it was aired, Grenada television in England told the true story and exposed Pop Buell, the farmer, for what he was.[17]

Van Dyke was predisposed to a dislike for the FBI and the CIA so he would have been wary about making the film. In an interview with Isaac Kleinerman, coproducer of a series by Barbara Hogenson for Sightlines in the fall of 1983, Kleinerman claimed that the network did not know at the time that Pop Buell was part of a "CIA ploy." He was adamant that had it known it would not have broadcast the program. Van Dyke's claims about the journalistic failure of this program in the series begs the issue of why he and a news commentator would have been allowed to film Pop Buell in Laos if the situation was as blatant and obvious as he described in his memoir. On the other hand, the disclaimer by the Kleinerman has to be judged in the light of Grenada's exposé.

Despite the Laos controversy, Van Dyke's reticence about television had been overcome by the opportunity to work with Cronkite, and had renewed his faith in working with professionals. In many ways Cronkite's self-confidence and special journalistic integrity inspired Van Dyke to look about for ways to maintain his own professionalism, built up over forty years of involvement in the visual arts. At age fifty-nine he was ready to put aside filmmaking, which over the last decade he saw largely as a period of lost years. Some say that his great charm was able to win over fate itself, which was about to present him with the last great career change of his life.

8

Doing One's Damnedest

﹩ IRIS BARRY, WHO HAD ESTABLISHED THE FILM LIBRARY AT MoMA in 1935, decided in 1954 to take a sabbatical in France. One year became ten and her curator, Richard Griffith, kept the program alive and functioning during that period but did not expand on her vision. As a historian, he engaged filmmakers on a one-to-one basis but was less interested in the institutional responsibilities of the rapidly growing museum, according to Van Dyke. Both Barry and Griffith knew Van Dyke, liked him, had written about him, and had added his films to their collection. They were aware of his energetic leadership in the annual documentary filmmaker's meeting, the Flaherty Seminar. In addition to arranging international seminars, the organization offered opportunities to be introduced to contemporary filmmakers and their works and gave historical assessments of the medium, all of which provided Van Dyke a means of staying current in the field.

Begun in 1960 by Frances Flaherty, the widow of Robert Flaherty, to honor her husband's pioneering work in film in the early twenties, the seminars were an attempt to promote and recognize the contributions of documentary filmmakers. Robert Flaherty, explorer and geologist, had produced the world's first dramatic nature documentary, *Nanook of the North*, in 1922. Van Dyke became friends with Flaherty in his later years and they shared a passionate love for all aspects of documentary film, a term John Grierson coined to describe Flaherty's films. Van Dyke and his

friend and colleague Ricky Leacock, who had been a cameraman for both Flaherty and Van Dyke, were interested in social change, and they both had been influenced indirectly by Flaherty's films. The Flaherty Seminars became for them, as well as a majority of the independent film community, the essential voice of their evolving field during the sixties.

Iris Barry was invited to make a presentation at the 1964 Flaherty Seminar. She returned to New York to appear at the seminar and at the same time had a meeting with the then director of MoMA, René d'Harnoncourt. She was asked to help the museum find a new director for the film library before she returned to France. Barry knew of Van Dyke's wide influence in the film world and his reputation as a respected artist. They met at the seminar and she asked him to help her find the right person to take the MoMA program to its next plateau. Van Dyke agreed to help and after her return to France, he began the search in earnest.

From late summer 1964 to the beginning of 1965, Van Dyke presented names of numerous candidates to René d'Harnoncourt, who did not act on any of his recommendations. Then in February, the staff of the film library invited Van Dyke to present a public lecture on "The Film Library and the Filmmaker," a transparent occasion for staff to assess Van Dyke's public presence and whether or not he was museum material. Even the public could not have missed the connection between an outsider lecturing on a MoMA collection and an official unofficial search for a director. Van Dyke related the collection and the facilities of the film library to the needs and interests of filmmakers, researchers, and students. Before he gave his lecture, but while he was preparing for it, d'Harnoncourt asked to meet with Van Dyke, who described the meeting in his memoir as follows:

He asked me how I saw the function of the Film Library within the Museum's structure. I told him that I believed it should be accorded the same status as other Departments and be renamed the Department of Film. I also told him that the members of the staff of the Film Library were talented, hardworking, experienced people who were using no more than a small amount of their skills. The functions of the department and the skills of the people fulfilling those functions must be directed toward a policy, and I was not sure that such a policy had ever been articulated. For fifty years I had been looking at films and for more than thirty years I had been making them. I loved them, but only

some of them. I knew the power of a film when it was a work of art, and I felt that a film department in a museum of art should help audiences to understand the differences between those works that were made with integrity and those turned out on an assembly line with the sole purpose of making a profit. I knew that theatrical audiences were shown only a very few of the fine films that were made in Europe and Asia. I had enough respect for audiences to believe that they could enjoy many foreign movies if they had a chance to see them. I hoped that the Museum could help give them that chance.

Performers should take second place to directors and writers, I believe, and film buffery [sic] and cultism have no place in a museum. The examination and exhibition of works done in the past should have equal emphasis with current films and filmmakers, but if there is a choice, then the past should take precedence over the present, if only because there is so much more of it.

René d'Harnoncourt was born an Austrian count. He was a large man with courtly manners who spoke with a slight accent. He had a ready sense of humor and his eyes twinkled as he listened to the brash statement I made. He rose from his desk and he walked to the elevator with me, put his arm around my shoulders and towering over me, he leaned down and said: "Monseigneur, will you take the position? Don't answer now; call me when you are ready." A month or so later, on November 14, 1965, in the Museum's auditorium, Rene presented me as the new director of the Department of Film to the audience assembled to see my program of avant-garde films.[1]

Van Dyke had agonized over whether or not to accept the offer; it was Barbara's strong encouragement that ultimately persuaded him to take up the challenge. The position meant a substantial cut in income, which was not good timing for their family with their sons Murray and Neil already in private school at ages thirteen and eleven. They also had purchased a modest country cottage (no heat or running water) in the Catskills, near their friends Sasha Hammid and Maya Deren, both noted filmmakers. This country retreat was where Van Dyke's children from both marriages came to know each other and bond. It was where Van Dyke could play the patriarch and teach his sons about hunting and outdoor sports. But it was also

an essential retreat for Barbara and the boys since Van Dyke was away for much of their family life. His long absences from home did not cease when he finally accepted the MoMA position. He now traveled internationally to develop liaisons with other collectors and collections, to lecture, and to engage with European filmmakers.

In the fall of 1965 Van Dyke received a letter from Ansel Adams concerning an issue of *Film Comment* that featured Van Dyke's accomplishments as a documentary filmmaker. It was a timely affirmation from his old friend; it bolstered Van Dyke's self-confidence as he was about to embark on another journey of no little risk:

I am tremendously impressed with the material in FILM COMMENT which you kindly sent us. My only comment in the negative area is that there isn't one decent picture of you. The front cover is a ghastly aspect of a great man!

What is important to me is that you are revealed for what you are—a person of damned impressive dimensions!! You touch so many things at their very real and very positive core! I am poor at verbalizations—but a million cheers for you and for what you have done and for what you stand for!

. . . It seems to me that you have used protest both intelligently and constructively—which is hard to affirm about many workers in the social vineyards today.[2]

On January 1, 1966, Van Dyke presented his first public program on avant-garde film, which was devoted to underground film. It was significant that he did not choose a more conservative subject from history or from the collection. He intended for the public and museum trustees to understand from the beginning that his policy for the department of film would be extremely broad and not based on his personal interests as a filmmaker. But most of all it was a defining moment because suddenly, within the span of a few weeks, he had reclaimed his lost self-esteem and returned to the core of his creative interests, to the realm of art and artists, where his very soul resided. In fact, during his tenure at the museum, documentary film (largely taken over by television) was the genre least explored by he and his staff. The following excerpt from his introduction that night served notice to the film world and filmmakers that the museum's contemporary film programs were to be broad indeed:

Film artists are discovering and using the machines of our time: Projectors using many widths of film, 8 mm., 16mm., 35mm., 70mm., and multiples of these—two screens, three screens, five screens. The ceiling, the walls, the floor, Projectorsol light, slides, or film carried by hand and directed against mobile screens. And a dozen other ways of using moving light and form.

All of this ferment means that there is a great deal of experimentation going on and we have invited you here this evening to share with us such an experiment. In November the Film Library had a retrospective showing of so-called underground films. Stan Vanderbeek, the man who coined the term "underground" just a few short years ago is here with us tonight. He and his associates are engaged in an experiment to develop an art form that will express the speed of our lives and the proliferation of stimuli that comes with that speed. We are privileged now to watch an artist at work.[3]

Van Dyke had always loved experimentation in making films and had an innate fascination for gadgets and finely crafted tools, including cameras and guns. Invention was an exciting part of the process of being a documentary photographer on location. These likes easily translated into admiration, curiosity, and support for avant-garde film. In 1954 he had directed a film called *Toby and the Tall Corn*, in which his cameraman, Ricky Leacock, intuitively introduced cinema verité, the most avant-garde style of in-camera editing for documentary filmmaking at the time. The style became a genre of film itself over the next decade. In a wide variety of interviews, Van Dyke admitted to not liking that particular style himself, but in the hands of his fellow filmmakers he said he always believed it had unique expressive potential not available to conventional short films.

Bosley Crowther of the *New York Times* reviewed Van Dyke's earlier program of underground cinema:

Already, at the invitation of the trustees of the museum, he has arranged a program of avant-garde films from the works of the members of the Film-Makers' Cooperative, which will be put on in the auditorium of the museum next week. The program will be a representative selection of "personal statement" films made by

such independents—sometimes known as the "underground"—as Kenneth Anger, Bruce Baillie, Vernon Zimmerman, Stan Brakhage, and Stan Vanderbeek.

. . . The organization of more programs and discussions of contemporary films is one of Mr. Van Dyke's prime intentions. He hopes to arrange the showing of new films from Czechoslovakia, Russia, France and other producing nations, as well as continue the regular showings of old films from the library's collection.

He also plans to schedule more talks and lecture series by directors and technicians from all over the world, and to strengthen the relations of the film library with other film archives in other lands. It has not been a secret that the connection between the New York archive and the important Cinémathèque Française has been something less than close in the last few years because of a coolness between Mr. Griffith and Henri Langlois, the director of Cinémathèque.

The growing popularity of the annual New York Film Festival that was started at Lincoln Center for the Performing Arts three years ago has pointed up the insufficiency of the Film Library in satisfying the appetite of an expanding New York audience hungry for the culture and erudition of films.

A few days later, on November 21, 1965, Crowther followed up with an article in the *New York Times* about the department itself and a message to Van Dyke. Crowther decried the long ten-year slide of the film library, which in his opinion had all but abrogated its responsibility to the public in its meager offering of programs and film showings. He attributed the film library's demise to the expansion of Lincoln Center's programming and to the success of the New York Film Festival. He praised the appointment of Van Dyke and challenged him to open the museum to evening showings:

The not unexpected announcement of Willard Van Dyke to be the new director of the Film Library of the Museum of Modern Art heralds what many people in the local film circles hope will be a considerable replowing and reseeding of the fields of cinema culture hereabouts.

. . . [T]he appointment of a new director for the Film Library comes none too soon, if that valuable institution is to hope to

survive and thrive. And no one with more evident capability and eagerness to help it do so can be thought of than Mr. Van Dyke.

Not only is he a creative and distinguished director of documentary films (he began as a cameraman on "The River" 30 years ago and has turned out a score or more fine ones, including "The City," "The Bridge," and "The Photographer"), but he has been energetically active as a teacher, lecture promoter of film-makers groups, and a devoted supporter of the Robert Flaherty Foundation. (Devotion to Robert Flaherty is, of course, sine qua non.)

... Mr. Van Dyke has his work cut out for him. ... As a matter of fact, he gave evidence that this is what he intends with his first program—a showing of films of independent or "underground" film-makers, put on in the Museum's auditorium this past week. A symposium on the work of these fellows, held on Thursday night, gave a welcome and exciting opportunity for a lot of people to let off steam about a trend in picture-making that is both amusing and annoying to older folks.

Competitiveness, which had been one of Van Dyke's more unattractive traits in the past, suddenly became one of his most important assets in working with the torrent of egos that universally inhabit museum staffs. Ted Perry, who followed Van Dyke as director of the department at MoMA, described Van Dyke as "tough—he didn't suffer fools. He could be warm, but that wasn't his forte." One glance at a partial list of MoMA trustees and its advisory committee to the department in 1966 is sufficient to realize how useful Van Dyke's penchant for control and extreme competitiveness was to the process of creating the first department of film. The trustees included David Rockefeller, Alfred H. Barr Jr., John de Menil, Philip Johnson, René d'Harnoncourt, Edsel B. Ford, Simon Guggenheim, John D. Rockefeller III, Governor Nelson A. Rockefeller, James Thrall Soby, the Honorable John Hay Whitney, William S. Paley, Monroe Wheeler, and twenty-five others.

The equally powerful advisory committee included Gardner Cowles; Jack J. Valenti, (president, Motion Picture Association of America); Robert S. Benjamin (chairman, United Artists); Robert O' Brien (president, Metro-Goldwyn-Mayer); George Weltner, (president, Paramount Pictures); Simon H. Fabian (Fabian Theaters); George Sidney (president, Directors Guild of America); Michael Mayer (executive director, Independent Film

Importers and Distributors of America); and Gregory Peck (member, National Council on the Arts).

These trustees and advisors, significant contributors to American arts and society, voted in January 1966 to rename the expanded film library program outlined by Van Dyke the department of film. This change gave Van Dyke and the department parity in terms of budget and administrative standing with all other departments in the museum. This was a monumental achievement within a bureaucracy that had been rigidly defined since the late thirties.

The most important letter that Van Dyke wrote to any colleague concerning his appointment was to Iris Barry, living in Fayence, France:

> Of course you know the news; what you may not know is how happy I am.
>
> The chance to have a second career does not often happen. The opportunity to use the knowledge, skills, and love of film that I have gained in the past thirty years is most welcome. Someone asked what a documentary film maker was doing in a job like this. I think the question was only partly facetious, but it led me to ask myself the same question.
>
> A documentary film maker, I believe is a fellow with an analytical mind who has a certain skill in approaching a strange situation, quickly assessing the elements in it, marshalling whatever forces are necessary to cope with it, establishing an atmosphere in which creative talents can flourish, and patiently persevering until the project has been brought to a successful conclusion. I can do these things, and I enjoy doing them. Is this task so different? You, dear Iris, would know better than anyone.
>
> I remember with much gratitude, the way you received me in 1935 when I first came to New York. Your ready acceptance of this young man from the West, your help to me in meeting Grierson and Rotha. And through the years I recall with admiration your quick perception of the false, your keen appreciation of the true.
>
> And so it is with gratitude and a reasonable amount of humility that I begin to work. I shall do my damnedest: I cannot hope to bring the same distinction to the job that you did.
>
> With admiration and best wishes,
>
> Faithfully yours, Willard Van Dyke[4]

During his tenure, Van Dyke did bring distinction to the museum, a distinction that equaled and in some ways exceeded that of his good friend. He continued to add great works to the collection, but he was much more interested in programming and the politics of the institution and the field. In order to execute an ambitious policy that would make independent film-makers the frontline of his programming, he first restructured the department's staff. He had decades of experience in selecting and organizing film crews and was especially astute at spotting and giving opportunities to new talent. He organized the department in much the same way. He promoted one of the most industrious staff members (Margareta Akermark) to associate director, put a former programmer (Eileen Bowser) in charge of collections to give himself a greater role in public programming, and appointed a new employee (Adrienne Mancia), who had been a distributor of contemporary films for a commercial company, as film event programmer, a position which was to represent his primary interest as director. Together, Van Dyke and Mancia introduced a wide range of new film showings and festivals devoted to independent filmmakers, classical Hollywood films, international documentaries, and animation and arranged events featuring artists, actors, and directors. In a very short time the film library became a lively and often controversial department.

One of the first programs Van Dyke personally organized featured Maya Deren, who had been a close friend and the wife of Sasha Hammid, Van Dyke's collaborator on several films. Deren, whose work helped pave the way for avant-garde film in the forties, had died in 1961. The following introduction by Van Dyke, which preceded the evening's showing of her films, provides an intimate glimpse into the personality of both Deren and Van Dyke:

The Department of Film is privileged to present a program of films by Maya Deren. Miss Deren was one of the first Americans to use the short motion picture as a medium of personal expression. Her work was immediately recognized, by the forward looking and the young, as being fresh and important. It is probably fair to say that Cinema 16 would not have been nearly so influential in the immediate post-war years without her films.

These are very special films, very personal films, made by a woman who can never be forgotten by those of us who knew her. To pretend that it was always easy to know her would be to do her a great disservice—for when has it been easy to live with anyone as

single-purposed as Maya was[?] Her work, and her attitude toward it, was all-important to her, and the intensity that she brought to life, lives now in her films.

There was a period when Maya and I weren't talking. Some petty disagreement, which has long since been forgotten, stood between us. Finally one night at Amos Vogel's apartment, I went up to her and said, "Maya, you and I ought to stop this nonsense. I want you to know that I think *Study In Choreography For Camera* is a very important film." Maya looked at me for a long moment, and then said: "Van Dyke, *Study In Choreography For Camera* is simply a tour de force. Maybe someday you will have enough insight to recognize the values in my more important films." Ten years later I believe we all have reached that point.

First, we will show four of Ms. Deren's films. Then we will hear brief statements from Shirley Clarke, Pearl Primus, and Amos Vogel. Finally, we will show *Meshes of the Afternoon*, which some people consider her best film.[5]

Van Dyke was seen by his staff as explosive and argumentative; he was, in their view, a womanizer and an artist who brought cult figures and working artists into the department to schmooze, sometimes all day. But they also recognized that underneath it all, he was a softy and, as Mancia described him, "a father figure." He insisted that department staff give energy and professionalism to their respective responsibilities and in return he left them alone. He took the larger arena of public interest as his domain, but in the sense of educating MoMA's audience to radical views by artists and to socially challenging issues.

The most controversial program he introduced were films made by the medium's experimentalists, the "underground" artists who explored sex, religion, and politics. In one dramatic case he used his position at MoMA to testify on behalf of Jonas Mekas, founder and director of New York's major archive devoted to underground film, Anthology Archives. Mekas had shown a film by Jack Smith titled *Flaming Creatures*, which was ruled by three judges to be obscene. The film had scenes of masturbation, transvestites, and other sex acts. According to Van Dyke, Mekas was charged for holding a public viewing of the film, and Van Dyke came to his defense. Mekas eventually prevailed. Defending Smith's film and one by Kenneth Anger, *Scorpio Rising*, which dealt with homosexuality, Van Dyke said that

if a viewer is secure in his own self, in his feelings about the world, in his emotional reaction to things, and if his relationships with other people are mature, then these films will not be obscene to him. If these films appear obscene, it is simply because of the viewer's own lacks and insufficiencies.[6]

When he showed *Scorpio Rising* at Cineprobe, the name of the program he introduced to showcase avant-garde film in evening performances at the museum, he introduced it by giving a history of short independent films as a backdrop. He showed several films and ended the program with *Scorpio Rising*:

> The last film on our program is called *Scorpio Rising*. I hope it won't prejudice you too much if I say it is, in my opinion, one of the most interesting short films of the past ten years. It has a curious history; first shown in Los Angeles it was promptly seized by the police, who made huge enlargements of single frames from the film. The film was banned, the producer appealed the judgment and his appeal was sustained. The scenes from which the enlargements were made only appeared on the screen for short fractions of a second. The judge agreed that the first court decision had been based on still photographs, not on the movie. The film subsequently played in theaters in Los Angeles, San Francisco, and New York.[7]

Van Dyke had a strong commitment to justice and individual freedom. He was an eloquent spokesman for human rights and decried invasive politics. This aspect of his character, which dominated his public persona, carried over in his relationship with artists and colleagues for most of his life. It was also what endeared him to staff at the museum. They regarded him as one of them, not a MoMA person, which meant an elite class of scholars and wealthy patrons.

In an interview with Harrison Engle in the year of his appointment, Van Dyke spoke about himself as a filmmaker in the spotlight of the present but also elaborated on his general philosophy of working with people. The following excerpt makes clear just how easily his directing approach in film was transferred to directing the department of film:

As for myself, I don't have a style. But I can say certain things about the way I make films that differ from the way others make films. One of these things is my concept of directing. The job of a director of documentary films is to direct the creative energies of the people involved in the film toward the needs of the subject. Now that means that the director attempts to create a climate in which the participants feel they can reveal the situation in front of the camera in a significant way through film. . . . I believe there is a kind of mystic atmosphere that can be created around the act of making films in which people feel comfortable, they feel stimulated, they feel able to give the utmost that they have to the film.

Van Dyke's relationship with other museum department heads and trustees was essentially cordial and professional. Although he had played a part in the history of photography as an art, he had only a very friendly, superficial relationship with John Szarkowski, director of the department of photography. Van Dyke would periodically drop in to chat with Szarkowski at the end of the day. But their conversations were far from intellectual and almost never about photography. But both Szarkowski and Van Dyke had been photographers early in their careers, and in that they shared a perspective that artists can bring to advocacy roles such as theirs as curators and directors of museum programs.

Van Dyke was seen as an exceptional diplomat by Szarkowski in most every arena of museum operation, and he marveled that he and Van Dyke could maintain so cordial a relationship in view of the fact that they were competitors for the same funds within the museum bureaucracy.[8] But in Van Dyke's own department he was also seen as a tough negotiator with the trustees and museum administration. In his own words, he relished a good fight.

In an article for *Holiday* magazine, Michael Herr wrote about MoMA, tracing its history of personnel battles between staff and trustees, its evolution of the physical plant, and its growth in public programming. He described Van Dyke as follows:

The film library was allowed to decline drastically before a suitable director was found to replace Richard Griffith. The worst neglect

involved a great number of the library's 3,000 titles printed on perishable nitrate base. . . . Nearly $750,000 is needed to transfer them to durable triacetate stock. The film library now has a director who is an experienced filmmaker himself, well-connected with the more generous foundations and knowledgeably involved with the young independent filmmakers, whose work the Museum had hardly explored before. The Modern was lucky to find Van Dyke, but luck is not enough. Unless more money can be found to underwrite the Museum's vitality, the standard charge against the institution of dilettantism could one day be justified.[9]

Van Dyke took the battle for preservation to the trustees at one of his first meetings and with their support won the necessary funds to put the collection on the right track for responsible care and management. In his memoir, Van Dyke said that an administrative staff member had told him that the trustees' executive meeting opened with a report that showed the museum's portfolio at it lowest point ever, and so when John de Menil presented Van Dyke's request for nearly a two-thirds of a million dollars for preservation, the room grew quiet. John Hay Whitney, who had helped Iris Barry establish the film library, sensed that the request was about to be denied and quietly said that he thought the museum had a responsibility to preserve its collections. He pointed out that the films were an asset equal to the equities in the portfolio and should be seen as such. Two other trustees, Celeste Bartos and Lily Auchincloss, became staunch supporters of the department of film.

With the collections on a secure path for preservation, Van Dyke turned his attention to a growing threat from the Lincoln Center for Performing Arts. Amos Vogel, a friend of Van Dyke's, was in charge of the film programs at the center. But Van Dyke learned that the center had plans to create an annual film festival, which was to include a special contingent of filmmakers from Czechoslovakia.

Van Dyke had already been cultivating and showing the works of Czech avant-garde and documentary filmmakers for several years, and he had rigorously developed an international program that involved much of Eastern Europe. He believed he was being upstaged by the Lincoln Center and took his case to the trustees, asking that they write to the powers-that-be of the center, who were their counterparts in the community. He suggested that the festival be a collaborative effort between the museum and

the center and that the two institutions make clear their separate respective film plans for the future. His astute manner of squelching the Lincoln Center threat resulted in a behind-the-scenes agreement to cooperate and maintain a cordial relationship with it.

The collaboration resulted in the Festival of New Czechoslovak Cinema, which included twelve feature films and shorts never before shown in the United States. The works, jointly selected by Van Dyke and Vogel, reflected work being produced by young neorealist and cinema verité filmmakers. Van Dyke soon established himself and MoMA's film department as the new way that film would serve the City of New York and the international community. He had won the respect of most of the museum's trustees and the majority of artists and film devotees.

In 1969 Van Dyke introduced a festival of Yugoslavian films. A review of the festival by Mark Finston of the *Star-Ledger* on November 14 provides some insight into Van Dyke's unabated obsessive love for travel:

To arrange the current Yugoslav film festival, Willard Van Dyke, the director of the film department of the Museum of Modern Art, made his usual comprehensive investigation.

He went to Yugoslavia and sat through 20 movies each day for six days. . . . He sees about 400 [films] each year. After 30 years as a documentary filmmaker, he was chosen to head the museum's film department, exactly four years ago yesterday. To mark the occasion, his wife had four Jerusalem cherry blossoms placed on his desk.

. . . Van Dyke has long been interested in the type of motion picture produced in the Iron Curtin countries and has initiated festivals at his museum of films from Czechoslovakia, Russia, and Bulgaria. Early next year, feature films from Romania and Hungary will be shown.

Van Dyke understood the power of his position; at the end of his life he claimed it was the sole thing he hated losing when he left the museum. Using that power and the visibility of his position at the museum, he also publicly addressed larger social and political issues. During the early years of Nixon's presidency, he wrote letters using his museum title to various senators, including Senator Javits, Senator Fullbright, and President Nixon himself, to protest against the Vietnam war. The following letter was sent to Senator Javits:

Is there no moral strength left in Congress of the United States? Americans know that the North Vietnamese have already won the war, and deservedly so. We have been there for all the wrong reasons. Must the President now use the so-called peace as a device for a personal power victory? I feel only shame for our entire nation, and I loathe feeling that about my country. It is clear that Richard Nixon cannot end the war without going on a personal ego-power trip. The Congress must cut off funds for the continuation of this obscenity. The mills of the Gods grind slowly, but they grind exceedingly fine and America will pay dearly for the massacre of the Vietnamese during the last 12 days. The trickiness of stopping the bombing before Congress re-convenes should properly enrage the Congress.[10]

But protest comes in many forms and can lead to demands that may at times leave even the oft preached-to choir without a voice. During Van Dyke's eight years at the museum he experienced two strikes by MoMA's staff. The first strike early in his tenure was over the right to form a union, which was won, and the museum moved forward. But toward the end of his time at the museum the staff, from guards to curators, struck again—this time for wage adjustment and benefits. It was a long and bitter strike, lasting six weeks, and Van Dyke found himself on the opposing side of his own staff in the battle. As director of a department he could not belong to the union and was informed that it was his responsibility to keep the department operating, however minimally.

When he would leave to go home in the evening, his own previously close staff members were in the crowd surrounding the entrance and exits, shouting at him for crossing the picket line. They especially resented what they thought was a choice on his part, not realizing that his job was at stake, though theirs were not. Ironically, years earlier, when Van Dyke had been president of the Screen Directors Guild, he had led a strike for that union. This was one battle he did not find palatable, and the event took great emotional toll on him. He was deeply saddened by what he knew would be a permanent loss of the close friendships. His drinking increased during this period and his family life suffered, broadening the rift that had slowly been growing between him and Barbara.

He continued down his well-worn path of escape by traveling to other countries. Now, instead of making film, he was searching for international

avant-garde films, taking extended trips to Yugoslavia, Bulgaria, Poland, Czechoslovakia, and other countries. He was acclaimed by the New York press and cinema journals for the foreign festivals he was arranging, year after year, at the museum. Barbara was also taking on more responsibility; she was a staff and board member of the Flaherty Seminar, and she held various programming positions for film societies in New York. As their children were sent off to private school, they both chose to hide from the problems at home by devoting more and more time to their work.

Van Dyke brought not only exciting new film to America but the film-makers as well. As his reputation grew in museum activities, he was invited to lecture, publish, and participate in international organizations like the International Federation of Film Archives. In 1968 he was invited to chair the cinema faculty at the distinguished Salzburg Seminar for American Studies in Austria, and all expenses for both he and Barbara were to have been paid. When she learned a few weeks later that he had not told her and had gone to Europe alone, she was hurt deeper than ever before. All the old suspicions surfaced, and their marital difficulties achieved a new intensity. It was clear that things were going wrong again and that his second marriage was verging on separation, so he immersed himself even deeper into the museum's programs and events. He intensified his efforts on behalf of the foreign film program and brought films from Sweden, England, Brazil, Japan, India, Russia, Romania, and Hungary. Two programs he developed, What's Happening, devoted to newly produced documentary works, and Cineprobe, devoted to underground film, became all consuming for him owing to the number of the events he had to organize to accompany the programs. They were such a success that they continue as part of the museum's programs today.

Near the end of Van Dyke's eight-year tenure at MoMA, Richard Oldenburg became director of the museum. His working philosophy was simple, bold, and elegant. He believed it was the director of MoMA's responsibility to "hire stars [and] support them," to "expect iconoclastic behavior [and] . . . competition," and to "expect to confront the Board of Trustees on curators' and department heads' behalf."[11] He considered Van Dyke a gentleman with grace and poise. But he also was aware that he was tough minded and that he knew what he wanted. He even admired Van Dyke's controversial moves, such as introducing avant-garde and foreign films into the collection and programs for the first time.

But Oldenburg's high opinion of Van Dyke could not stave off his mandatory retirement in 1973. Van Dyke had been asked to retire for the first

time in 1971 under then director John B. Hightower. But Van Dyke protested and sent him a letter describing the assurances that he had received from René d'Harnoncourt and Henry Allen Moe, a trustee, when he was hired. He had been promised that he would be treated as an exception, since he was fifty-nine when he accepted the position in 1965. Van Dyke was granted a one-year extension of his appointment by Hightower, who left the museum shortly thereafter. Oldenburg became director and recommended that Van Dyke continue in his position. Then in 1973, Van Dyke was forced to retire by museum policy, which could not be bridged any longer.

Van Dyke felt betrayed but believed that he had probably angered some of the power structure over his various programs, and ultimately accepted the painful, if inevitable, end to his time at MoMA. At age sixty-seven, he had remained ever the idealist and romantic, having not paid serious attention to the workings of the museum administration as it changed over the years. He had so focused on the realm of his own domain that he had not attended to the bureaucratic necessities of his contract. He had been hired under a very different museum culture, which had allowed for informal and much less businesslike arrangements.

But neither was he naive. For two years before his departure he had been giving guest lectures the State University of New York at Purchase. On his retirement from MoMA he was hired at Purchase as a full professor and director of the film program. The film program did not yet exist. It was up to Van Dyke to establish it as full degree-granting program, which he did with distinction over the next five years. He was then mandatorily retired from the university at age seventy.

During his years of teaching at Purchase he approached the creation of the film program in the same way he produced and directed films and directed the film department of MoMA. He brought new talent to Purchase, which he knew could and would produce. Among those he hired were Vlada Petric, whom he had given an internship to at MoMA, paying for his expenses to come to New York. He had met Petric when he had been in Yugoslavia years earlier and had been impressed by his knowledge of film history and his achievements as director of the Belgrade Academy of Theatre and Film. The internship was simply a device used by Van Dyke to bring Petric to America. Petric stayed in New York with Van Dyke's help; he eventually became a professor at Harvard.

He, along with Shirley Clarke, Miriam Arsham, Ted Perry (who later became director of the film department at MoMA), and other filmmakers

Van Dyke had known and worked with, enriched the program on a regular basis. But the most important artist he brought to the program was Dick Rogers, a young, talented documentary filmmaker at Harvard. Rogers essentially ran the program, developed the curriculum, and helped the students to take advantage of Van Dyke and his experience. Rogers eventually went on to become an acclaimed filmmaker in experimental and documentary works, especially for PBS. He later returned to Harvard, after Van Dyke's departure from Purchase, to become head of the Film Study Center.

The Purchase years were essentially years of pleasure for Van Dyke, with one exception when he and the university were sued for a million dollars, because Van Dyke had refused a student graduation. Although the suit was dismissed in court it took its toll on Van Dyke, and he suffered his second heart attack in 1976. He wrote the following letter to his old friend Ansel Adams on the occasion of Adams's gift of funds to MoMA to establish a fellowship in honor of Beaumont Newhall in 1977:

John Szarkowski has just told me of your generous gift to the Department of Photography at the Museum of Modern Art. How marvelous of you, and what a broad and forgiving spirit you have shown. [Adams had been very vocal over the years about what he perceived as mistreatment of Newhall by MoMA during his years as curator of photography]. All of us can take pride in knowing you, not only for your fine work, but your good works.

Those of us who have followed the Department of Photography and its turnings and twistings through the years have not always been happy in the paths it has explored, but it is an important place, especially for scholars, and you have recognized it for the good things it is doing. Bless you.

It has been so long since we have had a chance to chat I thought you might be interested to know that I have been rediscovered as a photographer and I have busily been reprinting for five shows and a portfolio. The return to the darkroom after forty years has been quite an experience. To carry a full academic load, act as a trustee to the American Federation of Arts, advise the State Department on overseas exhibitions, be a consultant to the Public Broadcasting Service and A.T.&T. was more than I should have been trying to do and I had my second heart attack on my seventieth birthday

in December. I seem to have recovered completely, but I can only take one or two days a week in the darkroom at this point.

I will be mandatorily retired from the College on August 30th, 1978 and I expect that I shall go back into motion picture production. There are several projects that interest me.[12]

Adams wrote back:

How good to hear from you! I had intended to write you because I just heard about your recent troubles with your ticker. I beseech you to take reasonable care of it. I have apparently a slight "insufficiency" which concerns me a little, but it is hard to keep an extrovert down.

It is good news about your new directions and gratifying to know of your resurgence as a photographer! . . . I appreciated your words about our donation to the Museum of Modern Art. To sum up, I always had great faith in the potentials of the Department, but frankly, as you clearly know, I detested Steichen. I think he put photography back 20 years as far as a purely creative art medium is considered. I think Szarkowski is doing a magnificent job and my recent contact with him and the Department have been most encouraging.

Contrary to common opinion, I am not married to the f/64 outlook, although my own work is produced as felt and has not changed much over the years. I almost resent people imitating me or Weston or any of the older characters, because the future of the medium lies in the young and innovative approaches. I personally find a lot of the photography today very weak, sometimes sick, and sometimes tongue-in-cheek. I think the same situation obtained when we were young squirts and you were conducting "Pump and Circumstance" in Piedmont [683 Brockhurst, Oakland].[13]

As early as 1970 Van Dyke had been rediscovered as a photographer when he was invited to have a show of his photographs at the University of Pennsylvania. He worked with a custom printer and produced the show while he was still at MoMA. He confessed in a letter to Imogen Cunningham that he was flattered but that he believed he had been a minor photographer

and was not sure that the work would hold up.[14] However, being rediscovered as a photographer helped him, finally, to rediscover himself. Although he was still in the thick of film at Purchase, no one was knocking on his door for him to make films.

In 1974 John Szarkowski invited Van Dyke to serve as curator for a major retrospective exhibition of Edward Weston's work at MoMA. The process of traveling around the United States visiting collectors, photographers, and friends who owned Weston's works reinvigorated his interest in photography but as an advocate and as one who still loved the medium, not as the artist he once was. He seemed to be waiting for the voice of his mother to tell him that he had always been the artist she wanted him to be, and it was all right now to enjoy that remote part of life. The show was a great success, but it was not until he was invited by the Witkin Gallery in New York to have a one-person show of his own work in 1977 that he knew once again that in his deepest soul of souls he was still a photographer—an artist. He had always understood that the visual aspect of his films were informed by his photographer's eye, but he had come to believe that to be a filmmaker was to deny the photographer in himself, which in turn led to his other natural talent—directing and managing people and ideas in filmmaking and at the museum with flare and imagination. Hilton Kramer of the *New York Times* wrote the review, which was published on June 3, 1977, about his photography and films that Van Dyke had been waiting and hoping for:

The career of Willard Van Dyke, though attached in one way or another to the creative use of the camera, has been a many-sided one. . . . in the early 1930's, he ran a gallery of photography. In New York from 1965 to 1974, he was director of the department of film at the Museum of Modern Art, and earlier on he had himself made a number of distinguished films. . . . A few years ago, he organized the museum's mammoth Weston retrospective, and today, in his early 70's, he is professor of theatre arts on the Purchase campus of the State University of New York.

Because of this versatile career as a filmmaker, administrator and teacher the work that won him his first renown—the still photographs he produced in the 30s—has in recent years been somewhat overlooked. Yet that work has earned Mr. Van Dyke a permanent place in history of American Photography. . . .

In 1932, joining with Weston, Ansel Adams, Imogen Cunningham and others, Mr. Van Dyke founded the f/64 Group in San Francisco as a way of confirming a commitment to "straight photography."

. . . It is interesting to observe how this "straight" mode of photography has changed for us since its first appearance in the 30's. Its preoccupation with formal definition, with a certain kind of light and precision, now looks almost as "esthetic" to our eyes as the pictorial style it supplanted. Indeed, the very notion of "straight" photography has been radically changed in our time— it now tends to mean something less formal and more casual, something closer to a snapshot.

But this change only enhances the strength of Mr. Van Dyke's strongest images. If we now see these pictures as part of a tradition, it is because work of this sort has effectively altered the way we think about the power of the camera to give us images of permanence. It is a good thing, in any case, to be reminded that Mr. Van Dyke contributed something important to this tradition that he helped to create.

But troubled personal times also came to a head during his years at Purchase. He and Barbara had decided to separate in part because he was seeing another woman and in part because their home life had all but disappeared. Barbara had begun coordinating the Flaherty Seminar in 1963 and was also serving as executive director of its international film seminars, which she did for sixteen of her eighteen years with the organization. In 1968 she branched out to serve part time as a staff member for the Center for Mass Communications at Columbia University Press. She also began to be called on by other organizations to serve as their film programmer.

Both Van Dyke and Barbara knew two young filmmakers, Austin Lamont and Amalie Rothschild, from the Flaherty Seminars. Austin Lamont later published *Film Comment*, an important journal of film during the seventies. At about this time Lamont convinced Van Dyke to let him make a film about his life. For several months they worked on the film, but eventually time, circumstances, and money inhibited their venture and the footage was put on the shelf, the film unfinished.

Barbara, ever the caretaker, suggested to Van Dyke that the opening of his prestigious show at the Witkin Gallery would provide the

perfect occasion on which to revive the film. She suggested that they contact Rothschild to see if she would be willing to work on the film. She agreed and Lamont became the producer, generously turning over all of his research and materials to her. Rothschild worked long and hard on the film, becoming a devotee to her subject, though she also worked hard to remain an objective professional.

At first Van Dyke did not take the effort seriously, but when he began to see the talent and the energy of the young filmmaker he changed his attitude completely and was soon deeply committed to it and prepared to do whatever was asked of him for it. The process of making the film continued, and it eventually became a polished documentary of the life and multiple careers of Van Dyke. Titled *Conversations with Willard Van Dyke*, it was released in 1981 and was reviewed with positive interest in newspapers and journals from New York to Los Angeles. In the January 12, 1982, edition of the *Los Angeles Times*, Linda Gross wrote a full-page review for which she interviewed both Rothschild and Van Dyke. Rothschild's own comments in the review about Van Dyke and about the content of the film were, however, rather cryptic:

"Willard is a man who's not entirely satisfied with his life and career," she said. "I admired his willingness to articulate his feelings particularly because he is a person that most of us consider a success. The truth is that the majority of people have mixed feelings about their lives," Rothschild said, "and I think it's poignant. There is a lesson to be learned in Willard's story because some of us right now are at the crossroads where we still can perhaps make certain choices."

By 1979 the separation from Barbara was complete, but the word "divorce" was never mentioned. In fact they continued to write to each other. The letters were at times loving and at other times brutal and accusatory. In 1980 Barbara wrote a letter that set the tone for the remainder of their life together:

One of the things that I enjoyed in our marriage was that we talked together a lot. At first you shared nothing with me of your film work. You used to discuss Affiliated matters in detail with Alla [Van Dyke's daughter] and I overheard, but it was years before you shared

your professional concerns with me. I figured it was a hang over from the competitiveness between you and Mary and I tried to be patient. Maybe the age difference and experience difference was too big an obstacle. I was certainly in a different place of development at 26 than you were at the peak of your career. I wanted to find out, you already knew—or acted as if you knew everything and that was often intimidating to me. But over the years you seemed to trust me a bit more and more and the best years of talking and sharing were certainly the Museum years. I miss that, but I also find that there is a whole world of ideas out there and others to talk to and share with. I don't want to lose talking with you—it was great fun to have a few drinks with you the other night. It was good to talk again.[15]

In 1984 Van Dyke wrote Barbara from their old getaway in the Catskills about the activities he was engaging in before returning to Santa Fe, where he had moved to in 1981. His closing remarks blew on the coals of their relationship, keeping alive the tempestuous love and life they had shared: "I love you and I am glad we can be friends. I feel more relaxed with you than I ever have." Nevertheless, in the background and in the seclusion of Santa Fe, he was involved in several affairs at that very moment, the most lasting of which was again with a young woman nearly five decades his junior.

Van Dyke and Barbara remained separated right up to Van Dyke's death, but they also remained married, seeing each other from time to time when things were just right on one or another visit.

During the period between 1977 and 1980 Van Dyke finally received recognition for his photography, which was nearly equal to the acclaim for his thirty years of his filmmaking. He had more than a dozen shows of his photographs made in the thirties at leading museums and galleries. Among the most important were exhibitions at the George Eastman House, the Carpenter Center at Harvard University, the University of Pennsylvania, the University of Missouri, the Milwaukee Center for Photography, the Clarence Kennedy Gallery in Cambridge, Massachusetts, Film in the Cities Gallery in St. Paul, the Kenyon Gallery in Chicago, the White Gallery in Los Angeles, the Wirtz Gallery in San Francisco, the Witkin Gallery, and the Neuberger Museum, among others. He also was recognized by the George Eastman House with a distinguished award for achievements in photography and film, which included a public award ceremony, an exhibit, and screenings of a selection of his films.

At age seventy-three he returned to making new photographs with a large-format camera very much like the one he used in the thirties. Polaroid Corporation had a program that gave a new product, large-format film, to leading photographers and Van Dyke was among those selected. With his son Murray as his assistant, Van Dyke made a number of Polaroid prints but found the new film limited in its applications. Nevertheless, the Polaroid program served to get him back into photography again and this time with color images.

In 1979 and 1980 Van Dyke went to Ireland with his son Murray and Amalie Rothschild. On this trip Van Dyke was eager to make photographs with conventional color film, which he would print as elegant dye transfers. Murray shared his father's interests in film and photography more than any of Van Dyke's children. He studied film at the School for the Visual Arts in New York. After graduation he worked for a several years with his father on various films and became an assistant to a number of other filmmakers, including Roger Barlow (one of Van Dyke's former colleagues and closest friends) and Godfrey Reggio for his classic film *Powaqqatsi*, about the human cost of modern life.

Color was an extreme challenge for Van Dyke as it had been for most photographers through the 1970s, at least among those who were pursuing the camera as an artistic medium. Color photography had a long history reaching back to the nineteenth century, but it was only in the 1970s that it was finally exploited artistically on a widespread basis. Van Dyke had seen both of his closest friends, Edward Weston and Ansel Adams, experiment with color in the forties and fifties but without great satisfaction or acclaim. So for him it was still a new frontier that held great challenges. The works he made in Ireland were color renditions of his work during the years of Group f/64, largely devoted to landscapes. These works represented his return to the principles and ideas of his earliest work with Weston. They were elegant summations of landscape and architecture, which replaced the grayscale of black-and-white images with vibrantly balanced selections of unique color found on the coast and inland dells. The trips were funded by the Ford Foundation, on the recommendation of Ansel Adams, who by this time was the most well-known American photographer in America. In 1980 Van Dyke wrote to Adams:

I want to thank you again for your most generous help in getting me off to Ireland. . . . I leave on Saturday the 21st with my son

Murray. We will be gone about six weeks. . . . Eastman Vericolor is a much more stable and flexible medium, but I still prefer a fine black-and-white image.

It would be impossible for me to convey to you the pleasure I am getting from returning to PHOTOGRAPHY. I understand why I went into the medium of documentary film, and I suppose I would do it again, but the pleasure of knowing that the image you are presenting is solely your own, and the amount of control you have over the way it looks is overwhelmingly important.

You and I have traveled long roads, quite different, but strangely in harmony. I think of our little band and each of us individually has nothing to be ashamed of.

P.S. Have you noticed the renewed interest in Mortensen? I wonder why. I recall with humor the way you and I rose to the attack, so many years ago. But I still think we were right. The one thing that consoles me is something Arthur Racicot said: "Like an army mule, he has no pride in his paternity, and no hope of posterity."[16]

In 1981 Van Dyke made a trip to Santa Fe, New Mexico, to visit his son, Murray, who had moved there in 1980. Murray had also discovered the hypnotic pull of the Southwest that had inspired his father and Weston so many years before. When he first arrived in Santa Fe, Murray understood his father's attraction to the famous little city: "On Saturday night at about midnight I was walking on Water street and in the silence I could hear a car start somewhere up in the canyon; a dog barked in the north hills. I could smell the piñon and juniper smoke and I knew I was home."[17]

After his visit Van Dyke decided to move to Santa Fe. It was the first time he had been back to the Southwest since he and Peter Stackpole had made their trip for *Life* magazine in 1937. On that trip Van Dyke had found Santa Fe's culture to be decadent and not at all the place he had remembered when visiting with Weston several years earlier. His general impression had been negative about everyone he met and everything he experienced, except the landscape. But, now, his love for the West and his renewed commitment to photography cast a different light on Santa Fe. With his son nearby, he rediscovered a sense of family closeness that he needed, and there was a new circle of friends and photographers to engage, including Eliot Porter, Paul Caponigro, and Beaumont Newhall, who were all living in Santa Fe.

Van Dyke was seventy-five when he returned to Santa Fe. He made a number of new friends and enjoyed regular attention from his son, Murray, and they often made photographic excursions together. He found himself regularly in the company of several women, mostly artists. He and Barbara continued to correspond in frank but loving ways. She knew through the grapevine that he was sleeping with a new round of women, and she would take him to task, still offended that he should carry on in this way and yet not divorce her. But then, she never wanted to divorce him either. He told her in one of his letters that he did not want a divorce because he wanted her to inherit whatever material things he might own on his death, including his small retirement and pension funds. He told her flatly that he thought he owed her that at the very least. The question of divorce never came up again, and to the end Barbara continued to hope that the separation might end and that they would once again be together.

In 1984 Van Dyke was invited to Harvard to be a visiting artist by Susan Zielinski, the director of the learning and performance program. He gave lectures, met students, and held court at dinners, typical of most visiting artist programs. But in those short few days he also struck up a friendship, a true friendship, with Zielinksi and began writing her letters immediately on his return to Santa Fe. Zielinski, a poet and very outgoing person, greatly admired his accomplishments but also enthusiastically enjoyed his frankness, openness, and easy manner in establishing an intimate trust with other people almost immediately, something she had seen at work with students and herself.

In September, Van Dyke learned that Zielinski had persuaded Myra Mayman, director of the Office of the Arts at Harvard and Radcliffe, to appoint him as the program's first artist laureate for the year 1986. On December 5, 1985, Van Dyke received the formal letter from Harvard. The letter stated that Artist Laureate program was being established to honor artists who had contributed a lifetime of distinguished achievement in the arts and to provide the time and an environment for them to continue work on projects in progress [his memoir].

In late January 1986 Barbara flew to Santa Fe to help Van Dyke organize his departure and to drive him to Cambridge. In spite of what they both thought about ever being together again, here they were, together, about to launch a new Van Dyke adventure, both equally filled with anticipation and excitement. But their love story was about to have its final chapter. As they drove through state after state and shared the most peaceful

time together since they were married, Van Dyke had his last heart attack and died in a hospital on January 23, 1986, in Jackson, Tennessee.

One year earlier on December 12, 1985, Van Dyke had written the following letter to his lifelong friend, Ralph Steiner:

> Toward the end of my stay in the hospital [near the family retreat in the Catskills] I had a very vivid dream. There was a very attractive man of uncertain age along side me. We were walking on the beach having an animated and stimulating conversation. The sky was overcast and the sounds that came from the sea were not reassuring, but I felt fine and I was enjoying the conversation. I felt as if my companion was an old friend, a person whom I had known always. I looked at him carefully and was surprised to see that he/she was androgynous. He smiled gently and said goodbye, assuring me that we would meet again; that I had been walking with death and found him an old friend. The androgynous part is puzzling.
>
> I developed a depression several days later, but this time I feel only a desire to get to work and instead of depression I feel euphoria. It is five o'clock in the morning and I am happily at the typewriter. My friend did not meet me on the beach this time, and I have a lot to do before I go with him.[18]

On February 9, 1986, Barbara organized a memorial service for Van Dyke at the Cathedral Church of St. John the Divine. Making presentations at the service were Pete Seeger, Ricky Leacock, Shirley Clarke, James Karen, John Szarkowski, Jonas Mekas, and Norris Houghton; in addition, Ralph Steiner sent a message, the text of which was edited by Barbara, to be read during the memorial. The full text follows, serving as a fitting end to a diverse and passionate life for which there was no reality but art itself:

> Willard was very much of a somebody and so he was able to give a great deal without diminishing himself. Wasn't it a great religious leader who said that by giving we increased ourselves? There is a saying the Jews have which, in a broader way, tells about giving and retaining. It says that the only money you can carry into heaven in your pockets is that money you have given away in your lifetime. Willard had little money to give, but his pockets were bulging with other kinds of gifts.

One gift I envied—I am somewhat of a Jewish Puritan, and all too often see things narrowly. I was astonished when Willard told me of lying on his back in the straw of a barn, looking up at the white painted ceiling on which there was projected 180 degree— we call them "fish eye" lens—films. They were experiments by a film maker whose work I thought wildly sloppy, and I started to sound off scornfully about this experiment. Very quietly Willard calmed me down, and spoke of the need for experimentation, even though without a sense of direction, in the hope of growth. I say at that time that Willard was far more patient and hopeful with the young than I, and I envied his greater openness.

Willard often spoke of his disappointment that his films did not—as one hoped in the idealistic thirties—change the world. But the fact is that he changed individuals with whom he came in contact—especially the young. Edmund Burke said: "All that is necessary for evil to prevail is that good men do nothing." So I think Willard did change the world. And for that we who knew him are in his debt.[19]

A Brief Chronology

1906 Willard Ames Van Dyke, born December 5 in Denver, Colorado, to Louis
 Williamson Van Dyke and Pearl Ames. Childhood (1911–19) spent in Fort
 Collins, Colorado; New Orleans, Louisiana; Los Angeles and Oakland
 (Piedmont), California
1918–20 Receives first camera, a folding Kodak, from family friend; works as
 extra in the film *Rubaiyat of Omar Khayyam*
1921–25 Attends Piedmont High School; meets Mary Jeannette Edwards; gradu-
 ates high school; embarks on three week adventure through four states
 with three friends; enters University of California, Berkeley
1925–26 Leaves the university after two years; meets John Paul Edwards; uses his
 darkroom and library to teach himself about art and photography
1927 Commits to being a photographic artist and becomes engaged to Mary
 Jeannette Edwards
1928 Meets Annie Brigman and Imogen Cunningham and Edward Weston
 through John Paul Edwards
1929 Lives and works with Weston for three weeks in the fall, which results in
 mentorship by Weston and lifelong friendship
1930 Continues working with Weston, traveling between Oakland and
 Carmel; rents 683 Brockhurst from Annie Brigman and establishes
 studio and gallery with Mary Jeannette Edwards; returns to University
 of California, Berkeley, for one year, where he directs and acts in little
 theater groups
1931 Organizes Group f/64 with Edward Weston, Ansel Adams, Imogen
 Cunningham, Sonya Noskowiak, Henry Swift, John Paul Edwards, and
 Preston Holder (the last of whom was interested participant but not
 member of original group)
1932 Has solo exhibition at M. H. de Young Memorial Museum in May and
 group show with Group f/64 at same museum in November/December;
 begins writing articles for *Camera Craft*
1933 Travels with Edward Weston and Sonya Noskowiak to Taos,
 New Mexico, at invitation of Mabel Dodge Luhan in June; exhibits with
 Group f/64 at Ansel Adams Gallery in San Francisco; has solo exhibi-
 tions at Watrous Gallery in Carmel and San Diego Museum of Art;
 gives Weston his first retrospective exhibition at 683 Brockhurst; forms
 union for service station workers

1934 Serves as photographer for government program (Public Works of Art Project in northern California); experiments in film with Preston Holder; writes article on Dorothea Lange for *Camera Craft* and presents solo exhibition of her photographs at 683 Brockhurst; introduces Dorothea Lange to Paul Taylor, who is frequent visitor to gallery; engaged by Taylor to photograph cooperative lumber camp in Oroville, California, along with Dorothea Lange, Mary Jeannette Edwards, Preston Holder, and Imogen Cunningham; makes first film of lumber camp; organizes juried exhibition at 683 Brockhurst titled First Salon of Pure Photography

1935 Abandons life as photographic artist to become filmmaker; ends engagement to Mary Jeannette Edwards; moves to New York; travels to USSR and Europe with family friend; returns to New York and meets Ralph Steiner, Paul Strand, and Iris Barry; joins Nykino and begins making films with strong socialist content; takes acting and directing classes and directs plays for the Group Theatre; makes living as freelance photographer for *Harper's Bazaar*, *Scribner's*, and *Architectural Forum*

1936 Serves as cinematographer and part-time director of Pare Lorentz's historic documentary film, *The River*, about land erosion along the Mississippi River. Other cameramen include Floyd Crosby and Stacey Woodard (film released in 1937 with music by Virgil Thompson)

1937 Photographs with Peter Stackpole on photographic trip across the United States from New York to California; makes last photographic trip with Edward Weston up northern California coast as part of Weston's Guggenheim project; finally gives up all photography for film career and returns to New York to resign from Nykino which becomes Frontier Films

1938–39 Finally marries Mary Gray Barnett on January 2, 1938 (marriage ends in divorce in 1950); two children, Alison (1939) and Peter (1941); forms company with Ralph Steiner called American Documentary Films; serves as initial cameraman for *Native Land* by Frontier Films but quits in dispute with Paul Strand and Leo Hurwitz; begins codirection and production of historically acclaimed film *The City* with Ralph Steiner (film released in 1939 and shown for two years at the New York World's Fair)

1940 Most productive period in film career as director and writer, resulting in five independent films, including *Valley Town*, *The Children Must Learn*, *Sarah Lawrence*, *To Hear Your Banjo Play*, and *Tall Tales*

1941–42 Travels to South America with Ben Maddow to make *The Bridge*, released in 1942, a study of South American economics in relation to North America (Maddow was writer; Van Dyke was director and cameraman)

1943–45 Becomes chief of technical production for OWI, Bureau of Overseas Motion Pictures, and serves as liaison officer between OWI and Hollywood scriptwriters; produces and directs four notable films, including *Oswego*, *Steeltown*, *Pacific Northwest*, and *San Francisco*, the official film record on the founding of the United Nations

1946–50 Cofounds Affiliated Film Producers, Inc., with John Ferno, Irving
 Jacoby, and Henwar Rodakiewicz and makes short films for U.S.
 Information Service, the Mental Health Board, and McGraw Hill;
 directs *The Photographer* (1947) about Edward Weston; divorces
 Mary Barnett and marries Barbara Millikin (June 1950)
1952 Son, Murray Weston Van Dyke, born New York (August 6);
 continues directing and producing films for Affiliated Films
1953–54 Directs commercial films for Ford Motor Company, *Omnibus* television
 series, and Department of Public Education; son Cornelius Van Dyke
 born New York (April 13, 1954)
1955–58 Continues making commercial and commissioned documentary
 films; directs with Shirley Clarke *Skyscraper*, which wins two awards
 at Venice Film Festival and is nominated for Academy Award; resigns
 from Affiliated Film and creates own company, Van Dyke Productions;
 directs films for Lowell Thomas's television series *High Adventure*
1959 Receives Blue Ribbon Award from American Film Festival for *Land
 of White Alice*
1960–65 Directs films for CBS television series (*The Twentieth Century*) with
 Walter Cronkite; appointed director of MoMA's film department
 (department founded by Van Dyke based on former museum film
 library directed by Iris Barry)
1966–73 Directs film department at MoMA and introduces programs for
 showing Hollywood classics and for acquiring and showing films by
 contemporary "underground" filmmakers and foreign filmmakers;
 named president of annual Flaherty Seminar; serves as chairman of
 Salzburg Seminar in American Studies; chairs Public Media Panel for
 the National Endowment for the Arts; forced retirement from MoMA
 (1973)
1974–78 Founds film program at the State University of New York at Purchase
 and teaches with various former filmmaking colleagues until retire-
 ment; separates from wife; receives Silver Cup for lifetime achieve-
 ment in film from George Eastman House International Museum of
 Photography and Film; has numerous solo exhibitions across the
 United States
1979–80 Returns to still photography and receives Ford Foundation Fellowship
 to photograph in Ireland
1981 Subject of documentary film *Conversations with Willard Van Dyke* by
 Amalie Rothschild; moves to Santa Fe, New Mexico
1982–84 Continues to make photographs and to exhibit; lectures nationally;
 appointed visiting artist, Harvard University
1985–86 Named first artist·laureate in residence for Harvard and Radcliff; dies
 of heart attack in Jackson, Tennessee (January 23, 1986), en route by
 car with wife, Barbara, from Santa Fe, New Mexico, to Cambridge,
 Massachusetts

Notes

Abbreviations

AA	Ansel Adams
AL	Austin Lamont
AR	Amalie Rothschild
AVD	Alison Van Dyke
BH	Barbara Hogenson
BM	Ben Maddow
BVD	Barbara Van Dyke
CCP	Center for Creative Photography
CW	Cole Weston
DLJ	David L. Jacobs
DO	Dick Oldenburg
DR	Donald Richie
HE	Harrison Engle
IC	Imogen Cunningham
IB	Iris Barry
JB	James Blue
JE	James Enyeart
JS	John Szarkowski
LM	Linda Montoya
LWVD	Louis Williamson Van Dyke
MB	Mary Barnett
MCVD(W)	Mary Catherine Van Dyke (Wanda)
MEM	Memoir
MM	Margaretta Mitchell
MVD	Murray Van Dyke
MW	Mike Weaver
PL	Pare Lorentz
RS	Ralph Steiner
SL	Susan Landgraf
SW	Sol Worth
WA	William Alexander
WVD	Willard Van Dyke

Introduction

1. Edgar Allan Poe, "The Daguerreotype," in *Classic Essays on Photography*, edited by Alan Trachtenberg (New Haven, CT: Leete's Island Books, 1980), 38.
2. Charles Baudelaire, "The Modern Public and Photography," in *Classic Essays*, 88.
3. CW/JE taped interview, June 2001, Carmel, CA, author's archive.
4. RS to JE, October 5, 1985, author's archive.
5. RS to WVD, July 1, 1985, author's archive.
6. LM/JE taped interview, spring 2002, Santa Fe, NM, author's archive.
7. WVD to MB, n.d., author's archive.
8. AL to WVD, n.d., author's archive.
9. BVD to DR, December 19, 1987, author's archive.
10. BM to JE, February 27, 1987, author's archive.

Chapter 1

1. MEM, 2–3, author's archive.
2. BVD to JE, n.d., author's archive.
3. *Hamlet*, 1.3.78–80.
4. WVD to AVD, n.d., author's archive.

Chapter 2

1. MEM, 1, author's archive.
2. MEM, 10–12, author's archive.
3. WVD short story, 1916, WVD estate.
4. MEM, 13, author's archive.
5. MEM, 15–16, author's archive.
6. MEM, 19, author's archive.
7. MEM, 24–25, author's archive.
8. MEM, early draft, 25, author's archive.
9. F. J. Mortimer, "The Year's Work," in *Photograms of the Year 1925*, edited by F. J. Mortimer (London: Iliffe, 1925), 6.
10. Van Dyke diary, 1925, WVD archive, CCP.
11. MEM, 30, author's archive.
12. The Stieglitz letter is referred to in a letter from DLJ to JE, May 13, 1983. The letter is located in the Weston archive, CCP.
13. RS to WVD, n.d., author's archive.
14. Howard Zinn, *A People's History of the United States*, rev. ed. (New York: HarperPerennial, 1995), 373.
15. MEM, 20, author's archive.
16. MEM, 22, author's archive.
17. MEM, 24, author's archive.
18. Judy Dater, *Imogen Cunningham: A Portrait* (Boston: New York Graphic Society, 1979), 42.

19. Thomas Craven, *Modern Art: The Men, the Movements, the Meaning* (New York: Simon and Schuster, 1934), 312.

20. MEM, early draft, 38, author's archive.

21. BM, *Edward Weston: His Life and Photographs* (Millerton, NY: Aperture, 1989), 103, 106.

22. MEM, 43, author's archive.

Chapter 3

1. WVD/BH, "The Reminiscences of Willard Van Dyke" (1981), 17, in the Oral History Research Office Collection of Columbia University.

2. WVD/JB interview, August 2, 1972, 4, author's archive.

3. IC to EW, July 24, 1920, CCP.

4. WVD/JB interview, 4.

5. Nancy Newhall, *Mexico*, vol. 1 of *The Daybooks of Edward Weston*, edited by Nancy Newhall (Rochester, NY: George Eastman House, 1961), 55.

6. WVD/BH, "The Reminiscences of Willard Van Dyke" (1981), 51–52.

7. EW, artist statement, 1932, CCP.

8. EW, from original typed document in WVD estate, copy in author's archive.

9. EW handwritten note, 1923, author's archive.

10. WVD/BM taped interview, 1972, author's archive.

11. WVD, MEM, 41, author's archive.

12. WVD, MEM, early draft, 51, author's archive.

13. EW to MCVD(W), 1933, CCP.

14. EW to LWVD, 1931, author's archive.

15. WVD/BM interview, c. 1970s, 11–12, author's archive.

16. Howard Zinn, *A People's History of the United States*, rev. ed. (New York: HarperPerennial, 1995), 378–79.

17. WVD, original unedited manuscript for Group f/64 exhibition catalog, Jean S. Tucker, University of Missouri–St. Louis, 1, 1978, CCP.

18. WVD, MEM, 41–42, author's archive.

19. WVD, MEM, early draft, 49, author's archive.

20. WVD, "Dialogue: Willard Van Dyke," *Photograph* 1.4 (1977): n.p.

21. WVD, MEM, 35, author's archive.

22. WVD, original unedited manuscript for Group f/64 exhibition catalog, Jean S. Tucker, University of Missouri–St. Louis, 2–5, 1978, CCP.

23. EW to Seymour Stern, May 3, 1931, CCP.

24. WVD, MEM, from loose note, n.p., author's archive.

25. WVD, "Photographers of Today," in *Modern Photography: The Studio Annual of Camera Art* (London: The Studio, 1934), 24.

26. EW, artist statement, 683 Brockhurst Gallery, July 1933, CCP.

27. WVD, MEM, early draft, 58, author's archive.

28. AA to WVD, letters, 1932–34, CCP.

29. AA to WVD, letters, 1932–34, CCP.

30. AA to WVD, letters, 1932–34, CCP.

31. "Group: F64," *Camera Craft* 1.3 (1935): 110, 112, 113.
32. *The Letters between Edward Weston and Willard Van Dyke*, ed. Leslie S. Calmes (Tucson, AZ: CPP, 1992).
33. *The Letters between Edward Weston and Willard Van Dyke*.
34. WVD, MEM, early draft, 69, author's archive.
35. WVD/BH, "The Reminiscences of Willard Van Dyke" (1981), 16, in the Oral History Research Office Collection of Columbia University.
36. WVD, original poem(?), n.d., author's archive.
37. EW, handwritten note, n.d., CCP.
38. WVD/MM interview, July 16, 1978, 2, author's archive.
39. WVD interview with Kent Harber, *Daily Californian*, September 20, 1978, 12.
40. WVD, "The Photographs of Dorothea Lange," *Camera Craft* 1.2 (1934): 461–67.
41. WVD, artist statement, 1934, author's archive.
42. AA to EW, November 29, 1934, CCP.
43. EW to AA, December 3, 1934, CCP.
44. Original film script for "Automatic Flight of Tin Birds," WVD archive, CCP.
45. WVD, MEM, 48–49, author's archive.
46. AA to WVD, February 2, 1934, author's archive.
47. WVD/JB, interview, August 2, 1972, 8, author's archive.

Chapter 4

1. WVD, MEM, 1, author's archive.
2. WVD, MEM, 51, author's archive.
3. RS, introduction, *A Point of View* (Middletown, CT: Wesleyan University Press, 1976), 9.
4. WVD, MEM, 56–58, author's archive.
5. WVD/SW, interview, n.d., 20, author's archive.
6. WVD to EW, 1935, CCP.
7. EW, draft of letter to one of his sons, n.d., CCP.
8. AA to WVD, February 1936, author's archive.
9. WVD to AA, March 2, 1936, CCP.
10. AA to WVD, March 16, 1936, author's archive.
11. WVD/JB interview, August 2, 1972, 22, author's archive.
12. WVD, MEM, early draft, n.p., author's archive.
13. RS, introduction, *A Point of View*, 12–14.
14. WVD, MEM, 64, author's archive.
15. Harrison Engle, "Thirty Years of Social Inquiry: An Interview with Willard Van Dyke," *Film Comment* 3.2 (1965): 34.
16. WVD to MB; all letters from the making of *The River* quoted here are from copies in the author's archive.
17. Paul Rotha, *Documentary Film* (London: Faber and Faber, 1952), 200.
18. Cited in Robert S. Snyder, *Pare Lorentz and the Documentary Film* (Norman: University of Oklahoma Press, 1968), 66.

Chapter 5

1. WA, "Paul Strand as Filmmaker, 1933–1942," in *Paul Strand: Essays on His Life and His Work*, edited by Maren Stange (New York, Aperture, 1990), 154.
2. WA, "Paul Strand as Filmmaker," 154.
3. WVD to MB, June 7, 1937, CCP. All these letters were written during the *Life* magazine trip of June and July 1937.
4. WVD, MEM, 29, author's archive.
5. WVD to MB, August 12, 1937, CCP.
6. WA, "Paul Strand as Filmmaker," 57.
7. WVD, MEM, 85, author's archive.
8. WA, "Paul Strand as Filmmaker," 156.
9. WVD/SW, interview, n.d., n.p., author's archive.
10. WVD, "The Interpretive Camera in Documentary Film," *Hollywood Quarterly* 1.4 (1946): 405.
11. EW to WVD, April 18, 1938, CCP.
12. MW to JE, May 1, 2002, author's archive.
13. WVD, lecture manuscript, 1938, author's archive.
14. WVD, lecture manuscript, 1938, author's archive.
15. WVD to EW, February 27, 1938, CCP.
16. Richard Barsam, *Nonfiction Film: A Critical History* (New York: Dutton, 1973), 113–14.
17. WVD to EW, February 21, 1939, CCP.
18. Robert Friedman, "The City: The Rhetoric and Rhythm," essay manuscript, 1979, author's archive.
19. Henwar Rodakiewicz to Harry Dartford, December 19, 1951, published in "Unseen Cinema," Anthology Film Archives, New York, 2001.
20. Henwar Rodakiewicz to Harry Dartford, December 19, 1951, published in "Unseen Cinema," Anthology Film Archives, New York, 2001.
21. WVD/SW interview, n.d., n.p., author's archive.
22. Quoted in Stephen J. Provasnik, "Rhetorical Visions of the American Dream in *The City*," (honors thesis, Bates College, 1990), author's archive.
23. WVD, unpublished statement delivered before Filmmakers' Cinémathèque, New York, at a showing of *The City*, 1965, author's archive.

Chapter 6

1. G. Roy Levin, "Willard Van Dyke," *Documentary Explorations* (Garden City, NY: Doubleday, 1971), 188.
2. WVD, MEM, 90–98, author's archive.
3. WVD, MEM, early draft, 91, author's archive.
4. Lisa Katzman, "Reel Life: Roots of the Social Documentary," *Chicago Reader*, April 5, 1985, n.p.
5. WVD/BH, "The Reminiscences of Willard Van Dyke" (1981), 208–16, in the Oral History Research Office Collection of Columbia University.

6. WVD/BH, "The Reminiscences of Willard Van Dyke" (1981), 216, in the Oral History Research Office Collection of Columbia University.
7. BM, diary on the making of *The Bridge*, CCP.
8. WVD, MEM, 122, author's archive.

Chapter 7

1. WVD, "Fact Films in War and Peace," copy of unpublished original manuscript, 7, author's archive.
2. WVD, "The Documentary Film," *Bulletin of the American Library Association* 44.4 (1950): 123–24.
3. WVD/SW, interview, n.d., 117, author's archive.
4. WVD to EW, January 21, 1949, CCP.
5. WVD/BH, "The Reminiscences of Willard Van Dyke" (1981), 367, in the Oral History Research Office Collection of Columbia University.
6. WVD to EW, May 14, 1950, CCP.
7. BVD/JE interview, August 14, 1999, 32, author's archive.
8. BVD to WVD, October 7, 1949, WVD estate.
9. BVD to WVD, October 24, 1949, WVD estate.
10. WVD, MEM, 137, author's archive.
11. WVD, MEM, 140, author's archive.
12. WVD/JB interview, August 2, 1972, 46, author's archive.
13. WVD/JB interview, August 2, 1972, 46, author's archive.
14. WVD, MEM, 237, author's archive.
15. G. Roy Levin, "Willard Van Dyke," *Documentary Explorations* (Garden City, NY: Doubleday, 1971), 186.
16. WVD, MEM, 258, author's archive.
17. WVD, MEM, 295, author's archive.

Chapter 8

1. WVD, MEM, 300, author's archive.
2. AA to WVD, September 16, 1965, CCP.
3. WVD, original speech, WVD estate.
4. WVD to IB, January 1966, author's archive.
5. WVD, draft of speech, 1965, author's archive.
6. WVD/HE interview, *Film Comment* 3.2 (1965): 28.
7. WVD, handwritten introductory remarks for Cineprobe program, 1966, CCP.
8. JE/JS interview, December 5, 1999, n.p., author's archive.
9. Michael Herr, "Museum of Modern Art," *Holiday* (December 1966).
10. WVD to Senator Javits, n.d., author's archive.
11. JE/DO interview, March 2000, n.p., author's archive.
12. WVD to AA, March 19, 1977, CCP.
13. AA to WVD, March 22, 1977, CCP.

14. WVD to IC, April 21, 1970, CCP.
15. BVD to WVD, 1980, CCP.
16. WVD to AA, 1980, CCP.
17. JE/MVD interview, October 11, 2007, n.p., author's archive.
18. WVD to RS, December 12, 1985, author's archive.
19. RS, original draft of speech, author's archive.

Estate and Trust Permissions

Ansel Adams letter used with permission of Ansel Adams Publishing Rights
 Trust
Imogen Cunningham letter used with permission of Imogen Cunningham Trust
Ralph Steiner letters used with permission of Ralph Steiner Estate
Barbara Van Dyke letters used with permission of Willard Van Dyke Estate
Willard Van Dyke letters used with permission of Willard Van Dyke Estate
Edward Weston letters used with permission of Cole Weston and Center for
 Creative Photography

Index

opinion on Willard Van Dyke's writing in, 6–7; Van Dyke, Barbara's, opinion on Willard Van Dyke's writing in, 9; Van Dyke, Willard writing, 6

mental health: Affiliated Film Producers, Inc., impact of, 242; treatment for, 244

Meshes of the Afternoon, 279

Mexico, 22, 39–40

Meyers, Sidney, 241

M. H. de Young Memorial Museum solo exhibition, 71–72

Millikin, Barbara. *See* Van Dyke, Barbara

Missouri, 182–83

Model L Parvo camera, 166

Modern Art: The Men, the Movements, the Meaning (Craven), 38

Modotti, Tina, 39–40, 55–56

MoMA. *See* Museum of Modern Art

"Monolith Factory," 115

Mortensen, William, 29, 75

moving pictures. *See* film

Mumford, Lewis, 201

Museum of Modern Art (MoMA), 222; Adams's donation to, 287–88; avant-garde film program at, 273–76; Deren's work featured at, 278–79; "The Film Library and the Filmmaker" presentation at, 271; film library, expanded/renamed at, 276–77; foreign film programs' success at, 285; job offer at, 272–73; Lincoln Center, competition/collaboration with, 282–83; preservation battle at, 281–82; retirement from, 285–86; strikes impacting, 284; Van Dyke, Willard's, programming initiatives at, 278–81; Weston, Edward, exhibition at, 289

Nanook of the North, 149

Nash, Edith, 82–83

Nash, Willard, 82–83

Native Land, 190

Nevada, 30–31, 43

Newhall, Nancy, 56

New Masses, 164–65

New Mexico. *See* Taos

New Orleans: childhood and, 168; life in, 13, 23; move to, 22; *The River,* shooting in, 163–66

New York City: art in California compared to, 126–27; Barnett moving to, 143; culture in 1930s of, 135; move to, 12–13, 18, 128–29. *See also* Film and Photo League

Nielson, Caroline, 203

Nightmail, 149

Nixon, Richard, 283

Noskowiak, Sonya, 63, 68, 70. *See also* "Sonya Noskowiak"; "Sonya Noskowiak and Imogen Cunningham at 683 Brockhurst"

Nykino: communism, views of, 134; documentary film, views of, 133, 145; Frontier Films emerging from, 176; joining, 132; mission of, 129

Oakland, 24

Obregón, Alvaro, 39

Odets, Clifford, 135

Office of War Information (OWI), 226; censorship of, 243; films made at, 239–40

Oldenburg, Richard, 285–86

On the Waterfront, 133

Oswego, 240

OWI. *See* Office of War Information

Pacific Northwest, 240

painting: realism in, 2; of Shore impacting Edward Weston, 40

Pale Horseman, The, 245

People's History of the United States, A (Zinn), 34–35

Perry, Ted, 276, 286

Peru, 223–24

"Peter Stackpole," 105

Petric, Vlada, 286

Photograms of the Year, 28–29

Photographer, The: production of, 246–47; response to, 247–48; shooting, 236–38

photography: Adams on making a living from, 96; Adams on society and, 79; art v. science debate surrounding, 2–3, 194, 196–97; of Brigman, 35–36; camera's purpose in, 53; in childhood, 26; color and, 293; Cunningham on society and, 79; Cunningham on Edward Weston, and, 51–52; of Daguerre, 2; dream of, 27–28; of Edwards, Mary Jeannette, 70; elusive nature of, 1; film v., 186; invention of, 1–2; memoir on work ethic with, 59–60; perfectionism impacting, 66; *Photograms of the Year* on modern state of, 29; Stieglitz on Edward Weston, and, 33; of Strand, Paul, in *Camera Work,* 38; of travel to Nevada, 43; UXA documented in, 89; Van Dyke, Louis Williamson's, opinion on, 19–20; Van Dyke, Willard, on state of, 75, 78–79, 90; Van Dyke, Willard, on transition to film from, 71, 194–95; of Van Dyke, Willard, rediscovered, 288–90, 292–93; Van Dyke, Willard's, ascension in world of, 69; of Weston, Edward, impacted by sexual experiences with Modotti, 55–56;

of Weston, Edward, in Death Valley, 66; of Weston, Edward, in Mexico, 39–40. *See also* portraits of Van Dyke, Willard

Photo-Secession, 14

Place in the Sun, A, 143

Plow That Broke the Plains, The, 126; Lorentz, Pare's, and Strand, Paul's, disputes during, 161–62; premiere of, 147; reaction to, 148

Poe, Edgar Allan, 2

poems: of Van Dyke, Willard, 85; of Van Dyke, Willard, compared to Edward Weston's, writing, 86

Point of View, A (Steiner), 129–30

politics: Adams on art and, 139–42; Adams on Willard Van Dyke, and, 136–37; of *The City*, 198; of Frontier Films, 176–77; Group f/64 and, 69; of *The River*, 172–73; Steiner and, 145; of Strand, Paul, 39; TVA and, 155–56; Van Dyke, Willard's, work hurt by associations in, 256–59; of Weston, Edward, 59; Weston, Edward, on Willard Van Dyke, and, 135–36. *See also* communism; Marxism; socialism

Pollard, Spencer, 209, 211–12, 218

Pop Buell, Hoosier Farmer in Laos, 268–69

Porrett, Fred, 221, 224–25

portraits of Van Dyke, Willard, *42–43, 47*; by Gilge, *48*; shooting *The Children Must Learn, 46*; by Weston, Edward, *44–45*

Potemkin, 127

poverty: in Tennessee, 180–81; Van Dyke, Willard's, compassion regarding, 181–82, 184–85

Powaqqatsi, 293

"Preston Holder," *104*

prostitution, 153–55

Public Works of Art Project (PWAP), 96–97

"Puppeteer's Hands," *103*

"Pure Salon," 78, 165

PWAP. *See* Public Works of Art Project

Que Viva Mexico. See Thunder Over Mexico

Quiet One, The, 241

Racicot, Arthur, 294

racism, 160–61

"Railroad Semaphores," *117*

Reggio, Godfrey, 293

retirement, 285–86

Riskin, Robert, 239–40

River, The: crew frustrations in making, 158–59; flooding impacting, 170–72; Lorentz, Pare, and Van Dyke, Willard, collaborating on, 150–53, 157–58; Lorentz preparing for, 148; New Orleans, shooting, 163–66;

politics of, 172–73; reaction to, 174; shooting, 228–29; Van Dyke, Willard, benefiting from, 175, 185; Van Dyke, Willard, hired for, 149; work ethic on, 166. *See also* "Black Man Singing"

Rodakiewicz, Henwar, 130, 192, 201–3, 245

Rogers, Dick, 287

Rollins, Lloyd LaPage, 72

Roosevelt, Franklin D., 173, 177; Lorentz's support of, 146; Van Dyke, Willard, on, 134–35

Roosevelt Year: A Photographic Record, The (Lorentz, Luce), 146

Rotha, Paul, 174, 197–98

Rothschild, Amalie, 290–91, 293

Rubaiyat of Omar Khayyam, 26

"Rune of Women," 52

Russia, 177; film, inspiration from, 123; travel to, 123–26

Salsbury, Nate, 187

San Francisco, 240–43

"San Francisco Bay Bridge," *121*

San Francisco Film and Photo League, 127–28

Santa Fe, 185–87, 294–95

Sarah Lawrence, 208

Saroyan, William, 166–67, 184

Saxe, Al, 192

Schamberg, Morton, 59

Scorpio Rising, 279–80

Scribner's, 68–69

Seeger, Pete, 208

sexism, 219–20

sexual abuse: in childhood, 24–25; credibility of claims regarding, 122–23

sexual experiences, with Modotti impacting photography of Weston, Edward, 55–56

sexuality: Van Dyke, Willard on Edward Weston, and, 58–59; Weston, Edward, questions on, 57–58. *See also* homosexuality

Sheeler, Charles, 49, 59, 130

Shell: promotion offer at, 95; threats from, 97

Shore, Henrietta, 40

Sibelius, Jean, 123

683 Brockhurst gallery: creating, 72–73; destruction of, 128; Edwards, Mary Jeannette on, 73; Lange's exhibition at, 88; "Pure Salon" held at, 78; Van Dyke, Willard, on, 74; Weston, Edward's, retrospective at, 75. *See also* "Ansel Adams at 683 Brockhurst"; "Sonya Noskowiak and Imogen Cunningham at 683 Brockhurst"

Sloan, Alfred P., 215–16. *See also* Alfred P. Sloan Foundation

Smallens, Alexander, 232